Originally published in 1996 by INANOUT Press. © Paola Igliori.

Stills of Harry Smith films courtesy of Anthology Film Archives.

Excerpt from William Moritz interview with Harry Smith and biographical sketch of Jordan Belson reproduced courtesy of William Moritz.

John Cohen interview with Harry Smith copyright © 1969 John Cohen (reproduced courtesy of John Cohen and SING OUT! Magazine Inc.).

"The Art of Alchemy" and "Harry Smith's American Folk Music" copyright © 1989 AS IS.

"The Birth and Growth of Anthology of American Folk Music" copyright © 1973 Oak Publications.

Excerpts from Anthology of American Folk Music copyright © 1952 Smithsonian/ Folkways Records. Excerpts from The Kiowa Peyote Meeting copyright © 1973 Smithsonian/Folkways Records.

Excerpt from 1965 Film-Maker's Cooperative catalogue reproduced courtesy of Anthology Film Archives.

Images on page 1, 13, and 265, Courtesy of Harry Smith Archives.

Photographs on page 27, 68 and 70, courtesy of Bret Lunsford's book Sounding For Harry Smith: Early Pacific Northwest Influences, KNW-YR-OWN, 2021.

Published by Semiotext(e)
PO Box 629, South Pasadena, CA 91031
www.semiotexte.com

New edition prepared by Hedi El Kholti and Peter Valente.

Special thanks to William Breeze, Raymond Foye, Brian Graham, Peter Hale, John Klacsmann, Bret Lunsford, John Mhiripiri, Rani Singh and Cayal Unger.

Cover image: Harry Smith, untitled (zodiac sign), ca. 1974. Mixed media on board, 14 ½ × 14 ¾ in. Courtesy of Anthology Film Archives.

Backcover: Harry Smith with his "brain drawings," ca. 1950. Photo by Hy Hirsh. Courtesy of Harry Smith Archives.

Design by Hedi El Kholti
ISBN: 978-1-63590-164-1

Distributed by The MIT Press, Cambridge, Mass. and London, England
Printed in the United States of America

HARRY SMITH

American Magus

Edited by **Paola Igliori**

With contributions by Moe Asch, Jordan Belson, Harvey Bialy, William Breeze, Khem Caigan, John Cohen, Rose Feliu-Pettet ("Rosebud"), Robert Frank, Debbie Freeman, Allen Ginsberg, Dr. Joe Gross, M. Henry Jones, Kasoundra Kasoundra, Jonas Mekas, Bill Morgan, Rani Singh, Philip Smith, James Wasserman, and Lionel Ziprin

semiotext(e)

Harry Smith, typewriter drawing, ca. 1980. (Harry Smith Archives.)

CONTENTS

Harry Smith throwing dice, ca. 1988.
(Photograph by Clayton Patterson.)

Preface by Paola Igliori

Harry Smith was a universal man who constantly synthesized what others treat as disparate "disciplines," and a polymath who sought the true unity in all manifestations. He recorded and connected the seemingly random, but often parallel, patterns of multifaceted things to get at their inner language.

What he left us can help us detect the systematic flowcharts of his various enquiries.

He gathered the layered sediments of human activity in motion, and the cosmos he created, with relentless humor and piercing vision, stands with the same ageless awesomeness of stalactites, illuminating the vast landscape of the creative mind and inspiring ever-fresh steps in the mapping of our own.

There is so much that can be tackled around Harry Smith, his work, his life, his extremes, that I feel I only possibly scratched the surface of it.

One could take, for example, the seven Hermetic principles (or universal laws)—mentalism, correspondence, vibration, polarity, rhythm, cause and effect, and gender—and structure a chapter of the book for each, working on multiple different planes around each one, often with a lot of twists and humor.

In the native Lakota tradition* there is someone called "Heyoka," who has a reversed quality; he is often literally a clown doing everything backwards; he's also a powerful, paradoxical teacher showing the other side of things. A harsh teacher slaps the lessons on, and not everybody can deal with them; at times they make you or break you.

To some, he is one who tricks himself more than others and a scoundrel, to some a sacred clown, to others a form of the Creator himself. His power is a mysterious power, a changing power, that can burn, but that also urges life to create itself, the power of growth.

* This trickster quality is present also in a lot of other traditions, but, to me, no other embodies it as powerfully.

The other day, I was reflecting on how connected this reverse power seemed to Harry, for me. I had just gone to pick up an image of two profiles kissing from *Heaven and Earth Magic* to use as a flip book; suddenly I realized it was a mirror image and the memory flashed back to me of writing from left to right as a kid and how, at times in my life, I've connected strongly to this energy. While these thoughts simultaneously flickered in my mind like fishes traversing a pond, we were printing the first test page for the book. This is how it came out:

Paula: When did you first meet Harry?
Jordan: Well, I met Harry in Berkeley about 1946 and I think I was still a student at the University there, my last year. I had a coterie of friends that were all artists and a generally bohemian group, and one of them went for a walk in the hills. Have you ever been

(This reinforced the realization of how powerful a connection is and the realization that computers are really sensitive and don't do all the rational editing we do!!)

The evening culminated with the house catching fire…!

As I said, this book is only a scratching of the surface. It hopes to be direct simple traces of Harry and a live map of different points of entry into the labyrinth. I hope it will be a pathfinder for other more in-depth works.

~~A few words man~~

> when I was a child
in Anacortes Washington
my father built me
a rowboat and I
spent many hours
looking at the waving
depths of the giant
kelp the search

for these undulations

has occupied me since

(4)

Pages 9–13: Harry Smith, pages from *The Black Book* (fragments of an unpublished autobiography), ca. 1989. (Courtesy of Raymond Foye.)

~~Agnethlas~~

My earliest recordings
were made about
1942 - they were
childrens songs ~~sung~~
by my mother

(23)

eye trouble caused
by ~~hearing~~ of the
~~eye~~ of another
child being blinded

on the same day
I had found a
rusted french horn,

made ~~first~~ experiments
with projection in
late 1920's using neg.
a flashlight lens
(linter in music)
the greater

⑤

PART 1

Friends and Collaborators

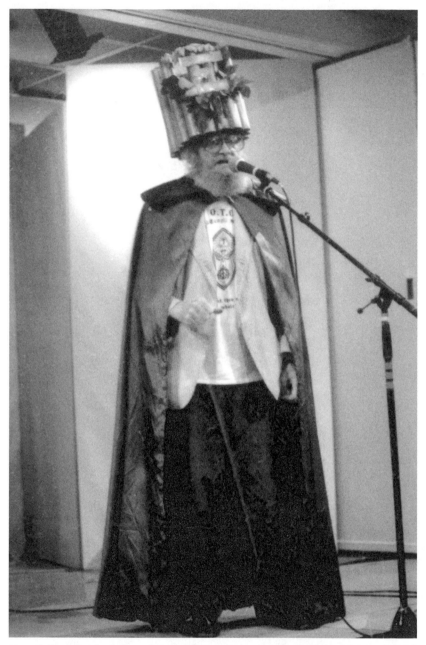

Harry Smith performing in *Seven Deadly Sins*, a student production directed by Marianne Faithfull and Hal Willner, at the Naropa Institute, Boulder, Colorado, ca. 1989. Smith's handmade crown is made of spray-painted paper towel rolls and his own cover design for the Weiser Books edition of Aleister Crowley's *The Holy Book of Thelema*. (Photograph by Liza Mathews. Courtesy of Harry Smith Archives.)

William Breeze

IN MEMORIAM, HARRY SMITH

Do what thou wilt shall be the whole of the Law.

Harry Smith died on November 27, 1991 at the Chelsea Hotel in
New York. He was born on May 29, 1923 to an Oregon family active
in freemasonry and occultism. He enjoyed propagating alternative
biographies: born in 1918, delivered of the Princess Anastasia on a
Russian gunboat off the coast of Alaska, or fathered by Aleister
Crowley who seduced his mother on a Pacific beach. Smith developed
his lifelong interests at an early age: occultism, music, anthropology,
linguistics, painting and film. He studied anthropology at a college in
Washington state. Around 1945 he moved to the Bay Area where he
held what was possibly his first and certainly his last regular job, as an
office clerk for ARAMCO. Since then he lived for art and gnosis with
little thought for practical consequences. With the occasional grant
(including two Guggenheims), the occasional patron, his friends, and
his indifference to adversity, he always got by.

The 1940s were a formative period in experimental film, and
Smith was a member of the small circle of California avant-garde
filmmakers. He worked with the influential Art in Cinema Society in
San Francisco, helping to arrange showings of films by Anger, Deren,
Markopoulos, Harrington, Broughton, and European filmmakers
like Cocteau. Most of these were "personal" semi-narrative filmmakers,
and although Smith would later make analogous personal statements
with his live-action superimposition films, he was at this time closer
in temperament and technique to the Surrealists and abstract artists
and filmmakers from whom he drew inspiration. He would hitchhike
to Los Angeles and stay with the Whitney family; he always acknow-
ledged his debt to them, especially in technical areas. Another
influence was Oskar Fischinger; Elfriede Fischinger recalls that
Oskar was proud that Smith had described his film as an homage.
Smith's close association with non-objective artist and filmmaker
Jordan Belson, a few years his junior, dates to this period.

Hilla Rebay of the Museum of Non-Objective Painting (now the Guggenheim) was so taken with Smith's and Belson's work that she arranged a grant to bring the young artists to New York. Belson eventually returned to San Francisco where he continues to live and work, but Smith stayed on. Except for a few "field trips" he remained in New York for the rest of his life.

Smith always considered himself more a painter than a filmmaker, and the distinctions were sometimes moot; e.g., he created the first frame-by-frame hand-painted films in America circa 1939. Unknown to Smith, the New Zealander Len Lye had made such films earlier, but Smith's are far more ambitious.

Sadly, Smith's paintings are little known and never shown, due in no small part to his ambivalent attitude towards his own work's survival. Throughout his life he destroyed with one hand as he created with the other; that his work survives has been largely through chance or the intervention of friends. Many films are lost or destroyed, and the original negatives of most no longer exist. He once rolled the original of a hand-painted film, representing years of work, down 42nd Street. He eschewed selling his work; although broke and fighting eviction, he told one hopeful collector to call Holly Solomon. It was a ruse; Smith had no gallery, nor did he want one.

In the early 1950s Smith created a series of "jazz paintings," which probably survive only in photographic plates. These paintings were synchronized to particular jazz tunes, traceable rhythmically note by note across the two-dimensional field. A pan shot of one of these (a "Dizzy Gillespie" painting) appears at the beginning of his *Film No. 4*. Many of Smith's drawings and paintings survive, as yet uncatalogued, in several private and public collections, but what survives probably represents only a fraction of his output.

Like the Whitneys, Smith experimented with film technique. In the 1950s and '60s he constructed an elaborate multiplane animation system for his unfinished *Wizard of Oz* film, and worked with 3-D and kaleidoscope effects; fragments of these efforts survive. Many of Smith's animated films employ overt magical symbolism and allude to drugs, two favorite preoccupations. He described *Film No. 10* as "an exposition of Buddhism and the Kabbala in the form of a collage. The final scene shows Agaric mushrooms growing on the moon while the hero and heroine row by on a cerebrum." This film was a

study for a more ambitious collaboration with Thelonious Monk, *Film No. 11, Mirror Animations.* This carried out the methodology of his jazz paintings in film, tightly synchronizing the animation to Monk's "Misterioso." His black-and-white *Heaven and Earth Magic (Film No.12)* was created in the late 1950s and early '60s by using sortilege to animate cut-outs from old department store catalogs and books. Originally six hours, it survives only in a one-hour version, with a *musique concrète* soundtrack by Smith that uses sound effects in an analogous manner to the cut-up images. In its graphic depiction of spiritual transport and transformation, this film is the true American *Book of the Dead.* In keeping with its alchemical theme, certain images are synchronized to the soundtrack by elemental attribution; e.g., when a salamander appears (the usual form of a fire elemental in magical tradition), a fire engine is heard in the soundtrack. In the 1960s, in a departure from his earlier work, his films incorporated live-action superimposition as well as animation. He continued to innovate technically; his *Mahagonny* required a custom synchronized multi-screen projection system of Smith's design.

Smith declared that "my movies are made by God; I am just the medium for them." Before I knew that Harry has said this, I had reached much the same conclusion. His art was pure Hermeticism, and he, a modern Prospero.

P. Adams Sitney recounts: "Smith even spoke of Giordano Bruno as the inventor of the cinema in a hilariously aggressive lecture at Yale in 1965, quoting the thesis of *De Immenso, Innumerabilibus et Infigurabilibus* that there are an infinite number of universes, each possessing a similar world with some slight differences, a hand raised in one, lowered in another, so that the perception of motion is an act of the mind swiftly choosing a course among an infinite number of these 'freeze frames,' and thereby animating them…Smith regards his work in the historical tradition of magical illusionism, extending at least back to Robert Fludd, who used mirrors to animate books, and Athanasius Kircher who cast spells with a magic lantern." (Sitney, *Visionary Film,* 2nd ed., Oxford UP, p. 235.)

Aleister Crowley remarks in *Eight Lectures on Yoga* that "the artist is in truth a very much superior being to the Yogi or the Magician… It is not for us here to enquire as to how it should happen that certain human beings possess from birth this right of intimacy with the

highest reality, but Blavatsky was of this same opinion that the natural gift marks the acquisition of the rank in the spiritual hierarchy to which the student of Magick and Yoga aspires."

Smith was all of these, and a Thelemite. Around 1950 he began A∴A∴ work with Charles Stansfeld Jones (aka Frater Achad 1885–1950) and Albert Handel (Jones' student in New York). Jones was the novelist Malcolm Lowry's magical preceptor as well; his influence is overt in both Lowry's *Under the Volcano* and Smith's later animated films, especially *Nos. 10–12*, particularly in the use of multiplied Trees of Life. (An amusing detail concerning Jones, courtesy of Harry, is that he used a drumstick for his magic wand.) He also knew Karl Germer [Aleister Crowley's successor as the world head of the magical society, Ordo Templi Orientis (O.T.O.)], and helped with the 1955 reissue of *The Equinox of the Gods* (the maroon binding) and other early Thelema Publishing Co. projects; Smith's long friendship with the Weiser family dated from this period.

Smith created a set of irregularly-shaped tarot cards, one of which is used by the O.T.O for its degree certificates, and used with several others for the paperback edition of Aleister Crowley's *Holy Books of Thelema* (Weiser) which Harry designed. He also studied the Enochian system in depth, compiling the only known concordance (forwards and reverse) of the language, indexed to Casaubon. Typical of the way his Gemini mind worked, he made a serious study of the underlying principles of Highland tartans, correlated them to the Enochian system, and painted elemental tablets that employed both; his work is riddled with Hermetic allusions. His magico-religious philosophy was rooted in the writings of Aleister Crowley, but greatly amplified by diverse other sources, including parapsychology, spiritualism, Egyptology, and oriental magic and mysticism.

Smith had a lifelong love of Native American culture and language, beginning with his childhood experiences with the Northwest Coast Indians. He spent years living with various tribes, particularly the Kiowa and Seminoles. In the early 1960s he flew to Oklahoma with filmmakers Conrad Rooks and Sheldon Rochlin to work on what became Rook's *Chappaqua*. On arrival, Smith disappeared without warning, showing up at the motel in the middle of the night with perhaps a dozen Kiowa tribesmen and bushels of peyote. Rooks and Rochlin pushed on westward by car to continue filming this

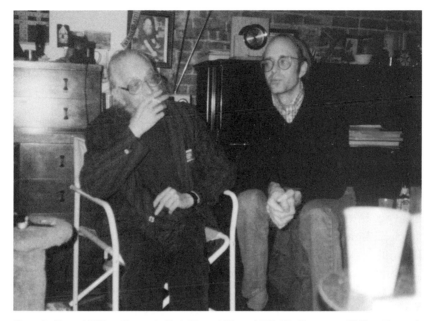

Harry Smith and William Breeze in Park Slope, NY, ca. 1986–87. (Courtesy of William Breeze.)

early psychedelic epic, but Smith stayed on. Some of his Oklahoma footage appears in his superimposition films. He later issued a recording of *The Kiowa Peyote Meeting* on Folkways Records. He also gathered an important collection of Seminole objects, donated to the Folkens Museum (formerly the Etnografiska Museet) in Stockholm. Smith's longest completed prose work is a comprehensive unpublished study of string figures around the world.

His other collections included an unusually fine library and fantastic collection of Ukrainian painted Easter eggs. When he had money, he usually bought a new book and forgot about dinner. He even amassed what was undoubtedly the world's largest collection of paper airplanes. As he found one (and he found them everywhere), he would note the date and place and file it away. By the early '80s he had no less than a dozen large boxes. The Smithsonian Air and Space Museum sent a special courier when he donated the collection.

Smith also spent years collecting records by early American folk and blues musicians, and in 1952 issued his multi-volume *Anthology of American Folk Music* on Folkways Records. Dylan and a host of other folk musicians would later draw on this anthology for inspiration

and material. Smith received a Lifetime Achievement Award at the 1991 Grammy Awards in New York, for fostering blues and folk music as a vehicle for social change. He was also an ethnomusicologist, a term he disliked for its cultural bias, whose interests ranged from Mongolian mouth music to Scottish *piobaireachd* bagpiping.

Like many experimental filmmakers, he was greatly helped over the years by Jonas Mekas and the Anthology Film Archives. In recent years he was sustained by his friends, especially Allen Ginsberg and Dr. Joseph Gross, and recently received a three-year grant from the Grateful Dead, which was continued posthumously to help catalog his archives. He was also a mentor and "shaman-in-residence" at the Naropa Institute in Boulder, Colorado and a gnostic bishop in the Ecclesia Gnostica Catholica (Gnostic Catholic Church) of the Ordo Templi Orientis.

Smith was a seminal underground force for several generations. A natural polymath, he moved easily from one field to the next, always leaving his mark. The true extent of his varied accomplishments has only become clear after his death, as his friends from different periods and fields have gathered and compared notes. His influence is as greatly felt in the work of the artists, writers, musicians, and philosophers he inspired and initiated, as in the work to which he attached his name.

Harry was my guru, friend and guide, and his great attainment will always be an inspiration. He truly gave his all for the Work.

"Slay thyself in the fervour of thine abandonment unto Our Lady. Let thy flesh hang loose upon thy bones, and thine eyes glare with thy quenchless lust unto the accursed one." —LIBER CLVI, v.9

Love is the law, love under will

"And the Sins of the
Children shall be visited
upon the Parents"

Born 1923 in Portland
Oregon to parents whose
folly regarding their gender
led to cyclical social and
religious mania ~~that led~~ forcing
Smith to accept his own
duality with generous enthusiasm,
and espouse the dualistic
dictum of "make a person
think they think and they
love you; make them think,
and they hate you.

Naturally ~~the~~ ~~Absurd~~ grandure
of his never-ending unhappiness,
combined with his well known
greed, have provided many
a private or corporate Marcenas

to finance his excursions
into that blunted hunger
on the boundry of voice
and vision
 (list ?)
He has made about
500 recordings for restricted
scientific use, in addition to
about 120 cuts commercially
released.
 (list ?)
and has produced 23 films,
about half of these being
easily available

His reason for coming to
Boulder is to find out why
he's such a damn fool, and
has heard that Naropa is
the best place to find out
such things.
 (The following synopsis
 are announced.)
I - "The rationality of namelesness"
II - "Is self referance possible?"
III - "Communication, quotation, and
 creation "
IV - "The grammar of awareness, "
 (films will be shown and
 recordings played with the
 above)

Harry Smith, handwritten autobiographical notes submitted to the Naropa Institute's Jack
Kerouac School of Disembodied Poetics, Boulder, CO, ca. 1988. (Harry Smith Archives.)

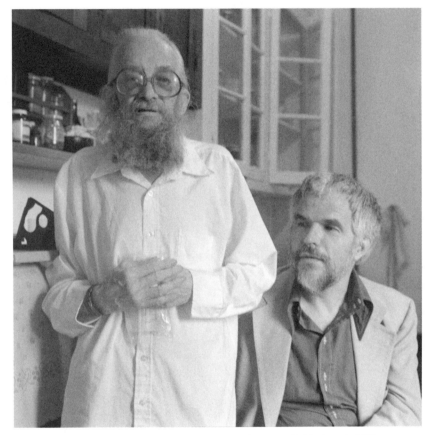

Allen Ginsberg, portrait of Harry Smith (*left*) and Stan Brakhage (*right*), June 1, 1988.

Rani Singh

HARRY SMITH: AN AMERICAN ORIGINAL
New York, 1995

Greetings and welcome. By way of introduction my name is Rani Singh. I was Smith's assistant from 1988 until his death at the Chelsea Hotel in 1991. After his passing the Harry Smith Archives was established in the State of New York as a 501c3 non-profit organization. As director of the Harry Smith Archives, I have been researching his life, locating artwork, much of which is in private hands, and trying to raise funds to support the ongoing activities and projects. Shortly after Smith's death the Harry Smith Archives began organizing bi-annual events in New York at Anthology Film Archives where we presented expanded screenings of the films with noted speakers. We also held yearly 'invocations' on the 4th of July at Naropa Institute in Boulder, Colorado to celebrate Smith's spirit and his fondness for the annual celebration. Harry Smith always said that his work would not be fully recognized until at least 50 years after his death, so I have about 46 years to go.

Some of you might not even know who Harry Smith is, while others have heard the outlandish stories that have circulated for years. For those of us who knew him personally he was a unique character with his nasally voice, witty banter and cosmological mindset. During his lifetime he inspired many people in a wide variety of fields, and now, many years later, we can still see and feel the residue of that influence in music, art and film.

The first time I met Harry Smith was in 1988 at Naropa Institute during the annual 4th of July picnic. Prior to his arrival at Naropa he had been staying at Allen Ginsberg's apartment in New York. Smith had been living in less-than-ideal conditions in a Bowery rooming house and Ginsberg had allowed Smith to move into his apartment on 12th Street in the Lower East Side. The situation had

The following text was culled from a slide show presentation given at Anthology Film Archives, April 1995, and "Articulated Light: The Emergence of Abstract Film in America," a symposium held at Harvard Film Archive, December 1995.

grown increasingly fraught and finally, under the recommendation of Ginsberg's psychiatrist he arranged for Smith to travel with him to Boulder for the Naropa Institute annual Summer Writing Program. A series of film screenings and presentations for Smith was organized in collaboration with Stan Brakhage at the University of Colorado. Little did Smith know that Ginsberg's intentions were to leave Smith in Colorado at summer's end.

The Fourth of July celebrations at Naropa were an annual tradition. Naropa's grounds were located just under the hill from the university's football stadium where the fireworks display was held. A large tent was erected for the month-long summer session where daily classes were held. This became location central on the 4th of July along with a BBQ setup, food and drink. As the day progressed people came with blankets and chairs preparing for the elaborate fireworks show.

Before his arrival Allen had told me that he was bringing Harry Smith to Boulder. "*The* Harry Smith," I asked? Surprise and wonderment overtook me as I wasn't sure if the Harry Smith that I had heard so much about from my professor Stan Brakhage *actually* existed. Eager to finally see and meet this mysterious figure I was primed and ready when Steven Taylor arrived by car with Harry Smith. His entrance was nothing less than gallant.

My first vision of Harry Smith was as he strode elegantly across the great lawn wearing a trench coat in 90 degree summer heat, headphones balanced on his head, a glove on his hand to steady the sound of his Sony Pro-Walkman (the second one he had "borrowed" from Ginsberg) that was recording the ambient sounds of the day. He walked directly to the tent and sat down at a table not talking to anyone, bony hands with long fingernails smoking Salem 100's constantly and pot every hour on the hour. He continued to record the buzz of conversation and surrounding activity which heightened as the evening darkened and fireworks approached well into the night.

I had seen Harry Smith's mind-blowing films for years, having studied with filmmaker Stan Brakhage at the University of Colorado, who would screen Smith's films regularly in his film history classes. Brakhage would preface each show explicitly: "You are about to see the works of one of the most extraordinarily inventive artists of all time." Brakhage's textbook was P. Adams Sitney's seminal *Visionary Film*, which situated Smith in the canon of American avant-garde cinema.

Sitney's description of Smith's ingenious methods of hand-painting directly on film and collage techniques continues to be among the most elucidated and well-informed written material on the subject.

It was hard to believe that right in front of me, sitting under the Naropa tent, was this mischievous gnome-like character that I had heard so much about. I sat down close to him and plunked a Coke down on the table. He perked up and looked right at me. This is where the plot thickens.

That summer Smith gave a series of lectures at Naropa on Surrealism and showed his films at the University of Colorado. He also attended many of the daily lectures and poetry readings, usually with his Sony recording device set to ON. Students and faculty alike were drawn to him, and he became a beloved and well-respected teacher. Humorous and sharp, his pointed observations and intellect intrigued us all.

At summer's end Ginsberg arranged for Smith to stay in a small cabin on the grounds of the Institute and a young disciple to take care of Smith's essentials. A reasonable request but not practical. I filled in the gap and started taking care of his practical needs. Jacqueline Gens, Ginsberg's secretary on the ground, was aware of my support and notified Allen that I was taking care of things. From then on I was then engaged and employed by the Ginsberg office to be Smith's main assistant and secretary. Little did I know that this was to be a lifelong position.

The scope of the job ran the gamut: from the usual grocery store visits (although the requested items were awfully strange) and doctor's visits, along with the inevitable prescription pickups and emergency bookstore runs, to getting him weird combinations of food, including raw hamburger, bee pollen, sardines, and endless amounts of Ensure (a caloric supplement), in addition to other controlled substances.

Smith's main projects in Boulder were his lectures, audio recordings and deepening his interest in the local area, primarily the Indigenous peoples of Colorado, the Arapahoe, Cheyenne and Apache. Prowling the local bookstores on a regular basis he continued his lifelong research that had begun as a young boy in the Pacific Northwest. He subscribed to U.S. West Voice Answering machine service. For three dollars a month, the telephone company would allow customers to record up to 165 three-minute messages that could be stored and

received at will. Intrigued by this technological possibility Smith would ask people to call in and leave messages containing dreams, songs and sounds from any remote locations. I assisted Harry in recording subsequent 4th of July celebrations as well as concerts, his array of loud cats, his phone messages, folk musicians, parties, cows at sunset, crickets at dawn, rodeos, sunrise and sunset activity, among many other everyday sounds that we all take for granted. Sitting for hours in his small cabin with headphones on, getting lost in the nuances of these recordings was an unforgettable experience. The sounds opened out onto a wide expanse. Listening to these tapes now it becomes clear that Smith approached the project as a found sound symphony.

Harry Everett Smith was born on May 29, 1923 in Portland, Oregon, according to his birth certificate. His early childhood was spent in the Pacific Northwest, primarily Anacortes and Bellingham, Washington. His father was a watchman for the Pacific American Fisheries and his mother a teacher on the Lummi Indian reservation. Harry's paternal grandfather had been a prominent Mason, his parents Theosophists. Harry said his father gave him a fully equipped blacksmith shop for his twelfth birthday and told him he should turn lead into gold:

> He had me build all these things like models of the first Bell telephone, the original electric light bulb, and perform all sorts of historical experiments. I once discovered in the attic of our house all those illuminated documents with hands with eyes in them, all kinds of Masonic deals that belonged to my grandfather. My father said I shouldn't have seen them and he burned them up immediately. That was the background for my interest in metaphysics and so forth. Very early my parents got me interested in projecting things. The first projections that I made were from the lamps of a flashlight.

Last year I was in Bellingham doing research on Smith, and a former student friend of his recalled Harry very distinctly as "keeping to himself, an intense fellow, a very studious type, with a slight hunchback and he always carried a 4 x 5 camera around." In high school he was in the art club, the chess club, the yearbook photo staff, and had a part in the senior production of "You Can't Take It With You." His stated ambition in the yearbook was to be a composer of symphonic music.

Harry Smith (*center*) with other staff of the Bellingham High School yearbook, for which he was a photographer. (Courtesy of Bret Lunsford's book *Sounding for Harry Smith*.)

By the age of 15, Harry had spent time on the Lummi and Salish reservations recording songs and rituals, gathering Native American artifacts, and compiling a dictionary of several Puget Sound dialects. A 1943 article from *American Magazine* depicts Harry posing with local Indian chiefs recording the spirit dance at the Lummi potlatch:

> When I was a child somebody came to school one day and said they'd been to an Indian dance and they saw someone swinging a skull on the end of a string; so I thought hmmmm, I have to see this. In an effort to write down dances, I developed certain techniques of transcription. I got interested in the designs in relation to music. That's where it started from. It was an attempt to write down the unknown Indian life. I took portable recording equipment all over the place before anyone else did and recorded whole

long ceremonies sometimes lasting several days. Diagramming the pictures was so interesting that I then started to be interested in music in relation to existence.

We'll never be able to separate the truth entirely from myth, but we can be sure that from early childhood there were instilled an appreciation of nature and an alchemical synthesis of the arts and sciences, which culminated in the melding of music, anthropology, linguistics, ethnology, film, occultism, design and the plastic arts.

Harry studied anthropology at the University of Washington for five semesters between 1942 and 1944 (in his transcript the classes include "The Evolution of Man," "American Indigenous Linguistics, Geology," and "Principles of Race and Language"). The day after WW II ended Smith was invited to visit the Bay Area where he attended a Woody Guthrie concert, met a number of bohemians, intellectuals and artists and experienced marijuana for the first time. Harry realized he could no longer be content at college and relocated to Berkeley.

Smith's first hand-painted films predate this period. He was surprised to find that others had done similar frame-by-frame processes, but none had matched the complexity of composition, movement and integration of his own work. His methods required years of intricate labor, working alone, painting on 35mm film frames or cutting out images to be meticulously filed and organized. Ironically, Harry always considered himself primarily an anthropologist and painter, rather than a filmmaker. "I was mainly a painter. The films are minor accessories to my paintings; it just happened that I had the films with me when everything else was destroyed. My paintings were infinitely better than my films because much more time was spent on them."

At this point in 1947, he was living in Berkeley at 5 ½ Panoramic Way in the basement of a Maybeck house owned by Bertrand H. Bronson, a University of California professor and noted Child Ballads expert. He also worked as an assistant to Paul Radin, an anthropologist at U.C Berkeley. This is when his record collecting began in earnest, an obsession that had started as a teenager in the Pacific Northwest, finding records near and far, even trekking by bus to nearby towns to hunt for records.

While living in Berkeley Smith regularly attended Art in Cinema, a series of avant-garde film programs screened at the San Francisco

Museum of Art. Organized by Frank and Jack Stauffacher and Richard Foster, Smith volunteered to help locate films which brought him into contact with the Whitney Brothers, Oskar Fischinger and Kenneth Anger. Smith was sent to Los Angeles in 1947 to meet with the Whitney Brothers and most importantly, Oskar Fischinger, who became a seminal influence. Belson recalls Stauffacher calling Harry to inquire what music should be played with particular films. Harry would then matter-of-factly reply with some perfectly appropriate selection. Art in Cinema was the first public venue in which Smith's films were shown.

It was at this time that he developed a deep friendship with the filmmaker Jordan Belson, both of them interested in exploring nonobjectivity, a movement that delved into pure abstraction and cosmic spirituality in art. Studying the correspondence between image and color, they concentrated on space, rhythm and movement in a given plane.

Smith embarked on a series of jazz paintings, murals for the walls of Jimbo's Bop City, and performance pieces at museums and small clubs that combined film screenings and live music. Harry would show his films at Jimbo's Bop City, the infamous waffle house and after-hours jazz club, to musicians as they improvised to the images on the screen. Attendees included Dizzy Gillespie, Charlie Parker, Dexter Gordon and Thelonious Monk. "I had a really great illumination the first time I saw Dizzy Gillespie play. I had gone there very high, and I literally saw all kinds of colored flashes. It was at that point that I realized music could be put to my films."

Film No. 4 begins with a shot of a painting:

It is a painting of a tune by Dizzy Gillespie called "Manteca." Each stroke in the painting represents a certain note in the recording. If I had the record I could project the painting as a slide and point to a certain thing. This is the main theme in there, which is adoot-doot-doot-attadoot. Each note is on there. The most complex one is this one, one of Charlie Parker's records. That's a really complex painting. That took five years. Just like I gave up making films after that last hand-drawn one took a number of years, I gave up painting after that took a number of years. It was just too exhausting. There's a dot for each note and the phrases that the notes consist of are colored in a certain way or made in a certain path.

Hilla Rebay, the first director of the Museum of Non-Objective Painting, now the Solomon R. Guggenheim Museum, had been corresponding with and sporadically supporting Jordan Belson and Smith. Rebay came to the Bay Area and visited their studios. After her return to New York she continued her correspondence with Smith, eventually providing him with a small stipend and a plane ticket to New York to continue his studies. Upon receiving a Guggenheim grant, he created two optically-printed films, a 3-D film, and several paintings.

In New York, Smith found himself in need of money and looked up Moses Asch of Folkways Records, hoping to sell him some of his records. Asch was impressed with Smith's erudition as well as intrigued with his collection—but rather than buy the records outright, Asch challenged Smith to produce a compilation to be released by Folkways. In 1952 Folkways Records issued his multi-volume *Anthology of American Folk Music*. These six discs are recognized as having been a seminal source from which the folk music boom of the '50s and '60s flowed. Ginsberg takes this one step further and credits Smith with indirectly influencing the 1960s movement as well as cultural and political revolutions around the world. Bob Dylan has acknowledged Smith's work as being a major influence on him and has covered many songs from the Anthology in his repertoire. Smith's work in collecting and preserving American song as literature and artifact is unparalleled. Upon receiving a Grammy Award for his contribution to American folk music in 1991, he said, "I've lived to see my dreams be realized. I've seen America changed by music and music change America."

In the '60s he would frequent the Five Spot to hear Thelonius Monk, which is where he met Allen Ginsberg. Harry was sitting in the bar nightly listening to Thelonious Monk play while he scribbled madly on a piece of paper. When asked, he told Allen that he was notating the syncopation, whether or not the notes came down before or after the beat, the distinct variations of the syncopation, and how that related to the human heartbeat and pulse. All this information would be utilized in future films. After a few meetings Smith invited Allen to his uptown apartment where they would get really stoned, listen to music, watch films for hours, and then usually Allen would get hit up for money. This trend would continue until

Harry's death in 1991. Allen ended up buying a *Heaven and Earth Magic* film reel from Harry. He wasn't quite sure what to do with it so he brought it down to Jonas Mekas, the co-founder of Film-maker's Cooperative at the time. After Jonas viewed the reel he asked Allen to introduce him to the creator of these mad images. That was the start of a long and fruitful relationship.

According to Bill Breeze, longtime friend of Smith and well known occultist, Smith began an earnest course of study of A∴A∴ system, a magical order founded by Aleister Crowley. He continued his studies in New York. Smith's *Tree of Life* is indicative of his lifelong interest in esotericism. Created while working at Lionel Ziprin's greeting card company Inkweed Arts, Smith also produced intricately designed 3-D cards and Christmas cards along with the *Tree of Life*. There was a four-inch space left on the paper while printing the silk-screened cards; Smith designed the image to fit in that space. Smith states it was his father who taught him how to draw the Tree of Life geometrically.

The Tree of Life is a collotype print with silk-screened color. It is the most important graphic symbol of the Cabala. It is the ultimate symbol of creation; all of nature is included in its schemata. As a visual diagram it is composed of ten spheres and 22 paths connecting the spheres. The ten spheres represent the numbers from one to ten, and 22 corresponds to the letters in the Hebrew alphabet. Together they are the 32 paths of Wisdom described in the *Sepher Yetzirah*, an early text attributed to Abraham.

Over the years Harry spent time with Native American peoples, the Seminoles in Florida and the Kiowa in Oklahoma. Actually, the story begins in 1964 on a Folkways-sponsored trip to Oklahoma. Harry was surreptitiously put on a train without a bar car. By the time he got to Oklahoma he went straight to the nearest watering hole. He drank until he somehow got thrown into jail, where he connected with several incarcerated Indians who introduced him to the peyote rituals and songs of the Native American Church. He returned in 1973 where he set up his equipment in his hotel room recording the songs and commentaries of the peyote songs. *The Kiowa Peyote Meeting* (Ethnic Folkways Records FE 4601) was released on Folkways Records in 1973.

Harry's broad range of interests resulted in a number of collections: Seminole textiles, tarot cards, pop-up books, gourds, Ukrainian Easter

eggs, string figures, paper airplanes and more, He would have these on display in his small room at the Chelsea Hotel. Look but don't touch. He donated the largest known paper airplane collection in the world to the Smithsonian Institution's Air and Space Museum. The self-described world's leading authority on string figures, he mastered hundreds of forms from around the world. Harry studied many languages and dialects, including Kiowa sign language and Kwakiutl. Smith said of his collections:

> They are indexes to a great variety of thoughts. They're like ency-clopedias of designs. You can look in the *Oxford English Dictionary* if you want to study words, but being that the designs on the eggs are so ancient, they're like 20 or 30 thousand years old, it's like having something superior to a book. These collections have been built up fundamentally to have an index of design types that I might want to use in my paintings.

Harry spent his last years (1988–1991) as "Shaman-in-Residence" at Naropa Institute in the small cabin that now houses the Harry Smith Printing Press, where his life's work culminated in a series of lectures, audio tape recordings, and continued collecting and research. In his autobiographical notes submitted to Naropa, he states, "His reason for coming to Boulder is to find out why he's such a damn fool, and he's heard that Naropa is the best place to find out such things."

Harry wrestled with the dark and light his whole life. He entered, explored, and projected the dark as light. He had the ability to be cantankerous and maddening, making scenes, throwing fits at film screenings, throwing projectors out the window at Anthology, drinking and getting belligerent. Towards the end of his life he stopped drinking alcohol; he mellowed and began to reconcile with the light.

The Tibetan Book of the Dead speaks of the spirit being reborn and spread throughout. Harry Smith's spirit was vast and all-encom-passing. Harry Smith was schooled in many cultures, master of many cosmographies, and intent on a comparison and synthesis of all sys-tems of knowledge. His way of thinking has affected this way I see the world. Hopefully it inspires all of us to think unconventionally, to unearth wisdom from all disciplines, to respect and learn from different cultures, to create and push ideas one step further.

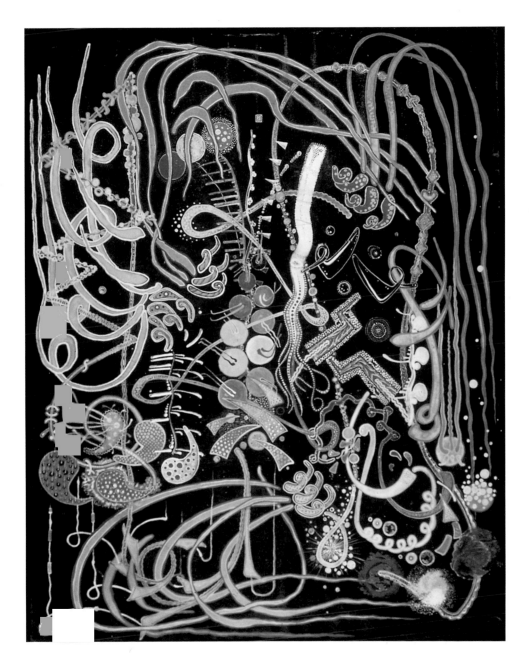

Harry Smith, *Manteca*, ca. 1948. A response to the song of the same title by the Dizzy Gillespie Orchestra. (Harry Smith Archives.)

Harry Smith, untitled (zodiac sign), ca. 1974. Mixed media on board, 14 ½ × 14 ¾ in.
(Anthology Film Archives.)

Harry Smith, untitled (zodiac sign), ca. 1974. Mixed media on board, 14 ½ × 14 ¾ in.
(Anthology Film Archives.)

Left: Harry Smith, *The Tree of Life in the Four Worlds*, 1954. Black-and-white collotype by Smith with color silkscreens cut by Jordan Belson, 18 ½ × 3 ¾ in. Published by Inkweed Arts. (Courtesy of Lionel and Joanne Ziprin.)

Above: Harry Smith, untitled, ca. 1980. Gouache on board, 21 × 21 ¼ in. (Anthology Film Archives.)

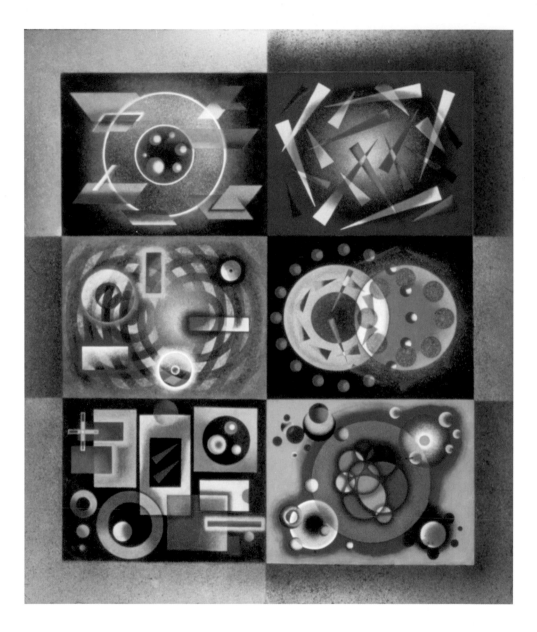

Harry Smith, Study for *Film #9: Prelude and Fugue*, ca. 1950. Oil.
(Harry Smith Archives.)

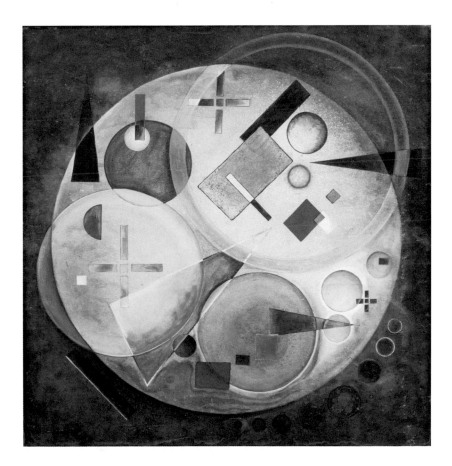

Harry Smith, untitled, ca. 1950–51. Mixed media on board, 23 ½ × 22 ¾ in.
(Harry Smith Archives.)

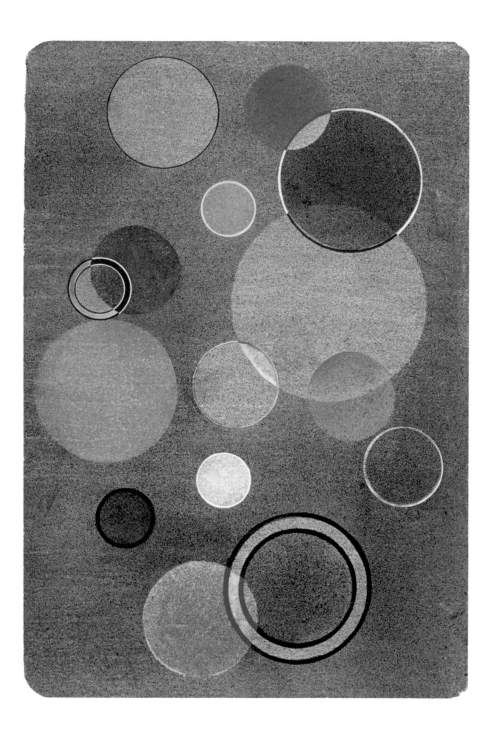

Harry Smith, *Homage to Oskar Fischinger*, ca. 1950. Work destroyed.

Jordan Belson

October 3, 1995

PAOLA IGLIORI: *When did you first meet Harry?*

JORDAN BELSON: Well, I met Harry in Berkeley, about 1946, and I think I was still a student at the University there, in my last year. I had a coterie of friends that were all artists and a generally bohemian group, and one of them went for a walk in the hills. Have you ever been to Berkeley?

No, I haven't.

It's a university town with a lot of trees; it's built on a hillside and it's got a lot of beautiful redwood homes. So my friend went for a walk up there around the fraternity houses and he looked. There was one window that was at eye level, so he had no problem looking in, not intentionally, but the interior of the room was so striking that he peeked in the window and looked it over and then came back and mentioned this to me, and maybe another person or two, and we went up to take a look ourselves. It was like a little museum gallery in there. It was all very neat, lit dramatically, with lights right over some artwork on the wall, and Harry had a kachina doll, and a few mysterious paintings, and nothing much more than that. He had a very tidy bunk, with a cot in one corner, and a rather large desk, and it was a nice little room. And as we were looking through the window, he came out and invited us in for peppermint tea. He used to always serve peppermint tea and he pronounced it "pepmit," just to be amusing, I think. He was so odd and strange, you know, a gnome-like, intense creature, and I don't think any of us knew quite what to make of him. I, myself, was very suspicious of the tea, actually, because he would make it in the other room. He had a little tiny bathroom which served as kind of a kitchen-bathroom, a little cubicle, and I often wondered what went on back there. He just seemed so strange and we were all fairly naïve; we had never met anybody

quite like Harry. He was extremely ingratiating, and charming and dressed in a sort of shabby, professorial manner with a tie and a dress shirt and a regular jacket; none of us were like that. We were very sloppy, paint-smeared art students. He had a few strange phonograph records around; he played for us jazz, very antique jazz recordings. He didn't have very many records around; he had a huge collection somewhere but I never saw it. They were old and scratchy records, a lot of hillbilly music, and there were his own paintings that were sort of like Paul Klee's; I guess Klee would be the nearest thing. One of them had a humanoid made up out of triangles and it had the letters S-S-S-S coming out of its mouth that later proved to be an illustration of someone turning on, or smoking dope. None of us had ever had much to do with that either. He was a very mysterious but intriguing character.

Was he already doing the paintings of the music?

No. Actually, it seemed that most of the work he was doing was somewhat along the lines of...the name eludes me...they were cut-out collage work, old steel engravings from the last century... Max Ernst. Max Ernst put out a very influential book of collages and these works of Harry's were very much in that vein. He'd also done the same thing with copy or text, and cut it up and rearranged it, so that it took on a different meaning than originally intended, and it was put under the illustrations. They were extremely neat and well-executed. He had a series of them on one wall. As it turned out, collage was a medium he worked in all of his life and the films that he's best known for are all collage films.

So he was already interested in the Surrealist idea of automatic writing and the randomness.

Right. As a matter of fact, at that time, I would characterize Harry as being highly influenced by Surrealism and Dadaism. Sometimes, when we'd go up to visit with him, we'd play that game, "Exquisite Corpse," which he introduced us to. It was a typical thing one might do, among other things, when visiting Harry. So we'd listen to his music, play with the "Exquisite Corpse," and scrutinize the strange

collages. He always had some interesting books around. I know he had a book on Méliès, for example.

Who's Méliès?

Georges Méliès was a French filmmaker. He was the one that made *Trip to the Moon*, back at the turn of the century. He was a magician and he became aware that film was a perfect medium for magic tricks. He did dozens, hundreds of trick films.

When did you see that Harry started studying the correspondence between sound and color and experimenting with different media?

Well, it was soon after getting to know Harry and visiting with him a number of times, and he had also been to my studio; that was just about the time a series of avant-garde films were being shown at the San Francisco Museum of Art. It was called Art in Cinema, a rather well-known, famous series. That's where I got to see, for the first time, Oskar Fischinger, Norman McLaren, the Whitney Brothers, and other pioneer abstract filmmakers that were shown, as well as other types of material, such as Surrealist films like *Un Chien Andalou*. And I remember being at Harry's once when he received a call from the director of those film programs asking what the appropriate music would be to play along with *Un Chien Andalou*. And he immediately snapped back Wagner's *Tristan and Isolde* which was the music played when it was originally shown. So he already had encyclopedic knowledge in two or three areas that I know of; he knew a lot about experimental film, folk music and jazz, and art, also. I think he was trying to actually instigate a number of Dadaistic events whenever possible.

Like what?

Doing outrageous things. There was this student that hung around with our crowd and one time, we were sitting in a restaurant with Harry and he put mustard on this fellow's finger and decided to gnaw on it in a mock ferocious way. We were all disgusted, of course. And I remember he would do things like taking a hairbrush and pounding on the back of his hand and then rotating his hand, his arm, very

rapidly, so that blood would appear on all the little spots where the brush had hit, and he would lick a slug from the garden, anything that would get a strong reaction. They were all relatively harmless. I understand that as he got older and got more deeply into drinking and drug-taking in New York City, he was more outrageous than when he was still a relatively mild youth in Berkeley. I guess he was about twenty years old.

Actually, he was twenty-three. He was born, I think, in 1923.

Oh really? I was born in '26 and he always seemed a little older, but he was never open about things like that; he'd make up stories, be mysterious. He knew a lot about Northwest American Indians, too. Apparently, he had studied anthropology at the University of Washington.

I also think he grew up partly on a Lummi reservation, because his mother was a teacher there, so he must have had some early contact with a lot of the Native culture.

Right. He was engaged in a certain amount of scholarly work, transcribing some folktales, myths, and whatnot. He claimed he was a teaching assistant in the Anthropology Department on the Berkeley campus but I don't believe that's true. I never saw any indication that he'd even been on campus. I think possibly the reason he might have come to Berkeley was that there was a well-known folklorist teaching there. I think his name was Paul Radin. What was it about Harry that got you interested in writing a work about him?

Well, the first time we met we started talking and didn't stop for about three hours and talked about all kinds of things that I didn't even know I knew. I think he kind of tapped into some universal source of memory. And what really fascinated me was the way he associated different things and how he kind of really observed patterns and found correspondences from one to the other. I read somewhere that very early on when he was young, he started wanting to record some Indian dances on the reservation where his mother was teaching and where he partly grew up. And in recording Indian dances, he started finding a method of taking notes, and

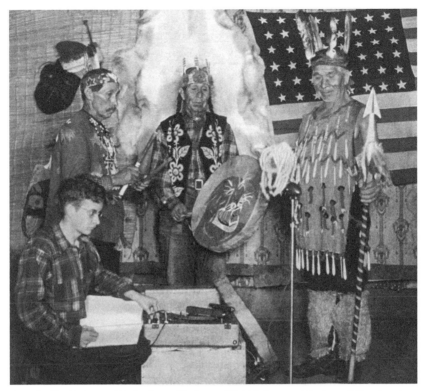

Harry Smith with August Martin, Jimmy Morrice, and Patrick George of the Lummi tribe, *American Magazine*, March 1943. Courtesy of Harry Smith Archives.

transcribing these dances, that was visual, and at that point the notes were so interesting themselves that he started getting interested in music in relation to existence. And I think the basis of a lot of his work is to see those connections; he is an alchemist of those connections. That really resonated with me. So I wanted to ask you about his first experiments with sound and color...

Rani Singh sent me a photograph of Harry on the reservation recording some chiefs; you must try to get hold of it. It was in a magazine article about a young boy-anthropologist recording Indians; he was probably was sixteen or seventeen years old. It shows him inside a teepee with a wire recorder or whatever recorder was used in those days and the Indians are around a fire, all dressed in full regalia. The article tells a little bit about Harry and what he was doing. She found

the picture in a boy's magazine, like *Boy's Life*, something from the early '50s. Anyway, I think Art in Cinema had a big stimulating effect upon him wanting to produce moving pictures and sound together in a way that he'd never done before. I know that it had that effect on me and a few other artists.

So, I'm just trying to fill you in on what got him started along those lines. He very industriously got to work, painting directly onto the film. It was rather amusing to watch him do that. He would have the clean film, with a thin coat of emulsion on it so that it would hold the dye, and a lot of colored inks, and a mouth atomizer that artists use for spraying on their drawings. He used it for painting, which was a good trick. I, myself, eventually started using the mouth atomizer. He would block out certain areas of the frame with pressure-sensitive tape, gummed labels that were cut in circles or squares or things of that sort, and stick them onto the film. And then he would spray the ink on it, on the parts that were not covered, so it would soak up the colors and texture. And then he spread petroleum jelly all over the film. Then he removed the tape and that would allow him to spray another color on there, inside the areas that had been previously covered, without affecting the areas that had the jelly on it. This is a technique that he sometimes referred to as his "batik" technique. He had some concept of the meaning of these circles and squares and triangles. I was never too clear on just what they meant to him. He did five or ten minutes of that kind of stuff and then he turned to other ways of making films. He was using the camera, but no longer painting on the film. He got paint all over this nice room that he had. He did it on the floor, so that the floor was sprayed these different colors, and generally made a mess of this room, which was previously remarkably neat, neater than any room he stayed in would ever be again, I suspect. From that point on, I know that the various places he lived in were always tiny little rooms, no bigger than a large closet, usually, and he'd crowd everything that he owned into it. So he had things hanging from the ceiling and things hanging from the bed; there was no room to move around at all; he just moved from furniture to furniture without ever touching the floor.

I remember you saying that not many people realize that his paintings are more important, in a way, or at least as important as his films.

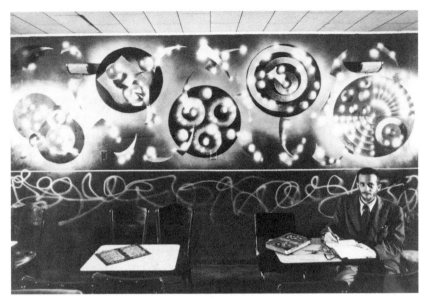

Harry Smith with his mural at Jimbo's Bop City, ca. 1950. (Photograph by Hy Hirsh. Courtesy of Harry Smith Archives.)

More important, I think, but films seem to have more of an influence on people than painting, for some reason.

When did he make those paintings to music?

He didn't paint those in Berkeley. He painted those some two years or so later when he moved to San Francisco, into a rather disreputable neighborhood called the Fillmore District. He had his own motivations for doing that. He'd gotten a little room right over an afterhours jazz joint, where musicians would come and play.

Was that Jimbo's Bop City?

Jimbo's Bop City. It was very important to him. Apparently, he got very seriously interested in bebop music, particularly Dizzy Gillespie's work, and all of these paintings that you're referring to were synchronized to Dizzy Gillespie's classics and the bop mode. On the slides that I have he wrote the name of the music that goes with the painting. There are about ten of those paintings, I guess, and a whole

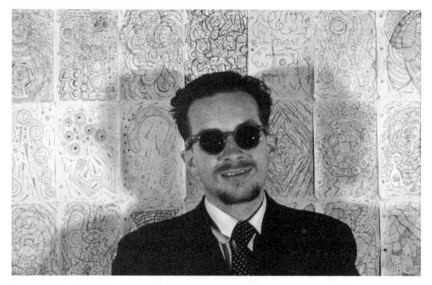

Harry Smith with his "brain drawings," ca. 1950. (Photograph by Hy Hirsh. Courtesy of Harry Smith Archives.)

bunch of drawings that he also made at the same time, but I don't think the drawings had too much to do with the music. He called them "brain drawings." The meaning of them is somehow immediately apparent; I guess you'd describe them as automatic drawings, which allow a certain freedom for the hand to move without too much interference from the mind, from the subconscious.

And was he doing the "brain drawings" around 1950?

Yes.

I heard descriptions of Harry showing his films to the musicians at Jimbo's Bop City, who would just improvise music on the film. Were you ever there when that happened?

He did that. I was never at Jimbo's, but I did see him do that at the San Francisco Museum of Art. Somehow it was arranged that he would have an evening of film showings and a lecture. He had some live musicians there, at that time. He used to show his hand-painted films at different speeds; he'd never really settled on any one tempo for them;

either he'd run the projector real slow or speed it up. I don't think he every really had any definite music in mind for them, because he kept changing the soundtrack throughout the years depending on what his interests were at the time, I guess. I'm not sure what music went along with those hand-painted ones. He considered the bop musicians to be some kind of geniuses and he never failed to promote them and their music whenever he could. He tried to get Hilla Rebay of the Guggenheim Museum interested. He did manage to reach her with some paintings that he did in that non-objective style, and promised her that he could make some films that looked just like the paintings. She financed those particular films and made it possible for him to go to New York. He did make those films. They were called *Film Studies* or something like that, and they were all based on those paintings.

I also read somewhere, that with these correspondences between different things, he was noticing the rhythm of the breathing, and that we breathe thirteen times a minute (I think that's what he said), and that our heart beats seventy-two times a minute; he kind of interlocked those two rhythms in different sequences, and used them as rhythms for the images of his films. I guess you would call it his observation of patterns of human activity.

He always maintained that he was trying to analyze or study the phenomena of creativity and he had a lot of theories about it that I didn't always understand or agree with. The one about the breathing and the heartbeat eluded me. I never saw his films in that way, and I never remember him insisting upon anybody seeing them that way.

I just thought it was really interesting that he was constantly observing natural patterns and then taking them in creatively in his own artwork. It seems to me this correspondence between things inspired him a lot.

I think his paintings are more infinitely subtle and sophisticated than his films; there's a whole world of difference there. He was always very embarrassed about art; he never really liked being thought of as an artist. Generally speaking, he had nothing but insults and sarcasm for most art and most artists. He preferred to think of himself as an anthropologist, and not acknowledge himself as an artist; but he

obviously excelled at it. Nevertheless, he always spoke of the work that he did produce as "excreta."

Excreta, like excrement?

Yes. He's written about it.

It's always hard to answer questions like this but what would you see as his most important contribution, if you had to think of it in those terms?

I think he was a truly inspired student of alchemy. He understood it perfectly and seemed to practice it to some extent. All the books and charts and things that he would make show that he had a really clear grasp of magick and alchemy and occultism to the point where he was probably as fully informed about it as anybody could be. When it comes to art, I think those paintings that were synchronized to Dizzy Gillespie's music as well as the series of non-objective paintings that he submitted to the Guggenheim Museum were remarkable.

What were the non-objective paintings like?

Have you seen that book *The Spiritual in Art: Abstract Paintings 1890– 1985* that the Los Angeles Museum of Art put out about four or five years ago?

No. Actually, could you describe them a bit?

They were mostly circles and rectangles, like the ones I spoke about before, and he did eight of them, all on one sheet of paper; each one was a little gem in itself and could easily stand alone. They represented moments in a film that he was contemplating making.

So he kind of did drawings as notes for paintings and paintings as notes for films and…

Yes. He was always interested in the 3-D stereoscopic phenomenon, a sort of old-fashioned thing, but very much in keeping with Harry's personality, and he got to understand it pretty well; he knew the theory

behind it and did a series of paintings that were three-dimensional in the stereographic sense of the word. In other words, you put them in a stereoscope and see them as three-dimensional. So he did a series of those which he sent to the Guggenheim Museum in New York, hoping to get the director to finance a three-dimensional non-objective film. He sent her these stereoscopic paintings and he also sent a stereoscope for her to see them.

What year did he do that?

About 1952, I'd guess.

So he was in San Francisco then?

Right.

Did you guys hang out together in San Francisco?

Yes. He'd come over to my studio or I'd go to his whenever possible. We'd go to the movies, or to eat at restaurants together, or go to other friends' houses and listen to music.

What were you working on then?

During that period, I was doing some film work which involved painting on long scrolls of paper. And Harry would come and work on those brain drawings, or sometimes he would make a painting with anything that was around just to get into the creative mode and do something. I've got a collection of things that he did while visiting. We were a group of people interested in the same sort of things and Harry was one of the figures in that group.

Who else was there?

Well, there was another filmmaker named Hy Hirsh, but he was a little older than myself. He and Harry always had an argument about everything imaginable, about different kinds of music, different kinds of art. Hy was a professional photographer who had a job at

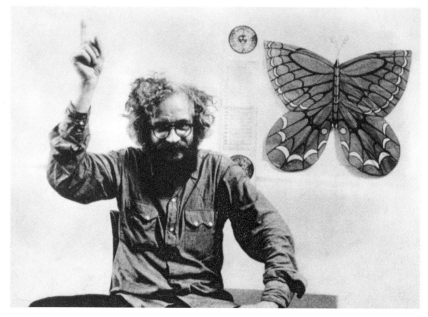

Harry Smith, ca. 1970. (Photograph by John Palmer. Courtesy of Harry Smith Archives.)

the Legion of Honor in San Francisco. He was their staff photographer. His job was to photograph the paintings and art objects for their files. He was very generous to Harry and myself with his knowledge about photography, and he had equipment he was willing to loan. He took some very good pictures of Harry at Bop City, posed in front of a couple of gigantic murals that he did there. I think he painted them in lieu of rent. I think Jimbo owned the building. I've never known him to pay rent, or to pay for anything, actually.

I think nobody has.

He had a different attitude about money, different from anybody else that I've ever known.

Who else was there?

There was an attractive young Australian woman named Patricia Marx, who was sort of a protégée of his. For a while she also started to make some films there. There were a lot of musicians, artists…

In what way, as you suggested before, did you see him as practicing alchemy?

I remember him living in this room in the Bronx. He had a huge magic circle painted on the floor, and of course, the only way to get into the room was to step right into the magic circle, because he had it painted right in front of the door. But he didn't want you to step in the magic circle, so you had to leap over it onto the bed which was nearby; it was the only place you could land. Anyway, he claimed he used the magic circle to invoke some kind of magical presence or force and he claimed that it worked: some fleshy object appeared in the circle. I suspect it did. He knew a lot about Aleister Crowley and studied everything Crowley had written, and he had a complete set of Crowley's publication, *The Equinox.*

To me his work is, in a way, alchemy, and maybe a good title for the book could be "A Modern Alchemist."

Could be. He definitely saw himself that way. I can't help it but when I think of Harry, I think of Rumpelstiltskin; he also managed to turn straw into gold in his own way. I think he was trying to do that and would extract his extreme price for doing so.

In what way?

When the first born was tricked into giving up the prize by some-one getting his name, he got so angry that he pounded the floor with his foot till a hole opened up and he fell in and was never heard from again. I mean, Harry used to have some anger like that too; he was very self-destructive; he'd tear his own clothes, tear his own work, pull the fire-alarm lever. Joanne Ziprin told me a story: when she worked for Harry, doing a film called *Wizard of Oz*, or actually, I think the real name was *The Tin Woodsman's Dream* or *The Approach to Emerald City*, she was doing a very elaborate drawing and they got into a fight about one aspect of the drawing he didn't like and he got so worked up about it, he tore it into a thousand pieces and Joanne left. But she had to come back because she forgot something and Harry was on the floor, picking up the pieces and putting them back together.

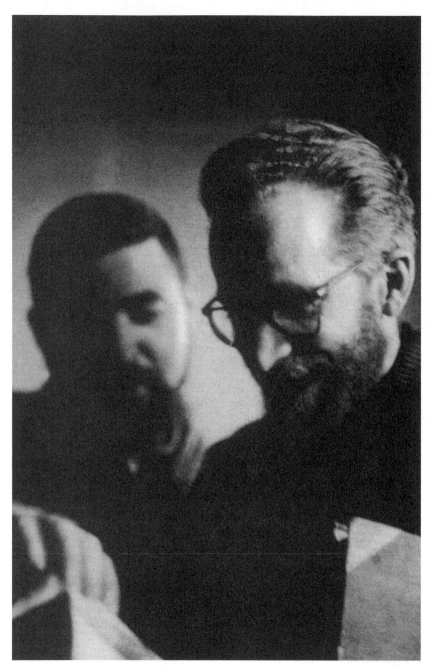

Lionel Ziprin (*left*) and Harry Smith (*right*), ca. 1952. (Photograph by Joanne Ziprin; courtesy of Lionel Ziprin.)

Lionel Ziprin

May and June, 1993

PAOLA IGLIORI: *When did you first meet Harry?*

LIONEL ZIPRIN: The morning after Joanne and I got married. We found a romantic seven-floor walk-up, like in Paris by the river and with a roof garden. Nobody knows who we are, no telephone, nothing. The next morning... I thought he was the janitor. I hear steps, a knock on the door. Who the hell is this? I open the door, and I jump back ten feet. There is this creature. He looked forty times older than how he looks now, with black eyes. The angel appeared at the door. I flew about ten feet. It's on West 88th Street and he just arrived. He says, "I just came from the airplane. Here I have an address of a Lionel." I swear he looked older than he ever looked afterwards, with rings, black rings under each eye, carrying a bunch of Indian feathers, a staff and a seal. Now I don't know whether this was Eskimo or what. It was a statue of a white marble seal breaking a circular magical seal. He threw the staff into the closet. I jumped about ten feet like when he first came. He says, "My name is Harry Smith." Okay. "Who sent you here?" "George Andrews," who was the son of a famous top dermatologist. He treated Churchill, Eisenhower, you know, all the kings of England. His last book was on flying saucers, part of which he dedicated to Harry and myself. He had thirteen children and lived in the Ozarks. So Harry said, "George Andrews sent me." I guess I had met George Andrews before and so I asked Harry if he needed any food, like pears, water. There were some pears. There was a little yellow table. There was no furniture. There was a lamp that we put on the yellow table. We put in a bureau and Joanne went out and got some boxes and put a mattress over them in the beginning.

On the floor are these books, because I had an interest in these things and I read a lot. There's a book about Aleister Crowley, some

Compiled with Previous Interview by Clayton Patterson with Kenneth Karpe, a long-time friend and business associate of Lionel and Joanne Ziprin.

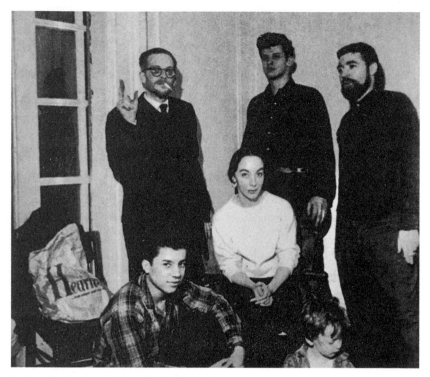

Left to right: back row, Harry Smith, Richard Paley, and Lionel Ziprin; *front row*, unidentified, Joanne Ziprin, and Leigh Ziprin. (Courtesy of Zia Ziprin.)

cheap biography by John Symonds [John Symonds, *The Great Beast* (London: Rider, 1951)] published in England and on the cover is a painting by Crowley of a spirit called Kwaw; it was not a good painting, but anyway it looked exactly like Harry Smith with a red beard. So he went for the book and he recognized that it looked like him. He started looking through Crowley and that was the beginning of his interest in Aleister Crowley [Harry's involvement with Crowley probably predated this incident as Harry told of meeting Charles Stansfeld Jones (Frater Achad), at one time Crowley's "magical son," who died in 1950.] So from then on he started to have an obsession about this man and he took off on that subject for years. I mean I had no interest in him. I thought he was sort of a comedian, a sort of comic Barnum and Bailey, a sort of W.C. Fields of magic. And I thought he was a harmless person. People thought he was a demon, the beast of the world. In those days, if a girl lifted a skirt over her

knee it was an orgy. You know what I mean? It was like Victorian times. Crowley grew up in a very stiff family. They were probably Anglican or clergymen, so he was like a little ahead of his time. On the other hand, before the revolution in Moscow, in 1913, he did appear with a whole group of Folies Bergères cancan girls in Moscow. He was also a mountain climber. He was a peculiar person. To Harry he became a thing. I didn't have that interest in him. I thought some of his books, like *777*, were okay, and *The Equinox* was interesting, you know, nicely printed. But I thought his magic drug experiences were mostly boring, that's all.

The other book on the floor which I had just finished reading was a translation of the Bardo Plane; it'd just come out from Oxford. This is from *The Tibetan Book of the Dead*, where the priest speaks to the body for 49 days. And Joanne made the enlightened remark about it; she said, "This is the Bardo Plane." And so he went into that and that began the whole Tibetan thing, right?

The Bardo Plane… that's why this Allen Ginsberg keeps Harry's body in the morgue for 49 days: because of the spirit. Harry is not a Buddhist, you know. How did they keep him for 49 days? What did they do? Put him in the freezer? Where was it?

In the freezer, I think.

In the Chelsea?

No, Saint Vincent's Hospital.

Yes, but do you realize that if you want a bed in Saint Vincent's Hospital with no medical attention and no food and no nothing it's $495 a day? You think the space in the morgue costs less? How did they keep him there? They had some pull with the coroner. And there were reasons for making this delay, for keeping the body on ice. What does Harry care about the Bardo Plane? It's a great book; it's a Tibetan book. In Tibet, they don't bury people. It's so cold you can't put bodies in the ground; so over there, the classical way is for a few families, that are like the butchers, to do it. You're high on a mountain, the corpse comes there, the priest whispers this Bardo Book (is he really interested?) into the ear of the deceased, telling him on the

first day you'll see a monster with green eyes (Tibetan iconography), holding a bone in his hand, and a bleeding skull and so on and so forth, and the priest says don't be frightened, it's only an illusion.

Okay, on the second day you'll see four red lights from here, three brass things, a demon holding a naked body… this over here, he's got a bracelet, he's challenging you with a javelin, but it's only an illusion. Next. So that's what the priest says in the Bardo Plane, translated by Evans-Wentz. The first edition was lying there. The soul of the deceased in Tibet, which is at the high point of the North Pole where the electric currents and probably the evolution of things are faster, where, on the 49th day, the soul is reborn somewhere; a baby is born or something.

So Harry got that book with the Crowley book and he went into all Tibetan things. Fantastic! At one point, he was writing to the Dalai Lama. Then the spirits came from California, because he brought his friends from Berkeley, Hube the Cube etc. And they ripped off all the Tibetan stores in New York (laughing), yikes. Count Walewski's store. Count Walewski's brother was the head of the Jesuits. Count Walewski was Polish, right? He is sitting in his store; he is like fat like a pig; he can't stand up; they have to hold him down. On the floor there are skulls and Tibetan musical instruments which they make out of the thigh bones, and jewelry, and hundreds of paintings, everything; Count Walewski can't rise; behind him are like all these baby skulls. He died in the store. So he was into Tibetan things, magic, folk music, and into all these things Harry did. Interesting.

Anyway, Harry arrived the morning after we got married, it must have been 1951, carrying all these notes and papers and he said he has all this art stuff. "What are you doing in New York?" He came to New York for three reasons: to see Marcel Duchamp, to see the Baroness Hilla Rebay of the Guggenheim Museum and to listen to jazz and go to Birdland, which we were going to every night like everybody else.

So he came the morning after. The marriage ceremony was in the afternoon and the party lasted until about midnight or one o'clock, and at around seven, or eight, the following morning, he arrived. Well, I interpret that many ways but I'm not ever going to do it for video.

So, naturally, since he was from the West Coast, Berkeley, and Joanne had come from Berkeley, they talked about Berkeley, Berkeley, Berkeley and Berkeley. I'm still hearing about it. He talked to her

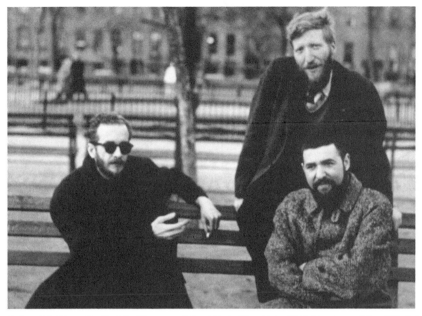

Left to right: Harry Smith, John Kraus, and Lionel Ziprin, New York, 1952. (Courtesy of Lionel Ziprin.)

about Berkeley as soon as they met. So he talked about Berkeley and began saying he has all these films and in this strange attic he showed us all his films in the next few weeks, right?

He had already done a lot of them?
Oh yeah, and he did those with the paintings, his paintings.

Which ones were the ones that he had already done?

Color study, magick, they're not magick, all kinds of films. And he showed us some films of his teacher, Hy Hirsh, who was murdered in Paris, and who did the first synchronized graphics, with music synchronized to film; one film used the music of Bach; and you know he taught him the synchronization process. And then he showed us all this stuff, so personal just for two people, all living in a theater for the next two months watching, every night, the films of this little bearded manifestation that had come in, that had walked in just like that.

What year was it?

1950 or 1951. Then he showed us these paintings of his. He had done these paintings in Berkeley; every little thing on the painting was infinitely detailed, every square, every dot, every curve. "Nights in Tunisia," Charlie Parker things, Dizzy Gillespie things, Thelonious things, right? Every note. So Harry would stand there like a schoolteacher. Things were projected here and the album was played. He has a stick like a school teacher pointing to every note (giggle). Unbelievable. So it was the beginning of a trip.

KENNETH KARPE: *There was a whole series of drawings he did of bebop, all the great bebop music.*

Yeah, that's gone.

K.K.: *Then he took those paintings and he did them with ink, and he made them multi-dimensional. So they looked like airbrush, but they weren't done with an airbrush. They were done with his hands.*

He did it with a toothbrush. He'd spray the paint on it so it looked like an airbrush; you know, take a toothbrush and put colors on it; comes out like an airbrush. Anyway, all those representatives of an entire era of music, like three months of Dizzy Gillespie, Bird, Thelonious, were gone. They were Kandinsky-like paintings. Every note a dot on the painting and Harry would stand there as a schoolteacher, with a pointer, pointing at each note as the music played.

"What are you gonna do in New York?" He was furious. I said, "You have no money. I mean how are you gonna live? This is New York City." But because of the Aleister Crowley thing I guess he met Mary Gorham at her bookstore, the Gateway, and she helped him for many years until she died under the wheels of a milk truck.

Every week I was supporting him and he found a little room. I don't know where exactly. I think it was a basement in Spanish Harlem and there he made like medieval alchemical mixtures, boiling them in jars for weeks, and he could not bear people. If I had a visitor he'd jump out of the window rather than be in a room with him, until he started drinking.

The only person he could bear was my late cousin Philip; he's about the only other person that he could talk to; he couldn't bear

fine artists. So then began the next thing from Aleister Crowley. But Harry being Harry, he got the first church translation of what's considered European Kabbalah: *kabbalah Denudata*, a sixteenth century German work [Christian Knorr von Rosenroth, *Kabbalah Denudata* (Sulzbach, 1677–84)]. And he started having all these works, bringing them to me every day.

Then Harry would go every day to the library and on parchment, actual parchment, he would copy out all the magical engravings. He had like a thing about photographic reproduction. He could do anything with his hands. This is before the alcohol. Then he would make translations of the Latin. At night, he would bring them to the house and the whole night goes. So, finally, there were like 2,000, 3,000 pages of fantastic ink drawings all from that world, and on parchment. Where is all that? There was just a truckload of art. On parchment, and in Latin, Hebrew, German, medieval French, he copied the drawings of those engravings and so accurately, it's uncanny. And every night he would come and bring all the work and lay it out to me and give me all these lectures. Now this is the European Kabbalistic tradition. It was a tremendous education. I was interested in magic, but not in that kind of detail, but Harry then went and did everything with European magic. There is what you call Christian Kabbalism.

But Harry was always interested in everything that could be made geometric, diagrammatic. Whatever you couldn't put in a diagram wouldn't interest him. So he was more of a philosopher. Whatever could be had, like a structure, or was subject to classification, stratified, was of interest to him. Tremendous!

See, he had two people who were important to him in magic. He learned from me a little bit but I just have a passing interest in those things. One was Athanasius Kircher, who was the head of the Egyptology department in the Vatican in 16-something. And the other one (you saw one of his engravings tonight) was Robert Fludd, a great man, who was the head of the Rosicrucians; both of them in England. There was also a third person, Theodore de Bry.

Then he made all kinds of things, three-dimensional art where you have to wear glasses and it pops out; I mean endless things.

So every night, I'd stay up the whole night. Every night we'd go to Birdland.

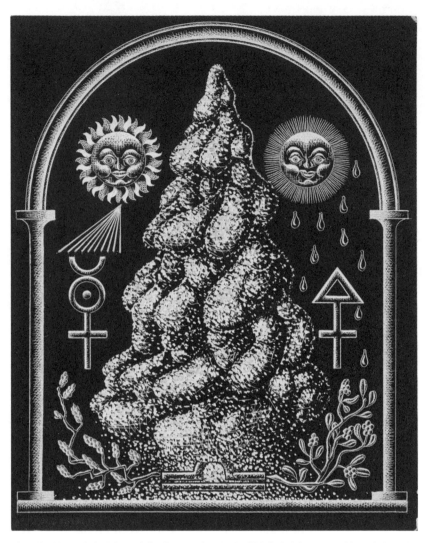

Harry Smith, study for Inkweed Studios greeting card, 1953. India ink on scratchboard, 8 × 6 in. (Private collection.)

Who was playing in Birdland?

All the great people: Bird, Miles, Dizzy, Bud Powell. Every night there was a scene but no words and every night we went there. Harry was very paranoid of being poisoned so he only drank milk. So at the same time every night, and for the next four or five years, we did that.

He brought me all his research, all the books; this is on a one-to-one basis. I mean, this should be in front of 500 people listening to a lecture. And all the time he thought I was insane. So I said, "If you think that I am insane why are you talking to me?" He says, "You are my teacher." I said (chuckle), I felt very bad, I said, "I'm giving up this whole subject," because, I mean, there's no point anymore of being interested in these things; Harry knew about billions of things; what am I to do? And any damn subject you talked to him about, Harry is like tuned into a computer memory bank somewhere on Pluto that has access to every subject in the world and he can talk about it. He can talk about any subject: anthropology, science, grammar, medieval logic, modern scientific electronics; he also knows how to work a camera, use any measuring tool; oh god, there's just no point doing anything. There's also the Tibetan thing. It went on and on and on and on for years. I felt very badly. I said, "There's just no point. I mean, I don't really care. I am not a scholar."

Then we went into business. Joanne wanted to do something creative, so she went into greeting cards. For the next few years, Harry is hired as a designer. His cards didn't sell. They were too peculiar for the American public. Harry would sit drawing Kabbalistic, capital K drawings, and you know that's what he'd do all night long, while giving his lectures, his interminable lectures! So I heard lectures every night for seven or eight years. Just for one person: me. Of course, Joanne would also listen to the lectures.

When did he do these three-dimensional cards?

Joanne had that idea before he came. Joanne…you know it's hard for me to talk about her.

You were telling me that it was amazing because she was really similar to Harry.

I didn't know this. She just seemed like a frail beautiful woman but she could do anything, anything! She could run the most complicated machines and printing presses. Who can run all this? You need to hire professionals. But Joanne knows how to do every little thing and so did Harry. But I made him feed the cats because I was so far out I

couldn't even look at a can of cat food in those years. If I saw a can of cat food I would die. Harry fed the thirty-two cats.

Thirty-two?

Yeah. Then I left. I said, "I'm leaving you. It's the cats or me." She gave away the cats.

You said you couldn't walk in your living room for months, maybe years. What were they doing?

They were doing the three-dimensional cards, films. It turned into a non-stop laboratory. Sometime later he allowed some people to come to see the films, the processing, everything.

That's great. Did Harry draw that?

It's a self-portrait as a devil.

What's that on? A scratch board?

Yeah. You see, if we were going to bring this out as a greeting card, the colors were going to be put in here. The scratch board was always the black and white base and then the colors are applied on the surface in transparent colors, except if it's gold or metallic.

It's a beautiful drawing.

I have a lot of his stuff. One set of drawings that he made cost me, the company, about $20,000. It was my fault. You see, Harry used to think I was insane, constitutionally insane. We used to fight because Harry's a scientist and I'm not a scientist; for him everything was precision. So he used to tear his hair. He says, "I tell you a thousand times that this this and this is and you don't know what I'm talking about." He always used to fight with me about science, about precision, about how to measure things, about angles, compasses, tools, about factories, and printing; I couldn't bear it. My wife was also about precision, so I suffered a lot from both of them. They were

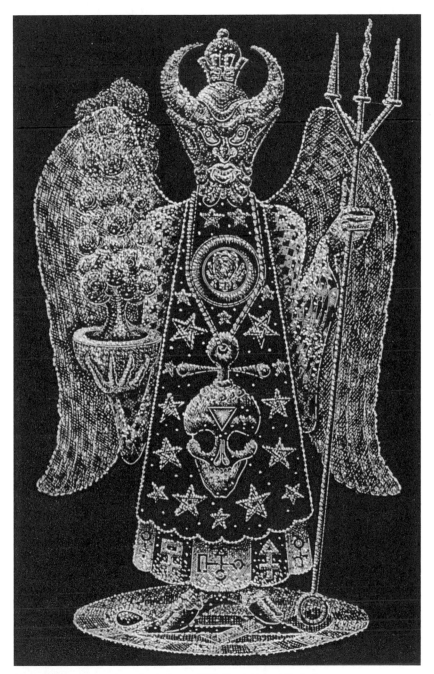

Harry Smith, self-portrait as the devil, ca. 1953. Scratchboard illustration.
(Collection of Lionel Ziprin.)

identical. They could do anything, any high-tech stuff and so perfectly. So Joanne gets the idea to bring out three-dimensional Christmas cards, you know, red and green and you look at them and they pop, right? I don't know how to do that so Harry will do it, okay? So we give him the large living room on 29th Street for the next four years. How do you make three-dimensional Christmas cards? You get wide screens and you make a design; here's a little deer running in the snow on the first thing. Afterwards, you make large drawings. Then you put another plastic screen on the frame and you now make snowflakes, candles, and Christmas wreaths. Then you make another thing with a little road leading to the cottage in the background and Snow White is going, right? And then you have a scene. Then you can angle it so it looks like a real scene. This takes eight months. Then you photograph it from this side, because it's like dimensional; it's like a real thing. And then you photograph it red from this side and green from this side. Then you get gelatin made in Europe, from the finest gel houses, which is exactly the color of the ink you print. And then you put the things to your eyes (I have the glasses somewhere) and they pop out. So Harry makes the glasses. I am not allowed into the living room for eight or nine months because I will bring a speck of dust. You know how Harry is. This is before he began to drink.

So it's all done and we get the things and they don't work. Why don't they work, Harry? All this money, $20,000, and now the damn thing doesn't work. He said maybe the inks aren't good. So Harry ordered another print run. It don't work.

Years later, I finally figured out why it didn't work. You know Harry is astigmatic; his glasses are so thick. So he wasn't seeing like ordinary people. Do you understand? He wasn't seeing like a customer was when he picks up the cards. So with all his damned science, hard damned science… right? And I had to get the money for this project from this son-of-a-bitch Greenhart, who was uptown. And I died to get this money. I didn't want to do the whole thing. I don't want to lose the living room for nine months. I need it; my things are there. Nine months with these cutouts… and that's why it didn't work. But it took me about ten years to figure out why it didn't work.

Do you have a Tree of Life drawing? Do you know what I'm talking about? Harry worked for the greeting card company for seven

years. He would only do magic drawings for himself. This was the work. And one day, we would use the European printing process, the very best collotype. There are only eleven such machines. You can get a run of about a thousand and then the gelatin plates dissolve. You get the most flawless reproduction. So he did this Tree of Life and we printed 500 copies. This is from Kircher. I mean, this is like the version of the *Tree of Life and the Four Worlds*. Here is the magic square, 2 x 2, 3 x 3. I don't want to go into this stuff. So it was printed collotype, black and white. He did it on scratch board. Originally the black was on scratch board, but that got lost too, and I don't have that scratch board anymore. Then for color, over the collotype printing, we did silk-screening. We had a nice silk-screening factory. Jordan Belson was one of the top filmmakers like Harry. They began in Berkeley before Harry came to New York. He was our shop foreman. He did a lot of things, like *The Right Stuff*...you know...special effects... and he does a lot of abstract films.

So he cut the screens for the colors and that's Jordan Belson's screen work, Harry Smith's tree, my paper, and I paid for it. I have a few copies. So Harry was into studying *this*. This is where Aleister Crowley comes in. Aleister Crowley categorizes knowledge and information but he's concerned with magical information according to these structures of this, this, this, this, and certain things fit here, certain kinds of facts and information, knowledge: angels, powers, drugs, herbs, magic symbols. This is the square of 7 x 7, 8 x 8, 9 x 9, 10 x 10. This is the earth. This is the moon. Then the planets fit in here, and of course it's all happening in four different simultaneous dimensions, which is really truly how it happens. I'll give it to you just in English. It's absurd to speak it in English. It says like "God Created," and one of these worlds is where the word "created" is, but when he says "He formed" or "He made," that's another one of these worlds. "He did," and "He made" is different than "He created." So it's happening in like four different worlds. And Aleister Crowley made a lot of use of this to classify all the data he had in his head. So Aleister Crowley and Harry... but I don't want the O.T.O. to kill me either. I kind of always had an interest in magic like as an odd tributary of the human imagination.

CLAYTON PATTERSON: *Why do people say he's Aleister Crowley's son?*

Mary Louise Hammond Smith and Robert James Smith—the parents of Harry Smith.
(Anacortes Museum Collection.)

He invented that. That's crazy. He was having quarrels with his father
so all of a sudden his mother…it's all untrue. He never heard of
Aleister Crowley until he saw *Kwaw* lying on the floor. He said,
"Who's Aleister Crowley?" I said, "Some Englishman magician." No,
he had never heard of him. Later, he developed some obsession about
him. I couldn't understand why.

What were his father and mother like? Did you ever meet them?

No. They lived on a reservation. They lived in Vancouver. They
worked in the canneries because there was the Depression.

C.P.: *Salmon canneries?*

Salmon canneries. He left Berkeley when his mother died of cancer. So
he had very odd and hostile attitudes about his parents. He said that on
his mother's death bed, he read her from a female psychoanalyst. There's
a center called the Karen Horney Psychoanalytic Center. He read her a
chapter in the book which I happened to have read even then, because
she was popular then. I just picked up the book on sadism. So he read
it to her as she lay dying. So he read her Karen Horney. So his mother
died, you see, and I guess that's when he came to New York. And he

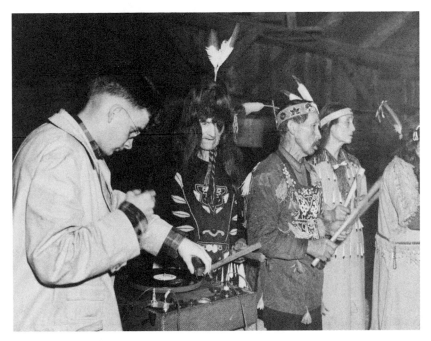

Harry Smith recording a Lummi ceremony, Lummi Reservation, Washington State, ca. 1942–43. (Photograph by K. S. Brown. Courtesy of Harry Smith Archives.)

didn't want to talk about that. But his father was still alive and I said, "Listen Harry, does your father know you're in New York?" No. "You know he's still your father. Don't you think he worries about you? Why don't you write him a card? Why don't you write him a letter?" No. He really wouldn't talk much about either of the parents. He talked a little about school, the work at the canneries, the reservation. Someone stole all the childhood pictures of his I used to have, of him in a crib, in a baby carriage, and just as a child. He was obviously a very disturbed child from the pictures. There was one picture where he's wearing shorts; he's standing in front of an uprooted tree, an old tree, and he was hung up on trees. He was in front of the tree and he looked like, distorted, and there he is, with the uprooted roots; he looked like a disturbed child. Terrible! Terrible! Then when he went to school he would do shocking things like putting an insect on a slide and then going into the room and projecting it so it was like 300 feet high, right? (laughing) Things like that. I don't know. Somehow or other he was always supported like he's an American. He's really an American. I don't

Four generations of Harry Smith's paternal ancestors, ca. 1890s. *Left to right*: Robert Smith, Robert Ambrose Smith, Robert James Smith, and John Corson Smith. (Courtesy of Murray Chalmers.)

just mean he's born in America. He's an American. So he always did receive support. He never missed a meal, you know. There was Mrs. Mary Gorham. I mean he was funded from a sort of social level.

Why were they living on a reservation?

His mother was a teacher to the Indians and Harry was, of course, already interested in that. He didn't know about magic and things like that but he was interested in symbolism and all the things concerning Indians.

What about his grandfather?

Now he told different stories about him. One he told was that his grandfather was the governor of Michigan; to someone else he said his grandfather was the governor of Washington State (I heard Michigan); he also said that his grandfather was the head of the Northern White Lodge of the Masons in the United States, which is possible; it could be checked here in New York. I don't know if that's true or not.

What was his connection to the Masons?

Harry?

Just his grandfather or…?

Harry didn't have any connection with the Masons. He hated all the secret societies in Europe. He was really anti coded systems. He was also a Marxist. These are things people don't realize. When he came to New York, he was almost a Berkeley Marxist and very much committed to psychoanalysis. So he really didn't have an allegiance to magic; he felt that the magic societies of Europe were elitist organizations. I mean Harry is hip. But it was worth investigating and the reason he idealized Crowley was that Crowley felt the same way. That's why he was kicked out.

So Crowley made himself like the most horrible man of the Renaissance: Pietro Aretino. They called him the "scourge" like they called Crowley a scoundrel and a blackmailer. Harry was attracted to Crowley because Crowley made fun of all the secret societies. So when you say Harry was a magician, what exactly do you mean? There are people like Bill Heine who are really that way but that's another story. So Harry made fun of all those things because he had a very cynical mind. In the beginning, he was pretensively, psychopathically anti-Semitic. I said, "Knock it off man, or leave my house." Like he'd throw the garbage out of his Chelsea room window and onto the roof of the synagogue next door but, you know, he was in New York and looked half Jewish anyway! With his little beard, starving, begging for a glass of milk. And you know that he looked like Steinmetz (who helped Edison in many of his inventions). He wanted to know about Jewish things like the Kabbalah, but he was mainly interested in anthropology. He went to a lot of Jewish bookstores. He used to come back with the most fantastic and rare religious texts, because he had knack for finding things. Now I got very jealous. I had a family, children. Do I have time to go out and find all these dusty places and drag all these things out? No. But Harry could find time. All I had to do was provide money all of a sudden. Money! My role was taking care of Harry, paying the rent, taking care of Joanne, taking care of the printing, taking care of this, taking care of that. And that was all. What kind of role is this? I no longer had time to write. I

gave up everything. Harry could draw. Joanne would sit and he'd work for fifteen hours with the colors. All of Harry's troops from Berkeley started to come. I got angry. It got me sick; it really did. But it was okay and these far-out talks with Harry…he'd frequently cry a lot when he'd see Joanne light the candles on Friday night.

Then he made these records, with my grandfather (Rabbi Naftali Zvi Margolies Abulafia), of the songs sung in north Israel (Galilee) where he was born, which is what they call in this world's literary history the Kabbalistic 16th century. The Crusaders built a temple here, another temple there. I don't think it's still standing. And that's where, in about the 16th century, a bunch of souls were born; when they refer to Kabbalism, they refer to that group all the time. Everything you read in English about this stuff is insane. But even the Jewish professors who write about it who are not religious, and they mostly aren't, are professors of these subjects; but still it's a tradition; it's an interesting academic tradition. If they're Jewish or not they write the same way.

So they made these records…

Oh, so Harry went to my grandfather every day for three years. My grandfather never spoke English.

Didn't speak English! How did they communicate?

I have no idea how. But every year my grandfather would make a party for the people that came from Safad (Tzfat, that's how it's pro-nounced). About three hundred people rent a hall here on Clinton Street and they have it every year. And Harry would wear a Turkish fez and white robes and light candles in the names of all the holy people in a tree that my grandfather designed which had hundreds of candles. That tree disappeared; it was about fifteen, eighteen feet high; and each tier was bigger than the other one. You get the picture? So then, my grandfather would sing all these songs and they would dance. You know how old people dance. And they did this on the anniversary of the death of Reb Shimon Bar Yocha. In fact, the anniversary is thirty days after the second night of Passover. So every year in Meron, thousands and thousands of Jews, mainly Yemenites, gather around his tomb and dance the whole night. So my grandfather

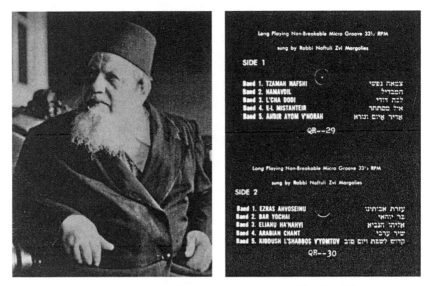

Left: Rabbi Naftali Zvi Margolies Abulafia. *Right*: Labels for Rabbi Abulafia's *Talmudic Legends and Liturgical Songs,* recorded by Harry Smith (private pressing, 1954).

danced here. Thousands, to this day...it's been going on for 2,300 years. I've never been there but I would sure like to go. And most of the Jews that come are Moroccan Yemenites and every year, for 2,300 years, thousands of people come there and dance around his grave because he said when he dies that we should dance. He was what they'd call the mouth of what is called the Kabbalah; anything of that which is true in this world is from him even now. If anyone ever said even a sentence that was true today in some store or synagogue or on the street, that is from him. But he lived about 2,200 years ago.

The Romans were then in Israel, and named it Palestine. He said something which incensed the Roman administration so that they were going to take his life and so he hid in a cave with his son for eighteen years in Meron. My grandfather went to the cave. Reb Shimon hid in that cave for eighteen years with sand up to his neck. But there was a little stream there and a tree and from the tree grew what they call Saint John's bread. One piece of it's enough for a meal for a whole day. I think you can still get it in New York. They bring it over. It's very hard and you take the pieces, and one little piece is like a whole steak. Harry heard all this and was interested, being he's an anthropologist. You see anthropologists are whites, super-racists. They come to look at

Indians; they come to look at Jews; they come to look at Africans. They are anthropologists. They are a superior white culture.

Looking at specimens?!

Looking at specimens, right. And I am sorry to say but Harry had a streak of it, whether it was the Kabbalah, my grandfather, or the Indians on the reservation. He was somewhat saved because of his Marxist understanding. But you know the attitude. He's Anglo-Saxon.

He's Anglo-Saxon?

Well, Harry Smith. Eventually, it's from the Anglo-Saxon. So they're looking at the races; they're looking at the Indians; they're looking at Japanese folktales; they're looking at Africans; and they're looking at bebop and Bird's blowing his brains out there, right? You know, *mmmMMM* (sound effect) and you know it's being classified, right? You know what that is. So Harry had a streak of that in him but that's not bad. He overcame it. What could he do? It's the best he could do. So here he's heard all this but then he really loved music.

So I had been attending these things since I was a little kid. Old people…you know it should give some relief…because he was in the cave all those years and I guess it couldn't have been too comfortable. They couldn't tell his wife. They thought she'd be tortured once she knew where he was. Probably all these revelations came. So Harry is an anthropologist and so he tapes this whole thing. After the taping is over, my grandfather comes over to me and says, "Who is your friend?" Cause I put a yarmulke on Harry; in my house he always had to wear a yarmulke. We converted him (laughing). We converted him. But I mean, this is how he had to be, that's all.

My grandfather said he was Jewish. I never heard my grandfather talk like that. It was the only time. So after it's over, Harry let him hear it. My grandfather didn't know what a tape cassette was. He says, "Oh, that's my voice!" (laughing). "You tell the Indian chief…" "You liked this?"…oh…right… "Magical, wonderful!" So then he gave it to my grandfather. My grandfather listened to all this, a little flattered. So the next thing (I don't know how Harry got into it) is that I have all these papers, the receipts, everything about recording

devices that filled the whole wall in the back of the synagogue where my grandfather slept. He lived upstairs, three flights in the next building, but he sometimes slept in the back, because he was heavy and old and he couldn't walk up the steps. So for three years, they recorded thousands of hours of music. I don't know what happened to that footage but it probably got stolen. Harry's an anthropologist, right? I mean a really authentic one who loves music. So at the end of three years, my grandfather, who was in his eighties, saw all of Harry's films, and said: "He's from another world; this could go on another 400 years; I have to have a professional studio do it." (laughs) And he went to the top. He was the first customer of the top rock recording studio, Cue. He walked in with his white long beard and they made fourteen albums, which I have. There's only very few left. He made a thousand of each of the fourteen. They were printed and labeled and everything, and shipped to him that week. A few days later he passed away and so did Charlie Parker. Charlie Parker and my grandfather passed away a day apart, in February 1955.

How old was your grandfather?

About 88–90. I have to do these records before I die. I have to get them distributed. So Harry brought out the album that everyone was talking about.

The Folkways Anthology?

Yeah, and Folkways also knew my grandfather, and I think that's how Harry got to connect with Folkways. They decided to sell one of my grandfather's, too. So Harry at least got his album out. He didn't get money either, but he hypnotized Moe Asch who knew he was a great musicologist. Harry was a great anything you wanted; this is an unnatural mind. I used to feel uncomfortable because I didn't know where the hell all this information came from? You never read, man. Harry never read books. He'd glance through a couple of books and he had a photographic memory. How did he do it? A lot of people just couldn't bear it. Where did it come from? And in such detail; it was a certain kind of structural and classificatory system with regard to info. I don't know…

He just accessed it.

Yeah, right? It doesn't matter what the field. These candles were manufactured in the year 1861. How, exactly? He'll tell you the whole thing: the designer, the machine, this, this, this, this, this, this. You want to know how salt is processed? He'd go into a whole thing about the salt industries from the last three hundred years. So it's a bit of a challenge. So Harry got his album published. My grandfather also got him into string figures which my grandfather did to entertain me as a child. There were also the thousands of books he collected on string figures from all the people of the world: the Hawaiian Islands, the Eskimos, Transylvanians, so and so.

I saw him once, when he was drunk, take an original Cagliostro manuscript, not many pages, written in colored inks, which appeared during the French Revolution, and tear it into pieces in my house and throw the pieces on the floor. This was when he was lighting cigarettes with ten-dollar bills.

No!

He didn't have that many, right? Harry took up so much of my time. He was here all the time. What would we do? This was insanity! Every night he's here the whole night, the whole damn night. Forget it! So when the second child was born, Noah (the first child was born a year after the marriage) he still would not leave. Joanne would pretend to get him out, but who could get him out? Harry was a sibling, you see. He would hang around married couples. Then he would start splitting them up and making trouble. And it was always a husband and wife because it was his parents, his mother and father. Then he'd set the fights between the mother and father. But children do that, you know. It's classic Freudian stuff. He'd make fights between Joanne and me. First he'd side with Joanne, and then he'd side with me. But he wouldn't really side with anyone because he's got to be diplomatic. He's the child between his own parents. You know, all of a sudden they're attached to the mother and then they're attached to the father and they know the whole politics of the parental. So that's what Harry did. I was his father. Joanne was his mother. And he separated his parents; his mother lived three hundred yards from the father, and he finally

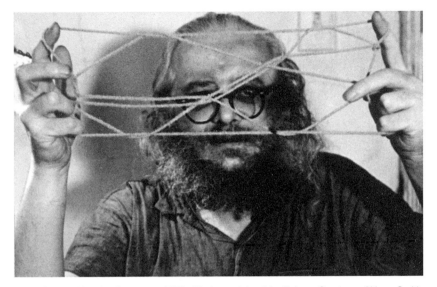

Harry Smith with string figure, ca. 1970. (Photograph by John Palmer. Courtesy of Harry Smith Archives.)

got the father to live in a separate house. It's not an uncommon thing that the children will do. He caused us a lot of grief but then he'd turn to Joanne, and say, "Oh, the food, the colors, the music…" And the next thing he's turning to me, and saying, "Here's the magic…," right?

Then one day the whole bulk of the artwork is gone, all the paintings, everything. Harry would go every day to the Jersey dumps, looking for it, and cry. That's why he started to drink. He was living on 74th Street and there were two Hungarian midgets who were the landlords of his apartment. There he had all the artwork of his life and all of his paintings and he came in one day and the whole apartment was empty. So the midgets told him that they emptied the apartment because he didn't pay the rent. At this time, he had another terrible thing happen. He finally became large, and a few million dollars were put into *The Wizard of Oz* to make a full widescreen film. The promoters of the film were unhappy that he made only nine minutes of it over a year while using expensive cameras. Nine minutes! Walt Disney would have taken 300 people in a year to make the first nine minutes. The only employee he had was my former wife. They made the film together, with Hieronymus Bosch cutouts from *The Garden of Delights*: Paradise, Hell, the famous triptych. They worked it out for

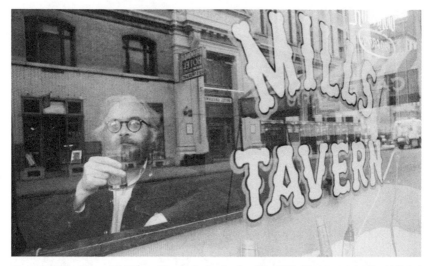

Harry Smith in Greenwich Village, New York, September 28, 1965. (Photograph by David Gahr/ Getty Images.)

a year using $4,000-a-week animation cameras, you know. When they made the *Wizard of Oz* film in this fancy townhouse uptown, I wasn't permitted to come. Just like I wasn't permitted to come to the meetings to discuss whether he should be cremated or not. But once I was permitted to come I didn't even care to go because I was busy at the time. I had a good job writing comic books. Whatever I was writing was happening anyway. So when I got there the whole place was my living room. Identical stage reproduction of my home in the mansion uptown. The boxes piled on the wall, the round oak table; it was like they staged a total reproduction of my home except for the $4,000-a-month animation camera that was coming down from the ceiling with twenty-two Cabalistic steps for the twenty-two letters of the Hebrew alphabet. The exact reproduction of my living room where I was living downstairs on 7th Street, right? She lived in my house (points to Paola), you know; this girl lived in the basement on 7th Street. Can you believe this? She was there when Harry died and she lived in my apartment.

C.P.: *I think that's where Herbert Huncke lives now too, isn't it?*

Yes, and she lived in my apartment for four years. So listen to this. Elizabeth Taylor, the actress, put in money for the film big-time. It

would've had a tremendous cultural effect to make a film like that. It would've been seen in widescreen.

What year was this?

It must have been about '63 to '64. So I told you the part about where all the art disappeared. Now wait, this is the other part, it goes together. So all the money was gone…the promoters…Madison Avenue promoters, right? Naturally, they took the money and one day Harry went home and didn't find all the artwork of a lifetime, of a lifetime! All the paintings. They go to the place and it's closed. What do you mean? They're in the middle of making a movie but it's all closed and the cameras were taken out. At this point Harry, who was a recluse all his life (if someone came in the apartment Harry would go and hide in the other room, you know, a recluse), lived in a little place in Spanish Harlem. Nobody came. He lived on yogurt and thought everyone was poisoning him. He was a total complete recluse. So when these two horrible things happened, that was the end of the film career and all the artwork disappears. At this point, Harry Smith begins to drink.

I don't want someone to shoot me…but I have a feeling…this is why I say poor Harry…he used to think it was somewhere in the dumps of the Jersey garbage lots. Somebody gave him a lot of pain. Naturally, to lose all that stuff is a terrible thing. He would actually go looking for little pieces every day.

That's so sad.

After that he gave up hope of recovery and that's when he started to drink. The film ended and the art was lost, and that's it.

When we went to Birdland, he would never drink; he'd order milk, you see? He'd order milk and he never spoke to people. Now he starts to drink. In one way, it could have saved his life but I mean he really drank until he'd fall on the floor every night. First Peter Fleischman (Peter Whiterabbit, who was the head of the Hog Farm with Wavy Gravy) and then Mark Berger took over for about the next ten years, you know, strong kids; they'd be with him every night 'til he would fall on the floor, and then they'd pick up the

body at Stanley's Bar, and of course Harry brought a mob. It was the first time he was in public and he was a legend. So here he was drinking every night and they would pick up the body and wherever they had to take it they would take it. At that point, he ran into Ginsberg, and at that point, Shirley Clarke, the film director, said, "Come to the Chelsea and I'll pay your rent." That's how he got to the Chelsea.

Now alcohol didn't go with everything else because his whole thing was precision, you know: animation equals precision. The artwork was super precise. Everything was about precision. But you see, he could have also wanted to live this way. Because otherwise the shock would have been too much. But now that he had all this alcohol, he socialized with people, screaming, yelling, going to the Chelsea, and they came into the room: scenes were created. So the artwork stopped a lot. And then he made that one ... Bertolt Brecht ... Lotte Lenya ... *Mahagonny* ... which was perfect for the Chelsea because you know the Nazis closed it the first night that it showed in Berlin.

Why do you say, "In one way it could have saved his life?"

It could have saved his life. I had a feeling maybe it did some kind of good because at least he was with people and he wasn't hiding in little rooms. His body wasn't all gnarled up like this all the time, you know.

Is that when he started making tapes of birds and broken glass or was that before?

Not before. He moved more with people; he spoke to people; he wouldn't go into fits. I'll give you an example. Bruce Conner would come and Bruce was just a kid, a great American painter and a friend of [Robert] Frank's. But Bruce would come down to the house and even with Bruce, a baby looking like he's from the farms in Minnesota, he would scream and throw things at Bruce. Harry was like a child. So, at least when he drank a big change came over him. It deteriorated the art but he started making tapes and things like that.

What happened to those nine minutes of The Wizard of Oz?

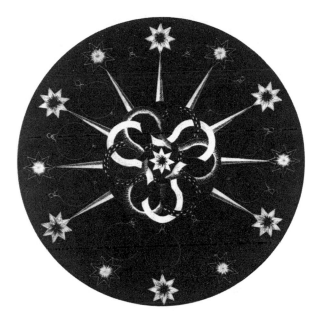

Harry Smith, diorama for three-dimensional Christmas card, ca. 1953. Collotype.
(Collection of Lionel Ziprin.)

He threw them under a truck. I think they were rescued under the wheels of a truck. Mekas knows all the secrets of the films, the nine minutes widescreen. Where are you going to see widescreen? At twelve o'clock at night or 1:30 at the Rivoli uptown. Is the Rivoli still a theater uptown?

C.P.: *No, it's not there anymore.*

There he would show it to investors. They robbed all the money. I was very angry with him because I told him, "They're going to rob all the money. You are an idiot, and you don't know what you're dealing with." He says, "I don't want to hear it, Lionel, you just want to meet the investors." I said, "Drop dead." You see? It was already high times; Elizabeth Taylor would come, Arthur Young, the biggest single stockholder in AT&T…people, people…and they were taking all the money. You should have seen the promoters. I mean, you just figured you got to be crazy not to know what is going to happen, right? You had to be crazy. I said, "HARRY." He said, "NO, LIONEL!" I said okay. Anyway…

But he always had this thing for commercial success?

Yeah, yeah, always. All he talked about was how to make millions. Yeah, it was fun. We were living in that basement when the *Wizard of Oz* movie was being made. The reason I remember this is that they worked twenty hours a day, the two of them. They would work together like two dwarfs over the thing, and all night. Then she would come home tired in the middle of the night. She hasn't slept for twenty hours and she's so strung out from this whole thing that she starts fighting with me. So I would sit in the kitchen. I didn't know what to do. I didn't know what she was talking about and she was so uptight. She would start fighting with me and then it was nine o'clock, and she had to go back to work, so she didn't sleep for months. And I would sit there. The only reason I didn't walk out was I gave her the courtesy of just listening to her. She just would scream and scream, wound up from the whole thing. And I would just have to sit and listen to her and I never heard anything she said! I mean, these are all artworks... there's a lot of things I can't say, but the main thing, more than the film, is the artwork. All the paintings that were synchronized to jazz. UNBELIEVABLE work. All his Indian stuff. He copied them and he made like sand paintings. He made all kinds of things.

What was his Indian stuff?

Well, he had lots of American Indian stuff. But then the spirits came, hundreds of them. Now who... how they came about I don't know, the whole underground... thieves and some that only stole dragons, but only from museums, because they could go through walls. But they were very respectful in the house. I didn't hang out with them. I didn't know who they were. They started graffiti; where the people died they'd graffitied the walls; that was before graffiti appeared outside. They would bring the spirit books, in Hebrew, Latin, French, which I have locked in places; some were written while unconscious on the floor, totally unconscious of what they were writing. Then there was an invasion of the spirits, but they were all connected to Harry. They talked more to me. I don't know how that happened. Well, they'd talk more to me because Harry would never give them a nickel (laughing). They all wanted a nickel. A bronze Buddha from the 12th century for

twenty cents. What did they need it for? (laughs) So here's the bronze Buddha. I said, "The police are going to think I'm a fence. They're going to come in here." We're starving on Avenue D in an apartment and he's got four thousand, twenty-two thousand dragons, mainly dragons but, I mean, from the 12th century, the 7th century, seven-clawed dragons, royal five-clawed dragons, and Buddhas, and Joanne is screaming, and diamonds are rolling on the floor. I said, "Get this stuff out! The cops are going to come. I'm going away for twenty years. How do I get all this stuff?" I said, "I don't want it in my house. I don't want all these people in my house!" (Especially since the captain of the Tactical Police Force, George Mould, became the landlord.)

She fed them, of course, like she fed Harry. But at first it was only Harry. Then it turned into forty and she fed them all night till dawn. She cooks all day long; this table is set in some otherworldly way; and then they come in at all hours and they all eat as much as spirits eat but at least you have to feed them. And then when it's over, there's forty-two more bronzes, thirty-two more magic things, seventy-eight more swords, all these things. Well, you know they never last. You can't hold onto that stuff. Most all of it is gone. They were very nice. They never used bad language in the house. They'd talk in tongues; all of them unbelievable. With Harry, at least, it was still in the realm of literature, history, and scholarship, but here it was for real. It's not the 13th century… this is impossible… there's a pentacle… I mean the *real* thing, not out of books anymore. I said this is unbelievable. This is not a Gnostic theatrical masque with some religious corporation and bring back some philosophy. I learned a lot from them. They taught me all these things more than Harry taught me. But they were dirty, their hands were all dirty, and you know, the books that I got from them, they smelled and until about a year ago they still smelled; for twenty-five years, they have this strange odor…

So here I saw Berlin right in front of my eyes, all over again, on 7th Street. It's Berlin, 1930. That's why Harry later did *Mahagonny*, you know, *Mahagonny*, the film, because that was shown in Berlin one night and they burned down the entire production. Lotte Lenya, Bertolt Brecht, Kurt Weill, all the big shots came to see it, and they burned it down, closed the theater after one performance. Why do you think Harry did it? Harry understands these things…at the Chelsea…Berlin. It could have happened all over again. I saw

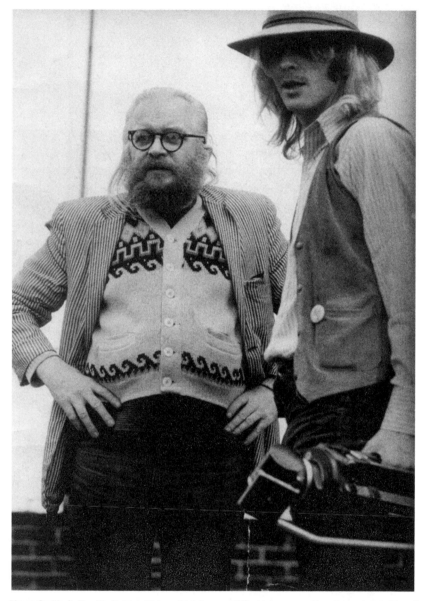

Harry Smith (*left*) with Patrick Hulsey (*right*), ca. 1970. Hulsey was the cinematographer of Smith's *Film #18, Mahagonny*. (Courtesy of Harry Smith Archives.)

everything and I saw Berlin in 1929, up to the advent of the Third Reich, in front of my eyes on the spirit level before it happened. They were all using amphetamine, synthesized amphetamine; they'd put it in their head. That's why the Gestapo… they didn't know they put it in and then they march for fifty-five hours. So that whole thing took place. In front of my eyes. It re-manifested. That whole world on 7th Street. But that's happened at the Chelsea too, and you think German Expressionism is cut off by the war, but the energy of it and the art then went to the Chelsea. That was another place, but on 7th Street, Berlin was reenacted. Harry would only come in on the sidelines because that's not really his story, but since it is his story, he did *Mahagonny* at the Chelsea (that's four projectors at the same time). Did you see *Mahagonny*? It's a complicated film to show. You should buy the album because it's just unbelievable music, with Lotte Lenya, one of the great singers. Harry used to cry during it.

Harry was drinking at Stanley's Bar where he became public. Hundreds of people came to look at this creature who would drink himself to collapse every night. Opposite, on 12th and Avenue B or C or D, was a deserted post office. So Joanne and Barbara Remington and Bill Graybelle opened a place called the Grove, a club to make a little money, money, no money, serve coffee and a little jazz and a little of this. It was open about two nights. That night, as they opened some dive, the Grove, Marlene Dietrich went into a club in Berlin, called the Grove, and discovers five kids in black jackets called the Beatles, that same night, and says to them, "Come back to London and I'll introduce you to Mr. Solomon," or whoever was there that became their manager, right?

So she brings them to London and six months later they come out with their first album. Harry's still drinking terribly and doing whatever he was doing over there in a bar on Avenue B and 12th Street. And Bob Dylan comes out with his album. Now the new music…so the spirits of the new music start to appear: rock. Very different. Oh, I was relieved to see them but I was also afraid. Because they drove away the other spirits who were very clean. These new spirits could take so many drugs and you wouldn't know. They were perfect gentlemen, right? Well-dressed, right? Not so hard yet. But they were absolutely cool, fantastic artists. They were electrode birds, aerial birds, not from the ground, not from the amphetamine that comes from coal in Germany,

you know. It didn't cost anything. They'd get it for twenty dollars a two-pound bottle, chemically pure. Nobody was using it; housewives weren't using it. So they drove the other spirits away. They invented light shows; they were into electrode chemicals, planetary things; the space program began. So space began and electronics, and then light shows. Did I talk about the light shows? The aerial spirits came, the air spirits, and that's when rock began.

Stuart Reed had an old projector that he found in a store. This is how light shows began. He showed the old slide projector to all the rock groups. They used to put a candle in it in the living room in 1870 and put a little slide with a silhouette (this is with all the movies of photography) into the projector. The candle would burn and the little picture would be on the wall. You remember those? It was about 1840. And they were very nicely made, like, you know, using beautiful wood, and the families on Sunday afternoon have tea to entertain with the projection of these slides.

So Harry brings the projector to Stuart because he finds it in a store and we put a bulb in there and Stuart is putting his fingers…just playing in front of the beam and colors are appearing on the wall…where do the colors come from?

K.K.: *Wasn't he using crystals?*

No, this was before. So we decided the colors came from a thin filament of perspiration on the fingers and the refraction. So, from this, he eventually started this whole light thing, but they were not with commercial stuff till…well, Harry said Stu was a planetary spirit. They made it so that the spheres, the planets, manifested in the room three-dimensionally and you could see this up close. There is not a telescope that will be set in space for the next hundred years that will be able to gain such proximity. Unbelievable! And so they drove away all the earth spirits and now they landed on the moon, and a new world began. The old magic was a little boring, you see.

When did you last see Harry?

Harry and I didn't see each other very much. It was as if everything we had to say was already said. After Joanne left, there was nothing

much to say. In fact, there was nothing much to say from the time of the drinking. He'd come around and he was always drunk and always falling on the floor and the children got very disturbed. I'd see him if I'd visit the Chelsea Hotel now and then, but still he was always very friendly. But we did have something. The last time I saw him he shook my hand. I was shocked to see him. He looked like a baby, three years old. Last summer, the summer before he died, Debbie Freeman, who showed the slides, had a show on 57th Street for the photography. I went and Harry attended. I was so astonished. I couldn't believe how Harry looked. He didn't have a wrinkle on his face. I said, "What is the matter with you?" So he said, "I'm gonna go down fighting, Lionel!"

When Harry left, I felt myself in a net being pulled over the river. You know how long it lasted? I just recovered. Ask Clayton. Clayton was worried. Every time, he said, "Lionel, I live not far from you and I have a bicycle. Anything the matter, I'll ride right over to your house." I felt myself dying for months. Now I don't know. I never had an attachment to Harry. I mean, I haven't even seen him for so long, right? I just couldn't function. When my parents died, I didn't react that way, and I don't say it's on account of Harry, but maybe it's a lot of memories, you know, from half a century.

Anyways, I'm glad that I met Harry before he went away, and we spent a very good hour, hour and a half, just personally talking, and there was like a feeling of good will. In fact, when I was with Ruthie and said goodbye to him (you know I never saw him again after that), he sang the Bar Yocha song that my grandfather used to sing, twice. He showed me he retained the memory of it.

(Humming it) Da da dum bum be de de de ba de de de dum dum da dum…well, the tune began like that. He sang it right on 57th Street as Ruthie and I waved goodbye to him. I couldn't understand how he looked this way. But he came to get some kind of revenge. I could pick that up from his head and I think the artwork that is lost will, in about fifteen or twenty years, maybe sooner if they're really greedy, suddenly accidentally supernaturally manifest.

Harry was a perfectionist. So wherever he is, may his soul rest in peace, right?

Amen.

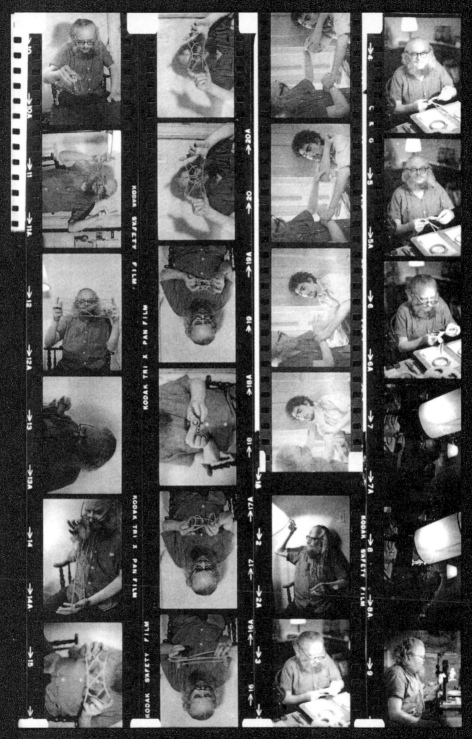

Scenes from the Chelsea Hotel, New York, ca. 1974. (Photographs by Debbie Freeman.)

Debbie Freeman

July 7, 1993

DEBBIE FREEMAN: I was standing in front of the Chelsea Hotel. It was probably a spring day. I had lived there maybe five or six months, and he walked up and started talking to me, making some kinds of comments about my green eyes, and then we became friends. I used to go and visit him and I suppose I was a little bit shocked, because I had never met...well, I can't say I had never met anybody like Harry...but I hadn't met anybody (laughs) like Harry. He was as about as eccentric as they come. So I used to go and visit him on the second floor in this room that he had in the Chelsea, and it was all very cluttered...I don't remember...maybe he had a lot of boxes and that's why it seemed like there were things all over the room.

I left for Europe. Then I came back about a year later and Harry was at the Chelsea, on the seventh floor, and starting to shoot his film *Mahagonny*, so he was in quite a frenzy. He was drinking a lot of alcohol and taking more speed and more marijuana than before and everything got crazier and crazier and I got crazier and crazier. He had a lot of people hanging out with him, and that was his sort of diabolical side. I mean, he would have temper tantrums and throw the goldfish down the toilet or break his glasses or something. And he talked about these tantrums much more than they actually happened, but eventually the scene got even more destructive. That's kind of why it ended, because some of the people were starting to get violent. I won't say they were just *threatening* violence.

PAOLA IGLIORI: *What year was this when you met him?*

I must have met him in '68 or something. When I came back he was...well, I guess Shirley had given him a camera to use and Patrick was helping him. I had introduced him to someone named Lyonas before I went away and Lyonas' brother-in-law was Patrick. I think Patrick was shooting it. I can't remember. Harry was doing all these other weird things like videotapes of us. He used to throw me on the floor (laughs)

and don't ask me what the symbolism was; he would push me down and sort of climb on top of me. Symbolism! Anybody could figure out the symbolism but me. Well, he had some complicated rationale.

There were these other people in this scene like this guy who was a dealer, blond, and from Texas, who was helping Harry substantially in his drug intake, which Harry didn't really need but seemed to enjoy. So *Mahagonny* was made in some kind of diabolical frenzy. I mean Harry was very…he was evil at that point. I mean, a lot of people really probably hated him, or if they didn't hate him they grew to hate him because he was very destructive and he was very, very manipulative. He knew how to tune into your weaknesses and then use them against you. If he was critical in putting you down, that was a way he could control you. Harry's philosophy was …I take it that it what it was similar to or the same as Aleister Crowley's in that way that life is fantasy, life is an illusion. You have to pick your fantasy, and the degree to which you can convince other people that this is reality is what makes it real. So this is a kind of power game, and at the time I thought it was magick, but then the whole scene in New York got permeated with this. I mean that's what people are doing now. Everybody's self-created. This is just what it's about. So everybody's sort of manipulating everybody into thinking they're important or trying to at least. Harry was really before his time. Yeah, the whole scene now is Black Magick (laughs). They don't know it. They think they're something else, just egomaniacs. But he was very shrewd. I mean he manipulated a lot of people that way, and he manipulated people into thinking that he was some kind of a guru or some kind of wise man or superior being, and Harry was very involved in that manipulation. And putting himself on a pedestal and getting people to kind of worship him.

What were the things he actually loved doing?

Taking drugs. Putting people down (laughs).

What were the tapes? You started saying that he was videotaping and…

Oh yeah. I don't have them, but I found out they're part of Shirley Clarke's collection, and I've heard that her daughter has them in California. It would be interesting to get those.

So what kind of things would he do? You said he would push you down…

He would jump on me. He had other people taping. This guy, this Texan, would do the taping. I've forgotten his name. But you know, everything was like…it was like documentation, and like as if every little gesture of Harry was so important and significant because he was so important and significant. So I mean, there's a certain kind of arrogance about it all. And I'm sure that the drugs he was taking (he would eat Dexedrine every day) and the marijuana and the alcohol helps sustain this kind of egomania. When he got older, obviously, he changed a lot and he became much more benign. I think he needed people. At that point he was…he sort of felt he didn't need people…one person dropped out of the scene, someone else would come along.

Was he then taping his noises of broken glass and the birds? Do you remember some of those experiments?

I don't know that he was doing it then. I think he was just very focused on the film. He was photographing people, which was unusual for him. It was the first time he photographed people…like maybe not the first, but one of the few times…

Like portraits, or what…?

Yeah. And sometimes they'd be doing something. You haven't seen *Mahagonny?*

No…

So he would have them doing things that were maybe emblematic of something and then he'd have four screens together; it was still very abstract. He was constantly playing *Mahagonny* and he really liked to manipulate people's fears and use those. He was quite a character. I mean, at a certain point, I stopped hanging out with him because it was starting to make me crazy. If you hang out with somebody who's crazy they'll sort of take you to the edge, and if you're smoking pot…I mean, I started to feel like my mind was traveling in outer

space and that you could actually astrally project out of your body which was kind of scary. I didn't think I was ready for that, but maybe that's similar to when the soul leaves the body. I mean, I finally would go to sleep at like five in the morning because I was afraid. I was afraid of dying and that's why I couldn't sleep and so that's kind of how Lionel came into the picture. I kept calling him at five in the morning but that was more the end of the story. I don't know maybe the middle…what was the middle?

Did Harry stay up?

I think he was up at night, and he probably would sleep during the day and then…I can't remember…but I would imagine it was something like that, because he was too old to really stay up day and night.

Yeah. Was he already living with all those birds?

One or two birds, not more than that.

But was he taping them?

I don't know if he was taping the birds then or not. I think that was later. It's my memory that he would do one thing at a time. I mean, when he was really focused on doing *Mahagonny*, he was figuring out the scenes and then doing them, and he did a lot of the animation with the powders. The animation was really extraordinary in *Mahagonny*. Really beautiful. He would use these different colored powders and they'd be moving and swirling around so they were very like, not necessarily like on another planet, but like something in outer space. They're really beautiful.

And he would film this?

Yeah. This was the animation that was in *Mahagonny*. And then he would photograph the trees in Central Park and he would reverse the picture. He did four screens so he could have people in two of the screens and then in the other two screens he could have the picture of the trees and then the reverse of it so they made this kind of chain.

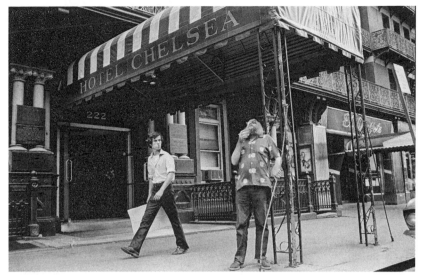

Harry Smith (*right*) in front of the Chelsea Hotel, ca. 1973. (Photograph by Peter Angelo Simon.)

Kaleidoscopical.

Yeah, that's exactly what it was; it was like a kaleidoscope. And then he had colored filters, so the colors could be changing too, and so there was constant motion.

Lionel was saying that at a certain point his work was very much about precision, and then when he moved to the Chelsea and started drinking it wasn't so much about precision anymore. But, from what you're saying, it sounds as if it still was.

Yeah, but the drawing wasn't about precision. This was more the animation, but his drawing could no longer be that precise because of the alcohol and it's true you can't be that technical. But he wasn't drawing then. He was mainly driving everybody crazy, but it was a good time to be driven crazy, because everybody was crazy anyway. I mean, everybody was taking a lot of drugs and there were a lot of interesting people…a lot of them met Harry and were intrigued by him, you know…people like Marty Balin and all kinds of people…Patti Smith and Robert Mapplethorpe…and Shirley Clarke was a good friend for a long time… I mean, she was very supportive of his work…and Jonas Mekas.

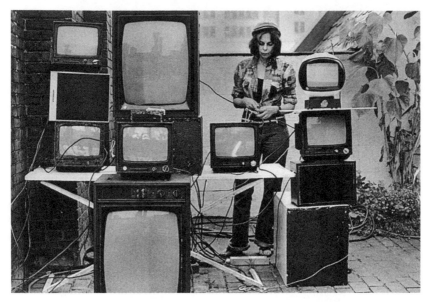

Shirley Clarke on the roof of the Chelsea Hotel, 1973. (Photograph by Peter Angelo Simon.)

Who's Shirley Clarke?

She lived in the Chelsea for a long time. She did a film of a Living Theatre play called *The Connection* that was written by Jack Gelber. It was about the heroin scene. She filmed it and then she did another movie called *Portrait of Jason* that was a monologue by this black guy. I don't know how to describe who he is. Then she did some interesting videos, and she also did things with many screens, like experiments with video. She was, I guess, a *cinema verité*-type photographer.

Did Harry do anything with painting music when you met him, or was that much earlier?

That was before. The first time I met him he was doing the water-colors. He was doing watercolors in the bathtub or something. That's when I first met him. He had some special technique of how he would wash them and it was a secret. I mean, maybe somebody else knows how he did it. So that was that phase, and then later he was just working on the film.

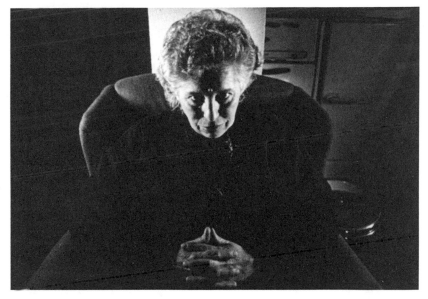

Peggy Biderman at the Chelsea Hotel, New York, ca. 1970. (Photograph by Claudio Edinger.)

And you were hanging out a lot together. Peggy [Biderman] was around then too, wasn't she?

Yeah. We were all hanging out a lot, compulsively. I'd say I probably hung out with him for a good six or eight months and it just got to be too heavy; the scene started to deteriorate and I don't remember how long it was. There was this crazy guy named Jacques Stern who was a cripple and he used to visit Harry. Jacques claimed he was either an illegitimate son of the Rothschild family or something but he was quite well-off and Harry was trying to court him to get money for *Mahagonny*. And that didn't work out so well. There was another crazy guy around named Will Royster who was at that point presumably doing a book about the Hell's Angels. And he either...I don't know if he actually hit Harry or he pushed Harry or he broke down the door... because it was always a power game as to who could be in control. This guy was a violent guy and it got heavy with Jacques, too. I think that Will was working for Jacques. Jacques was the reason that Harry left the Chelsea Hotel. Jacques was a very strange guy. In fact, I had moved out of the Chelsea, and I moved into this little apartment on Gramercy Park, and Jacques moved into

the building next door, and he was one of the reasons I moved out of that place, too! Because he was pulling a loaded gun on people, and he had these big windows facing the street. I mean, who wanted to have to think about a loaded gun being pulled on you as you walk out the door in the morning? I guess that's where the power game ultimately will go; it's a matter of life and death. I mean, if you can't control somebody, then you kill them.

When was it that Harry left the Chelsea?

Well, it had to have been something like '74 or '75.

And where did he go then?

He went to this other hotel called the Breslin, and that's where he lived with all the boxes.

Oh. Robert Frank's film.

Yes, that was in the Breslin. And then he had all these boxes. That's when he started collecting books and records, and I think that's when he did the last artwork.

But he had already been collecting used records when he was putting together the folk anthology and this was much earlier, wasn't it?

Yeah, but this was something else. This was not just recording; he was collecting.

What kind of records would he collect?

I don't know, things like folk music, everything. I guess the idea was that he would eventually sell the whole collection. I guess it was his way of expressing another kind of control. Expressing what he thought was important and what goes together or something. But he was a kind of legendary figure. I mean, I once mentioned him recently to some people that didn't know that I knew him, and they were quite impressed that I knew somebody who was a legend in his time. But I think one

of the amazing things was that he had such a scientific mind, and yet he was so creative too, and you usually don't find that combination.

Although you could say that maybe his art was a little bit mechanical, a little bit too scientific. He probably did better with powders and pebbles than he did with people. I guess he had a lot of problems with people. He was sort of infantile and still living out his Oedipal problems with his mother and father. I think he probably got along better with women than he did with men. That's the conclusion I drew. He was probably more competitive with his father and somehow his mother was okay. But for a while he had a reputation of splitting up marriages.

Lionel was talking about him trying to do that between him and Joanne.

Yeah. He probably split up his mother and father, or he tried to and it didn't work. I think they lived separately and he used to go from one house to the other. But by the time I knew him he had retired from that game. I mean, he was a very strange person. I think Lionel said that he was a recluse for a long time, which you can see. He was kind of an introvert, but probably used the drugs and stuff and the alcohol to be less of a recluse.

Did you go and visit him at the Breslin? Were you still good friends?

In the beginning, I didn't, because I sort of dropped out of the scene for a while.

Taking distance…

…from the whole thing, and then, when I came back into the scene, I got in touch with Harry and I used to go there and visit him, too.

And he had a room full of records?

Boxes. Everything was in boxes. It was all piled up. It was like being in a warehouse. I guess he never felt it was that permanent, except that the whole center of the room was taken up with bookcases. It was a maze of bookcases. And he had the records on those bookcases.

And where was the bed? In the middle of the maze?

On the edge of the maze. And he would always have people kind of squished in. There would be the bed and these two little chairs and you had to sort of squish in.

Did he do something with his records? Or did he just collect them?

I think it was part of his sort of egomania to think that…but he had an interesting eye too, so I shouldn't say that. I think that for Harry everything had to be a projection, a statement. So he couldn't just buy records or buy books. He had to create a collection. Although Lionel, I think, used to think that that would be a way he would make money, because he would go and sell the collection, and it would be worth much more; the total is worth more than the sum of the parts. But I think it's also probably a way of manipulating his friends into giving him money (laughs).

Who did he hang out with at the Breslin in that period? Who were his best friends then?

Who were his friends? I think there were some. I don't remember, exactly. Maybe there was some music and young people. I can't remember who I saw there. I didn't know that much about who he was hanging out with, because I didn't hang out with him that much or when I did there weren't that many people around. I mean, Harry was always very secretive about his friends, and he would separate them. His friend Harvey was there at that time.

Who's Harvey?

Uh, he has a sort of thin face and a little beard and mustache and he works at some kind of a scientific magazine. He's one person… but Harry tended to, you know, divide and conquer. He didn't let his friends know too much about each other, or he didn't introduce them to each other. And later we figured out why. It was because once they started to communicate they found out all these things. Like we found out that for years he hadn't paid his rent in Boulder. But

Paper airplane from Harry Smith's collection. (Photograph by Jason Fulford. Courtesy of Anthology Film Archives and J&L Books.)

nobody would have known that from him. It was like from each other we found out all his naughty tricks.

When was it that he was staying with Ginsberg? Was that before or after the Breslin?

It might've been after. I think he stayed with Allen, and then he stayed with this Frenchman named Jean-Loup [Dumortier], and that's when he started collecting these little toys and little objects. I don't know what happened to that.

Did he have paper planes?

Probably. I guess he was a shopaholic. He was a compulsive personality, so he had to be compulsive about something. So if it wasn't drinking it was shopping. I can understand that. But he was also kind of confined.

He was also really interested in human activities.

Yeah, but from some very distant point of view, like a mathematician or something. I liked Harry, but I mean, for a long time, he was

impossible. He was terrible in the Chelsea. He was very mean to people, and nasty. I think he liked to see how far he could go, and push people to their limits, and…

Was he vulnerable with anyone, where he wouldn't play those games?

No. Later he was more vulnerable because he was getting older and weaker and he didn't have a home or he was moving around a lot. I guess for a while he was living in some place down on the Bowery where he had some tiny room but he never let anybody go there. Maybe Joe Gross went there.

Like a men's hotel?

Yeah. But I think it was later. That's when he got vulnerable.

But you stayed in touch throughout?

Well, eventually I would hook up with him again.

And in the last years were you close again?

Well, not very close. Harry was always trying to get money from me, so that was always a tie, a knot. And there were times when I'd see him a lot, and then times when he'd sort of drop out of my life and then he'd show up again. There was a time I saw him a lot. I guess he was staying at Joe Gross'. I was talking to him at the time, but then he moved to the Chelsea and I didn't know that.

That was recently?

Yeah, that was before he died. He moved to the Chelsea and I didn't hear from him. I thought he'd gone back to Boulder but then someone told me he was in town and at the Chelsea. And then I saw him a few times before he died. That's the way he was. He could drop out of your life and you wouldn't hear from him or know where he was, and then suddenly you'd hear from him again because somebody would tell you where he was.

How was it, those last few times you went to see him? Did you have the feeling that he went there knowing?

Oh, he knew he was going to die. That was very clear. He was in so much pain, or in so much discomfort, that I think he just really longed to die. I've seen that happen to people before. He really didn't want to be kept alive any longer because he felt it was just going to be a waste of money and because he was going to die anyway. He must have felt very weak. He was very thin. In the last few years, he wasn't that comfortable. I mean, he had trouble eating and everything sort of just deteriorated. It's amazing he lived as long as he did, considering how he abused his health, how poorly he ate, and how many cigarettes he smoked.

How little he ate?

Later he had trouble swallowing, so it was such an ordeal for him to eat.

He wasn't always just like that, just eating yogurt?

No, no, it was just because it was hard to swallow. I mean, he would always eat very peculiar things…you know… strange things out of cans that you really didn't want to know too much about because it was too horrifying. But I guess he probably liked being as peculiar as he could. He probably liked to shock people a lot.

I got the feeling that maybe with Peggy he let his guard down a little bit. Did you think so?

I don't know. He was just Harry. I think he had trouble relating to people in any way except some kind of fight or competition. Intimacy was not something he felt too comfortable with. I don't know. I think his compulsion to control things was overriding. But he was always very funny, and that's how he could get away with a lot of things, and torture people, and still they would speak to him because it was always done half in jest. But a lot of it was that he just needed money and he wanted to get as much from people as he could get. He felt that his art came first, and therefore everything else was secondary.

Jonas Mekas, portrait of Harry Smith at the Hotel Breslin, New York, 1978.

Jonas Mekas

July 10, 1993

JONAS MEKAS: Harry often said he was the son of Anastasia. Anastasia had two children and the bones of two children are still missing; he used to say that his mother was Anastasia and he managed to mystify many, many people who really believed that he is, was the son of Anastasia. And he managed to make it very, very real so that even I, now, I don't know, maybe he was the son of Anastasia. He said, "My mother was Anastasia," and traced the details. It's in some of his interviews. We have printed it in the past two or three other interviews, but I think it's in this issue here (pointing) [*Film Culture* No. 76, June 1992] that he talks about Anastasia (laughs).

PAOLA IGLIORI: *When did you first meet Harry?*

I met Harry maybe in 1961. I had already heard about Harry from Robert Frank. Robert Frank was in San Francisco and met Harry Smith and when Frank came to New York, he began saying that he met the greatest filmmaker that there is, Harry Smith, and you have to meet him, and there is nobody else like Harry Smith. Then a year later Harry Smith arrived in New York. That was around 1961 or '62. I was running a showcase in '62 or '63 at the Gramercy Arts Theater on 28th Street and Madison. I don't know what I was screening. That was long ago and I would have to check the exact dates. I think one of the films was Andy Warhol's, one of his early new films like *Kiss*, and Harry Smith walks in. I had never met him before. This was in 1962. I thought that he was 60 or 70 years old.

He said, "I'm Harry Smith and I hate you!" I said, "Harry, you don't know me. Do you know what it means? You are saying that you hate somebody?" And I looked straight at him, and said, "Do you know what you are saying?" He looked at me, turned around and walked out. And then I did not see him for like two weeks or three weeks. Then he comes back. I was running, at 441 Park Avenue South on the corner of 29th Street, a Film-Makers' Cooperative and

Film Culture was published from there. I lived there, slept there under the table, and the rest was taken up by the office of the Film-Makers' Cooperative. He comes in. I see Harry Smith, and he drops his three or four boxes of films, and says, "Can you take care of these, can you show my films, here they are, you can have them, do what you want with them." And maybe he stayed, maybe we spoke. All I remember is that he dropped his films off and he walked out.

Which films were they?

Those were *Early Abstractions*, *Late Superimpositions*, and *Heaven and Earth Magic*, his key works. Then, a few days later, he again came back and I found out more… these were actually prints… the originals do not exist… or he doesn't know where they are. To tell you the truth, even now, today, we don't know. Maybe they exist somewhere, in studios somewhere, but these were only prints. Originally *Heaven and Earth Magic* was in color. We have only a black and white version. So all we have now was preserved, the negatives made into negatives, so that they don't disappear. And that is how we know Harry Smith's major work today. Have you seen films by Harry?

Yes.

I still have those original prints but we had screen copies made from those prints. A week or two later, he moved into the Film-Makers' Cooperative. He said, "I have no place to stay and I have all these machines." He had structures, machines constructed specially to project *Heaven and Earth Magic*.

You know, every evening we used to screen films by new film-makers, like Harry, Jack Smith, whoever was making anything, and they used to come by in the evening and screen their films in progress. So he screened from '62–'63 on that contraption, on the special machine where there was a screen and the film was projected. It was projected on a screen that has ornaments around it. And he projected, around the film itself, other images and designs, and also used color filters here and there. So it was like every time it was slightly different and it was impressive. I think it's a masterpiece, even when you see it in the black and white version as it is projected now.

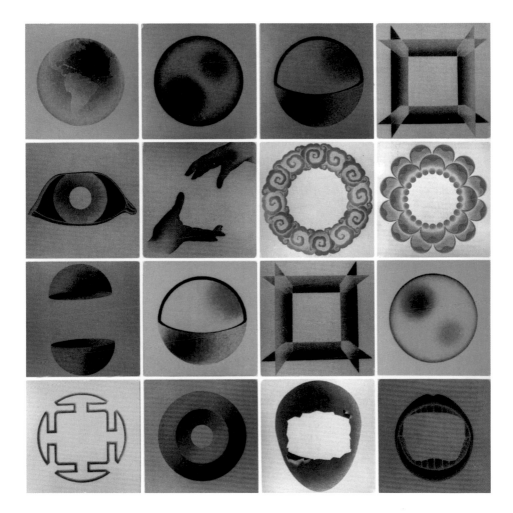

Harry Smith, frame filters for the projection of *Film #12: Heaven and Earth Magic*.

Harry Smith, typewriter drawing, ca. 1970–72. (Harry Smith Archives.)

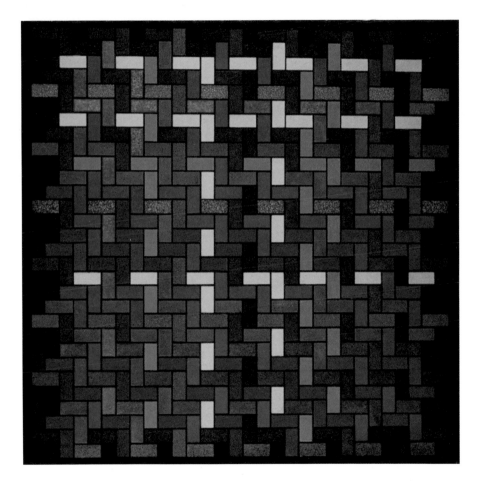

Harry Smith, *Enochian Tablet*, ca. 1982. Watercolor, gouache, ink, acrylic, and enamel on board, 31 × 31 in. (Anthology Film Archives.)

Stills from Harry Smith's *Film #3: Interwoven,* ca. 1947–49.
Stills from Harry Smith's *Film #2: Message from the Sun,* ca. 1946–48.

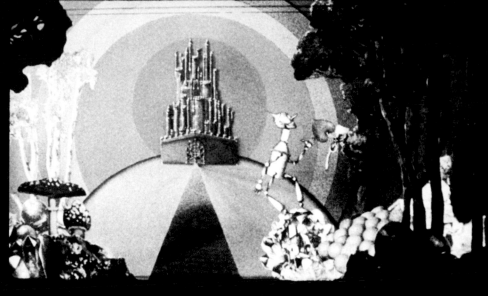

Top: Still from Harry Smith's *Film #16: Oz: The Tin Woodsman's Dream,* ca. 1962.
Bottom: Aleister Crowley's *The Holy Books of Thelema.* Cover design by Harry Smith.

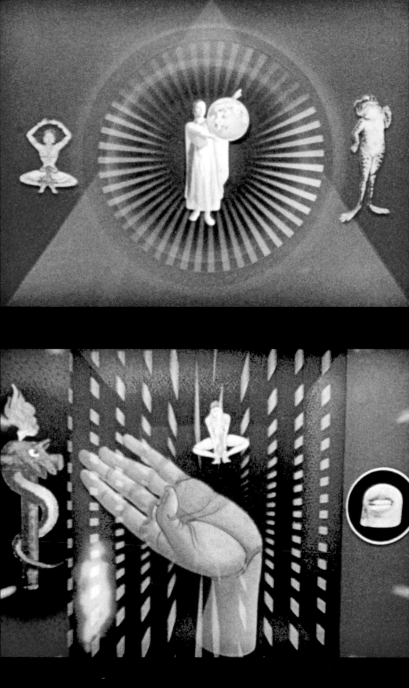

Stills from Harry Smith's *Film #11: Mirror Animations*, ca. 1957.

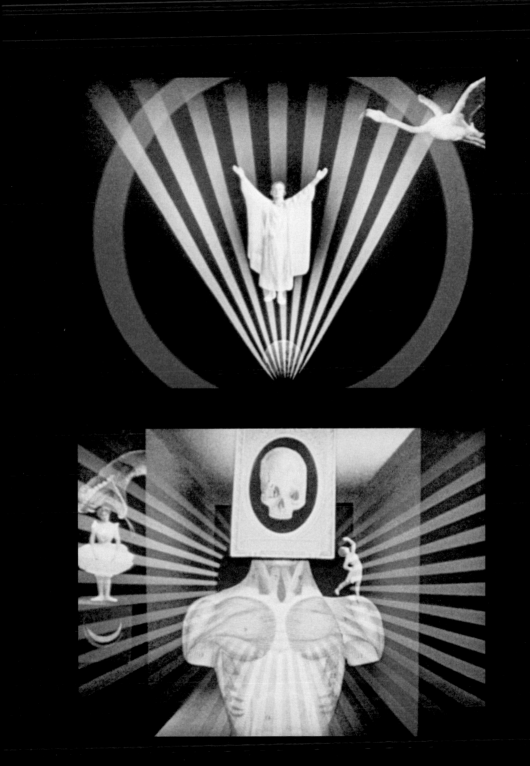

Stills from Harry Smith's *Film #11: Mirror Animations*, ca. 1957.

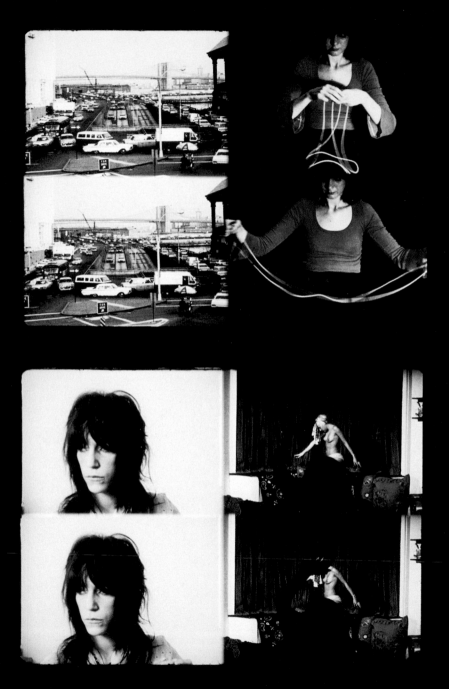

Stills from Harry Smith's *Film #18: Mahagonny*, 1970–80.

Heaven and Earth Magic?

Yes, I am talking about *Heaven and Earth Magic*.

Do you ever show it now with the original machine?

Wait, wait, okay, I will finish my little story. At this time, he was very temperamental. He was in a very heavy drinking period and clashed with a number of people. And one day, I come in and Leslie Trumbull who was working there, or David Brooks, I don't know, said "Harry Smith threw out that projector into the street and luckily there was nobody there. He threw out the machine, destroyed it!" We collected whatever there was. One of his friends moved it somewhere and maybe those pieces are still somewhere. I don't know where. Maybe it could be reconstructed if somebody has it. But this was just one of the typical Harry events: throwing out stuff through the window, down into the street. The next time he did that was at the City Hall Cinema, in downtown Manhattan. The film was *Early Abstractions*; he used to project that one. I would have to check the dates, but I think it was in early '63. I rented the theater and Harry had an evening, so we had a special projector and tape recorder. The soundtrack was the Fugs. Are you familiar with the Fugs? All the early screenings in New York of *Early Abstractions* included music by the Fugs. [A band with Ed Sanders and Tuli Kupferberg. Harry produced their first album.] One evening we are screening. He comes in and somebody said something. I don't know who that person was. All we heard in the middle of the projection was…crash crash. He grabbed the person, threw down the projector and the tapes, and everything. The show stopped and he ran out and that was the end of the show. And that was also the end of the Fugs soundtrack, and the next stage is the Beatles, which remained till now.

That's what I've seen.

Yes. The video version Sheldon Rochlin of Mystic Fire Video produced has some kind of African track [Actually by Teiji Ito, who did several soundtracks for films by his wife, Maya Deren] which Harry hated. [Harry approved it for video release.] We cannot do the Beatles

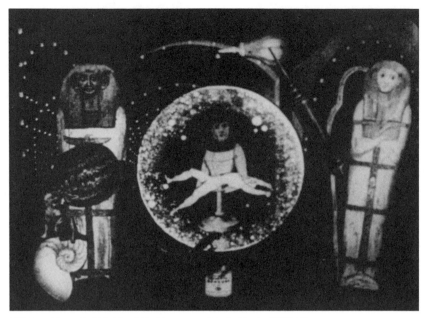

Still from Harry Smith's *Film #12: Heaven and Earth Magic*, 1957–62.

anymore because they will sue us. So they put that in and that is not Harry's. Next, in 1980 we had a presentation of *Mahagonny* at Anthology Film Archives on 80 Wooster Street. You know, it's a four screen/four projector piece and it's very complicated. It also involves color gels and all kinds of things going on. Harry was always there and he had to do it himself. There was this psychiatrist and doctor named Dr. Gross. You may have heard of Dr. Gross who took care of him. Without Dr. Gross, Harry would have been dead already 10–15 years ago. What he did to Gross was so bad always that I don't know… Gross had to be a saint to cope with Harry. To take care of him and his teeth…oh his rotting teeth!…which I think practically killed him. But that was the period when he had an argument with Dr. Gross and told Dr. Gross never to come to see his shows. And here comes Dr. Gross. He said "What are you doing here! You can't @#!!A@*!#!" He had a fight with him and then he ran upstairs. He grabbed all the gels. He ran into the theater. He threw them into the street and broke them. I have them all. I collected them later in the street and I put them in a box and we still have them, and that was the end of the show. That was the end of *Mahagonny* (chuckles): Dr. Gross coming in.

Still from Harry Smith's *Film #12: Heaven and Earth Magic*, 1957–62.

What year was that?

That was in 1980. Was that the last fit? There was one more fit, I think. One year later, in the library, when somebody said something and Harry had some very rare book that was important to him, and he took it and tore it to pieces and threw these pieces. Again, of course, I collected them. I will show it to you. Just yesterday I found it. The book was Michael Maier's *Atalanta Fugiens: Sources of an Alchemical Book of Emblems* by H.M.E. de Jong. I was organizing my junk and I found it. You see what he did?

Wow. In shreds!

And this is typical. Somebody just said something, and he had this book with him. It sent him into such fits that he tore this book to shreds.

Wow. That's something. I heard also that there was nine minutes of The Wizard of Oz *that he destroyed.*

I don't want to leave you now with the image that he was a crazy man going into those fits. I think that he was one of the kindest, sweetest human beings I have known in my life. I think that when he went into those fits, first he had to take many drugs. This is very similar to George Maciunas from the Fluxus group. Because of his health and asthma, he had to take so many doses of cortisone and all kinds of drugs. After he took the cortisone he said, "Nobody should talk to me because I will go into fits for I don't know how many hours." Now Harry acted crazily also when he took some drugs just to suppress the pain that he was going through. If something happened during those hours, he had no control and he just went into those fits.

So he went through pain already before? What did he have?

Whatever he took before arriving to New York, we know very little about; one has to interview the people in San Francisco that he knew. Between '62 and '66, he went through heavy, heavy drinking. There were two women, Barbara Rubin and somebody just known as Rosebud, that saved him. Rosebud simply wanted to marry him. I mean, he used to walk the streets at night, drunk, and pull down the fire alarms, and he always ended up being arrested. So they used to have always to go bail him out, and they took such care of him that they managed to slowly dealcoholize him so that he stopped drinking or not too much; they got him away from drinking. Rosebud came to me, and I will never forget it. I also feel guilty because I thought he was like 60 or 65 or 70 when I met Harry. He looked so old and shabby. So Rosebud asked, "How old do you think he is?" because she couldn't have figured it out herself. I said, "I don't know," and I felt that she is sort of in love with him, and I said, "I have to be honest. I think he is like 60 or 65, not that it matters." I don't think he was. He was only like 50 or 48. Or even less. He was like 45.

Wow. 45 and looked like 70?

And let me see…he was born in '23 so he was only 40.

But maybe he wasn't really born in '23.

We had to get the date to get him a grant. We tried… some other women also… and Holly, my wife, did all the work getting his Social Security number to see that he could get some money, grants and whatever. So they had to locate his birth certificate and they dug it out. We know that his birth date is '23, early somewhere there, in the spring of 1923.

So he was only 40 years old?

He was only 40. And I thought he was like 70.

Somebody else told me that. Lionel Ziprin said the first time he met him, he looked much older than when he saw him the last time.

Yeah. Later he never changed.

Do you have the nine minutes that he did of The Wizard of Oz? *With the cutouts?*

Yes, we have the film.

Oh, you do! Because I heard so much about it. Because, apparently, for months he was working on it and then that project also collapsed and he threw that out as well.

Yeah, yeah, probably the same way.

Did you ever show that?

Yes, we have shown it.

When did he do it? Do you know?

I have to look up the dates. Sometimes he refused to give the dates, but he gave two dates, '62 and '67. *Oz* is in '62.

And when was he making the tapes of broken glass and of birds? I heard there are quite a few tapes of birds' noises and…

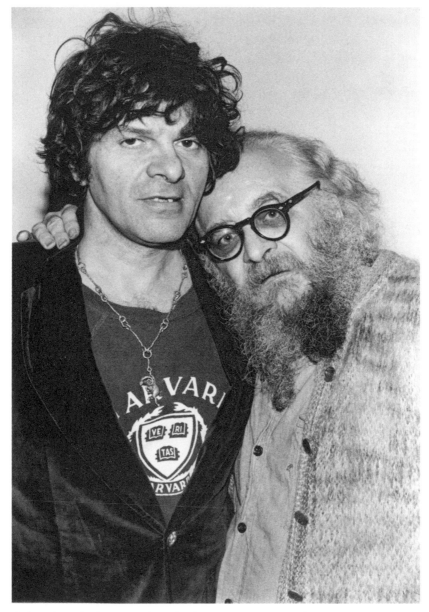

Gregory Corso (*left*) and Harry Smith (*right*), 1974. (Photograph by Gerard Malanga.)

Well, that's in the Chelsea Hotel. That was '68 and '74. I was also living at the Chelsea at that time, next door.

Really!

Next door and imagine all those scenes. Gregory Corso coming and Harry refusing to let him in and they start burning mattresses. Actually, that was the reason I moved out of the Chelsea. I thought some day they would just burn it down. There were all kinds of disasters going on there. Yeah, he was at the Chelsea between '68 and…I moved out in '74…but he stayed a few years longer than me.

Did he use some of those tapes of broken glass and birds with some other film project, or not?

I'm not so sure what you are referring to. I know that's the period when he lived there, and he had those canaries, but what kind of broken glass?

I heard that there are some of these tapes, but apparently there were lots of tapes he did of just the sound of birds and pigeons as the drumbeat of New York, and then some tapes of just the sounds of glass shattering.

He taped everything. Now let's forget about his filmmaking for a moment. He was an anthropologist interested in recording civilization, the present civilization, and all aspects of it, as much as he could, by collecting the books that were published and by collecting all the songs and music. You must be aware of his large music collection. And then there's the other stuff. He walked through the streets. He collected boxes of crushed cans of Coke, all kinds of tin cans in the street crushed by cars and what shapes and colors! I have a box here that he collected. Then he collected paper planes made by children in different neighborhoods; paper planes made by American children, white American areas, and those made by Black children, and by Puerto Rican, Spanish kids in different areas. He made all kinds of different paper planes and he collected those. Then he stayed at Allen Ginsberg's place. I don't know for how long. It could have been ages but it could have been just one year when he was really sick. Allen comes home one day and he discovers that Harry had drilled a hole in his window in the glass, cut a hole so that

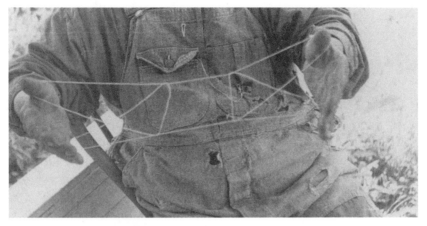

String Figure made by Joe Billy, Swinomish Reservation, 1942. (Photograph by Harry Smith. Courtesy of Harry Smith Archives.)

he could put the mike out into the street and tape the sounds of the street in New York in 1980 at night and at six in the morning and at seven in the morning and at 2 p.m. And he made hundreds of cassettes, hundreds of cassettes of the sounds of New York on the Lower East Side, simply from anthropological interest. Human, that's how he was.

He also collected toys.

Yeah, toys. You give him money and he will just walk around and go to all these antique places and he will spend everything, no matter what you give him. He was buying things he was into, you know, things that related to things he thinks are important to keep. And when he lived upstate in Allen's place at Cherry Farm, he shipped boxes and boxes of materials, and of books. We have 200 boxes of books. A list was made of four or five thousand books that have to do with linguistics, anthropology, the history of the music of various countries, various ethnic groups. There were boxes and boxes that he felt must be preserved. These are important documents.

There were also string figures.

He had string figures, pieces and patterns of design, with exact descriptions of how to reproduce hundreds and hundreds and hundreds

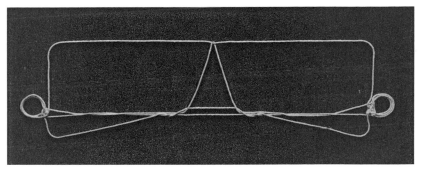

Harry Smith, string figure, 1960s. String, glue, and board, 8 × 20 in. Photograph: Jason Fulford. (Courtesy of Anthology Film Archives and J&L Books.)

of them. It's the only such collection that exists. He could do three or four hundred of them himself.

He could?

This guy, who was an expert, told me that that he could. I have the name of somebody from California who is an authority on string figures and was very anxious to have access to Harry's information. He said that Harry knew two or three or four hundred different string figures by himself.

From different civilizations?

Mostly Native American Indians…

Because he grew up on a reservation.

I never heard that. That could be true. Later, when he was in his twenties, he lived with two or three different groups of Native American Indians. That's where he taped his [Kiowa] peyote ritual songs for Folkways and they accepted him. That was when he was going through the first drinking period and he was so heavily into it. He sort of fitted in. The American Indians that he stayed with were also very heavy drinkers. He met them in jail. And he did a lot of taping. I think that is the period when he picked up many of the string figures. But that was already in the '50s. He was in his thirties. I

never heard that he grew up on a reservation. Somebody will dig it up. There are people who one can trace back and begin to interview, those who knew him when he was studying anthropology.

I heard his mother was a teacher on a reservation in Washington state.

Could be. I don't know. That's a period I don't know.

I know he was with the Kiowa Indians for a long time when he made those tapes of peyote rituals.

Somebody will investigate his youth and his early years. I don't ask too many questions. I'm so busy and always have to deal with the practical daily situations, like screening films. I don't ask many questions about people's past, where they come from. It's not my nature. And then if they tell me I forget…so…

He also did a lot of watercolors and for a long time.

Yes, he did a lot of painting. That was much before his interest in film. Rani has collected now, I guess, a large list of his paintings and she has slides of many, many of them. She's preparing a catalogue of his artwork. Many different people have collections. He borrowed money. He would say, "Give me one hundred and I will give you a painting," and some ended up with like 20 pieces or so. At Anthology, we have maybe 30 pieces and they are important. Someday, maybe a couple of years from now, some exhibition will take place. Henry Geldzahler agreed to curate it. He thinks very highly of his work. So there is a lot of work.

I heard he made some paintings to the music of Dizzy Gillespie.

Yes. Those paintings were used in one of the films that is part of the *Early Abstractions*. And he used Thelonious Monk.

Synchronized to the music.

Synchronized, yes. It was sort of like an interpretation. He worked with *Mahagonny*, frame by frame and note by note, keeping extensive

records and notes and notebooks of the breaking down of all of *Mahagonny*. I guess he did the same with Thelonious Monk's piano piece by breaking it down note by note and then creating images to coincide with the sound like a reaction to the music. He was really meticulous and very, very, very mathematical.

Did you notice that he would focus on a certain area in depth during different periods, or did he always keep lots of things going at the same time?

When I met him in, let's say, '62, he had already gone in total depth into music, American music, Native American music, as well as painting, and all the mystic and Talmudic sciences. I mean he was considered one of the authorities on the Talmud. So that was during the period we met. Supposedly, his father was really high up in Freemasonry. He inherited a lot of this interest in religious science.

Did he have to your knowledge any relationship with his father while he was in New York? Did he keep in touch with him?

Not that I know of. But I know that when he died, in the little ceremony that took place at Saint Mark's Church, there was this group of not Masons, not Rosicrucians.

Oh…the O.T.O.

I have the program. I can look it up. But I cannot tell you now and my memory for those things…my interest is not that deep (laughs). But they came there and, you know, they performed and they asked not to take any pictures. I had a video camera. I taped them anyway. I considered it absurd not to take any pictures. Harry, supposedly, was one of them until he died. He was one of the highest priests in it with those strange robes. So he continued to be part of it, whatever this "it" was. He had several different lives he led that I did not know about. I have no time for it. But there are people that can throw some light on it. Sheldon Rochlin's partner at Mystic Fire Video, for example. He is very involved in that religion and was there, so he could give you some information on Harry's religion. So it's endless, as you can see.

And you saw him when he came back to New York?

Yeah. When we moved the Anthology to where we are now, on Second Street and Second Avenue, in '85. There was a little room and Harry used to come by and he needed a place to work. So, okay, you can stay and do what you want. This is your home now. So for two or three years we used to refer to him as our artist-in-residence. He used to come by, you know, every morning. He comes here, works. He had all his stuff here.

What did he used to do?

Read books, make notes on them, and also paint, and make drawings. He did a lot of painting, and a lot of reading, working with his books. So that was in '85, '86, '87. Then he became very sick and he moved to Allen's place. Then Allen could not stand him anymore so he arranged for him a teaching job at Naropa Institute, which prolonged his life because he felt very good there and healthy. Students were helping him and his health improved.

Did he like to teach?

You have to talk to Rani about how he conducted his classes. But he was allowed to teach at home so that he was again the professor-in-residence. He did not have to have any set schedule. He had freedom. There is an outline, a description of what he proposed to teach when he first came there and it was (laughs) amazing and it's printed here: "Rationality of namelessness;" "Is self-reference possible?;" "Communication, quotation and…" I don't know what kind of weirdness. It was all about quotation and communication and commas and parentheses. In any case, he was allowed to teach from his own room. He had a room, an apartment. He was comparatively happy there until something happened where he couldn't stand it anymore and he moved back to New York. I guess that was the last year of his life. Maybe he just craved for more variety. From what I know about Naropa, it could be very narrow. It could become very depressing at some point. I think he needed more scope. So he came back to New York.

How did he survive through all those years and be able to buy all these books? You told me he'd swap his paintings sometimes, but he must have also had other sources.

Everybody respected him very, very much and did everything they could to lend him money on any promise, on any exchange. Between maybe 1975 and until taking the Naropa job, I think Anthology Film Archives saved him. We advanced him thousands and thousands of dollars and every week he used to come and collect regularly for it. It was a certain sum. During the same time he managed to get some other monies against paintings from other people we are discovering now. But also from the rentals, and from the Film-Makers' Cooperative, for his films, and then we bought his films. We ended up buying all these films and giving him monies. Since he had nothing else, he gave us his films and his paintings. He said, "You can have all the rights. We'll put them in distribution and you can have the rights." So he lived on rentals from the Film-Makers' Cooperative or sales from the American Federation of Arts.

You mean like royalties?

Yes. All the royalties. Now after he died, it's a different situation. But he never took any of it.

He got a Grammy award before he died, didn't he?

Yes. But you have to ask Allen about that. He went from Naropa to get the award and he was with Allen and he has incredible stories. I don't know much about the details. How Harry couldn't leave Naropa because of six or seven or eight cats and I don't know how many birds. And when they awarded him the Grammy he said, "I cannot come to collect unless you pay. I have to bring my cats and the birds." And they paid for it.

They paid for the cats and birds?

Yes. And he went to this flashy hotel with his cats and the cats destroyed the room because they scratched everything. It was a disaster.

He brought them to the Grammy Awards?

Yes. When Allen tells the story it's so funny and I don't know all the details, but he came with his cats and birds and everybody panicked there.

When did you last see him?

Maybe like a week or so before he died. He had great problems with his legs. I have some notes. He came and he looked at some things he had and made some jokes and then I think we helped him into the taxi and he went. This was just about a week before he died. To mask his sweetness and goodness he used to spit, and act very bad and nasty. Some people who did not know him well enough got the impression that that's how he is: nasty, spitting, angry and kicking Harry. But that was only like a mask, a screen. Kenneth Anger is very much like that. Kenneth Anger is one of the sweetest people in real life as a human being that I know. But he puts on that mask in all kinds of ways, suggesting that he is very, very bad, Anger itself incarnated. But of course, Kenneth, the same as Harry, can be very bad when they really feel that this person is bad. Harry can look at you and read you. He could see that this person wants to exploit, is not good and then he is vicious. He can just tell and then he spits and there's no pretension, no politeness. The same with Kenneth Anger. He can bite you if he feels that there is any bad intention there. Strange that these two, Harry and Kenneth, always fought, not that they hated each other. I guess it's like theater, and they would just clash.

But you always forgave him. I was looking through my written diary as I was organizing and I saw, "1980 Robert Frank: I saw Harry and I promised never to speak to him again, he was so nasty." But Robert Frank, he's another great and very good person and he always forgave Harry and helped Harry.

In 1971, I think, or '72, Kasoundra made a photograph of Harry and then she worked it graphically and she produced a limited edition of silkscreen prints, maybe 200 prints, 20 x 30, Harry's portrait. We still have a number of copies. Harry always laughed about it but he liked it. It's a portrait of Harry with glasses and there is another Harry reflected in the glasses and it's okay.

Kasoundra Kasoundra, portrait of Harry Smith, ca. 1971.
Silkscreen, 20 × 30 in. (Courtesy of the artist.)

Rosebud and Harry Smith at Max's Kansas City, New York, ca. 1979. (Courtesy of Rosebud.)

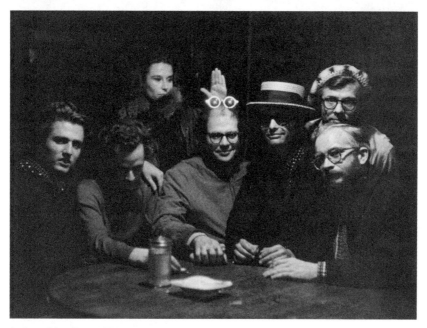

Left to right: Gerard Malanga, Harry Fainlight, Kate Heliczer, Allen Ginsberg, Piero Heliczer, Peter Orlovsky and Harry Smith in the back room at Café Le Metro, New York, 1964. (Photograph by Gerard Malanga.)

Rose Feliu-Pettet ("Rosebud")

October 12, 1995

PAOLA IGLIORI: *You were Harry's "spiritual wife," weren't you? I remember reading that interview (with Mary Hill) where she asks him, "Do you love me?" and he replies "I don't love you like I love Rosie." That's beautiful.*

ROSE FELIU-PETTET ("ROSEBUD"): Dear Harry. Well, I suppose what I should do is tell you a story about Harry which might illuminate him a bit. I'll tell you about the day that we got "married," which would have been in January 1965. I had just hitched back from San Francisco. I met Harry at a café, a poetry shop. It was called the Metro; it was on Second Avenue and Saint Mark's Place, and at that time it was the center for a great deal of the poetry work that was going on in the city. It was a gathering place and they had open readings of every sort. I walked in one night with Allen Ginsberg, I think, and Ed Sanders, Barbara Rubin, a few other people. And Harry was sitting there all tiny and fierce, and I was wearing a beautiful long jade green antique cape that I'd found in a junk shop, and as I walked past his chair he clutched at it and tried to pull it off of my shoulders, saying, "It's mine! Give it to me now!" And I think I made some little gesture, threatening to pull his beard or tickle him or something. We started to laugh, and soon got into a crazy conversation. He looked like a manic little troll-person and was very rude and very funny. But gradually we developed a most interesting friendship.

He was living at that time at a hotel called the Earle, which has since been renamed. It's the George Washington Hotel over by Washington Square Park. I moved in with Harry; basically we were living there for several months. I was eighteen at the time. Harry did not have many female friends. He was surrounded by a lot of young boys, young protégés, but I fit right in. They were all best friends of mine. I think I introduced him to many of these people. I was fascinated by him. We had a very deep affection. I was always trying to climb into bed and sleep with him, but he did not like to be touched.

He couldn't abide it, and he was forever pushing me out of the bed onto the floor and making me sleep on the floor. If any sex entered Harry's life it would have been more in thought than in deed. As far as I know he was celibate. But if he'd lusted after anyone, it probably would have been young men, because he was always chasing a friend of mine, Rennie Jones, around the room; this friend was meanwhile chasing me around the room... and none of us ever caught each other!

So what we did basically was a lot of drinking. Harry used to have me wake up at eight or nine o'clock every morning and go out in the street to panhandle enough money to buy two bottles of white port, which is the most unpleasant alcoholic beverage that exists in my opinion! I would do this and bring it back to the hotel, and we would begin to get loaded. We also spent a lot of time doing various drugs; it was a very druggy period! We spent our days generally wandering around the Village. He knew everyone. We'd go hang out for hours visiting all these amazing people, like an old blind man who'd turn out to be Doc Watson, for example, and drinking in a sleazy bar on Bleecker Street with a man who claimed to be Hubie Hatfield, the only survivor of the Hatfield-McCoy feud! And sitting in doorways half the night listening to old street musicians like Harmonica Slim. And we spent lots of time at the Folklore Center with Izzy Young. I guess that's where Harry met Dylan. And we hung around the Factory a lot, with the Warhol people.

We spent a lot of time at the movies on 42nd Street, the Film-Makers' Coop, at theaters, poetry readings and the like. Harry was a tremendous heckler; he was impossible, actually. He would think that it was very amusing to heckle people, to call out and insult them during readings or whatever, and usually people were good sports and put up with it, but sometimes I think they were terribly humiliated, because he was very fierce and uncanny in his ability to know exactly how to wound people. Though his heart was gold, he sometimes became aggressive in the name of good clean fun. It didn't always turn out that way.

So we were living at the Earle Hotel, and at this time a lot of Harry's activities were focused in the so-called "underground" film scene in the Lower East Side: Jonas Mekas, Jack Smith, Barbara Rubin, those people.

Well, anyway, we got involved with Piero Heliczer, who was a filmmaker, among many other things, and Piero had a very complicated scheme to do a film based, I think, on the old Flash Gordon

Harry Smith (*right*) with musician Harmonica Slim (*left*) in Greenwich Village, New York, September 28, 1965. (Photograph by David Gahr/ Getty Images.)

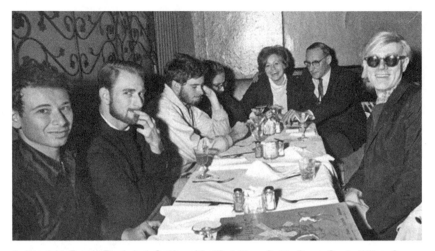

Left to right: Ronald Tavel, Jack Smith, unidentified, Harry Smith, Panna Grady, William S. Burroughs and Andy Warhol at El Quijote, New York. (Photograph by David McCabe.)

cartoon strip. Harry was of course to be Ming the Merciless, and I think I was meant to be Flash Gordon's girlfriend, whom Ming the Merciless runs off with, or something of that nature. It was all very free-form, to say the least. It was something that had flowered out of the mind of Piero but of course made no sense to anyone else; it had nothing actually to do with Flash Gordon! So we all gathered, it was quite a crew of us, to do some filming: Harry and I, Gerard Malanga, Edie Sedgwick, Barbara Rubin. Andy Warhol was there, he was in it too. And from somewhere Piero had discovered, I think in an abandoned apartment, a beautiful turn-of-the-century satin wedding gown with a long, long train, in tatters but extremely beautiful. I think I was actually chosen for this part by process of elimination, being the only woman there that could get into it. Those old dresses tend to be real small. So I was chosen.

The film had no script and no obvious plot. Piero directed me to get into the wedding gown, and then we proceeded down to Orchard Street where what was to happen was that Harry was supposed to escape with me through the streets. We filmed this on a beautiful sunny afternoon, walking along old Orchard Street amongst all the shoppers and the pushcarts. I don't know how he was meant to run off or abscond with me because we were obviously having such a wonderful time together! Harry had obtained a gallon jug of wine, Gallo

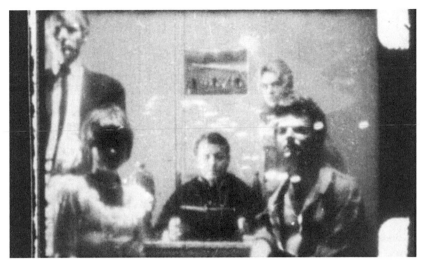

Still from Piero Heliczer's long-lost film *Dirt*, ca. 1965. *Left to right*: Andy Warhol, Rosebud, Charles Henri Ford, Edie Sedgwick, and Gerard Malanga. (Provided by Rosebud; courtesy of the Gerard Malanga Movie-Still Collection. © Marisabina Russo.)

Red Wine, which was the cheapest, the nastiest. And we proceeded to hit that bottle. We were drinking constantly. So Piero and the rest of the crew followed us along the street as we peered into shop windows and climbed up staircases and climbed down again, and everybody in the street was fascinated by this very odd couple. Because Harry was of course very tattered and disheveled, as usual; his glasses were always broken and held together with tape, his hair was flying in every direction and there I am in this satin wedding gown with a long, long train that was being lifted and carried by someone behind me. At one point a little Spanish woman comes up to us with a big smile and presses a dollar into my hand, all folded up tightly, and says, "Congratulations! May you have a happy life." We thought this was just delightful. But eventually, Harry and I kept nipping at the jug and we became so drunk that it was impossible to continue filming. Everyone was furious at us because all we could do was laugh and fall around. So they all abandoned us, saying we'd regroup on another occasion, when we were a little more in control of ourselves.

So Harry and I were left wandering around the streets of the Lower East Side with half a jug of cheap wine. I was still in the wedding gown. We wandered up to the Bowery, which, much more so in those days, was skid row, the last refuge of the terminal alcoholics.

The street was lined with a hundred, if not more, absolute derelicts. They were there in rags, stinking and covered with open sores and bruises. It was a horrible sight. They'd be just lying down in door-ways. Looking up the Bowery we could see so many of them. And as we approached the first, Harry looked at him and then clutched me (which he seldom did!), pushing me towards him, almost challenging, demanding "Kiss him!" And I knelt down in a wedding dress with a bottle of wine and kissed the man on the lips, and gave him a drink from this jug, and then Harry took my hand and lifted me up and led me to the next man. It must have been so remarkable a sight! I'm sure that, for many of these men, no one had looked into their faces in years, some of them. Then all of a sudden to be awakened from their stupors, to see this sweet, young girl in a wedding gown, kneeling down to kiss them and give them a drink from this jug of wine. What a remarkable sight it must have been! So we made our way up the Bowery, stopping and kneeling at the feet of each of these men. As we reached the end of the street, towards Astor Place, the sun was just going down. The bottle was nearly empty and Harry lifted it and we shared one last drink. And (for the first time!) he embraced me fully and kissed me on the mouth, declaring, "Now we are married, we'll always be married…you must remember that wherever you go, you're my wife for ever and ever." And this was our wedding day, and that wine was our wedding cake. And then we just tottered on back to the hotel, I suppose…and drank some more!

That was a wonderful day with Harry, and it was very indicative of the way he saw life. He could be so cruel and so cutting and so pre-occupied. But his entire life was an out-welling of this incredible compassion he had for everything that lived. He loved people so much that he could barely contain himself from weeping when he would look at people in the street. It was like that Beatles song, "Eleanor Rigby," "all the lonely people." He saw the innate loneliness in every-one, and I think it overwhelmed him. It's one of the reasons he drank and took so many drugs, because he was, deep down, a very unhappy soul. He had more humor and cutting wit and vitality than most any-one is ever blessed with, but at the same time, this sorrow was so deep in him. The whole family of man was his family. That's one reason I'm sure that he was involved in all the music, all the closeness through harmony that connects people all around the world.

Anyway, he referred to me as his wife until the day he died, which touched me very much because, although we never slept together, we remained very close always. I once took him to my parents' home. I announced that I had met the man that I wanted to marry, the man that I loved, and I brought home Harry, which was a terrible, terrible surprise! He was drunk and proceeded to locate my mother's cooking sherry and get even more drunk. Then he accused her of being Hitler in disguise! He said he'd seen through her, that he recognized her, and that she couldn't hide herself from his clear vision! She was Hitler! This distressed her more than words can say.

But my family eventually came to know and to love Harry, as most people did. It took time. And yes, we remained close through the years. Despite my travels, or whatever, we were always in contact. I was away in England at the time of his death. I was actually sitting down to write him a postcard and thinking, "I'm going back to New York in just a few days. I'll just save it and bring it to him directly." And at that moment I get a phone call from my husband, Simon, with the news that Harry had died.

When I came back to New York I made the decision to have him cremated, since no one seemed quite willing to decide what should be done with the body, which had been kept at the morgue for days. When I arrived back Allen Ginsberg asked me what to do. There had been many suggestions, including one rather horrible one of saving Harry's brain! But Harry and I had often talked of death and endings, and I knew that he wished to be cremated. Allen generously paid for this.

A wonderful thing about Harry was going to the first memorial service (at St. Mark's Church) and seeing so many different types of people there. He had circles upon circles of acquaintances and associates, none of whom knew the others. So at the memorial you would see an enormous contingent from the filmmakers group, say, and there would be the people interested in the occult, and then there would be the musicologists and musicians and all of these other strata, the layers of his life. Most of these people didn't seem to know each other, and they were all amazed, you know, the warlocks would walk in and go, "Who are these weird film people?" and the film people would see all of these musicians coming in to pay their respects, so that was interesting. Harry knew so many levels of life, so many types of people.

I was just thinking about how he was always connecting things. For example, Allen Ginsberg told me the story of how, when Harry was at the Franciscan flophouse on the Bowery, he would be recording the noise of the people dying there, their death rattles, and then noticing that there were certain times when that happened, noticing the natural rhythms. Like the birds singing in the morning, the people would cough and start praying at a certain time. He always connected…it was like always noticing the thread that linked…the inner rhythm, the cycle of things. I wonder what your memories are of all this?

That's very true. I actually sometimes used to perceive him almost as a little spider with big faceted eyes seeing everything, tugging here, tugging there, and effecting this incredible web. I've wondered, because Harry was, without doubt, a visionary, one of the most far-seeing and clearest-minded of people. I know that he was respected for this by so many people around the world, and that his influence was so great. I think he almost consciously did a lot of the things that he did, seeing the effect that they would eventually have. He did grab everything. He had enormous files on the way things connect, yes. When he was living upstairs on 12th Street at Allen's he would do the same, hanging a microphone down into the street to record street noises, ambient sounds; he had endless hours of these tapes, which make a beautiful music. And he did always talk about the fact that things occurred in cycles. Everything had its cycle, and everything was interconnected.

When you sit down and realize that a great deal of what Harry did actually evolved into much of what came to be called "the counter-culture," which itself has influenced generations of young people, you often wonder how much of it was thought out in advance and how much just stemmed from his innate interests in the topics. For a simple example, there is his work in collecting folk music, which did filter down and reach so many people via Dylan, among others who used his sources. He helped recreate an interest in this very basic, very of-the-people form of music, which developed into this enormous interest in folk singing and such, and which led to an entire generation of young people becoming more politicized, actually. And I think he might have deliberately wanted to see that, to bring people back to the heart of music. When you think about the way

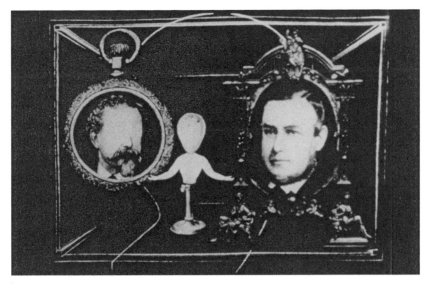

Still from Harry Smith's *Film #12: Heaven and Earth Magic*, 1957–62.

that his hand-animated films affected everything! You look at things that he did twenty or thirty years ago and you see how they predate and anticipate the psychedelic light shows; all of it very Harry-esque! All of the Monty Python animated collages, so much of what we take for granted now in popular culture, has its origins in Harry's work.

Some people say that there are, around the world, eleven wise souls who influence and control and encourage and change. And many people used to assume that Harry was one of them, because he seemed to know what would develop from his work, and to be amused by it, and to see it down the road five or ten or twenty years. He seemed to sometimes imply, in discussions with me, that everything had been done very deliberately. But that just might be Harry, after the fact, you know, because he did tend to exaggerate and even outright lie a great deal.

I think he's going to keep on being seminal, even a long time from now.

There are so many people that I continue to meet, who cite Harry as an enormous influence in so much of their work. And then I'm sure that there are people who we shall never meet who were influenced. Harry was, for example, probably the world's leading authority on

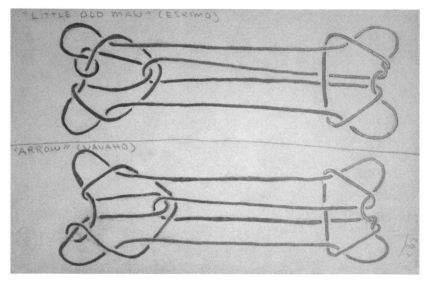

Harry Smith, page from string-figure manuscript, ca. 1960s.

the art of string figures. More string figures than you could believe existed! Hundreds! And that was a research project that I was involved with at one point. We would go every day to the 42nd Street central research library and he would have me copy out endless hours of text and copy drawings of the string figures. So there's probably a whole slew of string figurers out there who cite Harry as their guru. Then all the occult interest that he had. That was a very peculiar aspect of his life. I remember him once trying to nail a bat to my forehead, very seriously. It was frightening. I fled. I ran out of the hotel. Jackie Gleason was tremendously interested in the occult and Harry was the one who helped him amass his enormous library of books on the subject. It just seems that everywhere I go I meet people who unexpectedly come up with his name and say, "Ah, you knew Harry, he changed my life." And he will continue to do that, on and on.

The thing that amazed me was that he was like a walking British Museum, as Harvey Bialy called it; and at the same time, it seems, from the little I knew of him, that everything he did was with a childlike freshness, even if he was an incredible scholar. But when he was actually doing things, he had totally fresh eyes and linked it directly. Whatever I see of his work affects me as if it's something that I've seen for the first time. A creation.

He was certainly one of the most delighted people I've ever seen. There was this great inner sorrow and compassion and sad empathy, but the other side of that coin was his absolute delight in just about everything. He had a funny little cackle, like a little old troll, and we'd walk down the street, and he'd laugh at everything. He would laugh at the reflections of neon signs in a puddle, and the sheer beauty of it would tickle him until he laughed out loud, and at children playing, or at an old couple holding hands. He approached everything with this utter delight. He drained himself physically with the years of drugs and the drinking, but he managed to wake up fresh every morning and open his eyes wide and take things in as a new day. He went through his entire life like that. I never saw the man bored. I don't think it would be possible for him to be bored because a shadow falling on the wall could amaze him for an hour. He would love it and he would draw it, or he would reinvent it in some way and make it even more charming than it was. He was so very special.

I think one of the reasons that we were so close was the fact that I was not a formally educated person. I was not an intellectual. I was very spontaneous and quite innocent and had that same feeling of delight in all things. I always laughed much more than I cried and took a great deal of interest in everything around me. I was always poking him and pointing things out, things that he'd inevitably love. And this, I think, was our strongest bond. We would fall asleep sometimes laughing till tears were coming out of our eyes. We made each other very happy. Another reason he cared for me was that I was always, amongst all his friends, the one who was poorer than he was. He certainly did like to exploit people, if that were possible, and encourage money out of their pockets and into his. But he always felt very protective towards me since I never had anything. He always wanted to provide for me. It made him feel very fatherly towards me. But he would set me out on the most dreadful quests, encourage me to do very risky things, and sit back and observe and direct, and he took a lot of pleasure in that.

What kinds of risky things?

He was always encouraging me to walk along the railings on rooftops, things like that, quite dangerous things. He knew that I

could and he wanted to teach me to trust myself; he wanted me to develop the potential I had, to leap into the deep end of the pool with everything I did. And that was something that came naturally to me, but he pushed it even further.

I found that he was a great teacher for each person in understanding exactly what each person needed. Even beyond words, there was a great teaching all the time. Sometimes people couldn't take it. Did you get that sense?

It was as though he could X-ray people. For example, how when he harassed people or heckled them; he would always find the button to push that would cause the most distress, if that was his intention. He could also charm and cheer the saddest people. He did see very deeply into everyone and could touch whatever it was within them that he wanted to pull out, or he wanted them to pull out. I've never seen anyone that had that same ability. His power to communicate with absolutely anyone, old or young, from any walk of life, was astounding, because he was an alarming-looking character. The sort that many people would not feel comfortable talking to in the street. If he reached someone, they felt like he'd known them forever. Everyone used to call him a little Merlin, a little magician. There used to be a lot of rumors going around that he was the last living alchemist, that he was Aleister Crowley's bastard son...all these stories about Harry that circulated!

Even from the stories that Debbie Freeman told me, she almost went crazy near Harry, because he always pushed the buttons, like you said. But it seems to me that he had another purpose, that he was always stretching people, so if they wanted they could take it somewhere else, or just leave it there.

He really admired and enjoyed people who dared, people who pushed themselves to the furthest limits.

Did you participate in some of his work?

I didn't work specifically on anything with him. I observed him at work for many years, but aside from brief assistances in an almost secretarial fashion and providing him with white port, I didn't have

Rosebud in Harry Smith's *Film #18: Mahagonny*, 1970–80.

so many contributions to the work. I am responsible for the addition of the Beatles to the soundtracks of his animated movies. Because, before that, he experimented with a lot of different things, and I was an absolute Beatles fanatic and forced him one day. He was having a showing and was in despair about what music to throw on. So I said, "It's got to be the Beatles. You're the highest art form that exists in this animated technique, and the Beatles are, of course, the greatest music in the world, so you belong together." So we tried it and it worked perfectly, so perfectly that the music was used forever after. And somebody recently (Robert Hunter), at a screening, actually threatened, "Does Paul McCartney know about this?" I don't know. There was a legend actually at one point (Harry's story is full of legends) that the Beatles or several of them had actually flown over to New York specifically to see his movies. I don't know if that ever occurred but I imagine that they would have known of his work.

I did act in *Mahagonny*. There's a small segment because the film took so very long, and he was so very crazed on amphetamines at the time, and I withdrew. I was not involved with him so much, so the sections that I appear in are very brief, but he did love those. Harry gave me a great compliment. He said that someone who worked with D.W. Griffith so admired my work in that film that they said, "Why, this is the greatest silent actress since the Gish sisters, film her some

more!" But then I disappeared from sight for a long time. I will say that any small compliment from Harry meant the world to whoever received it. He was very sparing with compliments, but the one thing I treasure was the fact that he told me once that he'd loved only two women in his life. The first was his mother and I was the second. I just cherish that memory of him saying that to me.

What was the most important thing that he has taught you?

He refined my sense of compassion. He made me aware that it is necessary to keep reminding yourself to be aware, every day, of the delight of life, the sorrow of life, and not to judge. It's really not fair to judge. Everyone is so bound up with the same emotions, and the way they express themselves is often just a mask for these remarkable feelings that they carry within themselves. At the risk of sounding corny, he just made it so clear to me that you must love everyone, you must love them.

I feel with Harry that he was a great genius. Of course (not to use that word lightly), he was a superior person, and his intellect was vast, but at the same time, much of what he did was not beyond anyone else. He just pursued his interests more fervently than most people do. He didn't obsess, but he certainly examined so deeply everything that fascinated him. It's a pity life's so short, because he had so many fascinations, and he was not able to have the time to devote himself fully to some of the other things he loved. He just delved so far into his chosen spheres of interest, pursuing them. I don't know where he got the energy because he was a frail man. He was not strong, but he was passionately interested in things, and he created the time. For a man who seemed to sleep a lot he appeared like someone who never slept, because the amount of work that he got done in so comparatively short a life is impressive. The sheer scope of his accomplishments! And there's so much of his work that has vanished, so much that was stolen, as well as things that he tore up in frenzies, things that he burnt deliberately for whatever drunken reason.

Curiously enough, he lived for quite a while directly around the corner from me when I was a little girl. He was living right around the street. I may even have seen him in the street, but I don't recall.

Where was this?

Harry Smith and Birdie, 1980. (Photograph by Robert del Tredici.)

I was living on 74th Street in Manhattan and he was apparently living on 75th Street. You could have almost drawn a line from my house to his, right through the buildings between. And he told me that at that time, he had an enormous number of paintings, works connected with the never-completed *Oz* film, but being threatened with eviction or some such, he became very enraged and destroyed a huge amount of work. At one screening he even set the film on fire as it ran through the projector. We had to put it out. He could be very destructive! It's sad that so little of his actually remains.

What are some of his interests that are less well-known, maybe even small things that you witnessed over time?

Well, his curiosity about animals, the daily life and the communication between animals and humans and animals among themselves. He loved animals dearly. Whatever hotel he was living in, he generally had a pet. He would usually have a parakeet and it was always named Birdy! And when Birdy would die it would be wrapped in tin foil and kept in the freezer! When he lived in the Chelsea at one point, in this very crowded room, he had rigged up a very elaborate amusement park for the mice that were his fellow inhabitants. There were little

Rosebud's son Harley out-staring Harry Smith, ca. 1979. (Courtesy of Rosebud.)

walkways, there were rope ladders, there were ramps, there were tiny wheels. Food was placed on these things to encourage the mice to come out and amuse him. You'd be sitting in this room talking and there'd be mice darting up and down the rope ladders and sliding down the ramps and wandering around on the tabletop. And he was very happy with their company, because he loved them, and he would usually have an individual, generally a white mouse, who he'd keep as a pet, and who would always be called Mousy! And he also had a series of Mousies wrapped in tin foil in the freezer. He loved these things dearly. They were very important to him. He would go on about how they were the only creatures who kept him company in his solitude; when all his friends were gone, Mousy was there. It was very sad; it would make me weep sometimes, and I would promise to be more conscientious in visiting him.

I don't know, he was just interested in everything. Nature, the leaves of trees, the auras that emanated from all things. I know that he'd wanted to do paintings of the auras. Kirlian photography fascinated him. The auras of leaves and flowers were something that he really didn't have the time to explore as much as he would have wished to. Sadly he fell into an amphetamine trap and would get fixated on things that presumably meant a great deal to him, but to

the rest of the world are so obscure, like his sand paintings, which would go on literally for weeks. A lot of those appeared in the *Mahagonny* film. It's so difficult to watch. They're quite beautiful, but they go on and on and on. He never explained to me what exactly they were meant to indicate, but to him they had profound importance.

You were saying Harry had a really strong relationship with your son, Harley...

Well, Harry loved Harley very much from the day he met him. He used to jokingly refer to him as his own son. Harry always said that Harley was the strongest person that he'd ever met in his life, as strong as Harry himself was psychically. They met when I think Harley was about three-and-a-half years old and the instant they met the connection was profound. Harley, for example, was the only person who could out-stare him, which used to tickle him no end.

Harley grew up to be a musician, very into heavy punk and thrash metal music and Harry kept up with all the new music. He'd just been working with, or recording, the Butthole Surfers. He loved the name! He spent a lot of time towards the end of his New York years recording my son's band, the Cro-Mags. He would go to some of the big clubs like the uptown Ritz and be given a place of honor up in the balcony, or in the back, whatever. And he'd bring along a lot of elaborate recording equipment and make tapes, and even there, with this new crop of young spiked and studded kids, he'd have a name. On several occasions, I'd run into these young guys in the dressing room or wherever, who'd say, "Harry Smith? God damn yeah, he's here!" They would know all about him. They would have heard of his films or his musical work and be very knowledgeable about his life and his history and career. During one particular show, the band were getting ready to go on stage and I was in the dressing room, and no one, but no one, was allowed in there before the gig. But when they heard Harry was outside, "Oh, Harry Smith, God damn yeah, let him in." And Harry sat there while the band got ready to perform. Then we went up into the balcony where we sat while he watched the show, cackling and smiling and twinkling. Yeah, he had a very deep and abiding love for my son and my son for him.

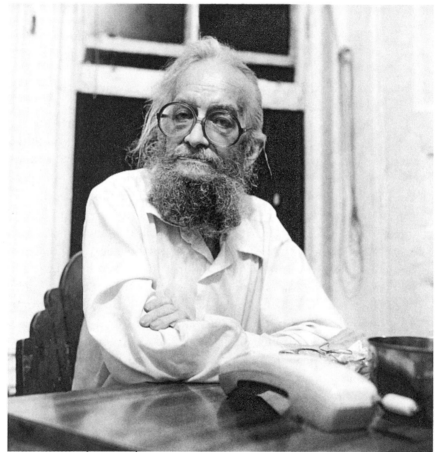

Harry Smith at kitchen table 437 E 12 St. Apt. 22, he lived in tiny guest room off to the side of the kitchen, suffered compression fracture of knee, bumped by car on First Avenue corner — so stayed on nine months before moving up to Cooperstown for half a year — still drank 2 bottles of beer in his room, taped ambient sounds of New York Lower Manhattan with a Sony Pro Walkman microphone wrapped in towel on outside window ledge, kitchen and front room. Night, June 16, 1988 another stay for several weeks before we both moved to Boulder-Naropa for the summer — there he settled down.

Allen Ginsberg

Allen Ginsberg, portrait of Harry Smith at 437 E. Twelfth St., New York, June 16, 1988.

Allen Ginsberg

September 24, 1995

PAOLA IGLIORI: *What's your first memory of Harry?*

ALLEN GINSBERG: I heard about him before I met him, from Jordan
Belson, who lived on Montgomery Street up the block from me in
San Francisco, a filmmaker who had learned a lot from Harry. Harry
originally came from Seattle, then in Berkeley as part of what was
called "the Berkeley Renaissance" in 1948, around Robert Duncan,
Jack Spicer, and other poets studying medieval history. I don't think
Harry was matriculated, but I think he had worked with Kroeber, the
anthropologist. While we were sniffing ether, Jordan told me about
Harry, this polymath brilliant fellow who'd invented the machinery
for making light shows and had left that behind when he left San
Francisco. The people working on rock concert light shows developed
their multimedia Fillmore West wall-collage projections from Harry's
equipment, including the idea of mixing oils or colors on a mirror
which was then projected on the wall, that produced liquid psyche-
delic images that moved and flowed.

He told me enough about him so that when I was in New York,
later in 1959, I went to the Five Spot to listen to Thelonious Monk
night after night. The Five Spot on the Bowery was then a regular
classic jazz club where once I saw Lester Young, and Monk was a
regular for several months. And I noticed there was an old guy with
a familiar face, someone I dimly recognized from a description,
slightly hunchback, short, magical-looking, in a funny way gnomish
or dwarfish, and at the same time dignified. He was sitting at a table
by the piano towards the kitchen making little marks on a piece of
paper. I said to myself, "Is that Harry Smith? I'll go over and ask
him." And it turned out to be Harry Smith. I asked him what he was
doing, marking on the paper. He said he was calculating whether
Thelonious Monk was hitting the piano before or after the beat,
trying to notate the syncopation of Thelonious Monk's piano. But I
asked him why he was keeping this track record of the syncopation

or retards that Monk was making, never coming quite on the beat but always aware of the beat. He said it was because he was calculating the variants. Then I asked him why he was interested in it; this is almost a Hermetic or magical study. I understood he was interested in Crowley, in magic, in numbers, in esoteric systems like Theosophy, and he was also a member of the O.T.O. But he had practical use for it. He was making animated collages and he needed the exact tempo of Monk's changes and punctuations of time in order to synchronize the collages and hand-drawn frame-by-frame abstractions with Monk's music. He was working frame-by-frame, so it was possible for him to do that, but he needed some kind of scheme.

I see. I also read somewhere that his observation of syncopation led him to notice that the heart beats seventy-two times a minute and that we breathe thirteen times a minute and so he kind of created a rhythmic playing around with the two.

There is a complex of body cycles. For instance, the vision is of thirteen to twenty pulses or blinks. I'm not sure about the number of breaths per minute. But there are some other neural cycles. There was a formula that seemed to fit the basic complex of cycles. It may be that he has it recorded somewhere, written down his formula.

He's mentioned intertwining these two as rhythm for his films in one of the interviews.

There are some lectures that he gave at Naropa, now transcribed, where he might've talked about this.

Did you see any of the paintings of the music which, I guess, were done earlier?

Yes. I had a lot of curiosity about his work and we met a few times at the Five Spot. Then he once invited me to his house, about which he was very secretive. He was very reclusive at the time and he had me swear that I wouldn't tell anyone where he lived, and it was 300 and ½ (!) East 70th Street, I think, off of Third Avenue or Lexington. I went there with him. It was a little tiny brick building two stories high. The downstairs was some kind of store and the upstairs was

some tiny apartment. He lived there for a number of years and very few people had ever been there. There was a bathroom, and the front room, and then the bedroom was in the back. The front room was all full of equipment and paintings and I was dazzled by the paintings. I have never seen them since those years. They were rather large, maybe 3 x 5, 2 x 3 feet, and they were of large animistic creatures representing the cosmos that had eyes and mouths and wombs and sort of like gigantic god-like worms or Ouroboros. They were byproducts of a funny kind of formulaic triangulation or Pythagorean calculation and at the same time freestyle doodles. And then they were watercolored and painted-in. They were very beautiful. So looking at them was like seeing in each a funny, bunking, animist cosmos.

That's wild!

So there were these creatures and there were other paintings including the *Tree of Life*, which I had here. You've seen it.

Yeah, actually I would love to use it as the cover for the book.

Mine is on loan now to the Whitney Museum. They'll be showing some of the works of Harry.

Oh, that's wonderful.

That will be a big part of the Beat show.

Oh, when is it going to be?

November 9th, 1995.

This year?

Yeah.

Oh, that's great! I didn't know about it! And did you ever see any of the paintings, which I heard he did with the dots, of the music of Dizzy Gillespie or Miles?

All sorts of things, yes. There were kinds of punctuations and dots, and commas, and odd little animate miniature markings or musical notations or little figures running along the canvas or paper. I got a very dim memory of those. Then he showed me his films. He would get me very high on hash, or grass, in this little tiny room. Then put on the phonograph while we smoked, and play "Round Midnight" or whatever music he was using. And then he showed me these beautiful films which are now on Mystic Fire Videos. But he had a lot more. And then, one day, he showed me the entire *Heaven and Earth Magic* and that was really amazing.

Was that in color then?

No, black and white. It took place underground and the first scene was the 19th century opening of the London subway and a woman in a dentist chair high on laughing gas. This was the elevator going high up and coming back down, ending in the London subway, at the inauguration of the London subway. But if you notice, there is a dentist chair and the lady in the dentist chair going higher and higher and higher, pumped up high like she's in a barber's chair, and it goes way, way up into an elevator shaft, ascending into the sky.

Is that the one where there is the scene with the two lovers going by in a brain-boat looking at the moon? [This is *Film No. 10,* not *Heaven and Earth Magic.*]

Yeah, it's an hour and a quarter film. Every time I went there he'd get me very high, sort of hypnotized me with the grass and the film! And then he'd hit me up for money!…twenty dollars…thirty dollars…fifty dollars…and I had a little money so I gave it to him whenever I was there. But I was beginning to resent it. But one day, when I was there, he said he needed a hundred and ten dollars and he would give me a copy of *Heaven and Earth Magic*, the entire movie, if I would give him that cash. Which I did. I bought it. I don't know what for. I didn't have a projector. I'll put it away or I'll keep it safe. It wasn't a great copy (it was a little dark) but it was an extra one. I took it to Jonas Mekas and told him that I met this fellow who made this remarkable animated collage cartoon, frame by frame. And Mekas had never

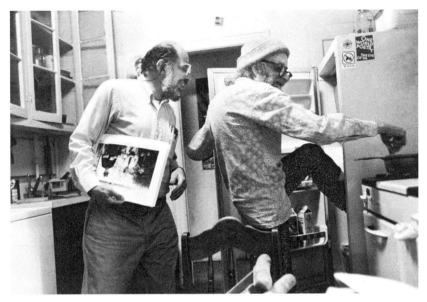

Harry Smith (*right*) with Allen Ginsberg (*left*), 1984. (Photograph by Brian Graham.)

heard of him. So I left this film with Mekas and then Mekas got in touch with me and said this is an amazing colossal genius! So they got together and Mekas began showing his films. Harry was very reclusive and seemed to be very reluctant at first of going public. He preferred to go around cadging money off his friends, collecting here and there; it was a small amount of money, maybe a few thousand dollars a year; he had many friends in different worlds.

Strange how he seemed to have a real openness to randomness and parallel patterns—

That's the key to his work.

But at the same time an almost maniacal precision for all the possible alternatives that could come out at the one random moment!

His interest in randomness was sort of an interest in chance and in actual linkage and synchronicity. But it's pretty much in the ethos of people like Cage or Burroughs or modem MTV. In a way, much of the MTV music videos comes out of this randomness. There is a

Left to right: Jacques Stern, Gregory Corso, Peter Orlovsky, unidentified, and Allen Ginsberg, Saint-Tropez, 1961. (Courtesy of the Allen Ginsberg Estate.)

direct lineage, I think: graphics, jump-cutting randomly or juxtaposition; a funny way of putting it together.

Then later on he went to Florida at some point and began collecting Seminole patchwork. While he was gone, I think it was during that period, I'm not sure, the landlord, who hadn't been paid for some months, threw out all of his paintings, everything that was in the apartment. That's what Harry said, but he was very mysterious about it, so I don't know what remained or what didn't remain, and apparently the great paintings that I was just describing don't exist any longer. I don't know what else was lost. He said that the landlord threw it all in the garbage.

Then he was in the Chelsea Hotel for a little while at a very interesting time: 1970–1972. It was when Barry Miles, my biographer, was living there putting together my 20 years' tapes for *Assembled Poems Vocalized*. And Jacques Stern was there, a friend of Burroughs and Harry's at the time. He had polio, was in a wheelchair, was a reputed member of the Rothschild family, and he had some money. We'd known him from Paris. He thought Burroughs and Harry were the great geniuses of the age. He was making plans to have a magazine feature them, but he was also very temperamental when he'd get

drunk or high on coke or whatever. He'd throw temper tantrums, smash things in the room. So there was Harry, Miles and Jacques Stern all living in the Chelsea. And I visited a lot. At that time, Harry recorded my complete collected songs, *First Blues*, which came out later, many years later, edited by Ann Charters, on Folkways Records, lately available on cassette [Allen Ginsberg, *First Blues: Rags, Ballads and Harmonium Songs*, The Smithsonian Institution, Folkways Cassette 37560]. Harry had also issued the green three-box, six-record set of *American Folk Music* that you also know about. That was one of the first things that I got a hold of. He gave me a copy first, then I bought another set when it was still available. And then the boxes collapsed on the crowded bookshelf. I don't know if you know the effects of the *Anthology of American Folk Music* collection, an anthology of rare old records he'd rescued from oblivion. Have you heard that?

About the effects? No.

The aftereffect. He put it out in 1952 and it was largely responsible for the '50s folk music revival wave in America. Peter, Paul and Mary did much of it, and also the Almanac Singers, Pete Seeger, the New Lost City Ramblers. But one of the people who studied it most closely was Bob Dylan. And Dylan took many of his tunes, such as "Ain't Gonna Work on Maggie's Farm No More," from that. Dylan's early education in blues was supplemented very strongly by Harry Smith. Everybody in the later white art blues, including Jerry Garcia, said they learned blues from Harry Smith's albums. And that was why, many years later, the Dead's Rex Foundation granted Harry ten thousand dollars a year. Because Garcia knew who he was; he was grateful mysterious Harry Smith was still on earth. So Harry had this exquisite impact on American music, and in the last year of his life was brought from Naropa to New York and presented with a Grammy for his contribution to the preservation and promotion of folk music.

Oh, I remember a beautiful line he said on that occasion: "I'm glad I lived long enough to see one of my dreams realized. I see America changed by music—"

"and music changed by America."

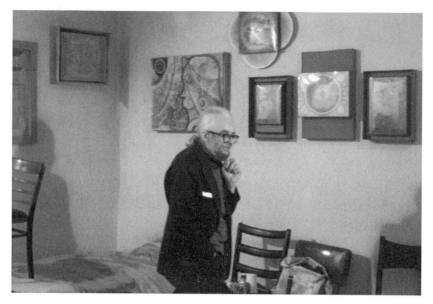

Harry Smith at the Hotel Breslin, New York, ca. 1980. (Courtesy of William Breeze.)

Yeah! I remember you once telling a story about Dylan coming to the apartment when Harry was staying there and Harry getting pissed because the music was too loud and not wanting to come out and meet him.

They didn't meet. Harry wouldn't come out of the bedroom; he was sleeping. Dylan was playing me a tape of *Empire Burlesque* and he wanted me to suggest an alternative title. I complained I couldn't hear the words. It was about one o'clock in the morning.

How long did Harry stay here?

Okay, so wait a minute. Then on the way, let's see…the Chelsea… then he went on this trip to Anadarko, Oklahoma and he always had some young kid as apprentice with him.

Is that when he spent a lot of time with the Kiowa?

Yeah, and he did the record of Kiowa peyote rituals, made while in jail for drinking along with the Indians who knew the ritual songs! Also during that period, when he was at the Chelsea, he recorded all

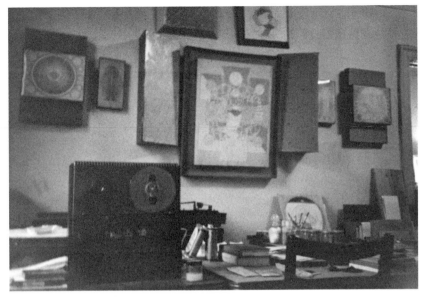

Harry Smith's room at the Hotel Breslin, New York, ca. 1980. (Courtesy of William Breeze.)

of Peter Orlovsky's songs, and Gregory Corso's early poetry. He was doing a series of recordings called *Materials for Study of the Religion and Culture of the Lower East Side*. That's anything that happened out here, like children's jump-rope rhymes, Gregory Corso, me, Peter, people talking, junkies talking, amphetamine babble, the noises of Tompkins Park, city songbirds; he recorded it all.

Did it ever come out anywhere?

No. The only thing that came out was my album, the one that Ann Charters edited for him. A lot of it may or may not have been delivered to Folkways. I don't know where all his tapes are.

There was a story that he drilled a hole in your window to put the mike out.

No, no, he didn't do that. I wouldn't have allowed it. Then, in the mid-'70s, he began drinking, so he got quite paranoid and he broke off with me and he wouldn't talk to me and a few other people, maybe because I didn't give money, or something, but anyway he got

very paranoid and cut off completely with most of the people he knew. Once, I remember passing him in a taxi on 13th Street, seeing him and yelling, "Hey Harry!" and he took a look at me and hurried away. Then he moved for lack of money, I think; he was moved out of the Chelsea and moved to the Hotel Breslin on 28th Street and Broadway. There he slowly softened up, quit amphetamines and got back in contact. Now at the Chelsea he was doing a gigantic, final project, which was *Mahagonny*, again to the rhythm of the changes of the music. He was shooting in color with a camera, maybe a 35mm, I'm not sure. So I'm in that a lot; he was shooting whatever was going on in the Chelsea, and around the city, the carnivals, anything; it was a collection of images, an image bank. He had made some frames through which the film would be shot and/or projected onscreen. So he had these very beautiful Moorish or Greek outlines, comedic or tragic masks, a Baroque theater proscenium. He built a machine which would coordinate four projectors at once, shooting through these various different custom-made frames, these proscenium-like theater squares. So there could be four cameras projected simultaneously with the images coming at random, and I think once, by hand, he broke glass plates of the frames in anger in a tantrum after the first performance. They've been reconstructed; at least some of them have. There were some paper cutouts, cardboard cutouts of the frames that are left. They are in the archives.

When was it shown?

Rani would know. The first showing was probably sometime in the mid-'70s.

It's kind of a step after Late Superimpositions [No. 14] *(an earlier Smith film) in which four or more films are printed on top of each other.*

No, no, there was a lot of that too (superimpositions), but basically it was four projectors, four squares, four different images projected simultaneously and the combination would never be the same, because if you used amphetamine there is no particular order. At that time, with the drinking and the amphetamines, he was very bad tempered and would smash some of his own work, too. So finally he

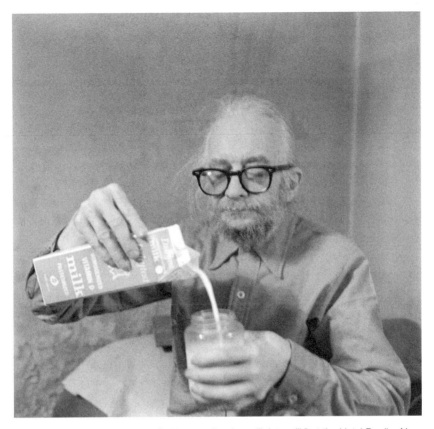

Allen Ginsberg, portrait of Harry Smith "transforming milk into milk" at the Hotel Breslin, New York, January 12, 1985.

was moved out of the Breslin, which was a hotel where a lot of the Africans who sell stuff on the streets would stay, because they were refurbishing the whole hotel and he had nowhere to go. He packed up his stuff and brought a lot of his stuff to the Film-Makers' Cooperative. And he had given a lot of his films and paintings to Jonas Mekas in exchange for money, or put down like in hock on a loan. So when he paid the money back he would get back the paintings. He never paid the loan. Apparently, there's a lot of it there now. Somebody just reported opening up a box and finding a lot of his paintings. But they're not yet included in the survey of materials. So he had to move from the Breslin, but he had nowhere to go. So I said, "While you're looking why don't you stay here with me for a

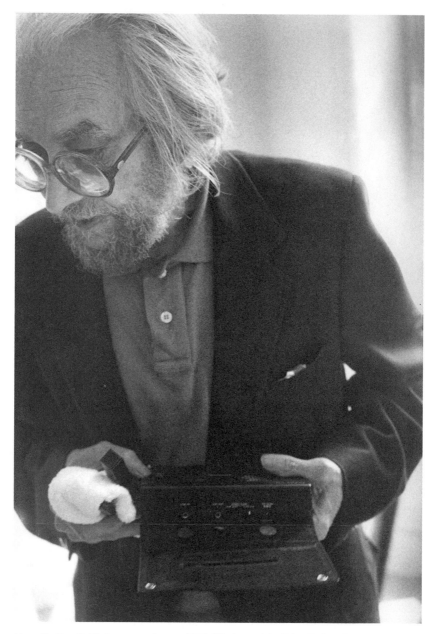

Harry Smith with his tape recorder, ca. 1987. (Photograph by Brian Graham.)

couple of weeks until you find another place?" He moved in and within a week a car had run into him. He suffered a compound fracture; the bone was crushed, broken, like shattered inside. Did you ever see the play *The Man Who Came to Dinner*?, where this old curmudgeon comes to dinner and ends up staying a year! (Laughs) He ended up staying eight months. He was still drinking beer.

He made all sorts of drawings and constructions, particularly using toilet-paper tubes and the cardboard tubes that are inside a roll of towels. He would set them up on a flat surface and glue them down, and cover them with a kind of glue to make them permanent and they looked like futuristic cities, round buildings, and he would draw on them a little bit. One day, angry at me for some reason or other, or angry at something, he smashed them: four months' work destroyed. So I took a lot of photographs.

Oh, you have them?

Yeah, they're all in my office. I've shown them. One of them, "Turning Milk into Milk," him pouring milk, is from his last days at Hotel Breslin. I don't have any earlier pictures. At the Chelsea he'd met Mary Beach, the translator of Burroughs and niece of Sylvia Beach, a Parisian friend and publisher of Joyce, of the Shakespeare & Company bookshop (not the new one, the old one).

I think I might have heard from Lionel about that.

Oh, Lionel Ziprin. Apparently Harry first came to New York to visit Lionel, who was part of the Hermetic group connected with Jordan Belson. Not to forget "Hube the Cube" from San Francisco, a bearded guy who had a newspaper stand, and was also a Hermetic amphetamine head. There was Harry and then there was Jerry Joffen, son of a rabbi, and Lionel Ziprin. Do you know him?

Yes, I do. What other kinds of things was Harry taping while he was here?

Then he began taping the ambient sounds of New York City. I had this kind of machine, a Sony Pro-Walkman (points to a tape recorder on desk), and he exhausted two of them or over-used them up. If he'd

see a machine of mine, he'd grab it for his studies; so I gave him one, but he got the other off of me too. He put the microphone out the window, wrapped in a towel, and just sucked in all of the sounds of the city for miles around with the microphone. Sort of like almost Cageian music. And it climaxed on July 4th when you get all the fireworks. That's mostly what he was doing. He did it hour after hour, day after day. Also, he'd take the machine to Brooklyn and tape Haitian street fairs, or Hispanic celebrations, and concerts in open parks. He was very good friends with Rosebud, who knows a lot about him; Rosebud Feliu-Pettet was his spiritual wife. She knows a lot about him and has a lot of stories. She knew him from way back in 1969, before he moved to this apartment. Rosebud's sister was going out with Peter.

Oh, I didn't know that.

Yeah, Rosebud's sister, Denise Mercedes. She stayed with Peter Orlovsky on the farm, late '60s, and lived here to the late '70s. I think Huncke was living at the Chelsea as well then, in the mid-'70s.

And Gregory too!

And Gregory was there. Yes, it was very explosive. I think that was the reason he left, because things were getting kind of murderous there. Somebody got killed at the Chelsea and it was related to Harry and drugs or something. So I think that's why he left. It was getting dangerous. He was paranoid. Forward to the mid-'80s: so because I couldn't keep him in this apartment all the time, the Beaches, who had moved out of town to Cooperstown, New York, offered to take Harry to the country, and take care of him for the rest of his life. So they took him up there and things worked out well. He started a collection of old, rusty farm keys, country implements of all kinds, 19th-century antique common farm equipment, locks, etc. But he drank as they drank. And so he was living upstairs in their town farmhouse. They got really upset with him for leaving shit around because he was shitting in a bag or something because it was hard for him to get up and down the stairs. They finally insisted that he leave. He wound up in a Franciscan flophouse down on the Bowery, a few

blocks down on Third Street or Second, collecting books. All the money he gained went to book collecting. I remember I once visited him there in this narrow little cubicle and he was making recordings there of people coughing and praying on their deathbeds. His cubicle was so crowded with stacks of books that he had to move sideways and shift a stack to open his narrow door.

Oh God.

You could hear sounds from all the other cubicles because the walls were made of paper-thin cardboard or wood. So he listened a lot; it was always people at the end of their lives groaning to God, people dying, coughing all night. Sounds of death as well had a synchronicity; he observed synchronicities here, like when the birds would begin singing; apparently, at dawn or at sunset they all sang. He began noticing the movement and cycles of natural objects. But Brian Graham (a photographer, who develops my film), reported that Harry was getting thinner and thinner from malnutrition and he was getting too weak to go out. I think Brian went there with Peter. And we asked Harry to come back here to my apartment for an interim. By then he quit drinking because he was so sick. He was here three or four weeks till summer, when I had to go to Naropa. So I brought him out to Naropa and he was in residence there from '88 on, known as the campus Philosopher-in-Residence. And there he began making tapes of the ambient sounds of Rocky Mountain Front Range; it was the same thing, including the climax on July 4th, with all the fireworks (laughs).

He had a little house right there on the campus, a little clapboard house. It was all his own. The custodians supposedly let him cheat on the rent and he kept buying books, but Rani Singh became his guardian-secretary and got him food stamps and SSI, etc. He was loved by all the inspired poets and gardeners at Naropa till he was called to New York in 1991 to receive the Grammy, plucked from obscurity! Though famous everywhere underground. (Phone rings; Allen talks and comes back).

I'm going to this *Tricycle* magazine party. I'm due there at four which is now. Rinpoche is in town. This is all too much. We'll have to finish another time.

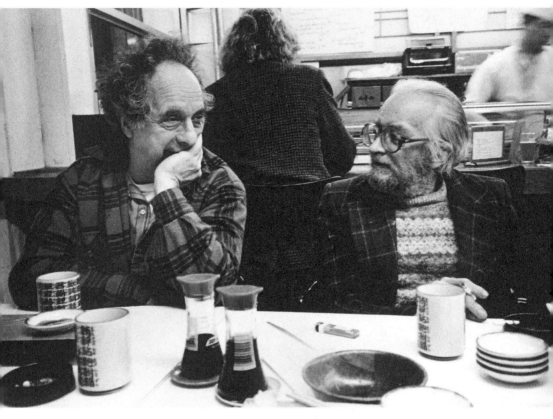

Allen Ginsberg, portrait of Robert Frank (*left*) and Harry Smith (*right*), March 29, 1987.

Robert Frank

October 17, 1995

ROBERT FRANK: Well, Harry, I think he was a genius. He was to me the only person I met in my life that transcended everything. He seemed to always be able to give you an answer that was really at the end of the line. He didn't have to go through all the shit. I think he was totally aware of his power, of his intelligence, of his memory, of his knowledge, and he was suffering a lot. But I think that the many things that he was curious about and lived took care of a lot of the misery in his life, and made it possible for him to go on and on despite the horrible way he chose to live. I don't know why he subjected himself to so much hardship; you know, sleeping out in the garbage cans.

PAOLA IGLIORI: *He created his life every second, I guess.*

Well, it was so that he would have control of it. He would not let anybody come in and tell him what to do, except maybe towards the end of his life. I don't know. I think he was always himself. I know he could be driven by tremendous rage and hate against a person or against a system. I remember once we had dinner at Lucio's restaurant with a friend of mine, and Danny Seymour's sister, Rosie, who used to live in the Chelsea and help him, and we ordered drinks. She was married to some Spanish guy and she came back and she got beaten up in the Chelsea Hotel and she got brain damaged. You know that guy I made the film with, Danny Seymour? So she was good to him; I think she gave him money and supported him for a while. You'll find out about her. What was I saying? So the waiter brings this vodka for Harry. But after the second vodka, all of a sudden the waiter comes near him and Harry raises this little glass and he throws it right at the waiter's face and says, "Heil Hitler" and "fuck you, I've had enough, I can't stand this place," creates a big scene. He could be very cruel to his friends, to anybody.

Do you think stupidity really drove him crazy, or what was it that unleashed him?

It could come on like a storm; all of a sudden you'd see it for two minutes and then it reached its full force. And with me a couple of times I decided not to see him anymore; he was really just insulting in every way. I just knock on the door and all of a sudden he has this rage against me. So then it would be best to leave him alone. I think he hurt many people that way.

I got to know him through Allen, a long time ago, when he lived uptown in a dark room, a completely closed room, with no windows, and dressed in black. He was a very strange figure then; at that time I didn't understand that much.

When was that?

That was maybe at the end of the '50s. Then I met him again because I worked with Conrad Rooks, the guy that made the film *Chappaqua*. There were a lot of Beat people in the film. He knew Harry quite well, and of course he gave Harry a lot of money to work on his films. I think he rented him a studio in Carnegie Hall. So I watched him. Harry was building a little model of an Indian reservation and he was working on a film, and Rooks helped him. Rooks was also very difficult, a very, very rich man, an extremely rich man who was just coming into the age where he could touch the inheritance of his father. This was Avon beauty products so it's a considerable amount of money, and he was just trying to make a film and he wanted to use Harry and Harry wouldn't work with him. So Rooks asked if I would work with him and I said yes, we could try; so one day he said, let's go and pick up some film cans there at Harry's. So we drove there; Rooks had a chauffeur and a car. I think I went to ring for Harry and he came down with two film cans and he stood there on 57th Street and Seventh Avenue, where Carnegie Hall is, with these two film cans, and Rooks sat in the car; I was outside the car; then he looked at me, and then he looked at Rooks, and took the two cans and threw them under a cab and the cab drove over them (laughing). He walked off and that was the end of the relationship with Rooks.

And then I went to visit him and film him in his hotel rooms. He loved a bird he had.

Birdy.

Yeah. And the bird would be flying around. I could see he truly loved the bird. He loved music, but he didn't play that much music except when other people were there, I think. So I decided to film him and there was not much talk; I mean he would sit there and look in his medicine, you know, how many pills were left. He talked a little bit about books, would open a book. Maybe when we have more time, I could show you these films. They're pretty interesting. And he would show some of the paintings.

I would love to see them. I saw one, that piece from the Breslin Hotel.

I made a little movie for my show, on five or six people, so he's one of them, and I think it's filmed in the Breslin Hotel, and he's walking out and then coming here to visit me. And I ask him how does it feel when you're seventy… I heard it was his birthday… and he looked at me, gave me that look of complete hate. For me and the whole thing.

He said, "It sucks!"

Something was wrong with his legs for a while and he had a hard time walking. He would always need money, but sometimes he would say, "No, I'm not accepting your money for a cab." I think sometimes it really hurt him to have to ask for support. I remember that he applied for a grant at the Council of the Arts for New York and half of his application was the Mass, the Catholic Mass, *la prière,* and the other half described what he wanted to do with his film and he gave that in. It's an absolutely wonderful idea.

Yeah, he was totally fearless, fearless about the world; he didn't give a fuck about what the world would say; he was always himself, no compromise. I think Allen was very good to him; he really helped him. For me, with a family and all that, it was really too difficult to keep up with him and so there would always be periods when I would see him but then it became too heavy. Well, I guess many people are not here anymore that really knew him.

He knew a lot of people in totally different circles, completely disconnected from each other.

Yeah. Did you talk to his doctor?

Dr. Gross? Not yet.

He was a pretty good friend. I mean he had to turn to him; if he had to turn to people it would be to his doctor and people for money and there was always Allen. I don't know how much Raymond [Foye] helped but Harry knew a lot of people.

Different worlds, from the street musicians and the bums to everyone, it seems to me. Rosebud was telling me that he always asked her to do really daring things. And I said, what kind of daring things? She said, like walking on top of buildings, on the edges, and stuff like that and she would do it; he really wanted her to push herself to the maximum of what she was capable of, and I think that's what he was doing with himself all the time, just being on that edge.

I think he would often resent that other people would use him, because he knew that everybody really used him; I mean they helped him but they sucked out some of this tremendous talent that he had. From him they would learn about magick, filmmaking, collecting records, music; it was amazing what you could learn from him. I remember I wanted him to be in a film of mine; I forgot now, fifteen years ago, he was living upstate… I think on Allen's farm… and I said you come down, we have a little scene, and we know what we want to do, you come down, and we'll pay you something. And he said, "Okay, I want a Rolls Royce to come and pick me up. I want twenty thousand dollars." I mean, he was absolutely serious. I think he did that with a number of people. All of a sudden he would decide not to be sucked into something where he would really have to give or he would be taken advantage of.

So he didn't do it?

No. He didn't. Once you met him, you couldn't really forget him.

What was the thing that most struck you about Harry? What stays with you most?

It was obvious that he was a very intelligent man; he would jump when you would start talking and he knew what you were going to say, and if it was too boring for him to listen to you he would come out with some question that would make you reveal more. If you couldn't do that, he would not be interested in you. Sometimes, he was very demanding that way. I think he liked children in a way because they could respond to that. My children were fascinated by him, especially Pablo; they didn't see him that much. He used to explain the string game. He was very patient.

He loved to teach.

In his later years.

I think with young people he loved to transmit, to really awaken their interest.

With young people, yes. He had very good eyes, sharp eyes. They could beam. I remember he would often be furious with Allen when Allen got this camera and started to photograph him. A couple of times he would just get up and walk out. I think he needed that to show you couldn't control him, that you shouldn't try to control him in any way. There was a very strong drive in him and he would show it, not by talking, but by his actions, by his behavior. He was a difficult man, but I think anyone with that knowledge and that self-assurance…I think it would be very hard to make a film with him. It would've been very good but you would have had to be up to it.

That's what inspired me to buy a video camera when I first went to the Chelsea and talked to him. And then after that I thought I wish my mind was like a camera and it recorded everything of this. Then I thought I'd really like to get a video camera and just put it in the corner and forget about it. And that's when I got the video camera; but I always thought I really want to be with him without the distraction of the camera, there will be time; and after a little while he was gone.

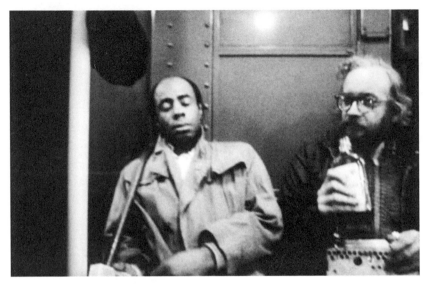

Roscoe Lee Browne and Harry Smith in Robert Frank's film *Me and My Brother*, 1969.

Did you record anything?

Nothing.

He was difficult that way. When I decided to take the video camera, I think it was whenever he lived at the Breslin. No, I used him in a wonderful scene with Roscoe Lee Browne, a black actor, in the subway. First he sat on a park bench on Sixth Avenue and he was sniffing glue; that's the scene in the film. He's quite good; he already looks old then; the first time I used him was in 1965. Then he goes into the subway. A lot of things are happening: a woman is selling something and the nun is sitting there, an actress you know, but the place is full of people; and he was sitting there drinking from that same paper bag; he had a bottle in it. And then he got up and threw that bottle at somebody. He liked to do that a lot.

He was just playing himself!

Yeah. But the first time I really wanted to have a record of him was in the Breslin, when I had the video camera, and mostly in his room. So I think most of that was shot in the Breslin.

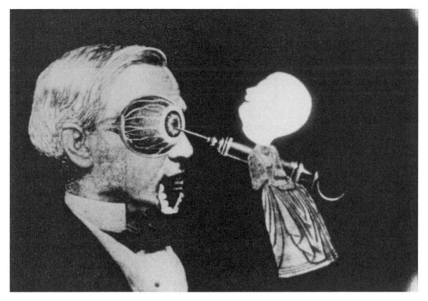

Still from Harry Smith's *Film #12: Heaven and Earth Magic*, 1957–62.

That was so good. Really good.

I think he would enjoy showing you a really small portion of his knowledge, of what he'd done. And he would say, "Look at this," and he would turn this very small Moviola screen and turn by hand his Super-8 film. You could barely see. And he would turn this and he would look at me and say, "You couldn't sit through three hours of this film." (Laughs) I remember when I saw the first animated drawings he made; this was before Stan Vanderbeek, who was the real big name at that time, in things like this. But he was way, way before him and these first films that he made were very, very good.

Like Heaven and Earth Magic?

Yeah. And some films where he used a lot of drawings. I mean representative films, where the mouth opens. I think of the last one, the one on Bertolt Brecht, *Mahagonny*. I remember once we talked about how I was seemingly successful and I told him that I really felt I'm going downhill. And he told me, "Yeah, well I know, the descent is more difficult than the ascent." It would be nice to reproduce in the

book a lot of these things that he was so interested in, that he was such a specialist in, a connoisseur.

He knew so much, so many different fields.

The variety of it is absolutely astonishing: black magick, paper airplanes, Easter eggs, the textiles from the Seminole Indians, and that first record, from Folkways, the catalog he made. That music was the beginning of a lot of things. He was so far ahead of his time; he's a hundred years ahead. This knowledge, this accumulating of things, would have been perfect in this age of computers.

I met a young kid a couple of nights ago. There's this new kind of ambient music which is something like jazz, but done with records and scratching, and computerized kinds of organic sounds that create an environment. Very far-out. And there's this image that looks like the cells of the body and maybe blood moving and it's all biofeedback from the TV, super-enlarged. They put a video on the TV and get these images that seem to go with this music. It's all done by smart young kids and I talked to the guy who did the images and I said, "God, this makes me think of Harry Smith." And he said, "Harry Smith? I love his work." And this kid is really young and he knew Harry's work and it was really inspiring to him! What comes back to you if you think of Harry?

It seemed he knew. He didn't want to waste time. He showed it in a good way. I said before that he could come right to the point, or express that you were at the end of his patience to listen to this crap. He was fearless, and you could also see the tragedy in his life, how much the world made him suffer and how much he dedicated himself to this lifestyle; he had to live it that way. I think towards the end, when he got this job in Boulder, maybe for the first time, he became more relaxed and he would not suffer that much. But then he would always come back here to the Chelsea. Well, I don't know what else I can say about Harry Smith. I wish he would come down a little bit, or up, from wherever he is. He certainly left a very, very strong memory of himself in my eyes and my head. I really think he was way ahead of everybody that I knew, way ahead of everything.

Dr. Joe Gross

October 25, 1995

DR. GROSS: Well, to talk about Harry. He is probably the most difficult person to talk about because there is so much; how to convey that to someone who doesn't know Harry is very difficult.

PAOLA IGLIORI: *When did you first meet Harry?*

I'm never sure when I first meet people because after I feel I've known them forever. But I think I first met him in the '50s, at the time when the Cedar Tavern was still where it originally was over on University Place near Ninth Street or Tenth Street. I remember there were a bunch of artists whom I knew and I would go there and I remember meeting him there. At that time, I think he was living at the Chelsea Hotel. But anyway, our paths kept crossing and crossing and crossing and crossing so we got to see each other and know each other on and off over a number of years. And without a doubt, he was the most extraordinary person I've ever met and I've met a lot of extraordinary people; well, maybe one of the two or three extraordinary people.

Wow! Who were the other two?

Well, I'll mention one other one, someone named Don Hammrick, who was sort of a scientific and theological genius from the West Coast, and later became known as Dr. Charnoe. He founded an early "New Age" commune north of San Francisco in the early '70s called "Harbinger." He was a totally remarkable person, but that's another story. I don't think he ever met Harry; I wonder why, because I usually introduce these people to each other.

But anyway, Harry had many, many different facets. He was so bedeviled by this sort of irascible temperament. And it's hard to be objective. Here's this person with this extraordinary mind and extraordinary sensitivity to all facets of music and art; I always assumed when I met him that he knew everything 'cause he seemed to know

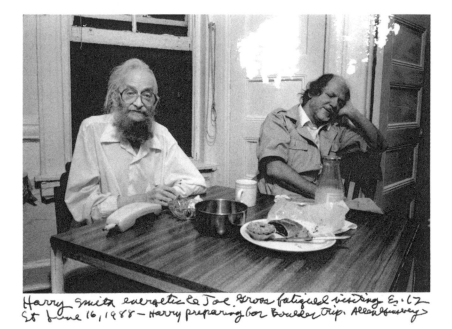

Harry Smith energetice Le Joe. Gross fatigued visiting E. 67 St June 16, 1988 — Harry preparing for Boulder trip. Allen Ginsberg>

Allen Ginsberg, portrait of Harry Smith (*left*) and Joe Gross (*right*), June 16, 1988.

everything. I knew at that time he was drinking a lot and that of course exacerbated his irascibility. So at times he would become totally impossible, which of course is your privilege if you are a mad genius.

At one point, he had been living in a little apartment; it was an odd address, like 237-½ (there was a "½" digit in the address) at East 77th Street or something like that, over near Third Avenue. This tiny little building. Then he had gone out to Oklahoma and there he was recording the peyote ceremonies; he got mixed up with the Indians, and was also drinking, and I think he was thrown into jail; a whole bunch of things happened.

With the Kiowa?

Right. And he had left all his books, and papers and films and paintings and God knows what in this apartment. Of course he never paid the rent. He never liked to pay rent. And so what happened was that the landlord apparently just threw everything out, or so he said. And Harry came back and everyone went totally berserk, including

Harry, as to where all this stuff had gone to. As a matter of fact, there was this other filmmaker, Conrad Rooks, who made the film *Siddhartha* and later made a film called *Chappaqua*, with Jean Louis Barrault having a cameo role, a fantasy about addiction; Harry was one of his mentors, and he was very close to Harry; so they actually went out to the New Jersey dumps to find out where the Sanitation Department allegedly had thrown his stuff. And then a couple of years later, I actually tracked down the landlord, who was sort of a Hungarian Jewish refugee from the concentration camps and very secretive and very paranoid and very sleazy in a way; I actually had a meeting with him, and I said, "How much rent did Harry owe?" He mentioned a figure and I said, well I'll give you a couple of hundred dollars and maybe you can find the stuff that was thrown out. He said, "I don't know, I think it was all thrown out, I'll look for it." I don't know whether he looked for it; he was impossible to track down; he only wanted to meet in coffee shops. He was a very strange individual. Maybe he's still sitting on all these things. Harry kept repeatedly losing or destroying his work, and at times he was responsible for destroying the work; his art production would just tend to disappear.

One of the things that came out in one of the interviews was that he was under such stress because of being evicted that he destroyed a lot of the work...

...evicted or addicted?

Evicted. He told somebody that he destroyed some of the stuff himself. Is that likely?

No. That may have been another case and another eviction. But in this instance, no, there was no doubt that the landlord...I mean he had gotten six months behind on the rent or something. When he came back it was gone. But other times he would destroy things. He had a habit when he was in a fury... I'm not really conveying Harry...of course I'm just starting on a small point at the moment... he would just take his glasses and smash them to the ground. That was one of his typical tantrums and I always thought of his tantrums as really rages...

[Editor's note: The tape went on running to the end. The tape deck was never touched, but nothing was recorded after this point.]

November 16, 1995

PAOLA IGLIORI: *Is it true you were like sixteen, or seventeen, when you met Harry?*

DR. GROSS: No, no. It's really hard for me to remember time sequences now, since retiring and sort of detaching; but no, I met him in the '60s. And that's at the time when the Cedar Tavern was active and our paths kept crossing and re-crossing many, many times. There was definitely a karmic connection, to use a standard phrase. And just to continue a little bit from the point where the recorder stopped recording last time, and I hope it's recording now, about Harry's rages, because I've seen a lot of people and experienced a lot of things, but Harry was the only person, when he got into a rage, on one occasion, in particular, that I was really afraid he was going to kill me. He was drinking of course, and alcohol naturally irritates the brain, and Harry was uninhibited to begin with. Even though he's a little guy physically, he had enormous strength in his hands. I mean, if you saw his hands, they were sinewy to the extreme. He must have done some physical work during his life, but I don't recall him mentioning that to me. But at any rate, we were sitting in a car after having been to some bar or other, and he'd been drinking a lot; he was next to me and he worked himself up into the most utter fury about something or other; nothing in particular. I had some scissors on the dashboard and he picked up this large pair of scissors and just held them like a dagger and I was really sure he was going to stab me. Since I was trapped in the car, before I would make a move, I knew that he could…there was no way I could actually defend myself in that position behind the steering wheel. He held the scissors and smashed the windshield; he had to do something; luckily he plunged them into the windshield. I ran out of the car. But I just mention that as one occasion of this primal, primal force coming out.

You were also telling me the story of when he left some of his work in your office.

Oh yes! Another strange thing. He kept having fires; wherever he'd be there'd be a fire. I don't know if he caused them when he was drinking but he smoked a lot, not just pot, but cigarettes, of course. So at one point he had been burnt out; his stuff was out in the street and he was wandering around, and I said, "Harry, why don't you just leave the stuff at my office, my apartment; it'll be safe!" So he brought some films and books and I don't know what the heck else and I put them in one of the closets in my office. Then a few weeks afterwards, I went out for some Chinese food and came back within an hour, and when I came back the street was filled with fire trucks, literally like three or four fire trucks. This was sort of an East Side, near Fifth Avenue, apartment. And I got to the door and I said to the doorman, "What's happening?" He said, "Oh boy, wait until you get to see your apartment." And I thought he was kidding. I get to my apartment and the whole place was incinerated. It was a fireproof building so the fire was confined to the bedroom. Everything in there was black and incinerated. And Harry's stuff, of course, had burnt up. The fire started in the closet where his stuff was. It was very mysterious. I couldn't imagine how the fire started there. The only logical thing, if you want to use logic for the illogical, was the possibility that there was a light in the closet and some electrical connection, and it burnt up. Harry, strangely enough, took this with great equanimity. I mean, it's almost as if he expected something like that to happen. I can't describe how astonished I was, and chagrined, of course: more of Harry's stuff lost. Anyway, that's life with Harry.

What's the thing that touched you the most about Harry?

Well, again, I've always been drawn to creative people, mad geniuses, having a bit of that myself. He was just so unusual and remarkable and also very funny. He was one of the funniest people I've ever known. And one of the most charming people I've ever known. But very few people actually saw that charm. He had moved into my apartment when he came back from Naropa, with six cats, or four; I never kept track of how many cats there were that he'd brought over from Naropa. And my apartment is extremely cluttered, so between Harry and the cats and my odds and ends, it was really just a totally mad scene. One evening, I had a lady friend over who was a painter

I've known since the '40s, Vera Mendelssohn, and she also knew Harry from the old days. It just so happened that I had lit some candles; it was a very charming little scene there. We were smoking whatever. And he, as he has been with certain women, turns on the charm in a way which is just totally captivating, debonair; it's really hard to describe. And that's one of my fondest memories; that to me is the real Harry. I'll never forget one other time. We were visiting this woman artist from Hamburg, who I introduced him to, and who was a friend of Bill Raphael. And here was this woman who was just an extraordinary artist and beauty, I mean a natural beauty, much more striking than Marlene Dietrich, much more charming and relaxed and the whole nine yards. And Harry just began to glow and he basically said to her: "Why don't you and I just run away right now?" Much better than that; I mean he was really captivating. I just mention this because people rarely saw that side of him. You'd have to see it to realize.

Of course at the Chelsea Hotel, which was a much more interesting scene than I imagine it is now, he naturally knew all kinds of people and there was this lady whose name I forget; she came from some wealthy family and owned an office building, and she was kind of a mad creative genius. She invented a flying saucer-church, a temple rather, that would be a flying saucer that she had patented. She also had all kinds of drawings. This is back in the late '60s, early '70s. And she had been subsidizing another artist, who wound up in San Francisco from Maine, forgot his name too, who had created something called a Cosmotron, which was a device, again in those days it was very new and original, that turned a TV image into a kaleidoscopic pattern. And that same effect was noticeable in Harry's movies, because whatever music you would play, it would seem to synchronize with the images on the screen. That was one of the more remarkable aspects, both of Harry's films and these kaleidoscopic images in color. The human brain, in a seemingly unusual way, but of course that's what it does all the time anyway, integrates the unrelated image and music and relates them together in such a way that they synchronize. It appears that the music has been exactly synchronized, as if it was on the soundtrack with the images. But of course it isn't; the brain is doing that; although I do believe that in some of Harry's films the synchronization between the music and the image was created by Harry. If it wasn't, then it's a miracle (laughs).

So do you mean to say that the brain naturally always strives for harmony, for finding the connection.

Absolutely. That's what it does. We see things as having form and pattern and relatedness and that occurs not only in terms of individual perceived objects, but in terms of all of existence, the universe, time; everything has a pattern that we, I would have to say, impose on it. But that gets into all kinds of esoteric things.

For example, in my experience when I take grass, I suddenly have revelations or what seem to me revelations about the connections between things.

Of course.

Is that just normal sense being heightened? I mean, is that what the brain does all the time and it's just a heightened experience with grass?

Right. But there's no limit to what it can do, ultimately, but I haven't experienced this exactly, it becomes a tendency that leads to a kind of mental orgasm where everything synchronizes.

Naturally, since I'm a psychiatrist by profession and inclination, I was trying to help Harry in various ways. In those days I was much more wary of medication and medication effects, and Harry would always tend to overdo things; whatever he had or did, he would overdo it. He told me he had taken I don't know how much peyote and mescaline not to mention any other drug he could get his hands on at various times; to accentuate images, he would take peyote and then start rubbing his eyes to induce these things, and so I was always wary about giving him various things. I'll never forget once, (but I don't think I gave them to him because I was very careful about that), he was doing this animated film, *The Magic Mushroom People of Oz*, and he had gotten financed by this Harry Phipps, among other people, who was this wealthy heir, and a junkie. He lived down in Palm Beach or somewhere in Florida and he had rented a studio in the East 60s with a twenty-four-foot-ceilinged living room where he installed an animation camera so that he could photograph at different planes, one behind the other, and he needed the height to get the separation of the planes. So Harry was going there to film this incredible film, one frame at a

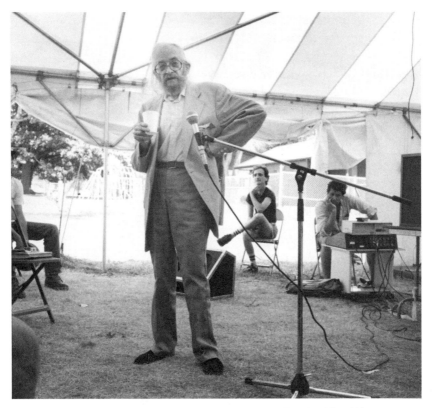

Allen Ginsberg, portrait of Harry Smith at the Naropa Institute, Boulder, CO, 1988.

time, and on this occasion he was well financed, so his pockets were literally stuffed with money. We'd be running around, and he'd be foaming at the mouth; whenever he took a lot of Valium (he had Valium at that time but not from me), he would just keep popping them and popping them and bounce around throwing dollar bills at everybody in sight. He'd shove fistfuls of dollars in cab drivers' hands.

For years, I was terrified that he would overdose on alcohol or cigarettes or something or other, but he managed to survive. Harry was actually a very tough guy, physically, even with all the drugs and alcohol. I prevailed upon him to get out of New York, and then he luckily got installed at Naropa where I visited him several times. In Naropa, he took me on a few tours around Boulder. We'd go walking around up hills and he'd actually be striding up the hills faster than I could. And I'm in reasonably good shape. So I was always wary about

giving him medication, but I got him at different times to use some Stelazine to sort of tone down his fevered activities. And then, of course, the great miracle of his life is that he stopped drinking, and that was at a time when I'd kind of lost contact with him. He was living in the East Village, I think, with a French fellow named Jean-Loup or something, and he had what he called a seizure. Now he kept calling seizures what I call tantrums, so I don't think he had a seizure physically, but he wound up in Beth Israel Hospital on the floor of the Linsky Building. He kept asking me, "Who's Linsky?" And when he got out of there he stopped drinking. I said, "What happened, Harry?" He said, "Well the doctors told me that if I kept drinking I would die." And so he just stopped. He's one of the few people I've known, maybe two or three others, who were able just to stop and he really stopped. I think he stopped all drinking. Previous to that, he had confined himself only to beer. I remember visiting him up in Cooperstown, where he was living with the Beaches, and at that time he was only drinking beer; he'd go out for his quart of beer and we'd be roaming around there.

I guess he must have invented the term "Urban Archaeology." I'd never heard of it before. He'd go around to just any old place and begin digging through the ground and coming up with all kinds of bits of broken bricks and broken bottle tops and pieces of glass and just any kind of odd and end, and he could tell stories about everything, every object. He was incorporating some of the objects into collages he was doing. The collages consisted of just anything and everything.

What kind of stories would he tell?

He'd point out the roofs of the houses and the angles that the roofs were built on, and how the angles changed because the snowfall changed and so the roofs were made so the snow could slide down; these kinds of things. And then with all these objects, he would know what they were originally used for. I mean, there was no end to his knowledge and I never understood how he incorporated all this understanding. So, in these collages, he would incorporate everything he could find, including, literally, I think, some dog shit he found that just fitted right in there, or some bird shit or something.

I've seen one painting he did. There was honey, feces and butterflies.

Yes, it must have been one of those. Then, of course, all that stuff was put in the barn and got rained on or I don't know what happened. Even Leonardo da Vinci's notebooks got locked up in some attic for a hundred or two hundred years, so it's just the nature of the situation.

One wild thing I heard was Lionel Ziprin telling me that Harry told him that on his mother's deathbed he was reading some kind of sadist treatise from a book by Karen Horney.

That Harry Smith was?

Yeah, to his mother on her deathbed!

I never heard that. Now, people with that degree of creativity will just create and invent things and it's not pathological; it's part of the whole thing. In French they call it Mythomania.

Back to the Chelsea Hotel. Around the time when I first met him, he was always on the verge of being evicted because he never paid rent; he just never paid rent. He'd be thousands of dollars behind and there he'd be in his room with all his books and his Ukrainian Easter egg collection, which represented prehistoric, pre-literate patterns and had nothing to do with Christianity or the Ukrainian Orthodox Church. He would just go and collect these eggs and, of course, they had to be kept; they were coated with wax, and basically, over a period of a year or two, they gradually hardened at room temperature. What would happen by boiling an egg happened at room temperature over a year or two, and they're coated with wax, so the gases in the eggs would gradually build up, and these eggs could not be touched. And so here's Harry, working himself up into a slow fury but telling anyone who was there, myself included, "Don't move! The eggs will explode!" It was really bizarre. As soon as I'd get up and move the chair, he'd say, "Don't move!" And that would go on and on and then here he is with all these eggs and he's about to be evicted; so I helped him out: I start paying the rent. Unfortunately, all the eggs got stolen. He had hundreds and hundreds and hundreds of these incredible eggs.

Wow. So many things got lost.

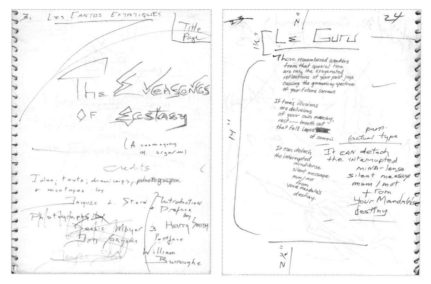

Jacques Stern, hand-drawn mockup pages for *The Even Songs of Ecstasy (A Cosmogony of Orgasm)*, an unrealized book on the Tarot with a planned preface and introductory poem by Harry Smith and postface by William S. Burroughs. (William S. Burroughs Papers, Rare Books & Manuscripts Library, Ohio State University, Columbus.)

And then, of course, there was the Chelsea Hotel! Other people may have mentioned that he was living on the same floor with Jacques Stern. Jacques Stern is another creative genius whom I've known for many, many years, and he wound up on the same floor as Harry, on opposite ends of the seventh floor of the Chelsea Hotel. And there were these two black, or gray, or striped magicians at each end, trying to sort of outdo each other, both in creativity and threats. Between the speed and the alcohol, it really produced a lot of sparks. Actually Jacques, who was paraplegic and rattling around in a wheelchair or braces, actually had Harry terrified, which is a good trick (laughs). And they actually created a book of poetry together which will appear one of these days, called *Even Songs of Ecstasy*. It was based on the Tarot and they had alternating poems: Harry wrote one and Jacques Stern wrote another. Jacques comes from an aristocratic background. We'd have dinner together once or twice, and he knew how to seduce Harry into joining a creative enterprise by flattering him and feeding him and doing all kinds of other things; that's when they were on good behavior. I think Jacques was doing speed in those days which is not a secret

by any means; when he and Harry got drunk or were on speed it would just be pandemonium. It was unbelievable.

Did he meet your mother? How did Harry relate to your mother?

Oh, yeah! My mother lived not far from the Chelsea Hotel. She was on about 8th Avenue and 27th Street, so I'd be visiting her and going to the Chelsea. I think this was shortly after I and a friend, Bernard Webb, an English fellow, had visited Harry. Harry said, "Shall we do this? I forget what it's called, some kind of Yoruba…"

The reading with the shells?

Yeah. It wasn't just shells but I can't even remember what it was. Harry had this magical Yoruba-type divination process, which he just went through all evening using different objects and numbers and patterns and I can't even remember what the heck it was. Anyway, the next day we went over to visit my mother and Harry kept telling this anecdote all the time. My mother, who was a Russian-Polish-Jewish peasant in her late eighties at that time, sat us down and began to serve me some food and said to Harry, "What would you like, hippie?" (Laughs) And served him very meager portions while dishing out a lot of food to me! She didn't approve of my associating with these hippies.

And how did Harry react?

He was very, very proper, but he often made fun of her. She kept calling him a hippie; she didn't have his name.

I have been driving in New York City since I was seventeen, so I drive around the city in a very relaxed way, which looks like I'm not paying attention, but that's just my style of driving. I don't have accidents. There was no particular incident that I recall but maybe I got into an argument with a driver about something or other, so Harry refused to ride in my car for years. We used to drive around and get stoned and talk about things; so one of my great joys was when he, after a number of years, let me drive him crosstown and then we began driving around together again.

I was just thinking about what Harry was doing all the time and about what you were saying before: that the mind tends to naturally connect different things and look at the systems of cycles and how they intercon-nect…what was I going to say?

That's the trouble. The mind builds up these things and then suddenly it dissipates. It'll come back. These things usually do. Well, what else can I say? There's so much to say about Harry that there's literally no end to it.

Yes. Oh, here it is: do you think that the things you suddenly see are those that you naturally resonate with? Or that there is a kind of objective connection?

That's the point. I haven't come to any final conclusions, but it isn't only "resonate with." Of course, the simplest example is the creative artist. Let's take Dali, for example. Dali used to look at different patterns and he would see drawings in the patterns, like on the wall, different shadings of paint. He would see images on the wall from the patterns, like with a Rorschach test; it's like a whole wall of existence. And then he would draw what he saw, but the cracks gave a framework to hang these perceptions on. If a person is paranoid of course he will see…if a person gets on cocaine or something, a person will actually start to hear and see strange things: people attacking him, lights, voices, all these kinds of things. The question is whether reality itself can be reconstrued by the mind. Art Kleps, who was with Tim Leary up at Millbrook and founded this acid church, the LSD church, or rather the Neo-American Church, excuse me, had a theory that people who were paranoid had paranoid delusions and actually see the terrible things they were afraid of really happening to them. The paranoia, in some strange, negative, synchronistic way, created these events.

So it seems to me, that whatever you fear manifests itself and whatever you subconsciously activate positively manifests itself. I guess that's what I was trying to get at. For example, in divination systems you can read anything into it: you can read fire, you can read water, you can read images, and you see what you want to see in it but you also see something that

can be prophetic and that relates to reality. So what's the fine line between the...I don't like to use the word "objective" (Dr. Gross laughs)... but between the real inner language of things and how you create your own reality according to what subconsciously activates you?

Right! And where's the dividing line and how far does it extend? There was this other highly unusual guru, Baba Ganesh, that I had known, and he never met Harry, but Baba Ganesh was from India; he was another utterly remarkable person. He's like a little Santa Claus in his late eighties or nineties and he was the guru to the hippies. He took all kinds of drugs and things and he was alcoholic, unfortunately. There are a lot of gurus who are alcoholic; being alcoholic has nothing to do with anything, it's just a separate, independent variable. Gurdjieff was alcoholic to a certain extent. I remember this great pronouncement of Baba Ganesh. He said, "I finally discovered something. Alcohol creates negative synchronicity." And very definitely. So there's a great deal of synchronicity in Harry's world and in the world of any creative person.

Harry had introduced me to Lionel Ziprin, and I am very glad he did; I might not have met Lionel otherwise. As far as the story about Harry reading this thing to his mother... I don't know. I remember Harry mentioned his family was very involved in the salmon canning business on the Northwest Coast. And that somehow the business had collapsed and his uncle, who I believe was running the business, took the business away from his own family and then ran it into the ground in some way. And then the uncle committed suicide, I think; it's some strange story. But I never got all these stories straight. One of Harry's grandfathers supposedly was a high official in the Freemasons and, according to Harry, went around the world initiating all kinds of people, including someone like the King of Egypt, and various other people; these were sort of high initiatory activities. Harry kept making different allusions to the Freemasons over the years and I got quite interested in it but never actually joined. Apparently, he knew a lot about this. I know one of the basic requirements of being a Freemason is you can't be alcoholic. But I never got too much into that with him.

Well, I feel I'm leaving out enormous amounts but, of course, the main thing about Harry was that he had this utter respect for every culture and society in the world and the feeling that no one culture

was superior to any other; each culture had its own genius. He didn't talk this way, but just made the point that each culture was a manifestation of God in some way and that each creative production was a manifestation, whether it was the string figures or some extremely elaborate cultural artifact, either physical or mental. Music especially had extreme degrees of subtlety and complexity and so forth, and that was worthy of analysis or study and understanding, and no music of any culture was superior to the other. And beyond culture, every animal and object and insect had as much value and interest as any other; the human species was interesting but not to be considered as a separate category or as a better category with respect to any other form of life. But Harry, of course, would be very ambivalent. I remember these cats, which he was so happy to have because they reminded him of when he was a child; he grew up with cats. In fact, he said that cats originally taught him how to walk.

Really?

Yeah. He had the cats before he could walk and when he'd just sort of crawl around. So he was happy to have these cats, but then, when he went away, he left the cats with me, or he couldn't take them to the Chelsea Hotel. This is one thing I feel terrible about, in retrospect. Of course, nothing to be done. He'd been with me a few months with all these cats and I said, "Harry, you can't be here. I can't get any work done. I can't get anything organized." He said, "Oh, you'll never organize your place." And so far he's been partially correct. And then he went down to the Chelsea Hotel and the cats were left in a home for animals, over on the West Side. So of course, with four to six cats, the bill for caring for them just kept mounting up and of course he couldn't pay it, and then eventually I don't know what happened to the cats; they either gave them away or destroyed them. But Harry then said, "Ah." It wasn't his exact words, but he was saying the hell with it. He accepted that thing. He didn't trouble himself about it afterwards.

I think he had been used to losses.

In the early days, back in the '60s, one of the things he used to do when he'd get drunk is keep pulling fire alarms. And the fire trucks would

come by and he'd get arrested and there would be all kinds of scenes, and he kept doing that over and over again. He used to tell me about all the interesting things that would happen when you were drunk and on the Bowery. He kept having a lot of pride in meeting various people on the Bowery, including, he said, college professors and all kinds of eminent people who had also gotten drunk and down and out.

See, I know I'm mentioning all these odds and ends, these anecdotes, but I feel they should be recorded, because in trying to get some understanding and appreciation of Harry and what he meant and what he is and was and will be, I think every element is important. And there's so many elements; it's like trying to reassemble the elephant.

One thing that may not be known to a lot of people is that Harry played the piano. At one time, he had a job playing the piano in a nightclub in San Francisco. I feel this is true as opposed to the myths he would create. When I hear things or read things I sort of file them in my mind under degrees of reality or probability, so this was quite real. He mentioned, at one point, playing in a nightclub and I asked him why he stopped playing and he said he fell in love with the torch singer there. The expression "torch singer" comes from carrying the torch when you have a love affair that ends and so you carry a torch looking around for the missing lover. It's a phrase for somebody who sings these romantic ballads. So he fell in love with the singer at the nightclub and it didn't work out, and so he stopped playing at the nightclub, stopped playing the piano. But I had a piano and very rarely he would sit down and start to play and improvise; actually, one of the times he did that I took him over to Huntington Hartford's house and there was this big piano there. Harry was always very appreciative of wealthy people. He was always trying to get money. That's another whole series of anecdotes, sort of an endless series of anecdotes. But somehow the inspiration of being at Hartford's house... he sat down at this beautiful piano and began playing. It was sort of a freeform style but hard to describe. That was very rare but, again, it's another facet of him.

At one point, he was again trying to raise money as he always was; in later years, there was just never any money; I mean, he just managed to support himself. He could never work within any context. He was always too paranoid about his work being misappropriated. When he was doing this *Magic Mushroom People of Oz*

film, before Harry Phipps overdosed in a motel in Florida, the money stopped flowing. I ran into the fellow who had been producing the film; he was a well-known person in that whole psychedelic movement, if you want to call it that [Van Wolf]. We were at a screening of a psychedelic film, (I forgot what it was called), but it was the first and earliest feature-length psychedelic-type film. And we were talking about Harry and I said, "Too bad the film didn't get finished. Why don't you raise some more money and get *The Magic Mushroom People of Oz* finished?" Because it was such an incredible few minutes that Harry had started. And he said, "Harry's a genius, he's a wonderful person, great guy, but I'll never go into business with him again. I mean that would be the craziest thing in the world to do." In those days, I didn't quite understand what going into business with someone meant. I do now. So I said, "Why don't you go into business with him; he has a lot to offer." He said, "No. Absolutely. Never again." And of course Harry could never deal in a businesslike way. There was just too much paranoia involved in his relation to money. He had great ambivalence about money.

I remember once we were trying to raise money from Arthur Young. Arthur Young passed away about a year ago, in 1995, I think. He had created or invented the Bell helicopter or an important component of the Bell helicopter. [Young invented the Bell differential that made possible the single-rotor helicopter. He acknowledges Harry's influence on his philosophical thought in his book *The Reflexive Universe* (Briggs & Associates).] He was very wealthy and also was studying esoteric astrology and all kinds of far out things. He wrote some very interesting philosophical books about existence. So I got Arthur Young on the phone and said, "Harry needs some money." He said, "I'm not going to give any more money to Harry." He described how once Harry had literally arrived on the doorstep of his house, down in or around Philadelphia, with ten boxes of books and stuff and refused to leave the doorstep until he was given some money. Sort of extorted the money from him. He said, "I'd rather give you the money to give to him." But I didn't want to get in the middle of that; I didn't feel it would be right at that point. Again, one lives and learns. In retrospect, I would have; someone should have tried to help organize some way of sustaining Harry, but of course, it wasn't possible.

Do you think he somehow wanted to always be in control of his life, even going to the extremes of maybe, at times, being on the street? I mean, don't you think he wouldn't really have liked to have had an organized life?

He would have if somebody else would pay the rent. I mean, he was like the ultimate artist. He needed someone to pay the rent, take care of the bills and all that. I remember quite an occasion once with Tim Leary, up at Kathy Hartford's sixteenth birthday party, up in Millbrook. I was talking to Tim Leary about various things and about Harry, and I was saying to him why doesn't somebody do something to help support Harry. And he said there'd be no end to it. If you gave Harry some money and if he had sufficient funds, he would try to turn the entire city, the entire island of Manhattan, into a sand painting! (Laughs) There's no end to Harry's possibilities when completely funded. Well, that wasn't perhaps totally fair.

He was really into his sand paintings for a long time, wasn't he?

Oh, he was into everything. And then, of course, these string figures. Actually, there was this girl, Cathy Elbaum, who was Tim Leary's secretary and editor of *The Psychedelic Review*. She got turned on to Harry, and got turned on to string figures, solely as a result of having met Harry, even though I don't think she had any college training at that time, or maybe just a year or two of college. This girl was like a sort of beautiful intellectual party girl, you might say. She went back to college and went to the University of Chicago for a Ph.D. in anthropology. You have to track her down. Just got interested in string figures through Harry.

It's amazing to me to see how many people he inspired and in how many diverse directions they all went.

Absolutely. He was also thinking of re-contacting somebody who was just like a neighborhood kid when he was growing up in Washington. Harry would tell this neighborhood kid about the Indians. Well, that kid later went on to be the head of the Anthropology Department at, I think, Washington State. Harry was thinking of maybe

Harry Smith at Percy Heath residence, early 1960s. (Courtesy of Harry Smith Archives.)

spending his last days up there. It was one of the places where he was thinking of retiring to, but, of course, he retired at Naropa.

Oh, I think that's beautiful.

One thing I wanted to mention is that it's so unusual for me now to see these early movies and photographs of Harry, particularly when he first came to New York, wearing these dark glasses and looking like a hipster. To me Harry was always older, much older, even as we both grew older. He was only about seven years older than I was but he always seemed a generation older. Even when I was in my mid-thirties and I guess he was in his forties, I always thought of him as older than sixty years old. He had this utterly ancient quality.

Even before I met Harry, I was collecting ethnographic records back in high school, and music from different cultures. But Harry, and also perhaps this Baba Ganesh, made me fully appreciate that recorded history's only a few thousand years old but humanity's been around for hundreds of thousands of years and there was no less genius then than there is now. Of course, there's this very parochial Western view of Western Civilization. Western Civilization is extremely remarkable, no doubt about that, but there's a very

parochial view that other people, other cultures, just because they're covered with mud and sitting around looking very untogether from the Western point of view, that their own soulfulness and genius and so forth is manifested in ways that are not immediately perceivable. And of course the existence of these string figures and also children's games were important to Harry; he was very interested in children's games and everything that had to do with childhood. I always thought he himself was, like any creative genius, fixated at the age of two, you know, where he still had that consciousness. As a matter fact, there's this quotation from Baudelaire in your book that says that exactly: "Genius is nothing other than the capacity to retrieve childhood at will, a childhood now endowed with the ability to express itself through virile organs and an analytic spirit that permits it to organize the sum total of involuntarily amassed data. It is to this profound and joyous curiosity that we must attribute the fixed, animal ecstatic gaze of children before the NEW; whether in the form of faces, landscapes, light…" Same thing. So, that childhood of humanity, that childhood of human culture, manifested its genius in various ways, one of which was the string figures which are spread all across the world. In pre-literate societies, string figures existed as a way of focusing creative intelligence onto some product, some thing. It was the equivalent of the TV and the newspaper. Being preliterate, it could be transmitted from culture to culture. It was a symbolic language originating as a childhood game, let's say, but it was a symbolic language which could incorporate anything. I mean, what we know of string figures is maybe one thousandth of what may have existed ten, twenty, thirty, forty, fifty thousand years ago; we have no way of knowing.

In fact, I was thinking that a sort of net or mesh shape carries a lot of important associations in different cultures. Like in some Native American cultures there is the dream catcher, which is just like a spider's web; this is the simplified vision that we have of it. I'm sure it's much more complex, but let's keep it simple. It allows all the negative dreams to fall out and instead catches all the things that we need to catch in the work that we do when we're on the other side, when we're asleep. And I've seen in Hawaiian Kahuna systems which are very ancient, thousands of years old, and to me incredibly evolved, a shape that's like a fisherman's net; they saw that at each conjunction in the net, each "crossroad" has been

energized with negative and positive and neutral charges that can be connected to powerful visual surrealist memories that energize the charges. As "the microcosm is equal to the macrocosm," you can apply it to a lot of things. But it was applied to a practical way of healing oneself, which is what they did often. They had systems to connect to the subconscious and deactivate the memories, energizing the positive ones and deenergizing the negative ones. By connecting with the subconscious, they also had a system to locate in which body (the mental body, the emotional body, etc.) the memories were located, or which areas of their lives were affected. It's amazing to me how people who are defined as "primitive" had systems that are so advanced and so effective.

Of course. The elaborateness of some of the analysis of so-called primitive music was just…I mean, when Harry would show me these books it was just amazing to me how complex and elaborate the systems were. All of these things are rapidly disappearing now. All relics of previous human consciousness in history are rapidly evaporating under the onslaught of mass media, which is a terrible thing. And Harry was perhaps one of the keepers; hopefully he will get reincarnated, as I wrote in this poem of mine. There'll be a reincarnation of Harry somewhere to try to bring back together and into consciousness the full extent of this history of humanity.

What was this poem about Harry that you showed me?

It's a sort of string-figure poem and I call it "God's Art Man's Heart." It's a string-figure poem dedicated to Harry Smith. I forget what inspired me to do it. Occasionally, I get inspired, and it's a metaphor in the same way that string figures are just a bunch of string, and yet it's imbued with so much meaning and so much variety, in the same way our flesh is, like we're walking string figures and God operates the strings, so to speak. That's what the poem is about and there it is.

Wow. That's beautiful.

Anyway, it's a group of complex images. Many mixed metaphors. In the same way that a net can trap birds, our spirit is the bird which is trapped by the net of our flesh.

Going back to that image of the Hawaiian Kahuna net, it's really connected to that. And like I was saying, what amazes me about these really ancient systems is that they're so incredibly creative in a really primary way and so directly connected to our own everyday existence and to our being able to sort of create and manifest things. And now with all this fragmentation, we've got so much in depth and we're so much in the mind in so many different directions; but it seems to me that we are so distant from connecting with the everyday reality and the influence of everyday life. And when I think of the alchemical pursuit of changing straw into gold, the real metaphor, the real essence to me of the metaphor, is changing, transforming the straw to gold in us. I mean, there is always the dark and the light and it's not about choosing one above the other; it's about the harmony. But the real metaphor of the alchemist is transforming it in our lives, through the shit we go through, and seeing what it shows us about ourselves in connection to what is happening to us. The dark is just as powerful a teacher as the light, transforming straw or lead into gold in us, based on the experiences we have.

Absolutely. It's the name of the game.

You showed me that poem you wrote about the fire-eating theater, which you also dedicated to Harry.

This was after Harry died. I was on a train going from Denmark to Hamburg to visit an old girlfriend of mine and my son, whom I hadn't seen in thirty years. I'll have to check whether it was actually after he died or before he died. It has to do with Harry as a fire-eater, becoming reincarnated as a circus fire-eater act. In the creative realm, particularly with Harry, there are all these strange synchronicities going on. I get to Hamburg and walk into the apartment and the first thing that I see, literally facing me on the wall, is a gigantic poster of Herman Hesse as a fire-eater. To compound the synchronicity, I just mentioned it to this old girlfriend of mine, and she said she had also heard a poem on the radio, the German radio, about a fire-eater, just that weekend. It was more involved than that, but this was the basic thing. So it was like a triple fire-eater synchronicity.

Harry said something I picked up. I was listening to this tape of one of his lectures at Naropa that was always kind of interrupted on different

levels with humor and depth and understatement. At some point, I picked up something which to me seems very indicative. He said that ideas "swirl around in currents, electric currents." And I thought of the "zeitgeist" or the "spirit of the time" and how so many times we can't explain how certain ideas happen in two different parts of the world at the same time. What he said made a lot of sense to me. For example, it's like the "earth spirit" electromagnetic path that the birds always follow in their migration. Ideas may have similar paths. This synchronicity seems to be like chords on a current.

GOD'S ART MAN'S HEART
(a string-figure poem for Harry Smith)

Man's Pathos is the awesome Word made Flesh;
Thru lapses of illusion's utter Word,
As space-time frozen gears begin to mesh,
Out pops jujubulationeering birds.

God stutters Life, His hale and fleshy Word,
Both traps and frees us through His holy mesh:
Who would not flee to Heaven as a bird,
From spider-time, its webs alive as flesh?

Our Lives, our Souls, our Spirits we then mesh,
A troubadour dream-dancing flock of birds,
As rivulets of feeling swamp our Flesh,
As Sages ponder mystic-facet Words.

Celestial judgements are a game for birds;
We navigators of the earthward Flesh,
Have brazenly presumed our very words
An altar where God's Heart and ours could mesh.

Through lapses of illusion's utter Word,
Who would not flee to Heaven as a bird,
As rivulets of feeling swamp our Flesh,
Such altar where God's Heart and our shall mesh?

(Flow-fastened by that All-Dissolving Voice,
Great interstitial Glories greet our Choice)

— By Dr. Joe Gross

Donald Weiser and company in his occult bookstore on Lower Broadway, NY, ca. 1969. (Photograph by Don Snyder.)

James Wasserman

October 25, 1995

JAMES WASSERMAN: I first heard of Harry Smith in 1973, when I was working at Samuel Weiser's bookstore. Vague rumors circulated about him. I was very interested in Aleister Crowley and people were telling me there was a sinister, dark adept named Harry Smith, who was surrounded by prostitutes and filled with alcohol and drugs, but that he was a true initiate of the dark mysteries. There was a legendary quality about him and people would lower their voices, quite literally, when speaking of him. The employees were angry at him because he would come in, just before closing, and would invariably spend so much money that Donald Weiser, who owned the store, would keep it open for him. They would be furious because he just had a pattern of doing that. But along with the anger, I detected a sense of humor and fascination with Harry.

Now, of course, I had no idea what he looked like and I was waiting and waiting for him to show up. I worked in the store for about six months and then I went to a different part of the business, so I was no longer in the store; but he had stopped coming for this period of time. I would ask people who worked at the store, "Did this Harry Smith ever show up?" And as I heard more stories about him from different people, I finally, as I got to know Donald Weiser better, asked him what he thought of Harry. He said Harry Smith is the most knowledgeable occultist he'd ever met in his life. Now to hear Donald say this about Harry blew my mind. Because it seemed to me that Donald had very little respect for the occult and for the people involved in the occult. The way he spoke of Harry was unique. It was the most unexpected response I could possibly have gotten to spark my imagination and further stimulate my interest in meeting him. He didn't speak of Harry exactly as a friend. It was that he regarded Harry as an expert in a field that I didn't realize he cared very much about. I would learn more about Donald as time went on but, in any case, Harry still didn't show up.

I began to have some problems with my ex-wife relating to my increasing interest in Aleister Crowley and one day in 1976, Harry just showed up in the office. He didn't even go to the bookstore. He came to the publishing office where I worked. I was introduced to him as a simple matter of course because I was standing in the room. Then he was taken into Donald's office and they spoke for some time and then they came out; I tried to say to Harry that I would like to talk to him sometime, but things were a little uncomfortable, not knowing him and feeling all these strong feelings at this point about really wanting to know him. Then about a month or two later I ran into him at the Village Vanguard where his good friend Percy Heath was playing. He's a jazz musician that Harry really loved; he had spent time at his house, and had lived with the family. I kind of walked up to Harry and said hello and that I wanted to talk to him more, and he was very polite and shook my hand and said that he remembered me from Weiser's and then just disappeared in the crowd and escaped, by saying something like "I'm going to go to the bathroom." And I didn't see him for the rest of the night, so I was very mystified and my feelings were hurt but I was still anxious to know him better.

Then some months later I had split up with my wife, and Harry showed up at Weiser's publishing office again; as he was leaving, he asked if I wanted to talk to him and said, "come on, let's take a walk."

Thirty-six hours later I returned from our walk. It was amazing. I mean he was an incredible human being, just incredible. My plans totally changed. I was leaving Weiser's. I had given notice at the time and was moving to California and going to work with a collection of Crowley's archives that had turned up in 1976, a very large and important collection of correspondence that I had been involved in finding. I was really anxious to go and had a woman that I was going to join out there and it was very set-up. But after those thirty-six hours, I just basically said to myself who wants to read a bunch of dead people's correspondence when I have a living, breathing master of what it is I seek to know right here in the city. And I stayed here and stayed as close to him as I could until he died.

I think Harry followed Crowley's dictum to always tell the truth but lead so improbable a life that no one will never believe you (laughs). As long as I knew him, I never caught him in a lie and he always told the weirdest stories. I met him when he was at the Chelsea

Left to right: Percy Heath, June Ellen Heath, unidentified, and Harry Smith at the Heath residence, early 1960s. (Courtesy of Harry Smith Archives.)

Hotel and there were bullet holes in a radio and there were these strange, nefarious characters populating his world. As the weeks and the months went on, I met all of them, saw that every single story I was told was really true, including his incredible connection with the Smithsonian Institution and his very widely inclusive career. I mean, the man was an expert in more things than most people ever even have the slightest idea about. He was an incredible book collector. He was so familiar with Crowley that he could quote him verbatim. He was completely fluent in the highest and most modern sciences. He was aware of folklore that was so esoteric that it spanned tribes and cultures that I as a mythologist and folklorist had never even heard about. His sense of humor was the most profound and sparkling that I had ever seen. All of these rumors, of this dark character that I had heard, were like his sense of humor. It's almost impossible to speak about him with just enthusiasm and adoration. I mean, I really loved him. His compassion for people was such a constant inspiration to me. His gentleness and kindness were all-encompassing. He was, in my opinion, a saint, a modern, American, New York shamanistic saint. And I mean that quite literally. He was a true adept. One of the most advanced spiritual teachers that I have met in my life.

Members of the O.T.O. Gnostic Mass team for Harry Smith's memorial at St. Mark's Church, New York, February 9, 1992. Left to right: Genevieve Mikolajczak, James Wasserman, Nancy Wasserman, Satra Wasserman. Not pictured: William Breeze. (Photograph by Don Snyder.)

Once I introduced him to a Tantric teacher named Harish Johari. They were like two children in a playground; they enjoyed each other so much. They laughed because they were both named Harry. Harish is also a writer, musician and artist. He's a fantastic individual. And he and Harry were just like playmates in some kind of cosmic wonderland. It was really cute to be able to observe it, because they shared something together that I certainly didn't with either one of them. They recognized each other and it was beautiful to see it because I recognized it in both of them from a distance.

I was most impressed and humbled by Harry's moral quality. Harry seemed to feel a genuine concern for human life; it was the way

in which he would ask about the well-being of my wife, or my son, or various people that he had met through me and that had an interaction with him. He cared about each one of these people, you know? And there would be people we would meet in the street; he would see an elderly person and he would just stop and engage in conversation with them. There was no sense of obligation, but he would offer little assistances to these people and it was very beautiful. I don't know how many other people were close to this aspect of Harry. It counterbalanced the image that I was originally given of this sinister, dark individual. My son adored him; my son grew up with Harry from his birth until Harry's death and he felt very deeply about him. Satra and I were very close together when Harry died because by that time I had split up with his mother and he and I were spending a lot of time together, just the two of us; Harry at that time was sick. So we would go and get food and see him, as he was getting more ill, and each of the things that we did were somehow like lessons because Harry would, let's say, ask for cigarettes and we would go to buy cigarettes for him. We would talk about the fact that Harry was coughing a lot and that he shouldn't really be smoking. But somehow it was his freedom to do that if that's what he wanted to do. And that I was honored to be able to bring him the comfort, even though a part of me was saddened that it was these poisons that I was bringing him. But to discuss it with a boy who was eleven or twelve was very much a lesson for both me and my boy. So it was wonderful. I think Satra understood something about life by being close to Harry's death.

PAOLA IGLIORI: *I got a feeling that he was an incredible natural teacher in whatever he did; like when he was angry, pushing people to the limit and shocking them so that they would recognize the other side of things. He would pull the carpet out from under them.*

No one ever humiliated me more or brought me such a sense of my inadequacy as Harry. He had a way of causing so deep a pain. I felt as raw as I knew that he could be. And to not live up to his expectations, not my own expectations, was terrible; it was the sort of tragic condition of the flawed nature of human life, and the flawed nature of reality. And I think Harry was a master of being able to understand and communicate that, but also with a kind of compassion,

even though there was the terrible aspect of Harry. I mean, he was unbelievably terrible and fierce and wrathful, but those were masks, I think, on a very loving man.

Extremes.

I think that the more authentic depth of Harry was his love, and his fierceness was very, very strong because he had such a great and brilliant character. But if I were asked to give the one quality of a human being that I think Harry truly incarnated, it would have to be love.

He also really loved animals.

And his birds and the little mice (laughs). He always had roaches crawling over glasses and things and if you were going to kill one, he would say, if you're ever going to kill a roach, do it very, very swiftly because their lives are so short that their sense of time is totally different than ours, and if you hit one and don't kill it immediately, the length of time they suffer is agonizing for them. To this day, twenty years after he said that to me, whenever I do kill a roach, I do it with swiftness because I seek to minimize their suffering and I always think of Harry.

When I met him, during the thirty-six hour period, it was so magical and so many things were happening. At one point, I saw something that I can only compare to things I had read about the Buddha. I was feeling senses of discomfort and senses of being wounded and senses of lack of trust and an unfamiliarity about what was going on and it was very magical and strange to spend that much time with him; I mean, I existed apart from reality in the period of time I was with him. At one point, his aura literally filled the room with a rich golden light that was profound. I knew that I could trust him. I understood completely that this was a man and a teacher I could trust.

That's beautiful.

I always feel a sense of failure, and that somehow I came short of what I wish I could have been for him. But that's also part of his legacy to me. Because there was a period that I failed him; I could never serve as fully as I wanted to.

What would you wish?

I just wish that I could have always had the right amount of time for him; that I had more money so I could have given him more of the things that he wanted; that I was a better student; that I was able to get him the right foods; to not make mistakes; just to have been more loyal.

I didn't spend that much time with him but I was saying to someone, the other day, that the first time I went to talk to Harry, I brought him some cards, and we started talking and I felt that he tapped into some kind of universal source of knowledge that I didn't even know I could access. And we started talking about things I didn't even know I knew. It was so profound and completely like time didn't exist. It was an incredible experience and I felt that he awakened something and he loved to awaken this in people, in anybody; he was like this natural, incredible teacher. I didn't know him very long.

Well, you certainly knew him very well because that's absolutely true of him. He was a natural teacher. And then going around to the people that he frequented, like in the bookstores, and seeing they all had the deepest respect for him. I mean it was incredible. He knew everybody and everyone knew him and they all had gotten past that kind of loony exterior of his that would immediately put people off and create distrust and strange weirdnesses. He was welcome at place after place and I imagine that extended well into other social scenes.

Circles completely unconnected and wide-ranging.

Well, he was the master at keeping the circles unconnected. You always could tell that he had different groups and different circles and that there was very little carry-over from one to the other. He was master at that kind of deception and playing, manipulating…

…The trickster, which in some Native American traditions is called Heyoka, *who gives you the other side of things, when you're thinking everything is clear, and it's a very sharp lesson, not a soft one. That was also one of his qualities. I don't know anything about the O.T.O. I know that he was connected to it and I saw the ceremony at the memorial.*

Were you connected to it? How did it happen that both you and he participated?

Harry was studying Aleister Crowley before I was born and he had made phenomenal advances in the system of magick and mystical attainment that Crowley taught. He had made deep, deep spiritual progress in that system while I was still in grammar school. He told me that Donald Weiser had asked him to help me out and set me straight because I was so deeply involved with Aleister Crowley and sex magick that I was going to lose my marriage and I was leaving Weiser's. Harry would introduce me to people, constantly saying that he was charged with curing me of sex magick (laughs). So right from the very beginning, Crowley was the focus of our friendship and our relationship. I was one of the younger generation looking to Harry for guidance.

Is the O.T.O. directly connected to Crowley? And what does it mean?

It means Ordo Templi Orientis or the Order of the Temple of the East. It was started in 1902 in Germany and Crowley was proclaimed head of the English speaking world in 1912. In 1923, he was made the world head of the O.T.O. Basically the O.T.O. split at that time between those who did and did not accept Crowley's revelation of *The Book of the Law*, which he infused into the O.T.O. The head of the O.T.O. was named Theodor Reuss, and Reuss accepted the legitimacy of *The Book of the Law* and allowed Crowley free rein to reorganize and reform the O.T.O., including rewriting the rituals. And Crowley did that for approximately the ten years preceding Reuss' death, and then Reuss named Crowley to be his successor. But when *The Book of the Law* was translated into German, certain of the O.T.O. groups broke with Crowley and didn't accept *The Book of the Law*. Crowley promoted the O.T.O. primarily in the English-speaking world, in the United States and in England and in Australia, and had quite a bit of activity going on. When he died in 1947, there was a very active O.T.O. group in California. Of course, Harry knew Karl Germer, who was Crowley's overall successor, and they were friends in the early '50s when Germer came over to the United States and lived in New York. In fact, Harry stated that Aleister Crowley was his father. He said, that at the time of his conception, his mother was walking on the

beach and a very handsome man rode up on a horse on the beach and seduced her and that man was Aleister Crowley. In any case, Harry felt very close to Crowley. He observed the activities of the O.T.O. through me and several of the other O.T.O. leaders who became his friends. He was very aware of our development.

So did you come across the O.T.O. before you met Harry?

Yeah. That period's a little strange. I believe I was a member of the O.T.O. by the time I met Harry. But I considered myself a student of Aleister Crowley for at least seven years prior to joining the O.T.O. Harry was consecrated as a Bishop by the head of the O.T.O. before he went to Naropa Institute. He listed himself as a Bishop of E.G.C. in a Naropa publication.

What is E.G.C.?

Ecclesia Gnostica Catholica or Gnostic Catholic Church. That's the branch of the O.T.O. that actually put on the Gnostic Mass in Harry's memory.

I see. I always remember reading somewhere somebody asking Harry "Are you a Kabbalah expert?" And he said, "Kabbalah means secret, so of course not. I would give as much knowledge to anyone as possible." And I thought that was really Harry; it seemed to me that it contrasted with what I perceived as the closed nature of such schools, because these schools were based on the principle of initiation so only the ones that were ready for it would arrive at a certain stage. I saw Harry more like a Plato in how he related to the Eleusinian mysteries and how he made them accessible to everybody through his works and acts. And so, for me there is a contrast between the two, but maybe that's because I don't know so much about this.

Right. But I think the tradition of the closed group always included the idea that artists and writers would communicate through their art to the larger group of society. They go to the smaller secret societies for a certain kind of personal nourishment. But then they're expected to go out into the world and teach as Harry did and to demonstrate the truths as Harry did.

Harry Smith, typewriter drawing, ca. 1980. (Harry Smith Archives.)

Khem Caigan

November 1, 1995

PAOLA IGLIORI: *It's strange, this is the first time we meet, so I don't really know how to angle the conversation. All I know is that you were a really good friend of Harry and you spent a lot of time with him; also, I was thinking of these notes that caught my attention this morning and I couldn't find any further explanation. They said that Harry was working on a system of equating the Enochian system to the Scottish Highland tartan patterns. And on the way over here, I thought maybe I can ask Khem about it and now after five minutes with you, you bring out this book on the Enochian system, so I think that's how we should start.*

KHEM CAIGAN: The business about the Enochian system and the tartans is one of those things... like a half facetious thing for Harry. The fellow that was largely responsible for the Golden Dawn system and for elucidating the Enochian chess system was Samuel Liddell Mathers, who additionally took the name, MacGregor Mathers. The Mac-Gregors were a Highland clan, and they had one of the older tartans around. It was one of those "clang" associations because you look at the tartan setts and you can see this sort of checkerboard grid system emerging from it. It's only natural to link the two of them, especially when you've been wired for any length of time, because everything becomes significant then and any sort of resemblance just challenges you to make it significant. So it's one of those things he had fun with.

I don't know anything about the Enochian system. But you were telling me that it's based on the four elements: water, fire, air, and earth.

John Dee and Edward Kelly, to take their story at face value, were approached by angels of the Presence and they were set the task of recording the elements of this language and it's referred to as the Enochian language simply because it's the language that the biblical patriarch Enoch spoke with Yahweh and the angels at some time in the past. It was at a time when angels and humans and the deity were

communicating after this fashion. And it was only afterwards that various misunderstandings crept in. So this was like the original primordial tongue, the first language.

And you were saying that they had different multiple degrees, like air/air would be the purest and the most near to the ideal.

On the tables, yeah. And it's a lovely language; the poetry is just incredible. So, if for no other reason than it's esthetically pleasing, it's a lot of fun to research.

And earth would be the most gross element?

More material. Like something you can bonk on (hits the floor). In this way of dividing the elements on the four tables, you had that particular part of the table that related to the element at its most pure. For instance, in the fire table you had fire of fire, but you would also have admixtures of some of the other elements that modified it, and it's those particular mixtures that rendered them a bit more tangible. You would have earth of fire, which would be the most dense; you would have water of fire and air of fire in between.

So, starting out at the very, very bottom of the scale, you would have earth of earth, which would be absolutely as dense as you could possibly get, and then, at the top of the scale, you would have fire of fire, which would be as tenuous and active and dynamic as you could possibly get.

Sure. So, for example, relating it to that correlation Harry was kind of half-facetiously and half-seriously trying to make between the Highland tartan patterns and the Enochian system, these crosses of colors that are the Highland tartan patterns could correspond to some of these crosses of the Enochian system and could, in a way, say, depending on what energies the clan vibrates, be like a secret name of the clan.

Absolutely. Especially in those particular setts or tartans where you see the complementary colors and where you have, for instance, blue and orange, which clash over each other. Or red and green, which again clash off of each other. It really stands out.

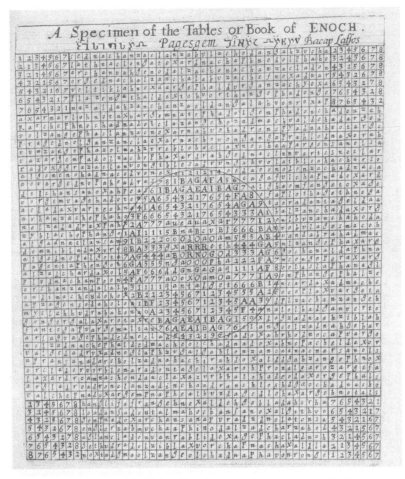

John Dee, "A Specimen of the Tables or Book of Enoch," from *A True and Faithful Relation of What Passed for Many Years between Dr. John Dee and Some Spirits* (London, 1659).

Wow. And what is the book you and Harry were working on together?

A True and Faithful Relation of What Passed for Some Years Between John Dee and Some Spirits [Meric Casaubon, *A True and Faithful Relation of What Passed for Some Years between Dr. John Dee and Some Spirits* (London, 1659, reprinted New York: Magickal Child, 1992)]. This is a facsimile rendition; we had one that was much like it, and what we did was we went through the text and set up these numerical charts for the frequency with which certain words and letters

would turn up. The idea being to syntactically relate the Enochian language and to see which languages it was most clearly related to. Based on the internal evidence, it's pretty close to English, as far as the way it's spoken. It's safest to say that it's Indo-European, which pretty much covers a multitude of things. The script itself is Amharic, which is an earlier form of Aramaic or Syriac script.

Is that the earliest form of script?

I don't know that it's the earliest one, but that particular area coincides with the Coptic-Abyssinian stuff. Also the Nabataeans had a very similar script; they're the ones that built Petra.

Oh. I see. You were mentioning that in Mahagonny *Harry was doing something similar.*

Well, as far as Enochian chess goes, yeah. He was trying to pull off something very much like that with *Mahagonny*. He had the imagery parsed in a certain way where you would have... let's see... it was: people, animals, scenes, and places and...the "and" could have stood for nature. And there was a palindrome that I remember learning so that I would be able to go through and categorize all these slips of paper that related to all these different images that had to be spliced, one after the other, for the film to be assembled. Just thinking about the task of whoever the poor soul was that was going to do the editing on this thing; that would have been formidable. I don't know if it ever did make it into the can, all that work, but I know that I had a pretty tough time with it, just with putting all these little pieces of paper together. I believe the palindrome went something like: PAS-APASAPA SAPANSAPASAPAN.

What is a palindrome?

A palindrome is a word or a phrase that reads the same in either direction like the phrase *Madam, I'm Adam*, or *Evil I did live* and *Lewd I did dwel*[l].

But how did you use it, in order to keep track of which piles were the animals, the plants...?

It was the order that I discovered in the layout that he had assigned me, and that was the way I could keep track of which grouping came in the series. I just happened to discover that particular order. So I would go through that particular sequence and I would start all over again with all these color-coded little slips of paper that were related, and that was the way these images were categorized. So you just start over with the next batch; we just had shoeboxes full of these things. In fact, I probably still have some and it's the same thing with going through the word counts for the Enochian language.

Yeah. It's always finding a system within and it's strange, like you said, that he had an almost maniacal attention to detail, at least in a certain period of his life; but it's always out of this chaos that he created these systems and, at times, it almost seemed there was an opening to apparent randomness in his things.

Well, he understood the nature of obsession and, in fact, he made studies of obsessive systems. There was the *Phreno-Mnemotechnic Dictionary*, which he pointed out to me a few times at the library; he suggested that I take a look at it. So Harry made a study of systems of madness and the *Phreno-Mnemotechnic Dictionary* is a fairly recent book in the history of what used to be called the art of memory or the "ars memoria." It goes back, at least, to Aristotle's time, as far as we know, where you actually construct what was called a memory palace and in all the places in this building you put different objects that signify certain things; you can just find yourself wandering, if you're delivering a lecture, for instance, and not reading from your notes; and so you're actually able to reproduce something like *The Iliad* from memory, simply by wandering down the halls of your memory palace. Everything speaks to you and loans you these things. But everything that you look at also enables you to project certain feelings that can be felt by your audience as well, so it was also a very magical system; understandably, it was condemned by the church because it was considered sorcerous and therefore damned.

This dictionary is recent?

It's sort of the same idea; the idea that you're actually able to assign ideas to certain structures that you hold in your mind and that you can recall anything. When most people think of something like this, they think of that autistic character in *Rain Man* that could simply reel off tables of precipitations in different geographical locations.

Or think of Harry, and all the incredible amount of knowledge he had! So maybe he practiced this!

Aspiring to the autistic state! And let's see, there was Schreber's *Memoirs of My Nervous Illness*; all kinds of material.

You were telling me Harry told you about many books that really got you started in different directions.

I was bookish to begin with. I have entire bibliographies that I worked out while I was at the library. "CATNYP" is nice, that computer system they've got, but I really miss those file cards. Those really nice, buttery-colored wooden cabinets where you slide the drawer out and flip through the little cards. I like the smell of old paper. And every book would lead to something else.

How did you meet Harry?

I was introduced to him while I was at Weiser's. That's where I met James and Bill Breeze and a lot of people. I think it was one of the first occasions that we met. I showed him this bed of nails that I brought with me from Florida. It was a bed of nails that I inherited from this guy that I worked with at the International House of Pancakes there. This guy used to sit on this bed of nails. I mean, the nails weren't that closely spaced, but there's a trick: you just sort of evenly place your weight on it. I guess it looks impressive.

Was that in the '70s?

I guess it was. I would go and visit him over at the Breslin, at first with James, and then pretty much on my own. I'd bop by. Give him

a ring. We'd talk, or I'd accompany him on his walks. I remember it was incredible how often we'd be walking along and we would find paper airplanes. It was almost like somebody would see us coming, and they'd fold up some paper and leave it on the ground; paper airplanes made of all kinds of things.

And when did you start working on the John Dee?

The frequency tables for words and such? I don't remember exactly when it was. It was an ongoing thing.

But in the '70s?

Yeah. Some nights that would be what we were doing; some nights we would just listen to *Mahagonny*: Lotte Lenya and Kurt Weill wailing away.

Bill Breeze was telling me to ask you about the concordances you worked out for the Enochian system.

Concordances? We actually recorded the number of times the word would occur in the entire manuscript. And we also kept a record of the pages and the paragraph numbers for just where you could find each word on each and every page.

He told me the word was given as it is and reversed. What was the reason?

That was the way they were received by the angels or rather the way the angels transmitted them, through Kelly to Dee. And then they had to transcribe it. The idea being that these words were so powerful.

So they were reversed to deactivate them in a way.

Yes, but it was more complicated than that because there's an entire book of just page after page of letters and numbers in grids, and Kelly would see these in the shew-stone and the angels would be—

In the what?

(AS OF 1970 E.V.) HELD TO BE `PRE-COLUMBIAN' IN STYLE; THE PANTHEON PRIMARILY AZTEC / TOLTEC IN PATTERN. THE OLDEST PAGE (THE FIRST PAGE) IS DEDICATED TO TLALOC / TULA. [OR TAJÍN OF TOTONAC REGION.]

DAY COUNTS PRESENTED AS DOTS / SUNS, OFFERINGS AS BARS PLUS DOTS. ORIGIN CONSIDERED SOUTH OF MEXICO, AMONGST THE CUICATEC OR MAZATEC ARTISANS (OLMEC OF THE GULF COAST IN 1600'S E.V.? COAST OF VERA CRUZ?) ¶ DOÑA MARWA <CE MALINALLI> OF PAINALLA? ¶

Khem Caigan, notes on the Codex Laud, ca. 1976. (Courtesy of Khem Caigan.)

In the shew-stone: it was either a ball of rock crystal about the size of an orange, I guess, that had been delivered by the angels (Gustav Meyrink wrote a novel on this: *The Angel at the Western Window*) or occasionally, it would be a black obsidian mirror, very, very well polished, that quite possibly came from the New World. They probably got it from Maximilian II, one of those guys; I forgot who. It was passed on along with a manuscript, the *Laud Codex*, which was a hieroglyphic text that came from the New World, before Columbus "discovered" it! It was one of those courtesies that came along with the parcel that was received by one of their patrons, I guess, and that Dee also took a shot at translating. We don't know if he got anywhere with it before all his things got toasted while he was away in Cracow!

What do you mean,"toasted?"

John Dee's house was set on fire while he was away on a trip; apparently, it was done by the people of his town who suspected him of witchcraft; many of his things burned in the fire. But to go back to the manuscript... Kelly would see one of these little guys come marching in, just like on the Elizabethan stage, in a Shakespeare play. There would be this table. They would pick up a little wand or pointer and begin pointing to individual letters on these grids. And Kelly would have to say something like "the forty-first down, seventy-first over." Dee would have to wander over to the table and he would find

a letter; he would assemble these things. If you can think of somebody chopping up all the individual letters and numbers in the New York *Yellow Pages* and throwing them all over the floor, and then having Brion Gysin and William Burroughs come wandering in, wired up with amphetamines, and splicing things together according to rules of dice and who knows what all, it's kind of on a par with that.

Wow!

I showed you some of the pieces that they transcribed out.

Yeah. So each one of the words would have such power that they gave it in reverse to kind of deactivate it. But did they tell them exactly what the word referred to? What its power was?

They also translated the words for them, sure. There would be beings like "Nalvage" and "Ave" and "Madimi," and some of them would be very playful and some very stern; they would all come in and relate different aspects of the mystery insofar as it would be given to them. Because they were all assigned certain tasks and they would be able to relate information that had to do with particular subjects, but they didn't have any one comprehensive Being that could explain the whole scheme to them. There wasn't any one Being they could refer to when they had a particular question.

Wow. That's great. So that book you showed me is the one with which you and Harry worked on the system.

This is a facsimile. It's in print. And then there's an excellent book dealing with the entire working: *The Enochian Evocation of Dr. John Dee* [Geoffrey James, Enochian *Evocation of Dr. John Dee* (St Paul; Llewellyn, 1994)]. It was published by Heptangle Books and I think it has now been released by some other publisher in paperback. More or less, at the same time, Athanasius Kircher was having a go at translating the Egyptian hieroglyphs, unsuccessfully, I might add.

Did you work on other projects with Harry?

Harry Smith with charts for *Film #18: Mahagonny*, the Hotel Breslin, New York, 1980. (Photograph by Scott A. Feero.)

Yes. There was *Mahagonny*. I told you about the different color-coded scenes and the palindrome. I read this morning that *Mahagonny* is still intact, and that they're going to show it somewhere.

I think so.

That's great, unless that's been struck by lightning or spontaneously combusted (laughing).

Talking about natural disasters, Jonas Mekas told me that once, in a tantrum, Harry destroyed a really rare book, Atalanta Fugiens *by Michael Maier. Did Harry and you ever discuss Atlantis? And do you think it makes sense that there could have been a very advanced antediluvian world?*

Well, he and I did discuss Henriette Mertz's book, *Atlantis in America.* I think that most people involved in the occult agree that the disasters themselves simply submerged the information. It's shared by people who take the time to enlighten themselves. It always has. When you talk about naturally-occurring disasters, one of the things

I find is the fact that people are constantly being barraged with disasters they have created for themselves. One of the reasons we can't really speak with any authority about the depth of so many ancient civilizations is because one of the first things that you find with a certain people's sense of power is that they go out and they locate the nearest repository of written and/or oral knowledge and torch it to the ground! With the Library of Alexandria they fed the furnaces of the bathhouses with the books to keep people in hot water; the Library of Bangor in ancient Wales, ditto. Every time a new dynasty came into ascent you had histories being destroyed and rewritten.

Yeah. Either through genocide or through absolutely destroying the artifacts and the literature. So history is always written by the winners and there are only fragments and traces left that we can piece together. You're right. It's a very important consideration. To return to the Chelsea. The Chelsea was a wild place then, wasn't it?

Oh yeah! There wasn't a single fire axe on the walls. Everybody pretty much copped them and kept them in their apartments for when they wanted to visit their neighbors, to break their way through their doors. There were rumors about there being bodies in the basement, buried in the basement, and bodies on the roof.

You told me something about sucking on a…getting amphetamine on a…

When Harry was all wired up, he was absolutely intolerant of the idea that you might have to go home and get some rest, so he taught me the fine art of using little bits of amphetamines so that I would be able to keep up with him. But just so that you would be able to keep yourself awake.

You mentioned putting it on a matrix?

Well, that's pretty much the way the tablets themselves were made [This was the pharmaceutical amphetamine called Desoxyn]. You had an inert matrix, almost like rubber cement, that the powder was in. You just put it in your mouth and suck on it for a while and then take it out. That way you didn't go into palpitations or something.

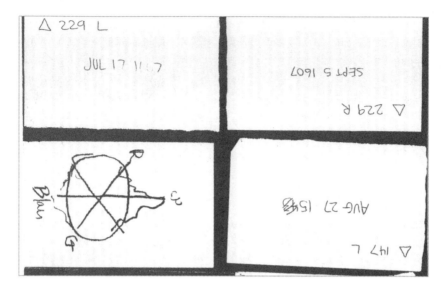

Harry Smith and Khem Caigan, notes, ca. 1977. Concordances for the Enochian work and a diagram (*bottom left*) bled by Smith of a color wheel—a model, handy for artists, of the spectrum of colors. (Courtesy of Khem Caigan.)

Then you were saying you could go down the hall, knock on doors, and borrow half a cup of…

Half a cup of whatever the drug of the week was. Yeah. There were all kinds of things.

Tell me what was most inspiring to you about Harry. I know that Harry was involved with so many different things, but tell me about your specific connection to him.

It was based on the idea that we were kindred spirits and were able to keep up with each other; we could discuss certain subjects, and there was always a pretty good chance that on this particular landscape, that we'd been through that territory before. And it's always nice talking with someone who has something like an educated opinion about things. Harry showed me so many things! He also showed me how to take posters down from walls. He would be interested in drawings that people had made on posters or band notices or something. We would return to these same sites several times, over a period of days, and there was this whole elaborate thing

Harry Smith and Khem Caigan, notes, ca. 1977. *Clockwise from top left*: a shopping list; an example of an alternative letter-frequencies group that could be used in cryptography, or emerge from the deep structure of language in a multiple-language disorder; another shopping list; and a tally of the number of shots having to do with nature, scenes, people, and animation in Smith's *Film #18: Mahagonny.* (Courtesy of Khem Caigan.)

of wetting them down with different substances. Then there was always the chance that somebody else would trash it before you got there; but if it was still there, you'd just very gently peel it off the wall. And then he'd take these things home and they would disappear into his archives. I still have a whole collection of posters and things from that period, all tucked away in some boxes. I've got quite a mess for that matter.

You were telling me about Harry showing you this Eskimo music…

Yeah. It was the first time I heard anything like that! They would actually sing into each other's mouths and you would get these harmonic overtones that would arise off of their individual vocal cords, so that you had these other sounds that would be produced from the combination. You actually had three voices going on, in a sense, while two people were singing. That's why I brought over for you the Harmonic Choir tape [David Hykes and The Harmonic Choir, a modern musical group using analogous vocal techniques involving overtones] because I can't lay hands on the Eskimo material.

But did you actually listen to it with Harry?

Oh, sure. We played music like that at all hours; that was one of the ways we annoyed the neighbors. In fact, there were a few times that I came in and the door had been smacked down by people with fire axes. People would come in and swipe his Ukrainian Easter eggs. I still have some of the eggs that he taught me to make; you just set them aside and let them dry. You can hold one against your ear and rattle it and hear the yolk inside.

Oh yeah? I thought that you would pierce it with a needle and let the egg yolk come out before you painted it instead of boiling it. How do you dry it?

You just let them sit over a period of a year or so and the egg yolk itself just contracts into a pebble inside and becomes very hard and dry. And if it doesn't explode on you, it's ready to go; then you start painting. There were also a lot of eggs that he painted as well as the Ukrainian Easter eggs.

Are any of the ones he painted still around?

Most of those were stolen.

Oh, they were. So much of his stuff was stolen or bartered or sold or given away. Well, there's still an enormous amount left to sort of detect the flow charts of his enquiries! I know that you're an active alchemist, and not only a mental alchemist but an herbal alchemist as well. Did Harry also do some alchemy?

Well, he pointed me in the direction of a few journals that dealt with it, such as a periodical named *Isis*, and another periodical called *Ambix*; they were just full of all kinds of information. That stuff wasn't just alchemical, it was also paleochemical, dealing with early metallurgy and such. And Harry talked about having a forge and other tools and such, given to him by his dad, and of making all kinds of instruments as a kid. I don't know if his dad was being face-tious or not, but he told him to try to turn lead into gold. And I don't know if he ever did that sort of work, but he certainly encouraged me

to go ahead and try it and explore it. There's a lot of material that's now been made available in books that you can get that deal with early chemistry. Most of the stuff I work with now are herbal tinctures and essential oils and stuff.

Going back to the subject of the Phreno-Mnemotechnic Dictionary, *I just realized, in my little experience, that we can access memory in our body, a universal source of memory that has mainly visual and archetypal images. I think that we can also access genetic memories, species memories. I mean, I'm very visual, so sometimes I have these images; once it was images of creation and I guess it was like molecules splitting, getting together and rolling and growing in a ball and then, with the inertia of its own movement, becoming little beings and growing into all kinds of shapes of animals and plants. Maybe that's species memory.*

They used to call it *anima mundi*, the soul of the world, and it was just like the blood moving in our veins, or the air that we breathe. It was a part of all life; in the same way that the air moves, so did this primordial consciousness. When people talk about the Akashic Records as a storehouse of ideas, the memory systems of the past, they pretty much take that metaphor and actually make a literal architecture within the mind of images, where you have this building and all these places, and you assign all these different furnishings and such, like with paintings. Everything that you distribute around you, just where it is in relation to all the other objects, contributes to the sort of museum that you're building of ideas; all those treasures.

You were also saying that in each molecule we have it all!

Well, that was like Lewis Thomas in his book, *Lives of the Cell*, where he was actually talking about coming to an understanding of all the different organisms in the body, all the cells being conscious, and all the molecules, all the constituents of cells, being conscious. He felt that was actually the collective unconscious of all life and that it could be found on the cellular and sub-cellular level. Then there was that biologist and chemist Albert Szent-Györgyi. I remember he got a Nobel Prize, but he didn't get a Nobel Prize for this really neat book, the title was something like, *Introduction to a Submolecular*

Biology, or something like that. At the time, that was considered somewhat heretical; maybe it was because he pretty much wiped out the distinction between what chemists think of as organic and inorganic, because he was talking about a submolecular biology, which already suggests that there's life processes going on at the atomic level. I don't think people liked the fact that he was sort of blurring the lines there.

Going back to the idea that the cells contain the whole memory, like the Akashic Record is in each one of our cells, I found in my experiences that there are certain places in the body in which different memories are stored, like our own family genetic memories, and species memories and soul memories about different lives maybe and archetypal knowingness. Sometimes I access things, and an archetypal store of images comes up at times as answers to questions I ask; it seems to me that they're connected to different energy centers in our body. I'm sure you can access everything from everywhere, but different energy centers retain different memories. And it's as if we live in multiple universes, and that we can access many things.

Sure, like when people use the Sephiroth of the Tree of Life, or in Taoist Yoga, where you have the different cauldrons, like one on top of the other, or in Hindu Yoga, where you've got the chakras. Certainly people experience this, though it's folksy; but it doesn't seem they're always distributed on the same plane. It's like there are a lot of different maps or a different kind of map that people can apply to the landscape, but it isn't the landscape.

Yeah. And I guess whatever the system is, it works for you if you connect to it, and so it's just a question of connecting, I guess. In a way, Harry was always creating these systems out of randomness and cyclical correspondences; he was always categorizing, detecting, creating.

He was never boring. There was this image, in Herman Hesse's *Demian*, where Pistorius was speaking about Abraxas, one of the Gnostic deities. He was sort of a rebus figure, not necessarily male or female, just a transcendent entity. Anyway, Pistorius says that if you become boring, Abraxas no longer uses you for his cooking pot.

" ... Our god's name is Abraxes and he is God and Satan and he contains both the luminous and the dark world. Abraxes does not take exception to any of your thoughts, any of your dreams. Never forget that. But he will leave you once you've become blameless and normal. Then he will leave you and look for a different vessel in which to brew his thoughts." — Herman Hesse, *Demian*

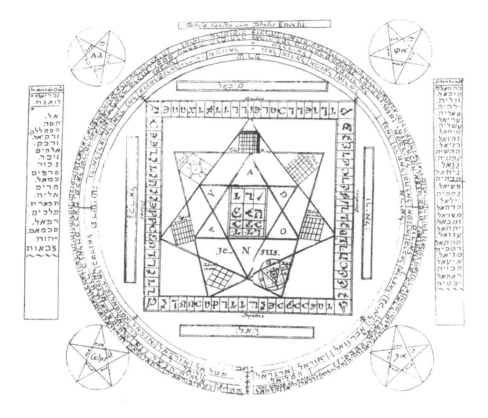

Khem Caigan, *Move Not for the Place is Holy*, ca. 1977. (Courtesy of the artist.)

The "First Series of Tri-literal Songs" (dictated, not in Smith's hand), "MS.L" of Harry Smith's untitled magico-surrealist grimoire, probably his longest surviving prose work (written 1973, revised 1978 and c. 1989). He wrote: "The first part of the work consists of a description of the worship of God as still expounded by certain sections of the O.T.O." The middle section has lists of 96 "images"—images in the sense of mediaeval *ars notoria*, and as understood by Giordano Bruno. Each image relates to a square of an elemental tablet of the Enochian system of Dr. John Dee. The last section of the work has comments on the text and instructions on using the work. Courtesy O.T.O. Archives.
— William Breeze

$$\frac{208}{205}$$

1. inside out
2. umbili-cal
3. why-is-it?
4. A red smoke
 — ORANGE —
5. A yellow smoke
6. An — A yellow-snake
7. A-green-snake
8. A-Blue — 11
9 A-Purple — 11
10 — a-red cross nurse
11 — 2 shells hitting the earth
12 — the hospital-ward
13 — As I live so shall you live
14 — Our flesh shall be eaten by worms.
15 — the great pyramid has 5 sides.
16 — the great pyramid has 8 sides
17 — Glory to the heron that stands on one leg.

Dict
11
19
73
4/10

18- The diabolical nature of cigarettes
19- a cat seizing birds in a papyrus swamp.
20- the king & queen queen at ease
21- Fire balls from the heavens.
22- A railway train
23- A railway station
24- 3 pyramids painted green.
25- It co red, it is red. — it is red
26- Dogs bark in the street.
27- The bamboo screens
28- ants eat butter
29- crocodiles eat eggs
30- Someone has a heart like a crocodile
31- There was a pool
32- There were 2 sisters.
33- The snake mentioned above had — all these colors.

Dict
11
19
73
5/10

34 – Ingrain – lives – mice,

35 – snow – faels – on roads.

36 – Glass – hurts the – foot.

37 – Pants – are – glue.

38 – Now – is – when.

39 – You – will die – from eating.

40 – There is – no – God.

41 – Milk – helps – bones.

42 – There is – no – 42.

43 – The snake – winds itself about –
 – the tortoise.

44 – The mountains – rise – on the left.

45 – A – mojo – root.

46 – Brer – rabbit – stuck.

47 – The death – of – X.

48 – Monsters – are – here.

49 – The gate – to – worms.

50 – the – Key of – Solomon.

51 – the – Kabbalah – Unveiled.

52 – the – Book of – ABra Melin.

53 – the – vault of the – — Adepts.

54 – The — – rites of – Isis.

55 – nineteen – eight – een.

56 – Galileo – was – proud.

57 Galileo – dressed in – black.

58 – Giordano – Bruno – died. "

59 – What – is – Death.

60 – It is – a – Serpent.

61 – Around – Moses'– staff.

62 – There – grew – a tree.

63 – Save – us – O Lord.

64 – Now – comes the – flood.

65 – Those birds – who brought the fire
 w/ one leg – now repent:

Dict
11
19
73
7/10

66 - Repent - repent - repent.

67 - Now we return - to the original - ceremony.

68 - The snake - uncoils itself.

69 - The tortoise - bites - the snake.

70 - It is - stamp collecting - possible.

71 - Did - Cheops - fill a grain measure?

72 - May - I - die.

73 - The crested hornbill - seeks - it's young.

74 - Is there a white snake - longer - than a hippopotamous?

75 - The house - shall be made of wattle - - + gum, dung.

76 - The mortar - is - the vulva.

77 - The pestle - is - the penis.

78 - The hymen - is - the door.

Dict
11
19
73
8/10

79 - The fire - is - the uterus.

80 - The basket of coals - is - the child reborn.

81 - This one - is - the rain.

82 - This one - is - the stone of ~~Xango~~ shango.

83 - This is - Sir Baldwin Spencer - - investigating opium.

84 - Death - to - Believers.

85 - Life - to - Non-believers.

86 - Birds - fly - w/ wings.

87 - All - are - hungry.

88 - The - arrival - of Superman.

89 - Is there - an - end?

90 - Rhythm - cures - all ills.

91 - Rhythm - causes all - illnesses.

92 - These ones - shall - live.

93 - The heron - stands - w/ both legs broken

213
210

1!

Drt
11
19
73
9/10

94 - The feathers — are to be placed outside, +
around — the sandpainting.

95 - Blessed Earth — I return — .

96 — My hands are outstretched — and —
— my body numb.

$$\frac{214}{211}$$

Dict
11
19
73
10/10

Harvey Bialy

October 9, 1995

PAOLA IGLIORI: *What's your first memory of Harry?*

HARVEY BIALY: My first memory of Harry was years before I met him (chuckles), strolling along Rockaway Beach, maybe November, this time of year, alongside Aleister Crowley.

Really? When was that?

1967 or 1968.

But you never actually saw them walking next to each other?

I didn't actually meet Harry in the flesh until the winter of 1983 at a friend's apartment on West 19th Street. Bill Breeze brought Harry by. At that time, I had just become the editor of *Bio/Technology*. Harry was very interested in the ninth degree science of genetic engineering, which in 1983, was really just beginning as a major activity in the world. So that was the occasion. After many years of knowing Harry through myth and legend and his work, I finally got to meet the great man. Harry was very funny in his usual acerbic way and Bill sat there and watched us fence around about different matters. Harry took a liking to me. From then, until the end of his life, we were close.

And what was happening in genetic engineering at the time?

Well, I don't want to talk to you about that. You can read about it. It's all well documented.

I was wondering how it connected with Harry.

Everything connected with Harry. Harry was an avid reader of *Nature* and one of the things I was able to do for Harry that he seemed to appreciate to no end was getting his copy of *Nature* to read

every week. Because if you read it in *Nature* it must be true, as he was so fond of saying. So I got Harry his weekly issues and we bullshitted; we used to call it high level bullshit, the nonsensical, the things that went on in *Nature*. Although Harry actually read the damn thing every week from cover to cover.

So there was actually a magazine called Nature?

There is a magazine called *Nature*; it's the world's oldest weekly scientific journal.

Oh! Kind of like Scientific American?

(Laughs) Yeah. Kind of like *Scientific American*…like the Brooklyn Museum is like the British Museum; actually, that's not such a good analogy; the Brooklyn Museum is very good. So we talked and, as I said, became quite close over the years. Contrary to myself, Harry would actually read *Nature*. He was particularly interested in the articles that had to do with astrophysics and different types of earth-science material, like earth formations and continental-drift ideas, things like that.

And what is astrophysics?

Stars, galaxies, movement of the heavenly bodies.

In relation to their influences on the patterns of life and man…?

No, in relationship to the mechanics of their own existence. *Nature* publishes a lot of stuff about astrophysics. At that time, Harry was living in the Breslin, one of those wonderful rooms in the Breslin, with Birdy, the parakeet flying around freely in the giant room there. Harry had with him thousands of books and thousands of records and a chair, one single chair on which a visitor could sit, but only there, not being allowed to move or to touch anything. And so once or twice a week, I would go visit him. I'd bring Harry books that I would acquire at my work and *Nature* and some blank tapes and Harry would exchange the blank tapes for full tapes he had made. He decided that I could profit from a short course in ethnomusicology. So Harry made forty-seven

ninety-minute cassettes and he said that after listening and appreciating and understanding all the relationships and formal matters of the material that were on those tapes, this would be a reasonable introduction to world music and I could begin to really study music from that point. So I have these tapes. I'd like to get them transferred to digital, to preserve them from the distressing funguses that eat up magnetic tape.

Was there also part of those recordings he did of the noises of the Lower East Side? Or was it just music?

No. These just contained music, abstracted from his vast collection; among other things, it was the first time I heard Mongolian throat singing. The tapes were always very interesting in the sense, in every sense, that the form of them was that the two sides would be from different parts of the world, but the music would be absolutely resonant. This was one of the themes that Harry seemed to pursue all his life. He had the uncanny ability to understand the basic connections between things that were seemingly completely disparate and the forces and dynamics and magnetic interactions and terrestrial activities and geomagnetic polarizations and terrestrial dynamics that made culture, that made music, that made art, that made all of the things that are timeless in human culture wherever it had reached a form that one could say was actually a culture.

It must be incredible to have a synthesis like that of all of Harry's…he must have had so many thousands of tapes…

These were not tapes. These were records. Harry had an amazing collection of recordings; I mean, the best example of any type of music that he was preparing. Of course, this was a subset that represented a course, an education in Harry's mind, an education that he kept reminding me of, because there were pieces on those tapes specifically for me. It's also the first time I heard Kora music.

Kora?

Kora music. The harp-lute of West Africa is an amazingly beautiful instrument.

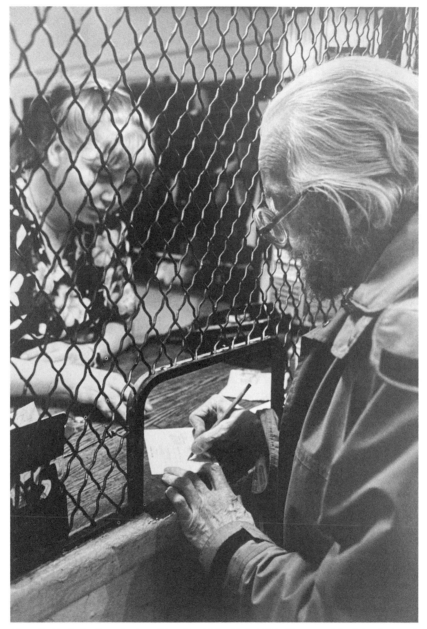

Harry Smith signing in to the Jane West Hotel, New York, 1988. (Photograph by Brian Graham.)

With singing?

Well, the examples on Harry's tape were only unaccompanied Kora. I didn't hear Kora singing until later. I mean, every strange music that I now have in my collection was sourced really by something on those tapes.

And you said Harry geared the tapes towards you?

Well, he always said that these were for me, that this was my education. I suppose he could have made a different collection for somebody else.

Do you remember some examples of this kind of really connected music from opposite hemispheres?

There was this yodeling, for example, from Europe (Switzerland) and from South America, as well as pipes from Bolivia and Africa. No need to go on and on about the tapes, but those were grand days for Harry; he was not drinking too much and had a steady stream of visitors of his own choosing; he was getting money from Jonas on a regular basis; the room in the Breslin was quite comfortable. But then the Breslin went out of business and Harry had to move. So from then, until the end of his life, he was really a nomad.

He didn't seem to mind that too much...

Well, Harry didn't seem to mind it; but you have to understand that Harry was not a normal human being. Harry was an extraordinary being that comes along maybe once in a hundred years or in a thousand years. Harry is a genius on the order of Da Vinci. So, of course, he didn't mind, and of course, he minded. It's cosmic injustice and then karma. Yes, he didn't seem to mind, because no matter where he was and whatever space he found himself in, he made it gigantic and it didn't matter where he was. He always found the treasures of the world absolutely under his feet; he heard things and saw things and tasted things that nobody ever had before. If you were with Harry, you could discover something new at every moment and it was in complete disguise. He was an occult master in the truest and highest sense.

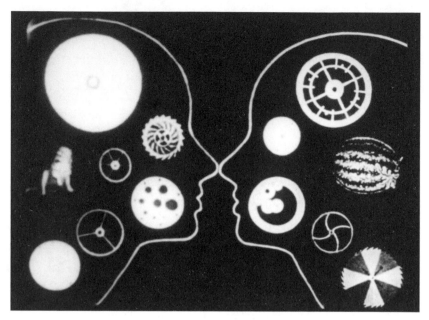

Still from Harry Smith's *Film #12: Heaven and Earth Magic*, 1957–62.

Yeah. He always went right to the inner key of things, to the inner language. He was also incredibly precise in many ways; for example, in the films. Even with all that opening onto to randomness, it was really precise.

Nothing random about Harry's films. Every millimeter of those frames is carefully constructed. That they open onto chaos is their genius; but they are themselves anything but chaotic; for example, with *Heaven and Earth Magic*, you can go for a very long trip on that film.

Yeah. When the faces start kissing and the wheels start moving and the cow falls through the wheels…

But if Harry only painted; if he had only collected one of the hundreds of collections that he made; if he had only studied one of the thousands of subjects he studied; if he'd only influenced one of the hundreds of artists and scholars that he influenced; if he'd only made films; in any of those areas, he would have been great but he did all of it and more. He was a man of unbelievable accomplishment and his work is scattered. His films are more or less intact, but his paintings

are scattered all over the world. His influences are vast. He touched artists of at least three generations, deeply. So, one can make the case that without Harry Smith there would be no modem culture. He was a singular force driving what is present on the landscape now. It took the Grammys long enough to get around to recognizing him, no?

When was it, '89? It was just a couple of years before…

Lifetime Achievement Award; then they kicked him out of the Hilton.

The Hilton? Why?

They put him up in the Hilton, and then they kicked him out because he overstayed his welcome.

He came with his cats?

I don't know. It was some story.

Harry, to me, is in the tradition of the great universal man. But while the Renaissance put man at the center, as master of the world, Harry looked at all the correspondences.

Yes, he did.

Lionel told me that Harry didn't even ever read; he just flipped through…

Oh, I don't know. My experience was that Harry read every book that he had. Or he was able to quote different parts on different days; he seemed to remember the publisher of every single book in his library and the date of publication. Anytime he went to a book, he would open it to precisely to what he wanted to show you. No, I think that Lionel is not telling the truth.

He's exaggerating.

Harry could make anybody feel like they didn't know anything.

Poster for Jack Shoemaker's Maya Press benefit reading, Berkeley, CA, 1970.

I'm sure. At the same time, he kind of opened totally new worlds.

It depended on who you were and whether Harry liked you or not. If he didn't like you, God, you were in deep trouble. There were some people who were captivated by him, literally, whom he didn't like, and who crossed him. It's a long list of people driven mad by Harry, through no fault of his. I'm thinking at this moment of the founding editor of *Bio/Technology*, a man by the name of Christopher Edwards; to this day, he probably curses me for introducing him to Harry Smith.

What happened to him?

He went stark raving mad, resigned the editorship, and disappeared into the Boston area.

In what way was it connected to Harry?

Oh, he ran screaming from the Breslin one night, after a conversation with Harry.

That's heavy.

It wasn't Harry's fault. Harry was just being Harry. And he had this way about him.

It's kind of hard to narrow it down, I'm sure, but what do you feel is the strongest influence he had on you?

Well, I don't know if Harry was an influence on me because I haven't accomplished anything to say that Harry could have influenced me. But knowing Harry was one of the great treasures of my life. It wasn't an influence. Harry's interaction with me and my children and my family over the years was an enormous gift, a blessing. He taught me so much. What he influenced about me, I suppose, were my standards, the calibration curves by which one measures the worth of something. Harry provided a whole other order of calibration.

In what way?

Harry was continually testing your precision in handling the real world as opposed to the illusionary world, and would always get you at your weakest point, where you were most vulnerable; Harry was merciless. Harry really had no pity for anyone's bullshit. Hearing Harry complain about his own life, in the sense that he complained, was an instruction on how any higher being would deal with adversity. Nonetheless, it was terrible shit that he was relating to you and yet, as you said before, it never seemed to bother him. Now you were with him when he died and you heard him sing, so you know. How many beings go out singing! "I'm dying, I'm dying."

"I'm dying, I'm dying." It was extraordinary...

(Laughing) He'd make me take him to yuppie restaurants for dinner, stockbroker type restaurants, and he'd say, "I wanna eat there." And I'd say, "But Harry, I hate those places," and Harry would say, "I wanna eat there. I know that restaurant. They have a good something." Then he'd go there and regurgitate. It was wonderful. I'd pay

with my company Amex card. Harry would drool in his soup, speak loudly, and make the waitresses blush.

Harry is this incredible humanist, and at the same time, he seems to be a link between an era that's ending and another era that's beginning. With all his amazing stratified knowledge of which we can detect the flow charts, it seems to me, from what you said about his interest in genetic engineering, that he was also somehow a link and a seed in this kind of post-human era, meaning all that now can be done with computers and all kinds of disciplines.

I think it's true that somewhere in Harry's work one can already see, fully formed, every major artistic development in the visual arts of the last half of the 20th century and probably the beginning of the next century. All of the imagery that is inherent in computer-generated art is already there in Harry's *Early Abstractions*. It's not that he's a link; I mean, Harry is like a crystal mountain; his work is there to be mined for all time, radiates in all time, as a link, or maybe as a hub. He's a hub the way Da Vinci is a hub. Harry was an artist of that stature. It's not even correct to talk about him in terms other than that. So, was Da Vinci a link? No. He is a central figure. His work continues to inspire. And Harry's vision was that big; for example, his paper airplane collection is in the Smithsonian.

He's connecting all the disciplines.

But had Harry been around a few more years, and somebody like Bill Breeze put a computer into his hands, who knows what could have happened. And he knew everybody and he remembered everything. He was a walking British Museum.

An encyclopedic mind.

Not an encyclopedia, but a Library of Congress, a British Museum. Harry knew everything. He wrote poems, too.

I haven't looked into his poems. Do you have any?

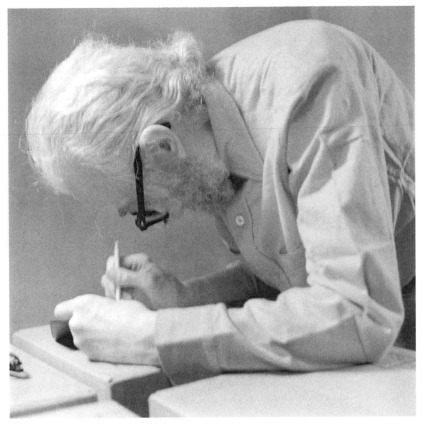

Allen Ginsberg, portrait of Harry Smith drawing, January, 22, 1985.

I have one great poem that you can reprint in the book.

Oh, I would love to. Do you have any images of his work?

Yes. I have his photographic Tarot cards. But Rani already has those on slides.

I was thinking of reproducing the Tree of Life as the cover.

Yeah. It would be nice to have something that remembered Harry.

Harry as alchemist of life.

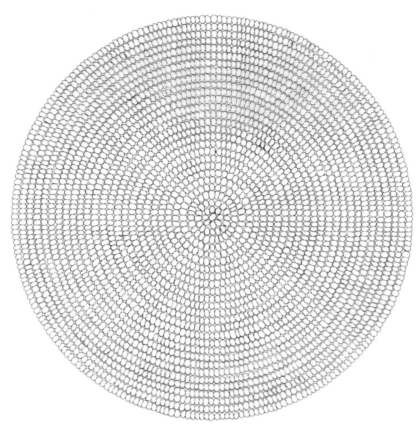

Harry Smith, untitled, date unknown. Ink on plastic. (Harry Smith Archives.)

Harry was a great magician. He was not only a Hermetic scholar but a magical practitioner of the highest order; he was a Master of the Temple, all those things; but he was also a liar, a bounder, and a cheat; he was a wastrel and a spendthrift and a scoundrel, a breaker of hearts; he was all those things.

And do you find that he has kind of put out the Hermetic knowledge so that anybody that has the instruments to read it can access it from his work?

Well, I don't know. If you look at *Heaven and Earth Magic*, you can see many Hermetic narratives; many, many, running through the course of those images. You can read Basil Valentine; you can read Hermes Trismegistus; you can see the alchemical allegories, etc.

Lots of alchemical allegories.

Yeah. Those gave instructions: the actual cauldrons and the meditations, and the visions and the smelting and the transformations. But it's not as though you could take those images and then reconstruct *Thrice-Greatest Hermes* or some alchemical text. It's not as though those images are themselves another encoding of alchemical knowledge, but rather the particular artistic vision of Harry's. It's a great work of visual art. It's not an encipherment, an encryption of Hermetic knowledge. It certainly isn't formed by that, but it's informed by all of Harry's being, which is much more than that particular library.

There seem to be multiple universes working at once.

Absolutely. The more you knew about anything, the more you could appreciate the genius of Harry's creations. So that's a measure of great art. For me, it all comes back to standards and calibration curves, and his unbelievable way of connecting things, of finding them; like finding the painting in the Louvre that rhymes with the painting in the Prado. Harry had ideas and theories about the great museums of the world, too, and about how their collections were really one collection; you had to view, to see, the Cairo Museum and the British Museum and the Louvre, and a few others, simultaneously. He never got to the Cairo Museum, but he knew it better than anybody. He knew it better than anybody who'd ever been there. He had every catalogue. He knew what was in every room, better than the guides. I know that was true because when I visited, in 1992, I asked for something Harry told me would be there and the guide told me, "Ah, you know, but two years ago we moved it." It was the most valuable object in the tomb of Tutankhamen.

And what was the object?

An iron knife. It was the most precious thing in the tomb. Gold, everything was gold, even dildos, but they had only one iron knife. Who but Harry would know that?

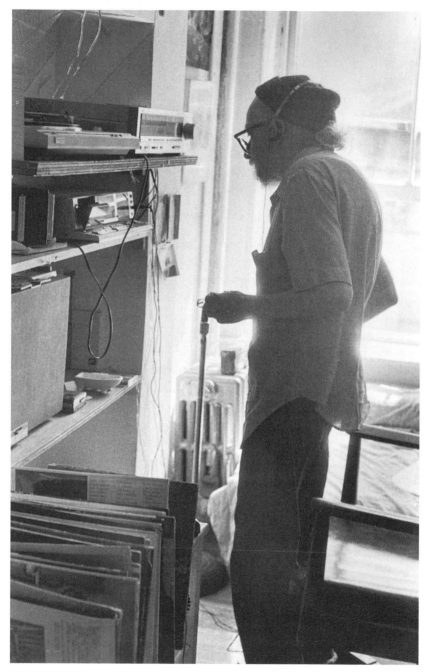

Harry Smith playing records at Allen Ginsberg's apartment, 437 E. Twelfth St., New York, 1988. (Photograph by Brian Graham.)

M. Henry Jones

October 26, 1995

PAOLA IGLIORI: *You did a graph of graphs of all the things that Harry taught you. You finally found it!*

M. HENRY JONES: It was a folder that I had cut apart to make a flip-flop kind of graph of some of the things that Harry had impressed me with while he was still alive. One of the stories he would tell me over and over again... I have it here, [points to long paper full of scribbles], it says "Henry Jones will talk about Harry Smith—bring Jimmie Rogers records." That would have been the record of him and the Carter Family, which was his last recording; Harry always told me that there would come a time when I would tell this story. He told me, time and time again, about how Jimmie Rogers was the first real super rock star created by Mr. Victor of Victor Records, and that his career was only a couple of years long. They had made him a super-star. They started with him after he quit the train business. He was a brakeman, so they called him the singing brakeman. He got tuber-culosis. He made a recording which I'm almost sure was at the Bristol sessions, which was a record that Johnny Cash was promoting on the back cover. I believe that was his first recording. Nonetheless, he went into the record-making business with Mr. Victor and I believe his first recording was "The Soldier's Sweetheart"; you can get that on the Bristol records. Apparently, he was getting sicker and sicker, so they had to build a special railway car that had an oxygen tent in it. They would bring him to the local town to do a show; then they would wheel him onto the stage under the oxygen tent; then they would take him out of the tent and bring him on stage, have him sing a couple songs, pull him back, and put him back in the tent. All along, Mr. Victor had told him that every time he did a show, every time he made a record, some of the money was going to go to a kids' orphanage, or I think it was like a farm, or a camp...it was a boy's camp. Victor would be saying to him "Oh yeah, do it for the kids at the boy's camp, Jimmie." And they would pull him out and prop him

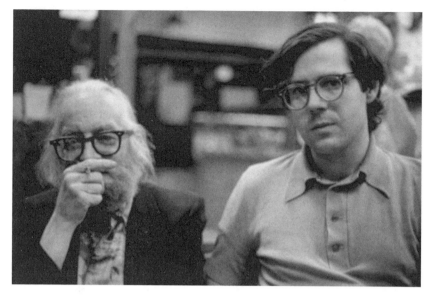

Allen Ginsberg, portrait of Harry Smith (*left*) and M. Henry Jones (*right*), May 13, 1986.

up there. It was up there in a church on 29th Street and it was very near the Breslin Hotel and Harry would always stand out on the street and point up to the church and say "That's right where Jimmie died. That's where they had him."

Did he die during the performance?

No. I was telling about the church; they brought him there after he couldn't perform anymore and he was literally on his deathbed. They brought him into a church and they built an oxygen tent up at this church with all this different equipment to keep him alive and they had the Carter Family come in and they did two records; one was called *The Carter Family Visits Jimmie Rogers* and then *Jimmie Rogers Visits the Carter Family*, in which you hear Mother Maybelle and everybody. You hear a knock, knock, knock on the door and then Jimmie says, "Oh who can that be? As I live and breathe, it's the Carter Family comin' here to visit me!" He could just barely get out a verse of the song, so he would, like, sing one or two verses and then the Carter Family would join in. Then the flip side of it was *Jimmie Rogers Visits the Carter Family*, where Jimmie says, "Is that there that ole clinch mountain you been singing about all the time?" And

they're pretending to be in each other's homes and it's actually quite charming. And soon thereafter, Jimmie died.

He had some wild stories. So the first...

I mean records had been invented for a while and they had the cylinders but he was the first person that was like a superstar of country music.

This (points) is a kind of a list of pinhole photography. Harry would oftentimes read from *The Book of the Dead*; there was one night he would sit there and read the hieroglyphic book. And that always brought on a strange air to the place. It was quiet. I would be working on doing photo cutouts or something. I spent almost every night over at his place at the Chelsea Hotel; I think it was 714, or 711; he moved at one point. I think those were the two rooms he had there. I would go there after I got out of the School of Visual Arts, and we would spend a lot of time together, usually most of the night, just sitting around, and him doing whatever he would do and me looking at his library because he had a magnificent library full of books and stuff; he would give me a book, and I just remember one time mentioning something about pinhole photography and he told me that if you cut a really small picture of a rabbit out of aluminum foil and then shoot a picture of like a babbling brook with the light playing on it, you would get all these pictures of rabbits on the film and I thought that was a pretty far-out leap for someone to make with that.

It says here (points to the graph) something about a ball of string and a soundtrack for a string-figure movie...

That's a film he talked about making; I hadn't seen him for a couple years and I walked over there and I saw him on the street and he said, "Oh you wanna come up? I gotta play you a record. It's for the string figure film." He made one string figure film I know I saw [*No. 16*], and that was with, I believe, a kaleidoscope... I think that was a 35mm film... oh what do they call it...the loony lens kit. He told me you just rent it from Ross Gafney. It's a kaleidoscopic lens attachment that goes on almost any camera and it rotates. And he shot a film with that in which a woman, a girl, is wearing a kind of '60s outfit with circles around; it's a green shift with red trim and there are

three ovals cut out in the bellybutton, in the two sides, in her back. There were some other films done the same way with a gentleman with different colored make-up on. But the girl go-go dancing was always my favorite of that type.

And how do the string figures come in?

As I recall, the string figures were on the end of one of those rolls, like a little clip of the string figure on that same piece of film; I'm not sure if it had the loony lens with it or not. [In fact *No. 16* includes a kaleidoscopic sequence of a red-eyed Harry doing string figures with what appears to be Tibetan red-and-white makeup on.] But he always wanted to make a film of just string figures, like a black-and-white, very high-contrast film, and he also talked about doing an animated string figure film. Anyway, I hadn't seen him for a couple of years and I run into him and he brings me up there. And he plays me a record in which a guy's talking about winding up her little ball of string and he's apparently talking about having sex with the girl and it's kind of a dirty song. He played this for me, and I remember thinking that's got to be one of the strangest songs I ever heard, and since then someone put it on tape, and I have it over here and I listen to it often. I'm not sure I know the singer, but it could be traced. I was quite happy to find it, because I thought that was kind of a lost one. You know, you go to someone's house and they play you a record and they're totally into it and you have a sense of what they're talking about and then that's it.

(Looking at graph) What's this: "mention Tom T?"

That says: "mention Tom T. Hall." That was an interesting story.

"You can't have a full house?"

Yeah (points) "you can't have a full house when the queen has been dealt to a friend." I was talking to Harry and that always seemed like a strange kind of quote. I remember thinking that was a strange one. When I was in high school, listening to country-western music for the first time, I just was fishing through the radio dial and I picked up, I think, Ernest Tubb doing "Waltz Across Texas With You" and I

said wow; this was a whole new type of music and I started listening to that exclusively. And that was one of the first things I said to Harry when I ran into him. He said, "What type of music do you like?" And I said, "Well, I like Mother Maybelle Carter." And he really picked up on that and we'd go to the Colony record store and buy records. One time, for some reason, he was involved in a project where he was looking for records about cards. And he says, "Do you know of any songs that have to do with cards?" I said, "Well, there's this one song by Tom T. Hall called 'Deal.'" And he's like, "Tom T. Hall? I've never heard of him. We'll have to go." He just like grabs me by my shirt, yanks me, and we just ran up to the Colony. I kept torturing these poor people about trying to find this Tom T. Hall record and finally the guy goes in the back, way in the back of the store. Harry won't leave until they produce a Tom T. Hall record. He comes out with this record of Tom T. Hall's *Greatest Hits Volume II*. And it's funny, because I've never seen Tom *T. Hall's Greatest Hits Volume I*.

I don't even know who Tom T. Hall is.

Tom T. Hall is a country-western singer. He wrote that song "Old Dogs, Watermelons, and…" He wrote many, many children's songs: "I love little baby ducks and red pick-up trucks."

(Pointing to graph) "Relationship of objects by subject, listing by Hermetic…?"

Yeah. It says here: "The relationships of objects by subject; i.e. categorical listing by Hermetic synthesis." And that's kind of wordy, but I think what I'm talking about is Harry was always one to categorize things. He always wanted to find a place where he could put something. I think that had a lot to do with his approach to his work which had a lot to do with organizing information, organizing objects into visual or audio groupings which he would work with. By taking these groupings and then working them, organizing them, arranging them, he would gradually familiarize himself with their relationships to one another; then the relationships that had been created, by giving these objects subject categories, could then be manifest as an artistic object. I think that was what that was about.

And what do you mean by Hermetic synthesis? Is it a sense of corres-pondences?

Yes. Correspondences have a lot to do with that. I used to think I kind of knew what the Hermetic thing was about, but I'm not so sure. That's a tough one: "Categorical listing by Hermetic synthesis." I think I was so tuned in to Harry when I wrote this that it's really hard to be at that same place again. But Hermetic synthesis has to do with the way in which, whatever it is you're doing, Harry would always say that it's not important that you finish, it's important that you're always doing it. He was like the wizard in the tower that's end-lessly trying to turn sand or lead into gold, and the process of doing was as important as the actual event of actually doing that. And he would insist on going about things not in a timely fashion, not in a fashion to get them done on time, but in a way in which he would have a chance to have the actual materials randomly associate them-selves with one another, until it got to a point where it would turn into art. I believe that's kind of what that's all about.

It says now on my page here: "Over and open process—oh here!—the random ordering." I looked at this earlier and it didn't make as much sense to me as it did when I wrote it; but it's too bad you couldn't have caught me when I was spewing this out. Let's see if we can get through this here. It says: "You side-switching the triangle which is the reverse arrowhead" and it says, in other words, "if you had six choices, right?, that will be an even number, you need to eliminate one." Harry was always saying that if you're going to make a decision, it's better if you're deciding among an odd set, because then you can just get rid of...you can pair them off. If you have six, let's say, first you just get rid of one, so you have five; then you can find two that are similar to one another. And if you like them, you can group them; if you can group another set together then you have the one odd one, and then you can decide if you want to get rid of the odd one; then you're back to four, so you can go re-eliminate, get down to three, and from there decide the one; or you can take the five, and pick your favorite and then group the other two and make them similar ideas so you can get it down to three. So if you have six, you just throw one out and then you get five, and then three; then you have your king choice and the two choices on either side of it

that would be similar. And you can keep those kind of floating around out there and keep going; because Harry was really big on choosing and not making random choices, but making random associations, and having people observe them and be able to, from their observations, have the choice make itself.

Wow.

So that's kind of a description of this breakdown here where you got one; I have a three, two, two and a three (pointing at graph).

Then you have kind of a triangle and a circle?

That's a strange one.

Here it starts looking a little bit like the Tree of Life.

Yeah. That's a strange figure. It's starting off with a diamond and that's a circle with the two fives…

Then you have eleven, nine and twenty.

Five-point side-switching sphere. Oh. I remember something about this. That's a lot of what I talked about when you have six; he would always talk about the importance of the number five in doing artwork. He liked five a lot, for all the reasons I just said. And so I put that in the middle of the drawing because, you know, double five is ten and…

…and ten, it's one, the Magician.

Exactly. So in five-point side-switching sphere, it says here "see bottom. Remaining three if it is…"

Harry always felt that information should be shared. There is another thing here about "last choice is as important as the first choice."

Yes. Let's get back to this thing about Harry and his information. He was a wealth of information and he was always the first person to just

hand it out randomly. He never held his cards; if he was working on a secret project that's one thing, but as far as people just rolling on him for information, he was endlessly helping people, suggesting things, giving people ideas for their art projects, their science projects, for all different types of crazy stuff. But he was the one person that always taught me that people who hold onto what they've learned, keeping it to themselves, are basically selfish and I don't approve of that type of behavior because of what Harry showed me. And my page here...getting back to this whole choice thing and arrangement...the thing I'm getting from this is that Harry was always into the process. The one thing that he said to me, that I particularly remember, was that the most important thing about reality is the relationship of objects. And he said that what makes everything real is the fact that things are ordered in the present status. In other words, things are set beside themselves and that is what makes reality. Reality is made up of just the placement of objects. Placement was a very important thing to him. The collections of things that he amassed were all set in their right place, and even though the room might be a mess, everything was where it should be. I think that's very important.

This drawing is pretty much about an approach that Harry never actually said to me, but it kind of comes out of the way he would approach things. It relates to making a group of choices in a fashion in which they can reflect upon each other... the numerology thing... he always made it very, very simple. I remember one time he was looking at these number books.

"Person walking by on the street" (pointing at the graph) *"It looks like it's from an alien ship!"*

Oh, thank you. But he was always one to simplify the stuff. One time, I told him about a dream I had and he had the dream book and he looked up the words and he looked up a number and immediately spewed out a bunch of information about what that would mean. I kept trying to get to the bottom of the whole numerology thing with him, because I was very hung up with that at the time. But he was always one to just let the numbers do what they would. He liked certain numbers and other numbers. I think he liked all the numbers.

Did you feel that what he said about the dream touched on something?

Totally, totally. He just clicked right into that. Those dream books have certain numbers that you look up and the numbers relate to a word and you have to cross-reference it with two books. So the person says what they dreamed about and the first thing that comes to their mind, and then you look up the number in the number book and it references an image. Say, someone came in with the word "toy." She said she dreamed of toy boats; this girl named Darcy came to my shop and said she dreamed of toy boats. I found "boats" but I couldn't find "toy boats," so I took "toy" and "boats" and the two numbers and added them together, and looked up the sum, and it referred, in some way, to her current status; she was completely happy. And all I had done was just understand that the numbers speak for themselves.

The boat is in the water, which is the emotional body and the toy is a playful, joyful thing within the emotional body. I'm always so amazed that there are so many ways of getting at one thing.

There really are. And that was the thing about Harry: he would just concentrate and study and work and go haywire, drive himself crazy, getting everything in exactly the right order and then he would just give it a kick and say "that's it." But he knew that when he kicked it, he'd chosen the right moment, and however it fell, was going to be right.

Wow. And that's what it says here: "The last choice is as important as the first choice."

Yes, definitely. One time, he told me a story about this song written by a guy, not that well known, and it was a song about astrology and he was very, very much into cyclical things. And that's the reason the last choice is as important as the first, because you make a series of all these choices but you're organizing all your different materials so that they can correlate and when you get to the end, it is the first choice. That's the reason it's just as important, because the last thing you're going to end on in most cases, if you want something that will exist and be harmonious and be able to carry through the time dimension, needs to be

cyclical or it needs to be connected. So after you get all these different numbers or art objects or sounds or visual images, and after you categorize them and label them and understand them and relate them and group them and make them all relate in a chain, then the chain has to be connected. And the connection is the first and the last choice.

Like in the Tarot cards, where the Fool is the first Tarot, totally innocent and at the same time intuitive, like a child, and the World is the last one, and they're the only two figures that dance in the whole Tarot: the first and the last one; the last one is wisdom and the first one dances after going through all the stages to arrive at wisdom. But the first and the last one, you're right, are the same in a way; they meet and it's gone full-swing. What have you here? "Harry loved the Bible Box?"

I have here that Harry loved Bible school. He used to talk about how he really got a kick out of a box they got to make in Bible school that had a crank on it and it was just a shoe box; you cut a little window and then you get two spools and you put a little wooden crank on it and you get a really long piece of paper and you draw pictures on it. And he always talked about making a film like that. He really got a kick out of that. He called it a Jesus Box; that's what we kind of called it together. Are you familiar with them?

No, I never went to Bible school.

Right. But he was saying it would be good to do as a Möbius strip.

So each kid would make a drawing and there would be one after the other on this long piece of paper and then you would crank it out?

All the kids in the class get the materials; you take pieces of paper and you cut them so you end up with a really long strip of paper; and that was why he was saying that was what got him into making films was this business of making this Jesus Box, in which they had Jesus knocking at the door, or Jesus as a little boy, helping his father carry his tools, or Jesus giving out the fish.

And this?

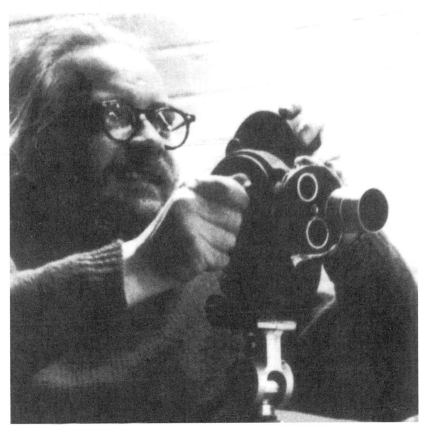

Harry Smith with Bell & Howell camera, ca. 1970. (Photograph by Jan van Raay; courtesy of Raymond Foye.)

That was something about the 70–DR or –DA; that was a Bell & Howell camera that Harry was always talking about.

A what camera?

Bell & Howell was an American manufacturer of cameras that Harry was always recommending to me because it was the camera where you could wind the motor out and put the hand crank on the drive shaft and turn the film through the camera with a crank. He said if you got the knack for it, you would just make your frame; in other words, you expose the frame by simply turning the crank one revolution. You could make multiple exposures and wind the film backwards and forwards. He was always saying that the best camera is the one that

already has film in it (laughs). He just loved the simpler cameras; he pushed that so much that the big fancy cameras are not really that important. What you need is the ability to control the exposure and the ability to purchase film. I have a few camera names here; these were Harry's favorite cameras. His first favorite was the B & H (Bell & Howell) 70–DA; that was the camera they shot most of the footage for World War II with; they used that on a John Huston film about taking some Spanish village. He liked the Kodak Cine Special and the 2709, which is another Bell & Howell camera, with the absolute best registration. He would always say if you want to be a filmmaker, you have to have a camera. People would oftentimes come over there to his place and try to find out what it would take to be an artist or filmmaker and he always said the same thing to them: whatever you want to be, you just have to start doing it. I'm a firm believer in that. Anybody that says they want to make a film, needs to get a camera and some film so they can start making it. Here I see written "Atomizer."

Jordon Belson told me about the atomizer and Vaseline, about the dots, the needle and the scratching, that he saw Harry using while he was making his first films at the end of the '40s. I guess that's the process.

Yeah, he would say if you can't get a camera just get some film, any type of film, and put it in the bleach, bleach it out, make it clear and then he says there's numerous ways you can make a film. He was describing, one time, the way he had originally made some of the *Early Abstractions* films in which you see this kind of moiréd spattered painting; he loved moiré effects; he would love to play with that stuff; he would find anything that would create a moiré effect; that's when the diffraction of the light scatters and causes patterns to emerge by putting two pieces of screen on top of each other, or two combs. We used to play with that a lot. At one point, I had a stereo viewer over at his place and two of these combs, and what we were doing was getting a 3D image of the diffraction of the light as the combs would pass between one another. And since each eye was seeing a different set of teeth that were similar, your mind was kind of stereoscoping to put them together, and so you got a very strange, dyslexic and very weird manifestation of light.

So you filmed this?

No, we were just screwing around with it, just playing. Kids do it. Did you ever do it? You just take two combs and look at the light and slide them back and forth and you get all kinds of diagonal views, depending on how you angle them: that's a moiré effect. He was really obsessed with all that stuff. I'm not sure quite how we got to that one. I was talking about his film.

About the atomizer.

Yeah. He would take a perfume atomizer, and put these Dr. Martin dyes in it and spritz it onto the film. I had always viewed that as a sort of moiréd effect. Once again, he's talking about the randomization. If you have a color field that's made up of little dots and the dots aren't all in the same place on the film as the film's being projected, the persistence of vision will have the tendency to link them. You'll have a sense that the objects are traveling one way or another, just depending on the way the spritzing out of the different pigments landed on the film; the sequence of the projecting causes it to have almost like a washing effect, or moiré effect, from the way in which your eye combines with the image it's seeing. Your visual cortex takes the image it's being presented with and struggles to make sense of it. By randomly throwing these dots of color onto the film and then putting it in a projector that projects the frames literally in a standard time-dimension, he created an ethereal image.

He sprayed the film with colored inks out of an atomizer, randomly, and with an even stroke. Then he put a piece of tape over each frame, and the tape was in a shape. He would cut little shapes out of Scotch tape and then animate them across the frames by referencing them to the above frame. Then he would cover it with Vaseline, remove the bits of tape with a needle, spray another color with the atomizer, and then use trichlorethylene, or dry cleaning fluid, to remove the Vaseline; that would be his first two-color step. Sometimes he would get up to seven or ten colors on the film. It sounds very simple, but if you've ever worked with 16mm film, it's very small! I mean, 35 is one thing, but to do it on 16 is insane.

It's kind of strange, but I completely forgot to mention the fact that Rani Singh had brought me pictures, from the archives, of Harry's work; she brought a 4 x 5 negative of a film frame that I had seen only as a black and white print at that point, and the film frames are like adorned. So I said to Rani, "Are there more of these?" And she said, "I'm not sure." But she came back and brought out a whole set of the film frames that actually went around the film.

Oh, that's what they are! Because she gave me the slides and I saw the thing with a rectangle in the middle and all kinds of ornaments around. Is that what they are?

Yeah, that's what it is. They are artwork that was made to go around *Heaven and Earth Magic*. There are different images: there's an eye; a sphere with like a shiny spot on it; a flowery frame; a geometric frame, like circular frames; these were intended to be projected around the film, while the film was showing. Included in this was also one drawing in which there was a rectangle with a cross over it, an X through it and a circle on it; clearly it was a layout for the projection; he had talked to me about that at length, at one point. He had told me about how the projector had been smashed, and that it was kind of too bad, but it wasn't done right in the first place. I took the negatives and made black and white transparencies using Kodalith film, which is kind of funny, because I needed the film real bad and I was trying to get the show together and I wasn't quite sure what I was going to do. All the places were closed, and I was walking down the street and I climbed into a dumpster and I found a box of 4 x 5 Kodalith film and I just pulled it out; I already had the chemicals. I had said like "Wow, I might be able to solve it like this. I wonder if I have any Kodalith film." I looked in my fridge... no... so then I was just wandering around, in a daze and... Bang! There's the film. It was something. So I had the chemistry already, and I mixed some up, and it was a really fantastic result that came from the exposure on his negative when I translated it into the transparency. I used Kodalith A and B developer and Dektol, which is a continuous tone, so that I was getting a black and white contrasty image that had a certain value of tones in it.

So what do you do with that?

What we do with that is we take the negative and put it on top of the film and shine a light through it and make a reverse of it, and that way his negative became a positive transparency that just happened to be the exactly the right size to throw on a Magic Lantern projector. And I had these two Magic Lantern projectors lying around, because I was trying to build a three-dimensional viewer, a three-dimensional projection device for my pinhole photography that I had been working on. So I had this equipment that had been designed in order to do alignment of the two images for a stereo show. And I said to Rani, "Look, we could just take these two projectors. I already have the gates made"; they were handmade by this guy across town. And we referenced them and did a little test here and she was impressed and then we went off and did that big show. I did the show about a year and a half later and I had seven projectors that all had matched lenses. Funny, once again it happened: on the day of the show, I passed by that photo shop on Mercer Street, Photographer's Place, and sure enough, they had an antique brass lens there and I had the other lens I was trying to match in my hands and I put them on the table and they were exactly the same; it was a perfect match and it was the day of the show!

That's great.

The important thing to remember, for me, is that I went to a very excellent school, where I was treated with kid gloves, and where I got a beautiful education, but the things that Harry taught me were so far above and beyond anything you would normally find in a school situation, except if you're lucky enough to have a really gifted individual as your teacher. He imparted the most important elements of my life, which is the use of random information and the categorizing of it, and making it work itself into an object or a sound or a picture. That's pretty much how I try to go about projects when I do them, and if they can't be done that way, I always try everything I can possibly work out to have them head in that direction.

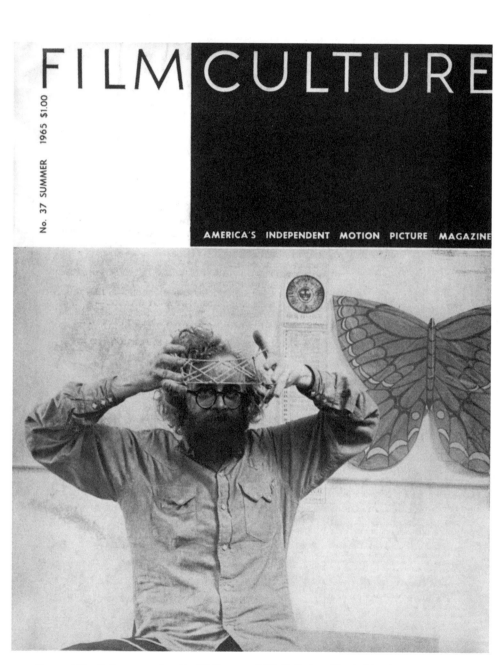

Cover of *Film Culture* magazine, No. 37, Summer 1965. (Anthology Film Archives.)

Philip Smith

AFTER HARRY SMITH

Aber dieses ganze Mahagonny
war nur, weil alles so schlecht ist,
weil keine Ruhe herrscht
und keine Eintracht,
und weil es nichts gibt,
woran man sich halten kann.

I never met Harry Smith, so my involvement with him has largely
involved the more or less coldblooded task of trying to make some
sense out of such ragtag fragments of his existence as I have happened
upon after his death. Admittedly, I have undertaken my investiga-
tions with some doubts as to their ultimate merit (although Harry
Smith is, for all I know, the greatest and most interesting artist of
his time): in consequence of this diffidence, my research has been
scattershot and partial, and I feel that I have barely yet scratched the
subject's surface. Nonetheless, my efforts have generally produced
exotic results, and strongly imply that many exciting and novel phe-
nomena repose undisturbed in this field, awaiting someone with the
diligence to find them out. To suggest the type of crooked intellectual
byway that one must traverse in this pursuit, I offer this simplified
transcript of an imaginary series of inquiries relating to Harry Smith:

1) One sees Early *Abstractions*;

2) Interest piqued, one reads the most-readily-available intellectual
discussion of Smith (the chapter "Absolute Animation" in Sitney's
Visionary Film) as well as Sitney's 1965 interview with Smith (in *Film
Culture* No. 37; reprinted in the *Film Culture Reader* and elsewhere);

3) One sees *Early Abstractions* again, paying especial attention to the
extremely brief shots of paintings (two or three very briefly shown

behind "End" and title cards of a couple of the films (these are lamentably absent on the Mystic Fire videotape, which is also missing the first few seconds of *No. 5*, plus a lengthier but rather shaky view of a painting at the beginning of *No. 4*);

4) One rereads the 1965 Sitney interview and observes that the painting shown with *No. 4* depicts the famous Dizzy Gillespie song "Manteca" (the most popular version of which one may learn was recorded for the Victor label on 12/30/47, thereby establishing a likely not-earlier-than point of chronology): this, one learns, was one of a series of paintings which Smith considered his principal artistic work of the period; in these he depicted bebop records in an oddly schematic graphical fashion;

5) Referring again to the Sitney interview and the *Visionary Film* essay, one observes that Harry Smith's *No. 13*, which evidently has something to do with L. Frank Baum's *The Wonderful Wizard of Oz*, is reported to include imagery derived from Viennese biologist Ernst Haeckel's *Art Forms in Nature* (*Kunstformen der Natur*), a bizarre series of artistic portfolios issued between 1899 and 1904 that sought to illustrate various forms of organic symmetry, particularly on the hitherto-unfamiliar microscopic level, via highly schematic diagrams of perverse formality;

6) By some quirk of fate (several months having passed and one having somehow seen *No. 11* [*Mirror Animations*], *No. 12* [*Heaven and Earth Magic*] and *No. 14* [*Late Superimpositions*] and developed a wholesome hobbyist's interest in Harry Smith's films, contemplating them over many a dreamy hearthside meerschaum on wintry evenings, the day's honest labors completed), one attends a screening which includes *The Tin Woodsman's Dream*, a seldom-shown fragment of *No. 13*;

7) One pays close enough attention to *The Tin Woodsman's Dream* to observe that, although extremely brief, it is a technical masterpiece of sorts and perhaps the most visually sophisticated of Smith's films (in one's opinion the much-lauded *No. 12* seems almost crude by comparison); but there is not the slightest trace of Haeckel influence to

be seen; furthermore, its running time of a matter of minutes is far from the three hours of footage mentioned in Smith's self-penned filmography (although one will have noticed that the latter document tends to be deficient in many matters of fact), and it lacks the stereophonic soundtrack of the ballet music from Gounod's *Faust* with which one has reason to believe it was synchronized;

8) Continuing to keep abreast of developments in the field of Harry Smith scholarship, and faithfully attended screenings and other events, one is finally fortunate enough to see a reel of "rarities" which includes camera-test footage from the aborted *Oz* project. Although it is a terrible print, with almost no color registration and an inky black appearance, it seems to show a series of tableaux of nearly unprecedented depth and strangeness (albeit one's judgment has perhaps been clouded by the many reflective, not to say monomaniacal, evenings with the tarry meerschaum, trying to piece it all together): one sees a view of the Land of Oz in the form of a Tibetan mandala, a mammoth and exquisitely crafted diorama with green glass domes that the camera zooms through in turn, entering each region. One of these is indeed based on microscopic life forms as depicted in Haeckel's curious portfolio series (a fragile original set of which one has meanwhile examined at the library of the American Museum of Natural History, despite a certain awkwardness when asked to explain one's purpose to the librarian). Another is a quite incongruous and extremely amusing translation of the central panel of Bosch's triptych *The Garden of Earthly Delights*. Into these alien landscapes are placed the familiar characters of the Oz story, faithfully rendered in the unmistakable style of W.W. Denslow's original illustrations. An added curiosity is that many scenes appear photographed through a wall of rectangular panes of colored glass, which may be set at variable distances from the camera. When the camera is near the panes, the entire image area may have the cast of a certain color, and camera movements may result in unexpected "wipes" of color across the frame. At other moments, the glass wall being positioned further from the lens, the entire widescreen image is broken up into fields of different color, producing an effect perverse in its novelty and formalism. One is hard-pressed to register even these few coherent thoughts as the images rush by; one must hurriedly squint at and

conjecture colors and nuances of lighting from the terribly-struck print; and above all one must try not to consider the possibility that this glimpse, of what one now imagines to be the grandest (if unrealized) conception of the most advanced cinematic mind of his time, is literally a once-in-a-lifetime proposition.

The epilogue to this sequence is unwritten, but three possibilities immediately come to mind. In the first, one manages, through a combination of brains, charm and financial savoir-faire, to effect the painstaking preservation and restoration of all surviving materials from Harry Smith's career, seeing them triumphally enshrined in a lavish yet accessible setting, a boon to mankind and an inspiration for generations to come (and, God willing, a death-blow to Hollywood). The second scenario sees one, overwhelmed by the complexities of a staggering task and bent under the sheer weight of one's conception of Harry Smith, entering a whirlpool of dissolution that suggests a parodic conflation of "The Rime of the Ancient Mariner" and "The Face on the Barroom Floor," with many a chance tavern acquaintance imploringly begged to lend an ear to help vanquish the phantom that mercilessly strangles one's heart, to no avail. Lastly, it may be that one is somehow imbued with a spirit of philosophy, and thereby strives to witness the consequent preservation or destruction of what one esteems as some of the most salient incursions of the Divine into an otherwise notably barren region of space-time with an undifferentiated sense of dispassion.

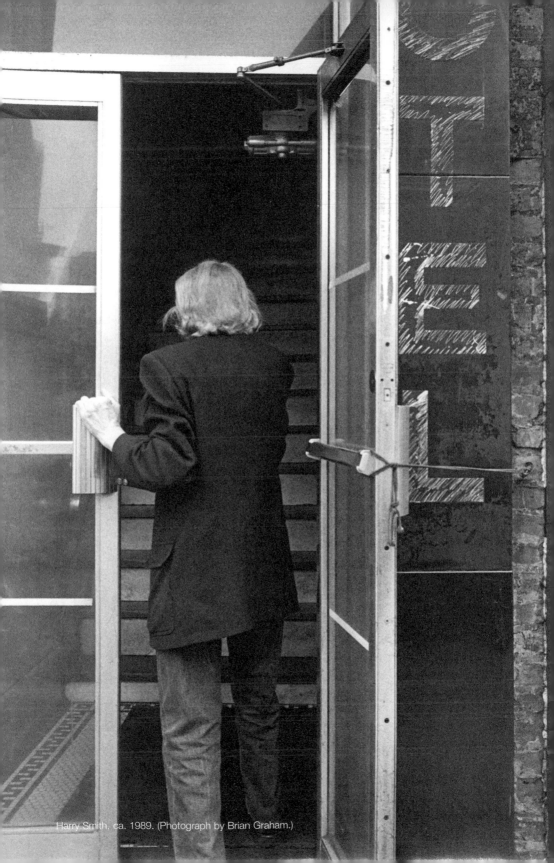

Harry Smith, ca. 1989. (Photograph by Brian Graham.)

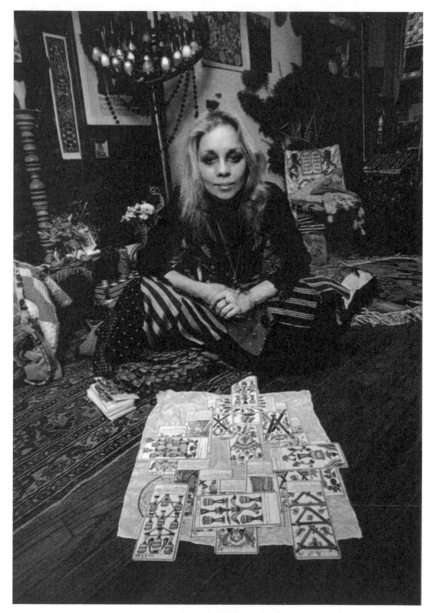

Kasoundra Kasoundra in her studio, NY, 1969. (Photograph by Don Snyder.)

Kasoundra Kasoundra

December 5, 1995

LIGHT-FINGERED HARRY

PAOLA IGLIORI: *You knew Harry really well. When you walked in, you said he was a double Gemini like yourself and that immediately focused me on the introduction for the book I started writing this morning, in which I was saying how Harry always tried to connect everything in the universe and see the inner laws of things. But at the same time, I didn't quite bring out yet the split or the other side that was constantly going on in so many things. What you said was so interesting that I think, even if I had no intention of starting on a new transcription and all that, we have to record it. So here we are.*

KASOUNDRA KASOUNDRA: Okay. Harry was a multiphrenic man. He was multiphrenic, completely. Had total control of everything but was so involved with thinking; he'd think so many things at the same time that he'd start with one side; take a wall, take any room, pretend it's a large sentence that continues from one wall to the next wall, to the next wall, to the next wall, and to the next wall, and it keeps going that way. Harry would talk about many different seemingly unrelated things but when you look at the four walls, as this long sentence, you see the pattern. When you look at his patterns of speech, you'll see that somehow all of those baffling answers that he's giving to you really make up a point of view. Each one has a definite place within that pattern. Since very few people have actually recorded Harry, you can tell by his own recorded conversations that he does speak this way. It also, I think, is a wonderful way of keeping a lot of people at bay, because he wants them to do their own research.

What we have to do is maybe take a good look at Harry. Harry was a very multifaceted human being, as we all know, and he was also an amazingly clever man. He knew a lot of people liked to pick his brain, so what he would actually do is combine a force of dialogue to the person. On a one-to-one level, Harry was basically very sincere

and not so compositely obscure, but when he got you together in a room… let's go back to the idea of the walls around you; you stare at one end on the left-hand side and you're working your way from the left hand to the right, and then you take a turn from that wall and it becomes another wall, and then you take another turn, and it becomes the whole wall. Okay. Then you start in the place where you started the sentence, and if you can read the entire sentence (say it's been written according to the walls) you'll get an answer. Somehow, along the line, you'll figure an answer out. That's if you're in a group, because he always had something to say about every subject in the cosmos. Harry was focused on understanding the cosmos like the cosmology of himself. He was just a nucleus of something, some energy. But his force of mind was so incredible that I don't think he could at one point, knowing what he knew, give to everybody what he wanted; but he knew he could keep them on a string by saying little things that would entice them to think for themselves. That's the gift he had: he made you think for yourself. He'd mention something out of the blue, and of course, all these people were kind of waiting there on the tips of their fingers, just listening for something that they could gather in their mind. And he'll just come up with something. Some off-the-wall subject, something that he throws in, and you start to think about it, and then you go and do your own research. So he was provocative in that way.

He doesn't feel like being the vehicle of their so-called "magna-mania pro genius." He wasn't thinking in terms of genealogy or generic qualities; he was thinking in terms of what he knew as mass, form, idea, stress, the emotional response of the actual spirit of the piece, or the person, and how it was passed on, how it came to be, how the complex composition of the universe works. That's what his real story was all about. But, basically, he was a visual man. His visuality was more than a substance of words. He would read something and then translate it through his mental and eye-contact quality. That's why his film and his evidence of film and things that are tangible are so important to look at; it's because with those you see it. And with those you see how he actually works out a process. It's very complex, but you can see it there.

Alright, one footnote here. This is really funny. This is how Harry's sentimental side works. He had a parakeet named A Blue

Kasoundra Kasoundra at Harry Smith's memorial at St. Mark's Church, New York, February 9, 1992. (Photograph by Clayton Patterson.)

Boy. Well, the Blue Boy died. So what did Harry do? Harry didn't bury him; Harry put him in a block of ice and kept him in his freezer. That's Harry! Harry was actually down-to-earth; he loved things that were alive and he loved things that he loved. He was a very simple man. I don't see him as a sexual object. I see him as a mind, an eye, a light. He was a real light! He was so beautiful that even though those people who could see him or know him or understand him, and never wanted to, would see one of his films and be very turned on by it. His eye-contact and his brain-contact were so intense. From reading what he knew and from what he observed of any quality of any type of visual thing, creating a context for visual things, he would get an idea and he would send it on a screen. That's how he was.

To know Harry was to love Harry, but he was one of those guys you could never put in a cage; you could never pin him down. He's always around you. No matter where you are, what you see, what you feel, Harry's there.

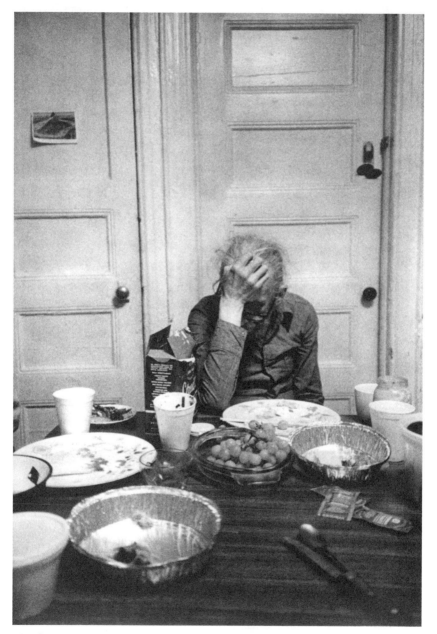

Allen Ginsberg, portrait of Harry Smith "exhausted over Chinese take-out supper," June 17, 1985.

Paola Igliori

November 17, 1995

JAMES WASSERMAN: *How long did you know Harry before he died?*

PAOLA IGLIORI: I never had a very developed sense of time, but I know I saw him about four times before the last time. The first time I had got some cards of some black musicians, like Mississippi John Hurt, Robert Johnson, Blind Lemon Jefferson, all the great ones, and I'd heard about Harry being at the Chelsea. I'd heard a lot about Harry and I thought that this might be a way I could meet him in a natural way. I went to the Chelsea, to his room, and I knocked; he was grumpy. I was kind of shy and I told him I had some cards I thought he might like and would leave them outside the door. And he just said something, but I couldn't quite understand it, and he opened the door and told me to come in but he was very nervous about all the piles of his stuff that were in the way. You know, shouldn't be touched.

Don't Touch Anything!

Well, kind of. I stood and he looked at me and I think maybe one of the first things he asked was, "Do you by chance have anything to smoke?" or something like that. I said, "Well, actually, it just so happens that I have some really fresh hashish I brought back from Morocco." And he was very happy and we sat down. I had my little pipe and we just smoked. And after that, I lost complete memory of the progression of what went on, but it was one of the most powerful experiences of my life. He started showing me all kinds of different decks of Tarot cards and we started opening books and talking about all kinds of things. Things that I didn't even know I knew came out. In retrospect, I felt as if I tapped into some kind of universal source of knowledge. We had very profound discussions. I seem to remember starting from different subjects but a lot was about the nature of "God" or so-called universal intelligence. After I left, I remember feeling very strongly that I wished my mind would have

been a video recorder and I could have recorded every nuance. It's funny, because today somebody asked me when was the first time I thought about doing a book about Harry. I said, "I never really thought about doing a book about Harry." I mean Lionel appeared at my doorstep after Harry passed and I started going to visit him. We started talking about Harry, and these were incredible times; we had some very special nights, going on all night with the candles, smoking one cigarette after the other, and talking about Harry and going from a space charged with time and memory to a space of total presence. He told me about all kinds of things and then he said, "Well, you should interview Jonas." So I went to see Jonas and he suggested Debbie Freeman. Then I met John Trudell, another incredibly powerful experience, and I left it a little bit on the back burner. I took it up again, and slowly the book came together on its own. But going back to that feeling of strongly wishing to record everything that happened, I think that was the time in which this energy created itself that now is supporting the creation of the book. He inspired me to buy a video camera because I asked myself how to do it when I had that thought. I said, "I'll buy a video camera and I'll learn how to use it. I can put it in the corner, we'll forget about it and everything will be caught live on video, because words can't catch it." I bought the video camera, but then I didn't want it to be between us. I thought we had time and I wanted to just enjoy, you know, whatever happened when I went to see him.

After he passed on, I took the video camera out for the first time and went to Coney Island and that was also kind of amazing. I'll tell you what happened. There was the Mermaid Parade; it's wild. Coney Island is an American ruin, the ruins of this fictional world that I think America is very much about. So there I was, amongst this kind of gigantic dinosaur of rusty roller coasters; there were Rastas, "Polar Bear" Clubs, and all that was passing by; there were the mermaids as well as all these other American icons, from transvestites with fishnet stockings to young girls, to old ladies; all kinds of things. Then I went inside this bar, which was an old bar with photos of Coney Island in the '20s, which caught fire, by the way. And in this bar, I continue with the video camera. I never stopped videotaping the women in line for the bathroom, all looking at themselves in the mirror, and the little Lolita swinging her bag, and the old sailor dancing

with a Russian, in a kind of sexy way. Suddenly, I heard drums and so I left and followed the drums and went to the beach. On the shore, there was a Yoruba ceremony for the ancestors, and people were throwing oranges and flowers, carried on the water, to the ancestors, with this drumming that was getting stronger and stronger and everybody dancing and getting in a trance state. The person that was next to the drummer started talking in tongues and went all the way into the water up to the chest. I went all the way into the water with my video camera, and it was very strange because you know how delicate it is to record something like this, and yet they didn't even mind or notice me. I mean, I was just there; I was dancing myself. It was powerful. Then, when this Yoruba group walked back to the beach, I heard some more music; I went up to the boardwalk and there was Sun Ra's Arkestra playing, with maybe twenty people surrounding them, right in front of this gigantic field of weeds and the broken roller coaster, and with a bunch of project buildings to the left, like mushrooms, and the sunlight flashing on the glass windows, and planes going by. I taped it and then interviewed Sun Ra for a short time. And that was the first time I got my video camera out which I had bought to film Harry!

I remember you made a great impression on him because he spoke highly of you to me.

Really?

Yeah, he sure did. You had obviously become one of those people close to him. I guess that brings up the next obvious question, because you shared in one of the most profound experiences of Harry's life: his passage. What was that like?

Well, one afternoon, around four o'clock, I found that I wanted to call Harry. And I called him and a woman's voice answered. He couldn't come to the phone, so I said, "Can you tell him that Paola is coming over and I'd like to know what he'd like me to bring," because he didn't eat that much. So she asked him and he said, "I don't know but tell her to come soon."

Who was the woman? Do you know?

I didn't know at the time, but later on I found out it was Rani. She had left; I think to try to find the car. I had a couple of things to do, but that word "soon" stayed in my mind, so I left after about forty minutes or an hour. I don't remember exactly. I got there around five-something, and I opened the door and Harry was coughing and there was blood everywhere, on the bed, and on these towels; he had a towel over his mouth; there was so much blood. And it was shocking to me, because that's exactly the way my dad died, with a burst vein, and so it was very shocking. And I was silent and I looked at him and I didn't know what to say. Well, actually, he managed to talk and said, "Oh sit down," which was kind of incongruous. And I did sit down and I didn't know what to do, so I just sat.

Rani was still there?

Nobody was there; he was alone. I just sat and I tried to get in touch with my feelings. Then I said, "Harry you're very, very sick. Maybe we should call a doctor." And he said, "No, please don't." Immediately, I knew he was going to die. And I realized, being Italian, that he didn't want to end in a hospital, with people doing things to him. To lots of Italian people, the most important thing is for them to pass in their own place, with their own people around. So I didn't say anything else. I stroked him; I stroked his forehead, and I think maybe I said, "I don't know what to do." He started coughing more and more and then this singing came out of him, this really powerful singing! And, at the beginning, I couldn't understand the words and then I realized he was saying, "I'm dying, I'm dying, I'm dying." It was so powerful. It was like some ancient, incredible chant. In the middle of this singing, a much bigger gush of blood spurted out, an enormous gush, and then he fell down and I saw, in that moment, he turned completely waxy yellow, just one second after falling down and I knew his spirit had left. At that moment, I knew I could leave him, because at some point, earlier, I called quickly upstairs to Raymond's [Raymond Foye's] office and said, "Harry's very sick. Come as soon as you can." I didn't want to worry Harry too much. I just wanted them to know. But they hadn't come. So, at that moment, I

Left to right: Raymond Foye, Allen Ginsberg, Jacob Rabinowitz, and Harry Smith, ca. 1981. (Courtesy of the Allen Ginsberg Estate.)

just ran upstairs and got them. Raymond came and called the ambulance. That was another thing that impressed me, in my mind's eye, very powerfully, and forever. The people came from the ambulance and they started pumping him to try to revive him. And there was a cop with the radio blaring, watching him, and talking with his legs apart, and the pumping made a sound as if this was his voice trying to speak, but it was only the air coming out. It was this sound in the foreground, and Harry's body on the floor in the hallway, you know, like those images in slow motion, completely like a film, and so many connections came to me. I realized that he didn't want to go through that while he was there. Also, strangely, later on, I found out about those sounds he was recording: Life sounds. When I interviewed Allen he talked about Harry in a flophouse on the Bowery, recording the sounds of people coughing and dying, and how he noticed it was like the birds singing all together at dawn and dusk, and that there were certain rhythms that occurred during certain hours of the night. Later, I thought he probably watched that scene with great interest.

Ever the scientist. So interesting that it happened to both your father and then Harry...

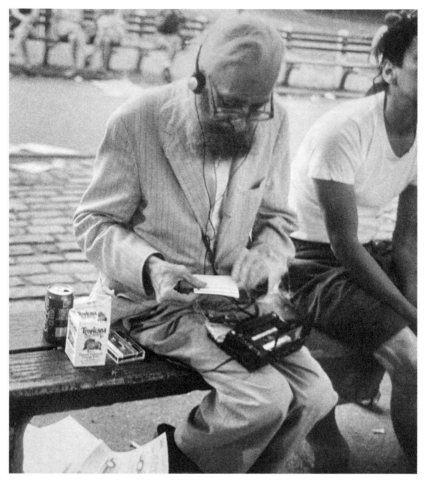

Harry Smith recording ambient sound with a Sony Walkman Pro in Tompkins Square Park, New York, 1988. (Photograph by Brian Graham.)

The other thing that I found out later on, looking at these interviews, was that he was born in the same year as my father.

Is that so? And you didn't know that?

No. Actually, I just noticed it recently. But I remember, one of the last times I went to see Harry, the smell; he had all this mucus inside him; it's like the smell of rotting. And there was all this phlegm inside him. He would spit on all his glasses, with ashes and cigarette butts

and moldy yogurt everywhere. It was all over the place. And he asked me if I could clean it a little bit or I offered to. I remember that I felt so much like retching, but I tried not to, and just cleaned it all out and there was all this slime. I mean, he was really extreme. I don't remember how many weeks before I went the last time, but that's another really strong memory.

You told me a fascinating story the other night about some of the things that happened after you experienced that with Harry, and in particular, the connection with the American Indians, which were so much a part of his life.

Something very powerful happened after Harry's death which I believe was related to him. One night, I was sitting in this room, in front of the fire. I was alone. I spent a lot of time on a farm alone, in my early twenties, and so the fire was my only companion. I used to bring in the wood and make a fire and, in the evening, I would sit in front of it, and read sometimes; but most of the time, I just watched the fire. I found, or at least it seemed to me, that I communicated with the fire. Sometimes the flames got bigger and there was some exchange. So I was doing that with the fire that night, and I started asking for one thing that began to formulate itself more and more clearly: it was to stop measuring myself in my creative expression against difficulties all the time; because I've always put together things, such as the first book on the artists, which was an exploration of the roots of creativity, with enormous difficulty. I always had to go through this tight, tight passage, and kind of push open with my head, and then things came. So I asked to be able to be more in the flow with my creative expression, and to let the things that were really essential to me come and surface and meet with the outside. And while I formulated this thought or image clearly, the image of Harry flashed in the fire. Then there was something else, which wasn't an image, but a female, powerful, erotic, creative energy. And those two things connected with what I had asked. And I felt that something powerful had happened, and I just let it go.

How long was this after Harry's death?

Maybe five days.

Five days?

About five days. And I just let it go. But I felt that everything had combined and something had happened. Those things are not completely conscious when they happen, but then, looking back, I can see it. Then, like three days later, I saw somewhere in a paper that a Native American man, a spiritual man, was coming to New York to give a talk and I just decided to go. Somehow, at the end of the talk, where there were about two hundred people; there was a small group around him and I was there. I ended up being one of the five people he invited up to his room, where we talked more. Then I told him, "Whenever you come to New York, if you don't like staying in a hotel or you don't know where to stay, I have a big house and I'd love it if you'd come to stay." That night, maybe around midnight, I received a phone call from him and he came to visit. And that was another amazing experience, because he started talking in a kind of language, I don't know how to put it, but it was really something, and I knew, I understood it profoundly. It was like coming home somehow; it was a language that really talked to me very deeply. This kind of language was seemingly simple but powerfully alive to me on many different levels. It didn't belong to my culture; I'd never known it before, and I hadn't read it anywhere, but I knew it profoundly. So we connected, and from that, a whole series of things happened.

Like, a while later, I went camping, for the first time, and again I entered into this space, which seemed very familiar to me. I remember I was in the water and I was talking to the water and I just felt so much pain suddenly. I asked the water to forgive us for poisoning her. There was a lot of sadness and pain I felt when I was saying these things to the water. Then these little dead fishes appeared, so I don't know if a message was being transmitted to me without my consciously noticing, because there were all these dead fishes. And then I began sitting on the ground. That was very powerful, too. And then I saw this old, old big tree. I was with some friends and suddenly I started saying things which didn't come from my culture either. I saw the tree as this old grandfather that had been standing and had been really brave for a really long, long time and was almost going, because he started to dry up and die. So I said, let's honor him. And then I noticed that there was a fox, dried up and dead under the tree. And I thought that she had gone to die

there for the same reason. Then my friends wanted to go in the forest, this kind of small, wooded dark forest, and I felt the energy wasn't good to go there in the night. All these things that were very powerful were talking to me. From that, things started developing very, very, fast and some of the most powerful experiences of my life happened.

Harry's connection to the Indians was so deep. He spent many years... whether he grew up on a reservation or not we don't know at this point. He never told me that he grew up on a reservation, but I do know that he was one of the only white people who was ever accepted to share in the experience of the peyote ceremonies and the sweat lodges. He was welcomed to study but more than just to study. Harry participated in the rituals and participated in all the spiritual activities that were taking place. He was accepted as one of the Indians, just like he was accepted as one of the people in whatever sphere he moved. It's interesting that your awakening to the Native American current seems to have coincided with the experience that you had with Harry.

Yes. With my asking whatever was the truest and most profound things in me to surface. That's what I felt the key was, somehow. I don't know, I just asked that whatever was more profoundly true in me would surface with creative flow and a space opened up. So that's how I connected all the things that happened afterwards, somehow, to Harry and to that other energy I mentioned before. My journey started from this; I mean, I'd heard John Trudell's music before, but then he came to New York and I went to hear him and I started doing this book with him; that was another, maybe the most powerful journey of my life. Powerful things happened. And I realized a lot of things, at least it seems to me, of how the soul...I don't know how to put it. But I realized that certain questions I had been asking myself were answered, for me, in this journey I started with Trudell, and with what happened while doing the book with him. So many things came out that were really powerful; one of the things that came out for me was the clear awareness that, just like in this life, we're stuck repeating and repeating and repeating a certain experience until we've hit our nose against what it is that holds us. I call it the "chainlink,"; we get the awareness of the patterns that plague us and then we can release them. I've learned this from my experience and I've really been able to feel it. The same

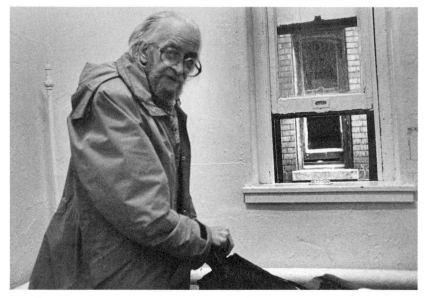

Harry Smith at the Jane West Hotel, New York, 1988. Smith intended to record sounds of the hotel's long-term residents through this air-shaft window. (Photograph by Brian Graham.)

happens from life to life. And until we see it, we keep on being held by these interpretations of this child-animal that we have inside us, that runs our conscious living of things, life after life. And I've seen, through the work I did with John, lots of things that I didn't even know I was seeking come to me, and this was one of them. It's one thing, knowing this consciously, but it's another thing, suddenly having the total experience of it. It blew me away. I realized, clearly, that what is me, Paola, and what is you, Jim, now, will still be Jim and Paola, but with a different name, walking in different shoes, some time from now. And so, I deeply realized that we really are the ancestors and we really are the descendants. And I realized the profundity of the simple and incredibly advanced system of awareness that the Native American people and a lot of the so-called primitive people have, and the ways of dealing with this, and with balancing all the different voices in us, without suppressing any of it, any of the amazing efficiency of their system of life, and the incredible freedom and creativity of their expression, the strong individuality and yet equal respect for everything.

Somebody said exactly this about Harry: that for Harry, man wasn't better than anything else in the world or in the universe, but everything was equally important and fascinating. Suddenly, I saw how

we all have our own unique gift and power, from plant to animal to different humans, and the more deeply I realized the uniqueness of each, the more clearly I felt the Oneness of which we are all part. And I've never found a culture that understood this like the Native Americans. Even though it's been very battered and is carrying a lot of repetition and grief and scarcity. But it is a culture that is still so alive and whole, with these strong spiritual values and everyday creativity that's very free.

Once I had a vision of a little red flower blooming, like in slow motion, opening up and opening up more and more and becoming a fruit, and this fruit opening up and showing all these shiny red seeds. I was flying on big wings over a plain while I saw this, over a gigantic plain, with lakes in it, and I'd never seen anything so vast. When I later went to South Dakota to sit next to the little house where the sacred pipe is kept and to ask that certain things be alive and transmit themselves in the Trudell book, suddenly the clouds opened. When I looked down there was the same incredible valley with the lakes that I had seen in my vision of the flower opening. Later on, I realized the flower, in fact, is in the book, and that the flower is the pomegranate, the fruit that has all the shiny red seeds. And it's the plant that my father always said is alive all the time, always doing little things, from flower to bud. And it's the fruit that was brought back from the dead when what's-her-name was kidnapped and sent to Hades six months of the year...

Persephone.

Persephone. That's the fruit she brought back. And it's the fruit of the many in one. I thought that was very profound and very related to Harry.

I also heard that the pomegranate was the true fruit that Eve gave to Adam and that it wasn't the apple.

Great! Well, it makes a lot of sense. Eve gave the fruit to Adam to enable him to enter Paradise, not the contrary. The early patriarchal controller religions inverted the story.

We'll have to check Harry on that. He undoubtedly would have known the reference.

PART 2

Documents

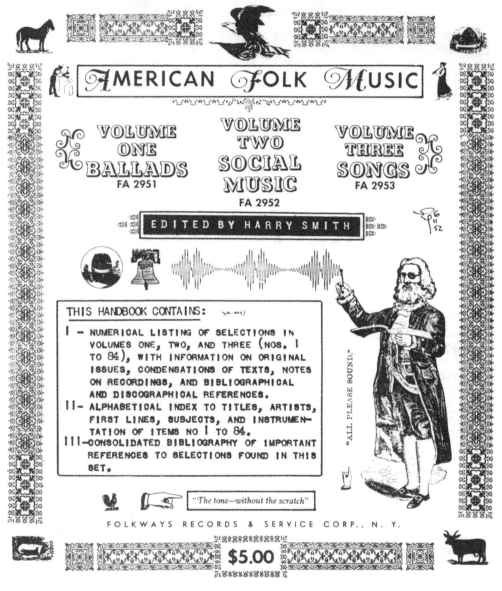

FOLKWAYS RECORDS Album No. FA 2951, FA 2952, FA 2953
© 1952 by Folkways Records & Servce Corp., 632 Broadway, NYC, USA 10012

AMERICAN FOLK MUSIC

VOLUME ONE BALLADS FA 2951

VOLUME TWO SOCIAL MUSIC FA 2952

VOLUME THREE SONGS FA 2953

EDITED BY HARRY SMITH

THIS HANDBOOK CONTAINS:

I – NUMERICAL LISTING OF SELECTIONS IN VOLUMES ONE, TWO, AND THREE (NOS. 1 TO 84), WITH INFORMATION ON ORIGINAL ISSUES, CONDENSATIONS OF TEXTS, NOTES ON RECORDINGS, AND BIBLIOGRAPHICAL AND DISCOGRAPHICAL REFERENCES.

II – ALPHABETICAL INDEX TO TITLES, ARTISTS, FIRST LINES, SUBJECTS, AND INSTRUMENTATION OF ITEMS NO 1 TO 84.

III – CONSOLIDATED BIBLIOGRAPHY OF IMPORTANT REFERENCES TO SELECTIONS FOUND IN THIS SET.

"ALL PLEASE SOUND."

"The tone—without the scratch"

FOLKWAYS RECORDS & SERVICE CORP., N. Y.

$5.00

Harry Smith, title page of liner notes for the *Anthology of American Folk Music* (Folkways Records, 1952). Smith both edited the anthology and authored its elaborate handbook of liner notes.

John Cohen

A RARE INTERVIEW WITH HARRY SMITH
December 1968

Every cultural movement has its dynamic personalities, its popularizers, aestheticians, financiers, historians and academicians. Despite himself, Harry Smith has emerged as the unheralded genius behind the scenes of the folk music movement in America. He is also greatly respected as an avant-garde film maker by avant-garde film makers, and his works have been shown at the Museum of Modern Art.

A visit to his room is a somewhat mystifying experience, for what appears on first impression as orderly piles of books and objects is actually a storehouse for cross-disciplinary investigations of visual, anthropological and musical phenomena. The closet is filled with women's dresses from the Florida Seminole Indians. One corner of the room, marked with a "Keep Off" sign, is filled with Ukrainian Easter eggs; on the bureau are stacks of mounted string-figures; behind the table is a movie camera alongside portfolios of his paintings and graphic work. In another corner is a clay model of an imaginary landscape which is re-created from a dream. On the walls hang empty frames from which the pictures have been ripped out. Under the desk lamp is the only other living thing besides Harry—a solitary goldfish in an orange clay bowl. A 19th century Pennsylvania Jacquard woven spread covers the bed. At other times there have been piles of beautiful quilts and other weavings from that area as well as a collection of paper airplanes from the streets of New York. Small file cabinets of index cards are distributed between the stacks of research books. Each book becomes more exotic by its juxtaposition with other such books—Mayan codices beside Eskimo anthropology studies, under a collection of Peyote ceremonial paintings et cetera et cetera.

In the notes to the Folkways Anthology, Harry included this quote: "Civilized Man Thinks Out His Difficulties, At Least He Thinks He Does, Primitive Man Dances Out His Difficulties," along with a quote from Aleister Crowley; "Do As Thy Wilt Shall Be The Whole Of The Law."
—John Cohen

JOHN COHEN: If the readers of *Sing Out* know of you at all, it would be from the Folkways *Anthology of American Folk Music* which was issued a long time ago (1953). That is just a part of what a total picture of you might be. Perhaps we could talk about the *Anthology* in context with everything else that you do.

HARRY SMITH: You didn't bring enough tape. I don't know what the purpose of doing this would be. Perhaps if we talk a long time, my brain will begin operating better. It doesn't sound like a good thing to do; start at the beginning and work forward. You don't want to work backwards?

JC: How was it that you first went to see Moe Asch?

HS: Somehow I went to sell him records, and soon he said "why not issue some?" Perhaps Pete Kauffman told me to go see Moe. He issued a lot of them, common things like Bukka White. I sold him things that were not quite up to what I wanted to keep. I had either hundreds or thousands of records when I first came here. They're at Lincoln Center now. The *Anthology* was not an attempt to get all the best records (there are other collections where everything is supposed to be beautiful), but a lot of these were selected because they were odd: an important version of the song, or one which came from some particular place. For example, there were things from Texas included that weren't very good. There was a Child Ballad, "Henry Lee" (Child 68). It's not a good record, but it had to go first in the set because it was the lowest numbered Child Ballad. Then there were other things put in simply because they were good performances. The "Brilliancy Medley" occurs to me. You couldn't get a representative cross-section of music into such a small number of records (six LPs). Instead, they were selected to be ones that would be popular among musicologists, or possibly with people who would want to sing them and maybe would improve the version. They were basically picked out from an epistemological, musicological selection of reasons.

JC: In its own way that selection told me where traditional American music came from, and predicted everything that followed in popular

music. It was the first opportunity many of us had to hear the country blues, early Hillbilly and Cajun music.

HS: Similar things like Cajun music were available from the Library of Congress before the *Anthology*, and there were current Cajun 45s from Louisiana, but most people hadn't heard them. The first time I heard Uncle Dave Macon was somebody playing old records in the basement of a funeral home that had been converted into a Salvation Army shop in Seattle. During the war they bought up all the records to melt them down or something so there were masses of records everywhere. There were masses of Japanese records. The Japanese were moved away from there very quickly and they had to sell everything, so I got a lot of good Japanese records, some of them recorded as early as 1895. I collected old Chinese records from about the same period. They'd be as early as any phonograph records made. So I heard an Uncle Dave Macon record in this shop, and I'd never heard anything like that. It was "Fox & Hounds" and I couldn't imagine what it was. Bertrand Bronson at the University of California played one Buell Kazee record for me. He had a collection of records, and he'd bought some Kazees when they first came out because they had Child Ballads on them.

JC: You'd not heard of Eck Robertson before you bought his records, had you?

HS: No, but you could tell they were of top quality. The first record I bought was around 1940. It was a Tommy McClellan record that had somehow got into this town by mistake. It sounded strange so I looked for others and found Memphis Minnie. I started looking in other towns and then I arranged for other people to look for old records. Someone found a Washington Phillips record. In looking through books like those by Odum & Johnson, there were lists of records. In Jean Thomas' book *The Lost Fiddler* they mentioned Jilson Setters so I started looking for those. There was a book from the 1920s published by Howard University, where I first heard about Blind Lemon Jefferson and Blind Willie Johnson.

JC: In other words, you didn't just buy records in response to a voice. You knew something beforehand.

Harry Smith at the Chelsea Hotel, New York, January 1, 1969. (Photograph by John Cohen.)

HS: I was looking for exotic records.

JC: Exotic in what terms? Lemon Jefferson wouldn't be exotic in Mississippi.

HS: Exotic in relation to what was considered to be the world culture of high class music. I'm sure you can find places in Mississippi where they listen to Paul Whiteman. There was a certain type of music that everyone was exposed to in the 1920s; the Charleston, Black Bottom, etc. Like the babysitters I had were doing these things. I was carried along, I presume.

I'd been collecting blues records first. I don't remember who the first Hillbilly singers were I heard. I think I got into it through Irish music. In that same store where I was trying to get Romanian bagpipe records. You could get a lot of that sort of records in Oakland, California by then. I went there for something else. At a party for Woody Guthrie...

JC: You knew him back then?

HS: Someone had taken me to hear him. It could have been at some longshoreman's hall in 1942. I'm sure it was like Communists. The person who invited me was connected with Harry Bridges. In the hall

I suddenly met a lot of people who had interest in records and stuff. Being naïve, I didn't realize they were revolutionaries trying to blow up the state capitol or something. I got interested in the Child Ballads from seeing Carl Sandburg's *American Songbag*. I was living in a small town in Washington and my father would bring me books from the library. I don't know why he brought that home, but he had been a cowboy himself and knew a lot of the songs. Now this sounds horrible and ruins my reputation, but one of the first people I heard was John Jacob Niles. He gave a concert. I found records of his (and naturally threw them out as soon as I found out that there was something better). But looking for those songs, maybe "Wild Bill Jones," I found versions on Champion. Re-pressings from Gennett. It was a commercial version of the song, a curiosity, because something that had survived orally for a long time suddenly turned into something that Sears Roebuck sold, and you could order it from Pakistan or wherever you might be. I would presume that my interest in the quality of the music went back to my mother and father; my mother sang Irish songs all the time, and my father sang cowboy songs. But they were naïve of the implications of it.

JC: My mother knew a version of the "Butcher's Boy" from the sidewalks of New York early in this century.

HS: It was recorded very early. A lot of those things came out on pressings that Eldridge Johnson made. They are eight-inch records, all autographed by whoever made them. I think they are all preceding 1888. They were made to be sold through New England and they are of higher quality than what came later. Things like "Frog Went A Courting" plus really amazing Victorian ballads, super dilly things like they imitate in movies when they show the Gay Nineties. Well, there are actual records of that stuff out. It's amazing subject matter, all connected with children freezing to death. I would presume, a realistic picture of life at that point, which has been suppressed because they don't like it to get out that children starved to death then. It was the big period of orphanages, just like it's the big period of broken homes now. A great many of these songs on the records were in a snowstorm, the poor kid peddling the papers at the Ferry Slip in order to get medicine for the father who is at home dying of

Asiatic Cholera or something. Now how did I get onto that? Well, a variety of these things converge.

JC: Where did you first hear of the Carter family?

HS: I would think from that mimeographed list that the Library of Congress issued around 1937, *American Folksongs on Commercially Available Records*. Shortly after that, two Carter Family records, "Worried Man Blues" and "East Virginia Blues" were reissued on the album *Smokey Mountain Ballads*. That album would come to stores that wouldn't ordinarily have Carter Family records.

JC: In that album John and Alan Lomax made hillbilly music respectable enough to have it sold along with Art music and symphonies.

HS: Sort of…there was no market for Hillbilly records where I was living. I can't imagine there being a market for anything when I reconstitute their musical taste. But there were several groups of Southern country people like the Carter Family in the hills south of Seattle. I bought several dulcimers there. My mother found the best one in a Salvation Army. It had been made in those hills south of Seattle. Somebody wrote a doctoral thesis on those people. They were immigrants that came in 1890 from the Southern mountains. I met Griff Borgeson, the one who later found Sarah Carter. He and his wife went in out of a thunderstorm to an auto court in the Gold Rush mountain country of California. We had become interested in the Carter Family by then, and Griff just casually mentioned, "Oh yes, we've been seeing Sarah Carter lately." For a while I couldn't believe it. I couldn't live until I found out where. They wanted me to guess where it was. So after I found out, I went up there and stayed a few days, a couple of times.

JC: When would that have been, and what would you do for a day with Sarah Carter?

HS: Would it have been 1945? She was making patchwork quilts, and I photographed them in color.

Foreword

BY HARRY SMITH
EDITOR, AMERICAN FOLK MUSIC, VOLUMES ONE, TWO, AND THREE.

BY 1888 MANY IMPORTANT RECORDINGS OF FOLK SONGS HAD BEEN CUT ON CYLINDERS, BUT IT WAS NOT UNTIL THAT YEAR AND THE PERFECTION OF THE GRAMOPHONE DISC BY EMILE BERLINER THAT INEXPENSIVE RECORDS WERE MADE AVAILABLE TO THE PUBLIC. OUT OF ABOUT THIRTY FOLK SONG TITLES ISSUED BY BERLINER BETWEEN 1895 AND 1899 THE MOST IMPORTANT WERE, NO. 3012, AN EXCITING BANJO AND VOCAL VERSION OF "WHO BROKE THE LOCK" BY COUSINS AND DEMOSS (RECORDED NEW YORK NOVEMBER 14, 1995); NO. 942, "DIXIE", WITH PARTISAN LYRICS, BY GEORGE G. GASKIN (WASHINGTON D.C. OCTOBER 14, 1896); NO. 670 "VIRGINIA CAMP MEETING" BY GEORGE GRAHAM AND BILLY GOLDEN (WASHINGTON D.C. MARCH 8, 1997) CONTAINING THE FIRST AUTHENTIC AMERICAN RELIGIOUS MUSIC ON RECORDS; AND NO. 0730, "A DAY IN A COUNTRY SCHOOL" BY GEORGE GRAHAM (NEW YORK NOVEMBER 15, 1999) WHICH INCLUDES A UNIQUE RECORDING OF CHANTED MATHEMATICAL PROBLEMS.

DURING THE EARLY 1900'S A NUMBER OF RELEASES WERE MADE, THE MOST FAMOUS BEING UNCLE JOSH'S UNACCOMPANIED "FROG WENT A COURTING" ON THE COLUMBIA, VICTOR AND EDISON VERSIONS OF "A MEETING OF THE SCHOOL DIRECTORS", ALSO BILLY GOLDEN'S SEVERAL CUTTINGS MADE AT THAT TIME OF "ROLL ON THE GROUND" AND "RABBIT HASH" HAVE VERY FULL TEXTS OF THESE WELL KNOWN SONGS.

THE MODERN ERA OF FOLK MUSIC RECORDING BEGAN SHORTLY AFTER WORLD WAR I WHEN RALPH PEER, OF OKEH RECORDS, WENT TO ATLANTA WITH PORTABLE EQUIPMENT AND A RECORD DEALER THERE OFFERED TO BUY 1000 COPIES IF PEER WOULD RECORD THE SINGING OF CIRCUS BARKER 'FIDDLING' JOHN CARSON. "THE LITTLE OLD LOG CABIN IN THE LANE" AND "THE OLD HEN CACKLED AND THE ROOSTER'S GOING TO CROW" WERE CUT, AND ACCORDING TO PEER "IT WAS SO BAD THAT WE DIDN'T EVEN PUT A SERIAL NUMBER ON THE RECORDS, THINKING THAT WHEN THE LOCAL DEALER GOT HIS SUPPLY THAT WOULD BE THE END OF IT. WE SENT HIM 1,000 RECORDS WHICH HE GOT ON THURSDAY. THAT NIGHT HE CALLED NEW YORK ON THE PHONE AND ORDERED 5,000 MORE SENT BY EXPRESS AND 10,000 BY FREIGHT. WHEN THE NATIONAL SALE GOT TO 500,000 WE WERE SO ASHAMED WE HAD 'FIDDLING' JOHN COME UP TO NEW YORK AND DO A RE-RECORDING OF THE NUMBERS. MR. PEER INVENTED THE TERMS "HILLBILLY" RECORDS AND "RACE" RECORDS. CONCERNING THE LATTER HE SAYS: "WE HAD RECORDS BY ALL FOREIGN GROUPS: GERMAN RECORDS, SWEDISH RECORDS, POLISH RECORDS, BUT WE WERE AFRAID TO ADVERTISE NEGRO RECORDS, SO I LISTED THEM AS "RACE" RECORDS AND THEY ARE STILL KNOWN AS THAT." UNFORTUNATELY THESE UNPLEASANT TERMS ARE STILL USED BY SOME MANUFACTURERS.

ONLY THROUGH RECORDINGS IS IT POSSIBLE TO LEARN OF THOSE DEVELOPMENTS THAT HAVE BEEN SO CHARACTERISTIC OF AMERICAN MUSIC, BUT WHICH ARE UNKNOWABLE THROUGH WRITTEN TRANSCRIPTIONS ALONE. THEN TOO, RECORDS OF THE TYPE FOUND IN THE PRESENT SET PLAYED A LARGE PART IN STIMULATING THESE HISTORIC CHANGES BY MAKING EASILY AVAILABLE TO EACH OTHER THE RHYTHMICALLY AND VERBALLY SPECIALIZED MUSICS OF GROUPS LIVING IN MUTUAL SOCIAL AND CULTURAL ISOLATION.

THE EIGHTY-FOUR RECORDINGS IN THIS SET WERE MADE BETWEEN 1927, WHEN ELECTRONIC RECORDING MADE POSSIBLE ACCURATE MUSIC REPRODUCTION, AND 1932 WHEN THE DEPRESSION HALTED FOLK MUSIC SALES. DURING THIS FIVE YEAR PERIOD AMERICAN MUSIC STILL RETAINED SOME OF THE REGIONAL QUALITIES EVIDENT IN THE DAYS BEFORE THE PHONOGRAPH, RADIO AND TALKING PICTURE HAD TENDED TO INTEGRATE LOCAL TYPES. VOLUMES 4, 5, AND 6, OF THIS SERIES, WILL BE DEVOTED TO EXAMPLES OF RHYTHM CHANGES BETWEEN 1890 AND 1950.

SAMPLE CATALOGUE ENTRY

NUMBER OF RECORDING IN THIS SET.

INFORMATION FOUND ON ORIGINAL LABEL

CONDENSATION OF LYRICS

GENERAL NOTES.

LIST OF RECORDS REFERRED TO

LIST OF BOOKS REFERRED TO

00

THIS LINE GIVES THE TITLE (OTHER DATA FOUND ON ORIGINAL LABEL)
THIS LINE GIVES THE ARTIST
THIS LINE GIVES THE INSTRUMENTATION
RECORDING DATE
ORIGINAL ISSUE NUMBER (MASTER NUMBER)

FOR THE BALLADS (NOS. 1 TO 27) THE TEXTS ARE REDUCED TO A FORM SIMILAR TO THAT OF A NEWSPAPER HEADLINE. FOR THE DANCES, RELIGIOUS SELECTIONS, AND SONGS (NOS. 28 TO 84) THE KEY WORDS AND PHRASES, AND TRADITIONAL ELEMENTS ARE CONDENSED AND PRINTED IN THE SAME ORDER THEY OCCUR IN THE SELECTION REFERRED TO.

INFORMATION, OTHER THAN THAT FOUND ON THE RECORD ITSELF, IS PRINTED HERE. FOR FURTHER DATA CONSULT ITEMS LISTED IN THE BIBLIOGRAPHY

DISCOGRAPHY: RECORDS LISTED HERE, UNLESS OTHERWISE STATED, ARE OTHER IMPORTANT RECORDINS OF THE SELECTIONS IN THIS SET.

BIBLIOGRAPHY: THE NAMES SUCH AS ARNOLD, BARRY 1, ETC, REFER TO THE KEY WORDS PRINTED BEFORE EACH ENTRY IN THE CONSOLIDATED BIBLIOGRAPHY. FOR EXAMPLE, ARNOLD— 60 MEANS THAT ON PAGE 60 OF ARNOLD'S FOLK SONGS OF ALABAMA A REFERENCE IS FOUND TO THE SELECTION REFERRED TO.

Harry Smith, foreword to liner notes for the *Anthology of American Folk Music* (Folkways Records, 1952). Smith both edited the anthology and authored its elaborate handbook of liner notes.

JC: Why?

HS: You have to realize that I'd been studying anthropology at the University of Washington so I had an interest in that sort of thing. I didn't know what I was going to do with them. They were like very nice abstract designs. I tried to get her to name certain designs which she thought resembled certain songs. She didn't understand me or what I was trying to say. It was some kind of a Rorschach response-like thing. She'd say, "Well that one is called Field of Diamonds, I guess that's like Diamonds in the Rough." I always took 5 by 7 pictures.

JC: What was your intended use for these correlations between song titles and quilt designs?

HS: Oh, some kind of compulsive activity. I don't know what the source of it would be. If you interpret things by some kind of neo-Freudian interpretation, it can be said to be a compulsive act, like a development out of making mud pies, they're a development of something worse, or better, whatever it is. But collecting records...I really don't know. I don't believe I liked the Carter Family singing too well until later. Of their recordings, I liked the first session they made the best. The room tone is more natural.

JC: I'm interested in why you would inflict this kind of test on Sarah Carter.

HS: It was like a way of investigating something. It was just what I might have been doing with the Indians at the same time. Before I got interested in record collecting, I got interested in the Indians. When I was in the fourth or fifth grade, someone in class said they'd been to an Indian reservation. This was in Anacortes, Washington on an island. It was only settled during the 1890s. My grandparents were there when there were hardly any white people there, if you want to classify people by color. So in school they said they saw somebody doing a dance, swinging a skull around. They gave their report on this in class. So I thought I had to go to that, and it was really impressive. It was a very good time to see Indian dances. And I made a lot of recordings there which unfortunately disappeared with everything

else I had. But they may be somewhere. By the time I was in high school, being as the school bus went to take people back to the Indian reservation, I would usually ride out there after school every day. So that was a continuous project over a long period of time.

JC: You were studying their visual patterns as well?

HS: Everything I could think of. I took photographs and made recordings, collected string figures and anything I'd seen in the standard anthropology books about what was liable to be the culture elements in that area. It was something to do. I presume it was because I was leading an isolated life. I mean we were considered some kind of a "low" family, despite my mother's feeling that she was the Czarina of Russia. We were living down by the railroad tracks, and I only realized a month ago that probably the rest of the people in town looked down on us. There were other odd types who lived along this railroad line. My parents came from good families. My great grandfather was the Governor of Illinois, my mother came from a long line of school teachers in Alaska.

JC: Someone once told me that you were thinking for a while that your father might have been some English Mystic who was traveling through.

HS: That was Aleister Crowley, and as a matter of fact, my mother did know Crowley at about that time. She saw him running naked down the beach. Perhaps in 1913 or 1915. I wish I had gone more into the chronology of my antecedents.

JC: But he's not your father.

HS: I don't know.

JC: Oh, you mean there's a possibility?

HS: Sure. I suppose there's a possibility that President Coolidge was. Because of my father and grandfather's interest in mysticism, the basement was full of books on whether Bacon wrote Shakespeare's plays, alchemy and so forth. I had a whole blacksmith shop.

I spent a lot of time trying to transmute lead into gold. My father was in the salmon fishing business and during the war they fished the rivers dry, so the canneries closed and that was my playground as a child.

JC: Was it your interest in the color patterns of the Indians which you transferred to Sarah Carter?

HS: Well, I made films at that point, the earliest abstract color films, which preceded meeting Sarah Carter.

JC: Had you seen abstract color films before? Why do you think you made them?

HS: I didn't have a camera and I wanted to make a movie, so somebody said why not draw on the film. It seemed like a good idea. I believe it was trying to find out about those designs. I wanted to find out if there was any correspondence between certain color patterns and certain sounds. It's a natural obsession not only with me, but with Sir Isaac Newton or somebody…Ostwald. They all try that business. It turns out to be a complete fantasy. There is no one-for-one correspondence between color and sound. I was looking for rhythmic designs to put into the films, which at that point were based on the heartbeat, the speed of the heart, which is about 72 beats per minute, and the respiration which is about 13. Then when I saw patchwork quilts, they looked like hand-drawn films, and I wondered if they could be transferred. There are a lot of reasons why I did that. It was partly because we were in the Mother Lode country. There wasn't much to do, to occupy the day.

* * *

HS: I don't recall the exact number of records I had. I think it was two thousand records which had been cut down from twenty thousand at one point. They were so piled around that it was impossible. There was no way of listening to them, but you didn't want to skip anything that might be good.

JC: What was the condition of your housing in California? Was it then as it is now? Working with movies, Indian Art and anthropology all at the same time.

HS: It's all the same thing. I gave a few lectures on jazz at the University of California. I was living in Berkeley. I did the work in the yard, like mow the lawn. It looked worse after I was through with it. Then I ruined the room making movies in there; I got ink and paint on everything. I was trying to record jazz bands there anyhow. Someone sat on the washbasin and ripped it off the wall and caused a flood. Upstairs lived Doctor Bronson, who had some good records. He tried to be nice to me. I didn't realize he was a great thing at that point. He tried to play the violin to illustrate some obscure point and I was sort of eeegh…I didn't know what to think. But he did have these few records, like Buell Kazee. I waited until he was out of town lecturing, and traded his wife some other records for them. He really hit the ceiling when he got back. But I did give him some good stuff. He eventually liked it. See, I had two copies of B.F. Shelton's "Pretty Polly." It was scarce, and he sings better than Buell Kazee, so I thought why doesn't he take it. Now I'm sorry I didn't find out more about Bronson's theories of whatever it is. Something like glottal-chronology, only applied to music.

JC: Were you interested in folk music as such, or folk music as part of something else?

HS: As part of something else, but I wouldn't know what, though. It has something to do with the desire to communicate, in some way, the collection of objects. Now I like to have something around that has a lot of information in it, and since then, it seems to me that books are an especially bad way of recording information. They are really an outmoded thing. Books aren't very old anyhow and Gutenberg wasn't that long ago. Now everybody is tossing paper in such masses that it's all over the street. So I've been interested in other things that gave a heightened experience in relation to the environment. Some people are nature lovers, some become export bankers; however I presume that all these are methods to communicate according to the cultural background that they have. So I am interested in getting series of objects of different sorts. It's a convenient way of finding information,

for whatever use. It does seem apparent since I started collecting records, that there are definite correlations between different artistic expressions in one particular social situation, like a consistency in using small lines in aboriginal Australian art, and the music is the same thing, short words. It may be connected with language. My recent interest has been much more in linguistics than it has been in music, because it's something that can be satisfactorily transcribed, whereas I haven't seen satisfactory transcriptions of music.

JC: The means of measuring folk music are inadequate?

HS: There is no interest in it. The needs of folk music are met by nothing more than reprints of earlier books on the subject. Occasionally there is a good book with good transcriptions from the American Indians or from Africa. It depends on the cultural contact, the reason for doing the thing. By the time that phonemics had been developed, to the point that it would have been possible to transcribe folk songs, there was no money-making reason to do it, for after all, the purpose of making books on folksongs is to make money. Everybody has to eat. We're all trapped in a social system where you have to do something to provide food and shelter. I thought for a while that drinking got me out of food and shelter, but it's a way of living that is pushed underground. Thousands and thousands of derelicts.

JC: I've heard people accuse you of living off others, of trying to disregard that whole concept of doing things that would earn your living. You've bothered me, my friends, and others, in the sense that you don't accept the fact that you have to earn money to be a fruitful part of society. Now that's a hard thing for me to say.

HS: Certainly, I've said it just before you did. Naturally that situation exists. There are certain ways you can evade that responsibility, but it's like the wages of sin is death. I try not to do that. I've reformed, but the strain on the poor fevered brain, of adjusting to capitalism after years of being a sort of Robin Hood type...

JC: I'm trying to translate your analogy now in terms of your own work. Of what value is your work to society, Harry?

HS: It's provided tunes that people made things off of. Now at this point there is a whole school of film makers that imitate some of my films. They phone me constantly to say they're making a film like that. They want to thank me. That type of film is a good idea; you don't care what happens really, you just shoot anything on top of anything and that solves problems. I haven't wanted to do anything that would be injurious. It's very difficult working out a personal philosophy in relation to the environment. Consistently I have tried different methods to give out the maximum. Some Czechoslovakians who visited recently looked on my films as outstanding, while nobody here thinks very much of them. Or what's his name, Godard, asked especially for me when he visited town, et cetera et cetera. So one of the things I've done is films, and I believe I added pleasure to people's lives through that. When I was interested in music, the simple fact of collecting new copies of a lot of records that will be important in the future is as valuable as anything.

After I assembled the *Anthology* and sold the remaining records to the Public Library, that was the end of that project. Then I devoted a great deal of time to painting, but through mischance I destroyed all of my paintings, and I abandoned my films somewhere in a theater because I didn't want to see them again. Somebody got a hold of them, and made copies and when I wanted better copies I got interested again. I try to bring people together.

JC: There were clues about yourself on the *Anthology* which have eventually been deleted. For instance, today the album cover shows a Depression photo of a southern farmer, whereas the cover of the original presented a list of the material printed over a background in subtle colors which was...

HS: It's a Theodor de Bry drawing out of Robert Fludd books...

JC: A hand coming from the clouds tuning this dulcimer...

HS: Monochord. Like something or other tuning the Celestial Monochord; it's forming earth, air, fire and water and the different astrological signs.

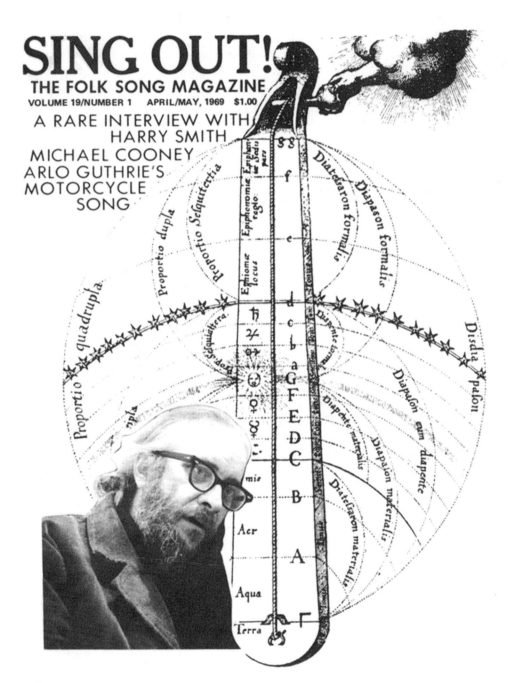

Cover of *Sing Out!* magazine, Volume 19, No. 1, 1969. (Courtesy of John Cohen.)

JC: You picked these out as the background for the *Anthology*?

HS: There were to be four of them, and four volumes to the first series. Red, Blue and Green were issued, so that the element that was left out was earth. The type of thinking that I applied to records, I still apply to other things like Seminole patchwork, or to Ukrainian Easter eggs. The whole purpose is to have some kind of a series of things. Information as drawing and graphic designs can be located more quickly than it can in books. The fact that I have all the Seminole designs permits anything that falls into the canon of that technological procedure to be found there. It's like flipping quickly through, and it's a way of programming the mind, like a punch card of a sort. Being as it goes in through the vision, it is more immediately assimilated than if you have to listen to a two-minute record. Besides, you can pretty much find the records a person would like on radio; there is a sort of correspondence between what is popular and what is immediately satisfying.

HS: Before the *Anthology* there had been a tendency in which records were lumped into blues catalogs or hillbilly catalogs, and everybody was having blindfold tests to prove they could tell which was which. That's why there's no such indications of that sort (color/racial) in the albums. I wanted to see how well certain jazz critics did on the blindfold test. They all did horribly. It took years before anybody discovered that Mississippi John Hurt wasn't a hillbilly.

JC: To my mind, the *Anthology* anticipated the popular Rock & Roll music which followed. Many Rock musicians are returning to those sounds. To me, today's music seems like an extension of the music on the *Anthology*.

HS: That's what I was trying to do, because I thought that is what this type of folk music would lead to. I felt social changes would result from it. I'd been reading from Plato's *Republic*. He's jabbering on about music, how you have to be careful about changing the music because it might upset or destroy the government. Everybody gets out of step. You are not to arbitrarily change it because you may undermine the Empire State Building without knowing it.

JC: You once told me of your many new plans for Volume 4 of the *Anthology*.

HS: The real reason that it didn't come out was that I didn't have sufficient interest in it. I wanted to make more of a content analysis. I made phonetic transcriptions of all the words in the songs, but those notebooks got lost. The content analysis was like how many times the word "Railroad" was used during the Depression and how many times during the war. The proportions of different words that might have some significant meaning beyond their exterior. Certain ideas becoming popular, the word "food" was used increasingly in the record catalogs during the Depression. I finally analyzed the catalogs rather than the records, because you can't do anything with such a small sample as there are in that set.

JC: To me the *Anthology* was more of a statement of interrelationships than a sampling.

HS: Well, the problems that were involved in those interrelationships have been solved since then, so there is no particular reason to bring those records out. They aren't as relevant and there isn't as great a possibility of them doing good, as certain other things might. Like I have all these recordings of the Peyote ritual, the Kiowa Indian music that I recorded in Oklahoma. (Its release has been held up for years because I haven't completed the cover.)

JC: Besides the films, your recent projects and recordings have all been with American Indians.

HS: Consistently. When I was in Oklahoma, I realized that it was possible to perform some kind of saturated study of something. It just happened that it was with recordings, although I went there to make films. It just happened that people were much more musical than the situations were photogenic. The Seminole project grew out of that but I didn't record their music. Then the egg business grew out of the Seminole stuff. The problems that I'd set myself on have to do with correlating music into some kind of a visual thing, into some kind of a diagram. It was much simpler to skip the music entirely and study

diagrams that had already been made. Being as my essential interest in music was the patterning that occurred in it (intuition or taste only being a guide to directions where this patterning might occur) it was just as well to collect some other object. I'm sure that if you could collect sufficient patchwork quilts from the same people who made the records, like Uncle Dave Macon or Sarah Carter's houses, you could figure out just about anything you can from the music. Everything could be figured out regarding their judgment in relation to certain intellectual processes. Like certain things sound good to a person in music, certain things look good to the eye. And at some level those two things are interconnected.

JC: Looking at the various projects you've been working on, with their visually bright-colored patterns, I see a progression of geometric designs from bold patchwork quilts to Seminole designs with small patterns, and even more intensely so in the Ukrainian eggs. My mind makes an associative jump to what has become psychedelic posters.

HS: I've drawn things like that, but so have others.

JC: In some ways, your drawings remind me of drawings done by young men and women on drugs. They were from Paris, shortly after the war. They had the same attention to details.

HS: Oh, those were like psychedelic paintings; those people had taken mescaline or something. I suppose precision art is like amphetamine art. Basically it's like staring at little tiny things. You can make millions of circles. I don't particularly like that effect because it takes too much time to get something meaningful. You probably think I'm precise but it tricks the eye.

JC: I remember in a printed catalog accompanying an evening of your films, it mentioned different drugs that were involved in the production of each film.

HS: At different points of my life I've taken some kind of drug or other. Naturally I've taken them for many years. The first one of those that became available was Peyote. I first took it on the road

just outside Sarah Carter's auto court. I wasn't sure if the top of my head wasn't going to fly off. Someone had bought the proper type of cactus in the floral department of a department store in San Francisco, so we ate it. Anything that changes the consciousness to a degree I think is useful. I presume it's a schizophrenic thing on my part, but it is helpful to be able to look at something that you have made, as if you hadn't made it. By the time a person makes a drawing or anything, so much time has been devoted to it that you're conscious of what's involved in it. Probably any drugs are helpful, even alcohol.

JC: Peyote gets one involved with the colors. What about some of the other subtleties of the states of mind that are available?

HS: I've tried different drugs as they became available. The results have been well investigated and they fall into a few categories. Some, like peyote cause visual hallucinations. LSD, which is similar in many ways, causes hallucinations of destruction.

JC: Did you ever work on a film under LSD?

HS: I made films after that, and naturally I used any information that had been gained. But if you're taking LSD you'd probably get your fingers caught in the gears. That sort of drug is really to gather data, possibly freeing the mind or for euphoric effects, or expanding it. Ed Sanders recently said that what is needed is a consciousness *contracting* drug. The mind is too expanded. Psilocybin (from mushrooms) is interesting because it's described in transcripts from the Aztecs a few hundred years ago. It would be interesting to see if it still produces the same effects. It would make you think, I would say. I don't like drugs that put me to sleep.

JC: I'm curious as to how many different ways there are of seeing things.

HS: Well, all those things tend to some sort of euphoric effect, but certain cases like nitrous oxide are notorious for giving people the feeling that they've solved the problems of the universe and boiled it down to one word. In fact, the person who invented it, Humphrey

Davy, thought it did that for years. It was only discovered much later that it was an anesthetic. For the varieties of experience, I don't think any serious research has been done. Just teams of scientists converging on San Francisco. But most cultures seem to use some sort of a mood-changing thing. I don't think there are any new inventions along that line. You know they were constantly taking LSD in France in the bread by mistake. Ergot gets in it and the whole town goes crazy. For thousands of years, it's been inherent in the baking of bread that it gets ergot, and panic sweeps over the place. I saw an article where they tie up the fact that revolutionary movements or peasant revolts in central Asia and Russia since 1400 have occurred during a shortage or famine.

* * *

HS: It seems that all human types occur everywhere and the releases are about the same. There's usually something that acts as a hypnotic, like alcohol or opium. Other things produce visions. Actually the two opposites are right in Peyote; it's strychnine and mescaline. I do think drugs are an important aspect of research into whatever I'm doing research into. It's like a way of greasing the mental processes to a degree. Now some of these things are supposed to be bad for you. I should say though, that most drugs taken over a period of a few hundred years in any culture probably aren't harmful. And that would include things of all categories, because things like Kava from the Pacific, and Pituri from Australia, Datura in this country (it's jimson weed, a hypnotic formerly used by the California Indians) are all hallucinogens. Depending on the social atmosphere of a particular time, they're either considered good or bad.

JC: I've noticed that hypnotic dancing often occurs in association with a musical drone. This seems to be part of the trance that one sees in both white and Negro Holiness churches.

HS: Is that what the doctor is trying to cure me of; breaking into dance and speaking in tongues? I don't think it's particularly valuable to investigate that. The thing that's interesting in those places is the personality of the individual, because the major message that has to

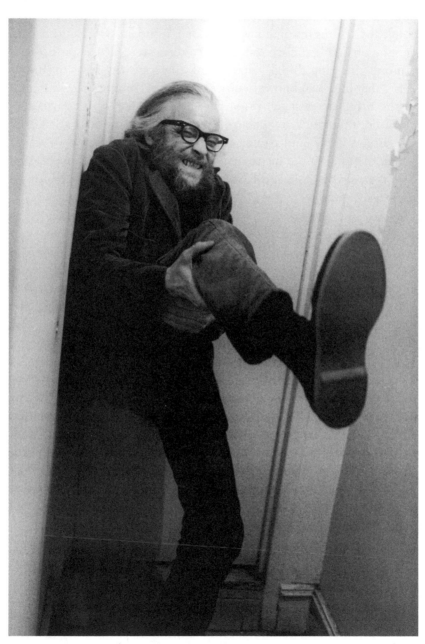

Harry Smith at the Chelsea Hotel, New York, January 1, 1969. (Photograph by John Cohen.)

be brought across to people is that everybody is thinking the same, although the stuff that is passed down or inherited determines the things that are thought about. The thought processes are all the same. The study of local trance dances doesn't really fit the existing situation as far as music exists in different parts of the world. It's more important to let other people here know that Africans can produce good music, than it is to study the history of these things. These problems are eminent to the survival of mankind. Soon they'll be fighting about who owns the moon. A direction has to be given to types of studies. What was this in connection with?

JC: Do you think that an effect similar to drugs could be found in trance dancing throughout the world?

HS: I don't think there is such a connection. I think all of these cultures would use some sort of drug, the major types. The hallucinating types are more widespread than the hypnotic types. But because of the power of Europe, the hypnotic drugs, mainly alcohol, have been dragged all over. I don't know how it is determined that a person is advancing in a trance anyhow, for there aren't any stable criteria for that. It's socially acceptable in Holiness churches, but it's a very strict thing. I mean if they start stripping their clothes in their trance, they are going to be in possible trouble. I don't see that much connection between people in different parts of the world going into trances. It all depends on the upbringing of the anthropologist, how deeply imbued he is with the Puritanical background of the societies that produce anthropologists, which are pretty limited. It's a pretty specialized thing to study trances. It's astounding that people can be supported to do that.

JC: Are you supported to do what you do?

HS: Pretty much. People keep giving me money. Foundations would, but they don't give enough. They are always dissatisfied with me for not doing enough. Given the amount of labor to get a few thousand dollars from a foundation, it's simpler to get it from somebody who will deduct it from their income tax.

JC: Izzy Young once explained to me how you'll go to him to borrow a dollar from him to get to where you can borrow ten dollars, to get to a train to Philadelphia to borrow a hundred thousand dollars.

HS: Yes, the chain usually breaks down with Izzy. He refuses the dollar so the whole two hundred thousand is lost. That's typical. I'm supported well for what I want. I want a limited amount of things.

JC: An involvement of yours which we haven't yet discussed is the string games.

HS: Every few years I get interested in string games, but I don't have all the apparatus for doing it.

JC: Don't you just need a piece of string?

HS: No, no. You need the instructions. I'm writing a book on the subject, thousands of pages of it are written but it has to have the references corrected, etc.

JC: What is it that you saw in the strings?

HS: Oh, it was some universal thing that seemed to be more widely distributed than anything else in places that didn't have so called "civilization." It was the only thing that I could isolate offhand that was produced by all primitive societies, and by no "cultured" societies. For example, string figures are found everywhere in the world except Europe and Asia (except for a few peripheral areas like the hills in the Philippines and Scotland). None of the places like France, Russia, Japan, China, Turkey have string figures, despite a great interest in games. It is a bit difficult to understand how the same thing is done in Patagonia as is done within the Arctic Circle or the Kalahari Desert, without leaving some evidence in Europe and Asia. I've had various theories for that; possibly it has to do with the parts of the brain that memorize letters (which usually seem to be around thirty or fifty and the things you have to learn to write a language) because string figures don't occur in a place where writing is done. It's a way of tying together a lot of diffuse areas. Unfortunately, there aren't that

many good collections. There may be pictures printed, but you have to have the instructions as well.

JC: What do you see in a figure?

HS: It depends on where it's from. Some places make realistic figures, like the Eskimos who make complicated, realistic, asymmetrical figures, whereas most of Micronesia and the Australian figures would be geometrical and are consequently named after flowers and stars and things. The techniques developed in these places are suitable for such geometric figures, while those of the Eskimos are for realistic animals, birds and people.

JC: I remember that some of the Eskimo strings act out little dramas, like a house falling down and the man running away.

HS: That occurs everywhere. The reason that there is a lot of drama in the ones from the Eskimos is that it was a carefully made collection. Anywhere that a careful collection is made (which would take a number of years to do in any place) there would always be moving figures. The other oddity is that the string is always the same length, no matter where it is, and that only one person does the string figures. Something similar to the string figure, but not in any way connected, is the cat's cradle which is done all over Europe and Asia. The cat's cradle is a game while the string figures are essentially pictures of something. They do have many other uses in the cultures concerned. My interest in them is merely as something that a lot of people did who are usually lumped together as being primitive. The distribution of anything else isn't the same, such as the bow and arrow, pottery, basketry or clothing, or any kind of conceptions. As far as I know the string figures are the only universal thing other than singing. But singing may exist universally for the same reason, such that a lot of experiences are lumped together as songs which probably aren't. Like tonal languages, as in Yoruba, lots of things that were identified as songs turned out to be poetry that is recited at a certain pitch. Or a Seneca thing which is spoken but because it's transcribed from a tape recorder, it is possible to indicate what tone each word is sounded on. Because of this possibility of transcription from tape

recordings it becomes very difficult to determine where speech ended and singing began. It is an artifact of the technical methods of handling the productions of peoples' vocal chords that classifies certain things as songs, and it may be the same way with string figures, they may have derived from many different sources.

* * *

JC: Another large area of interest to you is the occult and magick. You said your parents were involved…

HS: I'm not so interested in that any more. Those things were current during the 1890s. Different types of the occult, like supposed secret knowledge handed down, seem to occur only at the end of every hundred years. There is an interest in those things now, but it isn't anything like it was in 1890, and it will probably be bad again until the year 2000. By then, I presume, people will become exhausted attempting to find happiness out of technological means, and then they will move on to some other methods, like superstitious and metaphysical means. It's a kind of pendulum that swings. It basically has to do with the contact of large land masses: in Europe there is an habitual interest in mechanics and such, probably even prehistorically. In Asia (at least looking from the European standpoint) there is more mystical interest. So it swings back and forth and the people in between are crushed in the ensuing crusades, flower power riots or something.

JC: Yes. How do you view what's going on in popular culture in the past few years?

HS: I think it would be a good thing if it were to operate. It's the only salvation for society. You see, things still exist where individuals can produce enough food. The population situation hasn't got entirely out of kilter yet. It would seem that the world is going through a kind of disillusionment with machinery which obviously doesn't work very well. I think that turning back towards individual food production is about necessary. You probably don't believe that, for it is counter to the idea of having a city of the future with rocket ships all over the place, and everybody with their own helicopter and taking

injections to teach them mathematics. I would prefer to see this technological thing knocked out, because all the things I'm interested in, like singing, poetry, painting and stuff can all be done just as well without this large number of can openers, egg beaters, Empire State Buildings and things. I would like to see smaller communities that are self-supporting spring up. There was a movement towards that in popular culture, like the Diggers. It seemed to be holding out some hope for the future. A generation growing up, disillusioned with the possibility of the hernia cure being universally distributed. It may be healthier to live a life less concentrated, because of this terrible problem of living in the city and having to get money to live in the city. I'm trying to found new sciences, to entirely overhaul anthropology and turn it into something else. I have to depend on psychopaths to pay for that kind of research. Unfortunately the movements like the Diggers have been defeated. What is happening seems bad.

JC: Is it related to what happened in politics last summer?

HS: Partially. That brought the ideas home a little, although it was also disillusioning that so many apparently intelligent people could have any faith in politics. Yet there was some protest against the general notion of politics. I don't know whether presidents are elected on the basis of popularity or whether social processes put them in, for the same cycles seem to be gone through for a long time. For a while it seemed to be due to increased communication, and especially getting off the earth seemed to make it possible to have some kind of a worldview. Just the mere fact that you can open a *Life* magazine, which I wouldn't advise (though I'd rather look at *Life* than *Sing Out!*), and there's a picture of the Earth taken from the sky, makes the Amazon and the Congo seem closer. It makes it simpler to think of something like string figures, or (what I'm interested in) linguistics, mythology, and to see those things as units, simply because the Earth literally became smaller. Positive values can be seen in more agrarian-type societies, or whatever they are, anarchies. Those self-supporting societies have a lot of advantages; diseases don't spread easily from one to the other, etc. But I would say that things are probably going to get more strict and anti- those ideas for a while now, until the whole thing blows up.

JC: Can you tell me something about that collection of decorated eggs which occupies a corner of your room?

HS: The eggs are very interesting. There are certain reasons that people make them, but which I don't know precisely.

JC: Do you think it's related to the Seminole patchwork quilts?

HS: No. It's naturally different because the designs are painted on something, whereas the quilts are cut, and have other structural possibilities. Something about an egg leads to certain types of thought, evidently, and the same type of eggs have survived for very many years. By chance these thirty people who make them in America were displaced from the Hutzle Hills to camps in Poland, then sent to Germany, and a lot of them came to Canada and this country. These eggs were originally given only to a certain type of dance to help the husband determine which girl he wants to marry. I suppose the people who make them now lost their husbands. It's a psychopathic activity where a great deal of effort is put into something that can't be sold for anything. Each egg is different (absolutely no two alike) though there are certain basic types. I've been working on the egg thing intensely for three years now. I've gone through about 29,000 eggs, and have kept notes on each one. A rotten egg is about the most transient medium, it is about the most difficult thing to paint on and the whole thing is liable to explode violently in your hand at any second. Some of the best ones are made by a lady and her daughter who make about four dozen a year, and it requires all of their time to do that. The eggs, and the subject matter on them, are connected with the Shamanistic religion. I got one that had the rainbows woven into ladders separating the underworld from the upper world. The number of these eggs that are made keep certain monsters chained up somewhere. This has nothing to do with their function here, which his changed.

JC: Do you find any of those superstitious qualities in the designs from the Seminole?

HS: There are a limited number of Seminoles, and a limited number of ways a piece of cloth can be ripped and put back together; it is ripped by Seminole measuring methods. Also the sewing method can only produce certain angles. This type of design, turned at an angle and made of stripes, only developed about 1942, and being that everybody who made this stuff was saving samples (in case they wanted to make the same one again) it was possible to do an archaeology by going through a barrel of stuff one lady had. Without too much effort, it was possible to collect all of the Seminole designs. It is different with the Easter eggs because they are done in secret, and for sale. Originally they were done by farmers' wives, and they probably still are, but now they're made to sell, so the price has gone up, the quality has gone down, and nobody is learning to make them. What I've been interested in are unconscious developments of cosmographic notions that appear on the eggs, so I haven't had to know the people who made them, though I do have a general idea of where they live. One man I did know wasn't good and he tried to make some because he rented himself out to demonstrate Ukrainian folk art. His eggs were interesting mainly because he classified them; he told me things and gave certain ideas, but he died.

* * *

JC: I am curious as to why you feel that your recent Peyote ceremony recordings from Oklahoma are more important today than the *Anthology of American Folk Music* albums.

HS: Because of the fact that the method of commenting on music has improved. Somehow, the performance of music has to be removed from phonographs and radios and such, because those require a technological development of a high order, and constantly cannot help but suppress somebody. It's better to have people singing, and get more people singing then to have more radios, as far as music is concerned. Naturally, for information, you have to get it over the radio or telephone. I wanted to clear that up: why the *Anthology* is outdated.

Generally speaking, philosophy has progressed farther and everybody knows more regarding the evaluation of abstract ideas, so as much can be got out of listening to radio now as could formerly be

got out of listening to records, because it's possible to appreciate things that are closer to you. Previously, the *Anthology* was appreciated as a curiosity, but now people can get involved with a great variety of music. The Peyote record is important because it represents some kind of a comparable breakthrough, in that someone was willing to pay for such an elaborate exposition of a very obscure subject. I didn't go to Oklahoma to record the music, I went to make a movie, but got separated, and I wanted to collect some kind of data, there was so much around. Most physical objects were too expensive or too large to handle, so it occurred to me to make records because everyone was singing anyhow.

JC: This was when you were in jail in Anadarko?

HS: No, in the months succeeding that, although the first descriptions that I heard of the Peyote ceremony, or the signs of it, were in the jail. There were many paintings on the jail walls, all over it. Even Hopi drawings, certain scenes from the Peyote ritual, pictures of the altar and the people in there described it to me. I met a social class that I wasn't familiar with. I never found out exactly the original reason for arresting me. The method of commenting on music is what is important on the Peyote album. All the business of reference to books is outdated. I hope the project leads to some sort of understanding of cross cultural phenomena, or something.

JC: How about the whole new inclination of the hippie kids towards Indians and Peyote, etc.

HS: I hope they buy the records.

JC: Why are they looking in that direction now? You've been doing it for years. Do you feel any connection there?

HS: I saw a picture of Dr. Boaz taken in 1880 or 90. He looked exactly like a hippie; he had a pea coat and a beard. He was 24 or 25 when he first visited the Kwakiutl and I thought there might be a connection but there isn't. There always seems to be a recurrent romanticism regarding the Indians. It's due now to the shortage of Buddhist

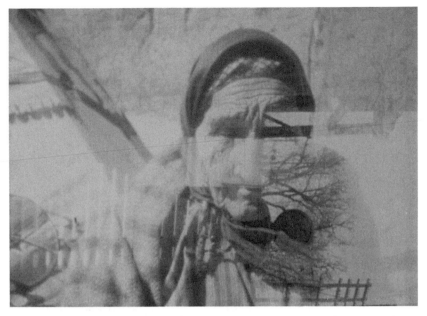

Still from Harry Smith's *Film #14: Late Superimpositions*, 1964. (Anthology Film Archives.)

headdresses. I've only occasionally run into any hippies who had much to say about the Indians. For a while they were naming cars after Indians, Pontiac, etc., and then there were Indian songs, Buell Kazee singing Little Mohee. I assume that most people who hold this interest will change, just as at any other time there's a great number of Bohemian types interested in art. Fortunately they don't continue on that form of life, or the government would not have survived as long as it has. I'm designing record covers for the Beatles' new record company. All my projects are only attempts to build up a series of objects that allow some sort of generalizations to be made regarding popularity of visual or auditory themes.

JC: In other words, you're just presenting the material from which someone else can draw their own conclusions?

HS: I hope to live long enough, if I survive this interview, to devote my declining years to writing about these things. I want to make sure of some points. It doesn't look like I'll make it, though. I'm leaving it to the future to figure out the exact purpose of having all these rotten

eggs, the blankets, the Seminole patchwork I never look at, and records that I never listen to. However, it's as justifiable as anything that can be done, as any other type of research, and is probably more justifiable than more violent types, like fighting with somebody or becoming an export banker. It is a way of fooling away the time, harmlessly, as much as possible. It's like a non-violent thing. If somebody comes in and wants to become violent, I warn them about the $5,000 worth of rotten eggs, which are liable to explode. There's to be no violence around here.

JC: To me, your movies fall in the realm of art, while the records are concerned with things between popular and folk culture.

HS: Movies are a different thing (they are a technological thing), more than music is. Anybody who listens to music can buy a guitar for eight dollars, and learn to play it and sing with the thing, at least sufficiently to please themselves and a few friends; whereas to make movies of the same subject is ridiculous, nobody would do it. So naturally my movies are made as a kind of final gesture towards film. They've just about run their course. There's no reason to have movies anymore because life is much more horrible and adventurous and everything. Movies are a sort of a sin; it's connected with graven images, looking at films or any type of art. My films are more or less educational; I've never done much with them as far as elucidating what the subject matter is, but they are like the basic rhythms that are in music. It's also a way of making money, more than with the Folkways anthologies which are a financial loss. I spend millions on these things and though they never pay for themselves, the films do give a little money. I don't want to make those things to entertain other people unless it is fairly costly. Some of my films are the most expensive ever made. One that is on the floor is eight minutes long and it cost over a million dollars. Of course a lot of money was misappropriated by my partner.

JC: You have said that popular trends are immediately satisfying.

HS: Any kind of popular trend is infinitely more wholesome than listening to old records and trying to institute change. It's more important that people know that some kind of pleasure can be derived from things that are around them rather than to catalog more

stuff; you can do that forever; and if people aren't going to have a reason to change, they're never going to change. Any kind of evidence can be presented, it's like a political move, and that's important. These little things like studying history or ancient stones also have to go, along with the phonograph, radio and television, if there is going to be any real development of music, or human happiness probably. It's a mistake that Herbert Hoover made, that notion that you can manufacture things forever and that there's always an endless market because there isn't. It's a crucial point in history, the last chance where the population can have an agrarian base to it. They won't be able to do that in a hundred years. I don't think people should spend too much time fiddling with old records; it's better to switch on the radio. I don't think that you can say that folk culture was doing such and such, and that in popular culture these things became disseminated, although I used to think that that was the case. I now believe that the dissemination of music affects the quality. As you increase the critical audience of any music, the level goes up.

JC: Doesn't it also go down because it has to appeal to a more divergent range of people?

HS: I don't think they're that divergent. There isn't that much difference between one person and another.

JC: This represents a change in attitudes in yourself over the years...since the *Anthology*.

HS: Certainly. I was just fiddling with those ideas then but they were current at that time. Everything is computerized now and you wouldn't dare bring out such a thing as the *Anthology* now, for it first has to be analyzed for how many C sharps there are, etc.

JC: Then how do you feel about art?

HS: That's such a specialized technique of the so-called West, that I don't think it's very relevant. If people were sufficiently busy, they wouldn't have any time for it. Painting, it's a ridiculous thing, and it's a bad habit, like too many laxatives. There are a lot of bad things

in European civilization, and that's one of them. The idea of easel painting: I've been driven to it by adversity. I couldn't be a railroad section hand, so...I took up easel painting. I'm pretty sure there have always been things like people dressing up in Indian clothes. It's a romanticism of a sort to be followed by something else when this dies down. I would say it hasn't much association with the Indians, other than that everybody is now more sympathetic to the Indians. After all, their grandparents were murdering millions of them. I suppose that children dressed up like Saracens during the Crusades, and when Genghis Khan was coming they all dressed up in Genghis Khan suits. It's all the same; Marie Antoinette was sitting around in a stable built out of solid gold. It's the same as they do now. It's a way of evading the catastrophe that overtook the Indians, and an attempt to irritate parents, relieve guilt, and other things all at once. Probably that particular concatenation occurs in every society periodically unless they get too smart and blow it up: no more Indians or nothing. Already through the tobacco they have given everybody lung cancer, and they're killing people off rapidly with that. A few more of these beads slung around heads——! No way to tell what effect it's really having. And when my records come out...like curtains!

JC: What do you mean "like curtains?"

HS: I'm just trying to be funny for the sake of the readers. I wish I'd stuck on the business about Engels pointing out the relation between machine and thought. The reason for looking at objects is to perfect the self. It's a kind of selfish thing.

This interview was taped at the Chelsea Hotel, N.Y., in November and December, 1968.

Moe Asch

The Birth and Growth of Anthology of American Folk Music
as told by Moses Asch

It's a long story. I started making records in 1939. The company then was known as Asch Records. During the war, shellac was confined to manufacturers who were in business before 1939 so I combined with Stinson who had the production but needed the titles.

In 1945, Stinson and I parted.

Came the end of the war, there was a boom here. At that time we paid $10,000 to an artist, and Disc had the top jazz artists. We issued *Jazz at the Philharmonic* in close cooperation with Norman Grantz who lent me the money to do it. Grantz later retired a millionaire when he used the money from his Verve Records to buy Picassos by the square inch.

But by 1947, I went bankrupt for $300,000 and started Folkways Records. People who were involved in folk music between 1939 and 1947 knew what I was doing. I was the only one during those years who was documenting and issuing anything of consequence. In those days there was a union strike and nobody wanted to hire musicians so they came to me. The GI's were coming back from the war bringing songs. Pete Seeger came back then with anti-war and anti-army songs that talked about the lieutenant who was selling shoes to the private; songs also about the housing, the prices and all that business.

So when I started issuing records again in 1947, this man, the closest I guess to Woody Guthrie as a character, came to see me. He had heard about me. His name was Harry Smith.

Actually his interest was originally in the American Indians of the Northwest. That's how he became interested in music as such and he documented very early. During the war, because he was so small, he was able to mount the guns in the fuselages of airplanes. He got extra pay and with all that money bought up records. That was also the same time when I bought my collection of 78s—a very large one.

Before the war, the record companies themselves decided what records would be allocated to dealers. The dealer, in order to have a

Columbia franchise, for example, would have to take whatever Columbia sent him. Those were the monopolistic days. Naturally, the hillbilly stuff, the country music and all of that they had to accept here (in N.Y.)—two of each or three of each.

Then we had the shellac shortage during the war—Asia was cut off and they were using boats for other things than shellac. So, in order to get shellac, the big companies offered eighteen or twenty cents for all the records dealers had in stock. New York Band and Instrument and all the other dealers I used to pick up records from had tables full of this stuff—the greatest music in the world that New Yorkers knew nothing about. Right?

Harry Smith had the same thing on the West Coast. He bought up thousands of records. He knew what he was doing because all this time he kept track of when the records were recorded and who recorded them. In those days, they issued catalogs that gave the date, the matrix number and the place of the session. In the early Victor and Columbia days, the dealer had all this information.

Harry Smith collected vast information. In addition to that, he is an intellect. He understood the content of the records. He knew their relationship to folk music, their relationship to English literature and their relationship to the world.

He came to me with this vast collection of records. He needed money desperately. All his life he needed money. He got it from the Guggenheims or he got it from me or from others. He always needed money because he was always experimenting in the movies. He is quite a well-known movie creator. That's an expensive thing to work with.

Out of his collection, he came to me and said: "Look, this is what I want to do. I want to lay out the book of notes. I want to do the whole thing. All I want to be sure of is that they are issued." Of course I was tremendously interested.

Harry did the notes, typed up the notes, pasted up the notes, did the whole work. He and I discussed the layout but he laid out the whole thing. You know, he is very nice to work with. He is very thorough. He knew the material. He knew when it was recorded and he can name the people on the record.

The sad part of it is that afterwards when I wanted to issue Volumes IV and V we ran into the problem of everybody wanting to get into the

act and nobody issuing a thing. The last effort was John Cohen and Sam Charters but both of them dropped the project. It was not pressure from other companies. Those people have never influenced me one way or the other. The real reason is I couldn't get the documentation.

The records were not available anymore. Harry had sold them to the New York Public Library—half of them. The other half I bought and Sam Charters went through them and we issued some of the things from the collection—Cajun and others on the RBF label.

No one knew the background of each record. Harry Smith disappeared. Then he started working on finger string games. Then he started working with the Seminole people, and now he is doing very well with moving pictures, so he dropped the whole project. Nobody picked it up at all. This is the horror.

It all is on tape. The problem is that Harry needed the records which were sent to the New York Public Library. The Library just taped it with no documentation at all and nobody has been able to reconstruct it. I have the tapes of Volumes IV and V but I can't get the documentation. There is no sense in just issuing it without the documentation.

The most important thing is the influence of the *Anthology* on people. It has been a take-off point for many of the younger musicians like Dave Bromberg, people like that. For the documenters, the *Anthology* has set a standard. It's rather interesting that when the White House wanted to get a record collection, the first record they ordered was the *Anthology*.

Pete Seeger just went to Asia. He took a plane and even with all that weight he took the *Anthology*. Harold Leventhal went to India and took the *Anthology* with him. When people are interested in American folk music, it is one of the best examples.

Wherever I go, the first thing they ask me is: "Is it still in print? Is *The Anthology of American Folk Music* still in print?"

Yes!!

From an interview with Ethel Raim and Bob Norman, March 22, 1972. We are very pleased to be able to offer Moses Asch's insights for the light they throw on Harry Smith. As this interview indicates, the *Anthology of American Folk Music* was very much the meeting of two great minds whose vision and wisdom combined to create a classic.

THE KIOWA PEYOTE MEETING
recorded and edited by Harry Smith
[from the liner notes to Ethnic Folkways FE 4601, 1973]

(The following notes are rather diffuse because the material essential to their understanding is on the recordings. The use of the peyote cactus, *Lophophora williamsii*, as a medicine and vision producing substance among a large number of North American Indians is so well known as to require no botanical or physiological comment here. My purpose has been to give a glimpse of the Peyote Meeting through the narrations and songs of Kiowa who were worshippers there, and this can only be gained through a close study of the records themselves. This booklet is ancillary to that purpose and no comparison with other accounts of the Kiowa rites are given. Persons interested should consult La Barre's book which has an essential account and bibliography.)

INTRODUCTION

In February 1964 Muriel Wright, that Grand Lady of the Oklahoma Historical Society, told me "If you want to see a real Western Town go to Anadarko." I decided to visit there for a day or so. It really turned out to be a Western Town; before I had been there half a day I was arrested and held a week for "investigation." Two guns had been stolen from the "Candy Kitchen" the evening I got there. I had also unknowingly got myself involved with some talkative but, according to the police, rather unsavory characters in one of the local bars that night. Nine years have passed since then, but for various reasons the material I collected has not been made public until now. The notes that follow were mostly written in the winter of 1964–65. I have left them unchanged partly because they represent the ideas I had at the time I heard the songs, and partly because I have been unable to consult all of the material on Kiowa Peyotism. I have, however, added a few quotations from Winston's records regarding the nature of music, a comparison of the short introductory statements about the "Four Songs" made by various singers, some meager notes on intercalation of songs and, also, on some of Everett's favorite songs, plus a few comments on peyote graphic art.

I would like to make it clear that of the people I later worked with, none were met in the jail; the unfortunate victims of that place only provided the contacts. Also it would be only fair to say that while I was in Anadarko I was drinking heavily and it was only natural that some of the people I worked with also drank. Everett was a hard drinker, but not an alcoholic; Winston enjoyed what he called a "nip" now and then as did Ray and Blossom. George drank not at all. The short biographical notes I collected from the singers were mislaid when the police gave me a few days to get out of town. At this time it will suffice to say that all of the

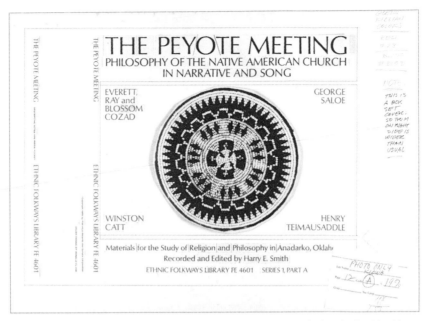

THE PEYOTE MEETING
PHILOSOPHY OF THE NATIVE AMERICAN CHURCH
IN NARRATIVE AND SONG

EVERETT, RAY and BLOSSOM COZAD

GEORGE SALOE

WINSTON CATT

HENRY TEIMAUSADDLE

Materials for the Study of Religion and Philosophy in Anadarko, Oklah
Recorded and Edited by Harry E. Smith
ETHNIC FOLKWAYS LIBRARY FE 4601 SERIES 1, PART A

Unused cover design for boxset of Kiowa peyote material recorded and edited by Harry Smith. (Folkways Records, 1973).

singers on these records were middle-aged persons of Kiowa background. George, and especially Henry, were older than the others, and Everett younger, but not by much. The personalities of the singers can be best learned from their recordings. They were all persons of happy, even disposition who took their poverty and disappointments with grace. They were mostly of what might be called a short stocky build. George was taller as befitted his former occupation as a wrestler. Henry was thinner than the others. Ray is Everett's older brother and was married to Blossom.

MY TRIP TO ANADARKO

Except for the police, white people are unique in the Anadarko city jail. This is not because whites are rare in Anadarko, far from it, but because, like the rest of that town, the jail is supported by exploiting the owners of the land; and so, the police arrest few but Indians. Out of the thirty or so people that almost starved in that place during the week I was kept there, only three were white; and thus it was I met some Indians and a short visit to Anadarko expanded itself into four months.

Anadarko (population about 5600) is on the Washita River sixty-six miles southwest of Oklahoma City. On the north side of the river live the Caddo, Delaware and Wichita; on the south side the Comanche, Kiowa

and Kiowa-Apache. Kiowa is really the only language heard spoken there (other than, of course, English). Once in a while the Wichita or Comanche will speak in their respective tongues, but I have infrequently heard Caddo, and Delaware, spoken except on request. The Anadarko Chamber of Commerce says that "Anadarko has always been an Indian town." As nearly as I could see, more than two-fifths of the population is "Indian," about a fifth "Negro" and the rest "white." I did what I could with each of these. Naturally, I did not set out to find the most wonderful singers or the most gifted narrators but to locate singers or narrators who were capable of projecting their individuality through recordings to other people. I was therefore very fortunate in locating George Saloe, Winston Catt and Cozads. All of these people were definitely music connoisseurs. As individuals they had all consciously collected songs that reflected their interests. Everett's former position as Peyote "Roadman" and his love of a good time are revealed in the large number of Peyote and "forty-nine" songs that he sang. George, as a professional singer, knows those marvelous traditional songs of the warrior companies and the social and religious ceremonies of the tribe. George, Winston, and Everett were all ascetics. A hundred years ago they would have been fasting in some wilderness. Everett for a while habitually slept in the front seat of a truck. George, painfully crippled, picked up shingles after the storm, Winston has made frugal living fundamental to his philosophy. I particularly hope that examples of the Kiowa approach to things will give an insight into how one people has dealt with the problem of rhythm in relation to thought, and that persons interested in the Ritual, but unable to attend a Meeting, will partake of the herb while listening to the recordings.

THE KIOWA

All of us like to think that our particular teachers are the smartest of all and best of all. Even so, the Kiowa are a remarkable people. They ranged within the historic period from Canada to central Mexico and from Arkansas to the borders of California (Mooney, 1898, p. 147). For the Kiowa, like most other North American Indians, had no nations; no government in the sense that we intruders understand those terms. Such rulership as existed was vested in the philosopher-priests of certain rites, and those rituals transcended boundaries between languages and of antagonisms, and thus it was that wanderers interlocked with wanderers. Supreme among these rovers were the Kiowa.

They differed from most other plains tribes in that they possessed a social organization so diffuse that its outlines can be ascertained only by statistical methods. They had no moieties or clans—those things would have been inappropriate for a group that was constantly absorbing refugees and lovers from the far-flung tribes that the Kiowa came in contact with. They also seem to have been the center of diffusion for the Peyote religion over a large area, and Kiowa rites give a very good idea of what the ceremonies consist of, at least on the American plains.

The amount of peyote used per capita in Anadarko is fairly staggering by ordinary standards. Hardly a day passed that someone didn't bring in a few laundry bags full; the whole plant, not just the top, was brought back. At one time I estimated that well over a ton a month was available. Not all of this ends up in nearby meetings, however. Quite a bit is sold or traded to other groups farther away from the Texas-Mexican border where the Anadarko tribes go for their supply. Also a surprisingly large number of plants end up in the hands of people who have no particular connection with the Peyote Meeting itself. They keep them around the house or on their persons to heal aches and pains, colds, etc. Everett, who preferred not to have gone to a Meeting for quite a while due to his drinking, showed me a dried plant he carried with him to ease the pain in his leg. The cactus is also said to be a specific against alcohol. From my own experience I believe this to be true.

The peyote plants are viewed as aesthetic objects and particularly beautiful ones will be passed around to be commented on. Especially esteemed are fresh plants of a leaf green color, having a medium length root of even shape with a round top symmetrically tufted. The single pink or blue flower on the plant is also admired, and people particularly like to show a plant thus adorned. I was told several times that red and blue, the colors of the Native American Church, were derived from the shades of the flower in its various stages.

Mooney, Marriott and Denman (the latter quoting Monroe Tsa Toke) give fairly long narratives, of supposed Kiowa origin, about a woman who had lost either her brother or her baby and discovers the herb in the ensuing search. A Wichita in Anadarko told me a form of this story in which the search for the baby led to plants that were seen at night.

The cactus were shining like stars, distributed in the form of a man on the ground. Curiously, I was unable to collect this narrative or any other material on the origin of peyote from my singers other than short statements by Everett: "The Indian man met the Mexican on the border and brought this herb here."—"We worship here, we worship there, poor Indian Man had to find something to worship." (side 1, band 5)

KIOWA MUSIC

It is difficult for us to comprehend systems different from those we have become conditioned to, and thus it is that any explanation of Kiowa musical systematics is almost impossible to put in European words. A brief attempt is necessary, however.

Each class of Kiowa songs possesses its own particular type of opening and closing phrases. In addition perhaps a third of the Kiowa songs have what are usually called "words," the rest are what the Kiowa call "plain"—they

consist of syllables only. There is no doubt that these syllables have fairly definite sets of emotional connotations. They are symbols in the same way that a white line means "Feather" (and hence "sky" or "up" or "joy") or a red line "ground" (and hence "earth" or "down" or "sadness") in the Kiowa beadwork. From a linguistic standpoint the vowel series of the "plain" songs conform to phonetic patterns more or less coincident with Plains Culture. There are extensions of the most common syllable series down the Mississippi and into the Algonquin North East. More specifically, they are coincident with the distribution of the Plains-vocabulary sign language of which the Kiowa were perhaps the greatest masters.

Netti gives a dated but still valuable analysis of Plains music. According to that author the Peyote songs are relatively recent and have characteristics that distinguish them from other songs of the same areas. If, and when, George Saloe's main mass of Kiowa songs are issued these differences will be discussed. It is interesting to compare Netti's statements regarding the music with some of those Winston gave in his description of the "Four Songs." Winston says: "It's not the music, not the Jehovah's staff; it's that thunder that's balled up (in the drum) and the history that goes with it; and the whip what you call a drumstick." "The songs that you hear don't have no words in them; but still they're the Gods' sounds that are given to the Indians (and) that the white man don't understand." "The wind that you hear out here, the sound of the reed and of the grass, the sounds of the birds that you hear out here, the sounds of your everyday living, the way that your Father in Heaven made, your Father in Heaven, you know, that!"

PEYOTE SONGS IN ANADARKO

When I awoke, after my first uncomfortable night on the floor of the "walk-around" in the jail, I saw by the increasing light on the wall at my feet that most ancient and thoughtful of designs, the circular and interlocked rainbows. Next to it there is an amazingly stylized drawing of deer by a tree—a type of art which A.S. later explained "came from Siberia." Further to the left there is a scissor-tail bird above an upturned moon letter "Peyote Altar." As I stared in amazement at this, my first friend D.W. came up and spontaneously gave a description of the Peyote Meeting which, despite the fact that I had read literature on the subject, and had eaten the herb itself frequently, for the first time made clear to me the purpose and ritual of the Native American Church. He also sang a song or two in a very low voice.

Peyote songs are likely the most popular kind of music among the Indians in Anadarko. Surprisingly, they are probably sung more frequently outside the meeting than in. People often divert themselves while driving, or sitting around, by singing them. I also have heard individuals walking alone humming them. Naturally, under these conditions there is no drum and sometimes not even a rattle. At home there is almost always a rattle handy and it is used. Sometimes a paper box is picked up and beaten like a drum,

but this act is much more frequent with "49" songs than it is with Peyote songs. Individuals are also much more willing to sing other people's songs out of the Meeting than they are in the Meeting itself, where they try not to duplicate other singers' songs but to sing ones that "belong" to themselves.

All of the songs in this set of records were sung under conditions that approximate the casual performances outlined above. They were made either in the home of the singer or in my hotel rooms at the Bryan. I had the opportunity of making recordings at an actual ceremony but decided against it; first, because I was anxious to record commentaries on the songs and, second, because I knew that several other persons were jeopardizing their chances of knowledge by making recordings at Meetings. At any rate, probably more can be learned, by the audience these records are intended for, from the descriptions that Winston and Everett gave, than could be gained from excerpts of an actual Meeting.

The main discrepancy these records suffer from is a lack of samples of drumming. The specialized peyote drum is of the greatest beauty, and the variety of tones that a good drummer can make, truly astounding. Its throb weaves among the notes of the tune and gives an impressiveness to the "Peyote Meeting" that once heard is never forgotten. But, due to my desire to get casual rather than ceremonial versions of the songs, 1 present no records with the drum. There are a number of rather inferior examples of drumming on other recordings, and it is hoped that in the future it will be possible to record this instrument in its full beauty.

Although the drum is mentioned more times on the recordings than is the rattle, the latter is the peyote instrument par excellence. I was often told that while it was possible to get along without the drum, the rattle provided the "real" accompaniment to the melodies, in fact was inseparable from the Peyote songs. Like the peyote plant itself the form of the rattle is an object to be commented on artistically. It is made from a species of small-necked gourd cut off a little more than halfway up the neck. Into this neck a wooden plug, loosely attached to handle, is fitted. The plug can be adjusted to give the desired tone as the beads, which are inside, strike the gourd. I made quite a collection of gourds in Anadarko. They are sold in various stages of manufacture in both of the pawnshops there as well as being available from individuals and even found wild. A good shaped gourd is round "like the sky" and is of an even light brown color. One that I got in Miss Tingley's pawnshop was of, to me, a beautiful red color but was said by others to be of an ugly darkness. Another was of a fine shape, but a scarcely perceptible dark stain on one side made it undesirable. Everett said, "I wonder why they did that." Other gourds though of fine color and shape were too thick or too thin to give the desired ringing sound when used. In use the rattle is revolved clockwise with various front to back motions to vary the speed of the tone. The possibilities of this instrument are heard to advantage on the recordings of Henry Teimausaddle (side 3, cut 7).

FILM-MAKERS' COOPERATIVE CATALOGUE NO. 3, 1965

A one-man show of Harry Smith's films in 16mm (color and black & white) is available for rental at $110. The total running time for the program is approximately 90 minutes.

> "My cinematic excreta is of four varieties: batiked abstractions made directly on film between 1939 and 1946; optically printed non-objective studies composed around 1950; semi-realistic animated collages made as part of my alchemical labors of 1957 to 1962; and chronologically superimposed photographs of actualities formed since the latter year. All these works have been organized in specific patterns derived from the interlocking beats of the respiration, the heart and the EEG Alpha component and should be observed together in order, or not at all, for they are valuable works, works that will live forever—they made me gray."

No. 1: Hand-drawn animation of dirty shapes—the history of the geologic period reduced to orgasm length. (Approx. 5 min.)

No. 2: Batiked animation, etc., etc. The action takes place either inside the sun or in Zürich, Switzerland. (Approx. 10 min.)

No. 3: Batiked animation made of dead squares, the most complex hand-drawn film imaginable. (Approx. 10 min.)

No. 4: Black and white abstractions of dots and grillworks made in a single night. (Approx. 6 min.)

No. 5: Color abstraction. Homage to Oskar Fischinger—a sequel to No. 4. (Approx. 6 min.)

No. 6: Three-dimensional, optically printed, abstraction using glasses the color of Heaven & Earth. (Approx. 20 min.)

No. 7: Optically printed Pythagoreanism in four movements supported on squares, circles, grillworks and triangles with an interlude concerning an experiment. (Approx. 15 min.)

No. 8: Black and white collage made up of clippings from 19th century ladies' wear catalogues and elocution books. The cat, the dog, the statue and the Hygrometer appear here for the first time. (Approx. 5 min.)

No. 9: Color collage of biology books and 19th century temperance posters. An attempt to reconstruct Capt. Cook's Tapa collection. (Approx. 10 min.)

No. 10: An exposition of Buddhism and the Kaballa in the form of a collage. The final scene shows Agaric mushrooms (not in No. 11) growing on the moon while Hero and Heroine row by on a cerebrum. (Approx. 10 min.)

No. 11: A commentary on and exposition of No. 10 synchronized to Monk's "Misterioso." A famous film—available sooner or later from Cinema 16. (Approx. 4 min.)

No. 12: A much expanded version of No. 8. The first part depicts the Heroine's toothache consequent to the loss of a very valuable watermelon, her dentistry and transportation to heaven. Next follows an elaborate exposition of the heavenly land in terms of Israel, Montreal, and the second part depicts the return to earth from being eaten by Max Müller on the day Edward the Seventh dedicated the Great Sewer of London. (Approx. 50 min.)

No. 13: Fragments and tests of Shamanism in the guise of a children's story. This film, made with Van Wolf, is perhaps the most expensive animated film ever made—the cost running well over ten thousand dollars a minute—wide screen, stereophonic sound of the ballet music from *Faust*. Production was halted when a major investor (H.P.) was found dead under embarrassing conditions. (Approx. 3 hours)

No. 14: Superimposed photographs of Mr. Fleischman's butcher shop in New York, the Kiowa around Anadarko, Oklahoma—with Cognate Material. The strip is dark at the beginning and end, light in the middle, and is structured 122333221. I honor it the most of my films, otherwise a not very popular one before 1972. If the exciter lamp blows, play Bert Brecht's *Mahagonny*. (Approx. 25 min.)

"For those who are interested in such things: *No. 1* to *5* were made under pot; *No. 6* with schmeck (—it made the sun shine) and ups; *No. 7* with cocaine and ups; *Nos. 8* to *12* with almost anything, but mainly deprivation, and *13* with green pills from Max Jacobson, pink pills from Tim Leary, and vodka; *No. 14* with vodka and Italian swiss white port."

— Harry Smith.

THE ART OF ALCHEMY

The Incredible World of Harry Smith

Living in one of the little white cottages next to Naropa is a man with long gray hair and a beard. The local children know him as "Mr. Magoo." From his two-room house, he tapes the predawn sound of squirrels chattering, of Saturday-night high school football games in the distance, of snow melting, and of Brazilian percussion sounds from the music building. He creates beautiful frozen slides from the natural elements he boils then displays in his freezer: mushrooms, egg whites, rosehips. Orchestral music from water dripping into a dish, a tea kettle and refrigerator sounds. Everything in his living room is a fragile ongoing experiment. Touch and you risk this elder's wrath. But get him talking and he will spin an impenetrable web around you from every direction.

Harry Smith. Music Archivist. Bishop. Anthropologist. Filmmaker. Teacher. Artist. Inspiration to poets and writers.

His 1952 *American Folk Music* anthology on Folkways Records is recognized as a pivotal influence on the American folk music revival of the '50s and '60s. From Pete Seeger to Bob Dylan (an old acquaintance who copped the line in the song "Stuck Inside of Mobile with the Memphis Blues Again," "all the railroad men just drink up your blood like wine," from a Bascom Lamar Lunsford song on the Harry Smith Folkways album, "I Wish I was a Mole in the Ground."

His artwork hangs in the Anthology Film Archives Museum in New York alongside works by Rauschenberg, Warhol (an admirer of Harry's), Beuys, Oldenburg and Rosenquist. Allen Ginsberg uses Harry's work on the cover and throughout his *Collected Poems 1947–1980* (Harper and Row). And his surreal films, made from the '40s through the '80s, are part of the Film Archive's "Essential Cinema" series.

Since he was a teenager in the Pacific Northwest, he has made sound recordings of anthropological interest, using the old "disc" and "wire"

From *As Is* magazine, Naropa Institute 1989. This article was edited by *As Is* editor Warren Karlenzig. Tim Hulihan and Eileen O'Halloran interviewed Harry for the article, along with Karlenzig.

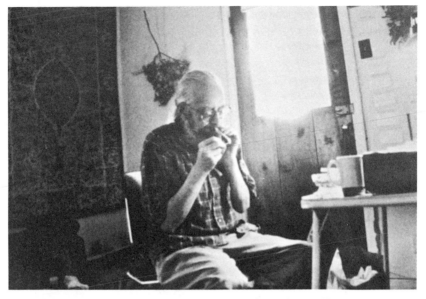

Harry Smith at the Naropa Institute, Boulder, CO, 1988. (Photograph by Peter Cole.)

methods before the tape recorder was invented in the early 1950s. Of note is the Harry Smith recording of *The Kiowa Peyote Meeting*, released by Ethnic Folkways Records in 1973.

Harry has been a teaching assistant working with the Eskimo language (which his parents taught) at the University of Washington and has taught the history of jazz at UC Berkeley. And of course last summer he taught "The Rationality of Namelessness," among other topics, while he lit up during the Naropa Summer Writing Program lectures. This summer he expects to teach Alchemy at Naropa.

The web will it will you will HINN of the natural worlds of hitea kettles from trees.

He is surrounded by aisimple Harry Smith. So mote it be.

"I received my original education in my mother's womb and found that other scholastic organizations were inferior. The object is to record," Harry explains.

A picture in some national magazine that Harry won't name has a photograph of him in junior high surrounded by people watching him behind

the controls of a tape recorder. His parents wouldn't let him read books at the table. He ate by himself, so he could read. He lived on some Puget Sound islands in Washington and for his first book read The Gold-Bug *by Edgar Allan Poe , which deals with secret codes. And the cryptic knowledge has been one of Smith's motivating forces ever since. Now he uses his tape recorder to crack codes.*

"The interesting thing to do would be to record different sunrises at the same time, considering certain whistling noises that have been heard by thousands, probably millions of people at this point, when the sun comes up. It gives out definite squeals."

Sunrise squeals?

"Yeah. And I'm sure there are periods also when major and minor surges occur—during conversations in a nightclub."

Harry will sometimes make continuous eight-hour tapes of driving in cars and going to nightclubs, driving in cars and going to restaurants (he eats liquid only), and being driven home. He will remain silent the whole time. An archive of the night's events, he calls it. Then he gets home and listens with his headphones, over and over.

"There are these major surges when everything happens, squirrels begin chattering, a plane goes over. That was the first thing that got me interested in the possibility of proving mathematically or any way, that when an airplane is going over it is the cause of those Tibetan long horns—(simulates noise) Oroar rrof—the air is full of them. Caused by low-playing planes.

Is that a plane? Is there any particular reason the universe is being constructed economically? Why bother to form an airplane when all that is necessary is the formation of the sound?"

In order to produce travel?

"No in order to produce maya, or in order to produce karma, the intermediary that is used between karma and dharma, being various types of squeals and whistles. These activate a great number of people

who become hysterical when these major surges occur. A three-hour recording is almost sure to get one because, like dreams, they occur every twenty minutes. You figure every three hours things like automobile wrecks occur or the bird feeder will fall off. Children scream. Then it'll all die down."

Harry has never seriously watched television. He doesn't even have a radio in his house. He keeps track of popular culture through the sounds of the streets.

"When 'Mr. Tambourine Man' [Dylan 1964] first came out I was in Florida with these loads of Cuban hash. That song was everywhere.

There was a time when I liked Dylan and Blake, too, but when you're lying in a nurse's arms mewing and puking, you don't want to have to hear someone say 'Hey! Mr. Tambourine Man.'"

And Harry says Dylan now means nothing in New York City, compared to more modern artists like Prince.

"Dylan will be happy to hear how popular his music is in Colorado."

I can't believe Harry has never watched television. The surreal possibilities are endless. Even without a picture.

"I've never been into television. Except in Miami Beach on Saturday mornings. I'd look at the cartoons. It was all that was happening on Saturday mornings."

What were his favorites?

"I don't know!" Harry yells. "I had no favorites. It was strictly a ceremonial act."

Yet he seems to know the Flintstones well enough. I was in a store looking at some pins with different Flintstone characters on each pin, and was trying to decide on which one I wanted when Harry softly declared, "I always liked Betty."

How does he know them if not from television?

"I think we had Flintstone cards. Playing cards with them on it. Although the Old Maid cards had the most interesting series of stuff— all these professions, like Ad Man, the next one is Bricklayer, it's like printed in Algeria, and the drawings are a good, kind of a slashy style. Where naturally the ones from Cincinnati, from the U.S. Playing Card Company are supposed to be approved by *Good Housekeeping*."

The topic of conversation regresses. Entity. Entity. What does it mean?

"Specifically, it's a tool—it's an amplifier of physical things.

It's interesting these people that tried to work out the law of social entropy. These psychedelic drugs among mental amplifiers which could be things like telephones, telegraphs…all the things our communities had classified as tools, which are three classes of things: wheels, lever, and screws. They are under (the classification) mental amplifiers."

One explanation, Tim offers, is an entity is when it conceives of itself. But at the same time it conceives of itself it's not the entity it thinks it is.

"That's a supremacist attitude," Harry says.

Supremacist?

"OF COURSE! That you're greater than the entity. The mere fact that I don't believe this thing can't think. There isn't any way to invalidate its effect. It merely proves that humans don't think.

I think that object and tool are better because they're standard themes that are in the literature. (Entity) smacks too much of, like crystals, Admiral Byrd flying into the South Pole."

What about your encounter with Admiral Byrd, Harry?

"My encounter with Admiral Byrd occurred in a cafeteria. I happened to be next to him in a line. That was it. Period."

What did he eat?

"I don't really know. It was probably on television."

As someone who has had their last rites administered to them twice, do you think the gods favor you, Harry?

"I'm not sure what you mean by 'you.' The language has to be improved. The recording machinery has to be improved."

Smith of the future.

"Another interesting thing that shows up on tapes through headphones, and if you listen on speakers, you might be able to hear it: when people walk by the microphone and when people are milling around, a certain kind of fuzziness and dropping volume is imparted into the signal. It's quite uncanny. Shutting your eyes immediately turns on the Alpha rhythm in the brain, about 20 to a second.

Ping-pong balls cut in half are quite good because they fit in the eye sockets and you can open your eyes under there and it's a flat visual field. They're cheap and efficient.

I also find music in the background interesting, like Bob Dylan (Ed: *Dylan's Highway 61 Revisited* was playing at the time). I hope it's on this tape because then it's possible to look for parallels between the ideas expressed on there. Because there is some general thought pattern."

Predictions for the future?

"(Killer bees) may become friendly with us. They will like Naropa. That's been the consensus here among everyone that I've talked to, that you have fun at Naropa."

And so does Harry.

"I'm always so happy when that assorted-colored Naropa cat walks by."

How should this end?

"Let me write you an IOU on this cigarette paper. Get me that invisible ink."

Harry Smith browsing a table at Strand Bookstore, New York, 1985.
(Photograph by Brian Graham.)

Bill Morgan

Harry Smith Collections
A Guide

> "I'm leaving it to the future to figure out the exact purpose of having all these rotten eggs, the blankets, the Seminole patchwork I never look at, and records that I never listen to. However, it's as justifiable as anything that can be done, as any other type of research."
>
> —Harry Smith

No other statement could better express the dilemma anyone faces who tries to find meaning in the collections of Harry Smith. Myths have been created concerning his collections; some have been substantiated by this inventory, others remain a mystery. Harry was so interested in myth and legend that one cannot help wondering which of the legends he created about his collections were accurate and which were exaggerations.

Harry's earliest collection may have been the folk music that culminated in the Folkways Anthology and the Peyote rituals. His recordings seem to have been given to the Library of Congress but there was no information on that collection. The present archive contains over 1,250 phonorecordings, but all are 12″ LPs, not a single 78 record and nothing bought before the 1960s. Harry Smith often referred to his collection of Seminole Indian blankets and dresses, none of which were found. There is no indication of what became of them. Harry was famous for his interest in Ukrainian Easter eggs, yet only 7 eggs were discovered, all recent purchases from the same store. At one time he said that he had spent $5,000 on this collection, and that he had notes on 29,000 egg designs: none were found. In one interview Harry said he planned to give his collection to the Göteborg Museum, again: there is no indication of where they went. No paintings and only a handful of drawings were found; no slides or photographs of artworks. Only two short movie reels were found and these were portions of earlier works. He didn't have personal copies of any of his films. Extensive notes on string figures were found, but not a single mounted string figure. At one time a reporter noted "stacks" of them in his room. Harry avidly saved receipts and many receipts indicate items that were not in the collection.

Probably what happened is simply explained by Harry's lifestyle. Throughout his life he spent all his money on these collections and never gave a thought to rent or clothing or food. Many times he left items with people to whom he owed money and these items were the closest thing to repayment that they would ever see, and Harry seemed to owe money to everyone. Simple trades were probably made, collections canceling debts.

All this may seem to indicate that nothing of value was left of Harry's collections but that is certainly not the case. There are, after all, 166 boxes of materials. The following description is organized by type of material and broken into more and more specific lists. As long as the collection is stored in boxes this list should be consulted before opening boxes so that an item can be located in the appropriate box.

[EDITOR'S NOTE: This is not by any means all of the things Harry gathered; a lot of this was in his room at the time he passed on; they are the remains of what was in his possession, not lost, bartered, or stolen on the day he died.]

THE COLLECTIONS
1. BOOKS
2. PHONORECORDINGS
3. TAROT AND PLAYING CARDS
4. REALIA, FOLK CRAFTS, AND ANTIQUE PAMPHLETS
5. POP-UP BOOKS
6. GOURDS
7. CASSETTE TAPE RECORDINGS
8. STRING FIGURES
9. FILMS
10. ARTWORKS
11. ARTICLES BY AND ABOUT HARRY SMITH

I. BOOKS

This is the largest of the collections. It contains 4,204 books and periodicals. Each book has been fully cataloged using standard AACR format, so that researchers, librarians or book dealers will be able to quickly review the collection. I have used longer, more descriptive subtitles than are necessary in order to help identify subject matter. The collection has been entered on Macintosh computer format so that access to titles, authors, publishers, etc. is fully computerized. The original catalog cards are in box #166 and will be useful when books are put onto shelves in a library. The computer program used for the bibliography is Pro-Cite and a copy will be available whenever it is needed. A print-out of the titles accompanies this report; it is arranged in alphabetical order. Floppy discs of the collection are also available when needed.

Harry Smith made extensive notes concerning the purchase of each book in the collection. He disguised and abbreviated the information so that it looked as if he had created his own cataloging system, but his interest was in the pattern of buying. In fact throughout all the collections Harry's interest seems to be in the pattern of things. Over time his codes changed thus obscuring their true meaning.

Harry noted the date and price paid for every book in his collection. He also recorded the name of the store where he purchased it and the time of

day he bought the book. On the first page of each book he has a combination of letters and numbers in pencil that give this information.

For example:

STR	purchased at Strand Books
9-6-83.1	purchased on Sept. 6, 1983
2-3-P	purchased at 2:30 p.m.
4.00	cost was $4.00

On many recent purchases he has left the sales receipt in the back of the book, especially computerized receipts that contain the date, time and price automatically. When one receipt contained many books Harry usually put the receipt in the back of the most expensive book. Prices are marked in the upper right corner of the catalog cards now in box #166. Using these prices it is possible to determine how much Harry spent for the entire collection. Although this isn't the value today, it is the amount of money he laid out over the years and gives a beginning point for appraisal. The total is $62,550.

The oldest date of purchase recorded in Harry's collection is Oct. 8, 1959. Some books appear to have been bought by Harry, then sold back to the store, and then repurchased years later. This, again, is due to Harry's lifestyle, he used the bookstores as pawn shops when he needed cash for something else. I have spent time in analyzing this financial side of the collection because this is what Harry spent a good deal of time recording. I have never seen another collection where place, date, and time of purchase were so important.

Of great importance to scholars will be the indexes Harry made to many of his books. These consist of long sheets of numbers referring to pages on which Harry had found something of note. These are either written on the first page of the volume itself or are written on separate scraps of paper. The books in which Harry has made notes are identified on the 3 × 5 index card with a notation in the top margin. Harry's separate note sheets have been removed from the books and placed in folders #22–89 in box #163 with references to the books they annotate.

Although Harry didn't buy rare books per se, his collection is quite valuable and very comprehensive in the fields of comparative anthropology, folk music, and natural history. It is an indication that once he made a commitment to collect something he did it comprehensively.

CONDITION

Harry was very careful about the condition of his books. He lovingly took care of them, probably never lent them. Almost all are in perfect condition. In some cases they lack dust jackets, but otherwise are in mint condition. Some of the boxes were packed by Harry himself. Some of the books in these boxes were wrapped in brown paper and Styrofoam chips. Some packages of books were labeled with a compass direction and

arranged inside the box by direction, i.e., north top, east bottom, etc. One of these systems was saved in folder #20, box #163, just to give an idea of his method. The books were organized by size within the boxes rather than by subject. Harry wrapped ten boxes of books individually in Saran Wrap and newspapers, these did not have the directional markings.

One problem that affected the collection was mildew. Several boxes of books in storage became damp years ago and have been incubating mildew. These books (219 of them) were isolated and sorted into four different levels of damage.

1. Smell of mildew but no visible staining
2. Slightly visible mildew
3. Heavy mildew, discolored covers, but restricted to outside covers
4. Mildew has eaten through covers and into spine

I discarded level #4 materials, totaling 28 books, that were beyond repair. A list of the discarded books is attached to this report. The remainder, I scrubbed with mildew retardant and have stored separately. It is important to keep these mildewed books isolated so that they will not contaminate the other books, as the mold will spread from book to book over time. Mildew can never be eliminated, it can only be slowed, but once it is in a book it can't be completely cleaned. I discarded only those which were attracting bugs and literally falling apart, but I would recommend throwing away most of the other books that are contaminated. The other option is to have those books professionally cleaned and fumigated. I spoke with a company that does this work at the American Librarians Conference in San Francisco:

Larry Wood, Director
Blackman-Mooring-Steamatic Catastrophe Inc.
303 Arthur Street
Fort Worth, TX 76107
1-817-332-2770

Mr. Wood felt that between $2 and $10 per volume would be a reasonable estimate, $2 being the slight mildew and $10 being heaviest. Again, remember that it can't be 100% eradicated. I would carefully monitor the boxes marked "mildew" to prevent spreading to other boxes. Boxes #67, #82–84, #111–116 are the affected boxes, they contain 291 books. Once you have decided what to do with the books, it will be easier to determine what to do with these titles. You may find it best to discard the books and replace the most important ones.

To prevent further damage during storage the books should be kept off the floor on pallets and not leaning against the walls as they are now. Actually the dampness that damaged the books probably came through the

wall and was not the result of a flood. The best protection against this will be to get the books onto shelves as soon as possible.

2. PHONORECORDINGS

This collection contains 1,252 records, for which Harry Smith paid approximately $12,750. The collection of phonorecordings is quite comprehensive and was assembled in the 1960s through the '80s. Its focus is on folk and regional music of ethnological interest. Each record has been cataloged and added to the Mac Pro Cite database. Floppy discs containing this information accompany this report. In addition, a photocopy of each album cover was made for cataloguing purposes and they are found in box #166. A printout of this collection accompanies this report.

The records are all in perfect condition. All records in the collection are LPs, 33 rpm; there are no 78s or older records. [Samuel Charters would be a good resource person to advise on what to do with this collection.]

3. TAROT AND PLAYING CARDS

This collection contains 214 decks of Tarot and playing cards, costing between $2,500 and $3,000. Most sets of cards are recent purchases and cover a wide range of children's games as well as Tarot cards. Most cards are in good condition. Decks are numbered from 7262 to 7476 and are found in boxes 156–157. A complete list of decks accompanies this report.

4. REALIA, FOLK CRAFTS, AND ANTIQUE PAMPHLETS

This collection contains 294 items. Many items seem to illustrate a popular interest of Harry's; that being items shaped like other items. For example: spoons shaped like ducks, banks shaped like apples, etc. The quality of artifacts in this collection was not important to Harry, most are rather cheap and poorly made. Not many are antique items, most are modern souvenir-grade folk crafts.

A complete list accompanies this report. It should be noted that at one time Harry owned many more items than are currently here.

5. POP-UP BOOKS

Harry Smith seemed to have an interest in these cut-out and moveable books. They are catalogued with the books in general but I have made a list here because they seem to represent a subset of the collection, maybe better placed in the Realia collection since it wasn't the contents that interested him, but the format. The collection contains 22 pop-up books. A list is attached to this report.

6. GOURDS

This collection contains 49 gourds. All are in box #154. These are just another set of the realia collection but since they are subject to rot and mold I have kept them together and as such they should be checked periodically.

7. CASSETTE TAPES

This collection contains 382 cassettes. Over a period of three years, 1987–1989, Harry systematically recorded everyday sounds onto cassettes. Most are identified only by the date and time of the recordings. These form a large part of his most recent work. Harry's occasional notes describing the tapes in more detail are kept in the cases with the tapes, now stored in boxes #158–160. This collection seems to be the raw material for Harry's most recent studies as described by Steven Taylor as the study of everyday sounds under amplification.

8. STRING FIGURES

This is one of the most important collections. This box (#161) contains the manuscript, notes, and index for a comprehensive study on string figures. Almost 1,000 pages of text with drawings of string figures are contained here. Although this box contains samples of different types of strings from different cultures, there are no samples of the figures themselves. Many people have mentioned that Harry had a large collection of the figures mounted on cardboard: none are here.

9. FILMS

There were two films found in the collection, described by Jonas Mekas and now stored in his Anthology Film Archives. Those are the only items not in the storage boxes; it seemed better to store them with Harry's film at Anthology. There were three rolls of undeveloped film that have been developed and are included here.

10. ARTWORKS

This collection contains very few items. See list of items in box #146, and folders #1 and #9. These, along with the manuscripts, comprise the only original Harry Smith material found.

11. ARTICLES BY AND ABOUT HARRY SMITH

There aren't many items in Folder #101 about Harry Smith. You might want to consider collecting copies of all those items since Harry didn't seem to save them himself.

In conclusion, you will see that indeed Harry has left it up to you to decide what the purpose of all this collecting was, and what will become of it. You may want to actively pursue retrieval of some of those collections, such as Ukrainian eggs, Seminole patchworks and mounted string figures. All this will be simplified when a decision is made as to what to do with the collections.

Biographies

Harvey Bialy (1945–2020). Born in New York City, he was educated at Bard College (AB) and the University of California at Berkeley, where he took a PhD in molecular biology. Bialy was a poet with several published books (*Love's Will*, *Babalon 156*, *Susanna Martin*, and *Broken Pot*), and appeared in Kenneth Anger's film *Invocation of My Demon Brother*. He was also a leading expert in the field of biotechnology, serving as a member of the International Advisory Board of UNESCO's *World Journal of Microbiology and Biotechnology* and as research editor of the journal *Bio/Technology*.

Jordan Belson (1926–2011) studied painting before seeing Oskar Fischinger and the Whitney brothers' films at the 1946 Art in Cinema screenings at the San Francisco Museum, whereupon he increasingly devoted himself to the moving abstract image. Between 1957 and 1959, Belson collaborated with composer Henry Jacobs on the historic Vortex Concerts, which combined the latest electronic music with moving visual abstractions projected on the dome of Morrison Planetarium in San Francisco. The Vortex experience inspired Belson to abandon traditional painting and animation in favor of creating visual phenomena in something like real time, by live manipulation of pure light, which was the technological basis for his more than twenty films from *Allures* (1961) to *Northern Lights* (1985).

William Breeze (b. Neuilly-sur-Seine, France, 1955) is a former computer and video industry executive who cofounded Mystic Fire Video, which first released Harry Smith's films on video in 1987. As a violist and guitarist he played with Angus MacLise, Marc Slivka, Psychic TV, Coil, Current 93 and other artists. Under his religious name Hymenaeus Beta he is the Outer Head (OHO) of Ordo Templi Orientis (OTO), and the Patriarch of its ecclesiastical arm Ecclesia Gnostica Catholica (Gnostic Catholic Church), in which he consecrated Smith a bishop. He manages the Aleister Crowley literary estate and has edited many of his major works. He curated the first posthumous exhibition of Crowley's paintings (October Gallery, London, 1998) and has acted as an advisor on occult and esoteric art to the Centre Pompidou, the Centre de Cultura Contemporània de Barcelona, the Venice Biennale and other institutions.

Khem Caigan (1955–2018). Born in Passaic, NJ, he was a scholar and writer and Harry Smith's assistant throughout much of the '70s and '80s.

John Cohen (1932–2019), folk musician, was a founding member of the New Lost City Ramblers, which from 1958 to 1979 performed and recorded traditional music, including fifteen albums for Folkways Records. After 1957, Cohen also worked extensively as a freelance photographer, and his photos have been the subject of major exhibitions at galleries and museums here and abroad. In the early '60s, he began to make films on indigenous music, tracing its roots in ancient cultures and examining its contemporary social role, and in the decades following he produced a remarkable series of films that have been acclaimed by scholars and critics as valuable records of our musical heritage, honored with major awards from film festivals as affecting works of art in their own right.

Rose Feliu-Pettet (1946–2015), "Rosebud," muse of the New York underground and Harry's "spiritual wife," was an active figure in the scene around the Anthology Film Archives, and inseparable cohort, in those early days, of Barbara Rubin. Harry Smith cast her in his final film, *Mahagonny* (1980), which he worked on for over ten years and considered to be his magnum opus.

Robert Frank (1924–2019). Born in Zurich, Switzerland, Frank reached adulthood during World War II. He studied and mastered the craft of photography, and immigrated to the United States in 1947—an outsider with a camera. A Guggenheim Fellowship allowed him the freedom to spend 1955–56 traveling the United States creating *The Americans*, which was published in 1958. These photos, snatched from the roadsides of forty-eight states, this portrait of the neon sorrow of America, a funny, crazy hustling wasteland as only he had seen it, would have a profound influence on painting, photography, and film. His first film, *Pull My Daisy*, made in 1959 with Alfred Leslie, again usurped tradition with its improvised, jazz-influenced style. Twenty-some films and videos followed. In 1994, the National Gallery of Art in Washington, DC, mounted a retrospective of his work spanning half a century, and with this show published *Robert Frank: Moving Out*.

Deborah Freeman takes photos of her shadow (and other concocted distortions), dabbles in the stock market, and tries to write funny stories about her mindset, whilst researching tales of her family's Holocaust past for a documentary film on the underground resistance.

Allen Ginsberg (1926–1997). His celebrated poem "Howl" overcame censorship to become one of the more widely read poems of the twentieth century.

Expelled from Cuba and Czechoslovakia, crowned Prague May King, and placed on the FBI's Dangerous Security List all within the same year, Ginsberg later traveled to and taught in China, Russia, India, Australia, Latin America, Scandinavia, and Eastern Europe, where he received Macedonia's Struga Poetry Festival's Golden Wreath in 1986. A member of the American Academy of Arts and Letters, he won the University of Chicago's Harriet Monroe Poetry Award in 1991 and France's Chevalier de l'Ordre des arts et des lettres in 1993. As well as cofounding the Jack Kerouac School of Poetics at Naropa University, the first accredited Buddhist College in the Western world, he was distinguished professor at Brooklyn College from 1986 until his death in 1997.

Dr. Joseph Gross (1931–2020) was raised in Brooklyn, NY, where early he picked up a gritty and ironic case of "street smarts," a lifelong taste for exotic locales, and a hunger for the camaraderie of kindred bedeviled creative spirits from the outer boroughs. After the usual trajectory of Stuyvesant High School, City College, and Columbia U., he spent the next six years at medical studies in Geneva, Switzerland, developing the continental arts of savoir faire / savoir vivre, before returning to NYC at the close of the '50s to take up cudgels of psychiatric training and practice. Several years of serious research in sleep and dreams at the Mt. Sinai Hospital gave an expanded dimension to the realm of the mind—ss did a most challenging and exceptional psychiatric practice, dealing with a pitiless assortment of mad, creative geniuses.

Paola Igliori, writer, publisher, filmmaker, and poet, was born in Rome, Italy. She first moved to New York in 1980, where in 1991 she became the publisher of Inanout Press—producing, amongst many other books, the first edition of *American Magus*. Her first film project, a feature-length documentary of the same title, premiered at the Anthology Film Archives, New York, in 2001. In 2003, she returned to Italy, where she founded and runs Villa Lina Bio-Officina, a multidisciplinary and multicultural association that conducts seminars, conferences, and creative research. Her anthological and biographical book, *Red Flower Vision: An Esoteric Memoir*, was published in 2021 by Wild Embers Press, Portland.

M. Henry Jones (1957–2022) began making animated films at age thirteen, and pursued animation and 3D photography for the rest of his life. His film *Soul City* was a groundbreaking experiment in color and sound synchronicity. The film toured most major museums and directly influenced the rock video format. Moving images and 3D were his principal obsession. He continued to work with lenticular photography but moved increasingly on to the fly's-eye lens, which he saw as a logical extension of the delight he found early in animation.

Kasoundra Kasoundra (1936–2021) wrote in 1996: "Double Gemini, as I see myself now—near death experience—(change) etc. has given me more strength—my skin sweats art, culture primitive, and soul—All Beauty is Truth."

Jonas Mekas (1922–2019), poet and film director, was born in 1922 in the farming village of Semeniškiai, Lithuania. In 1944, he and his brother Adolfas were taken by the Nazis to a forced labor camp in Elmshorn, Germany. At the end of 1949, the UN Refugee Organization brought both brothers to New York City, where they settled down in Williamsburg, Brooklyn, where he soon got deeply involved in the American avant-garde film movement. In 1954, together with his brother, he started *Film Culture* magazine, which soon became the most important film publication in the United States. In 1958 he began his legendary Movie Journal column in the *Village Voice*. In 1962 he founded the Film-Makers' Cooperative, and in 1964 the Film-Makers' Cinematheque, which eventually grew into Anthology Film Archives, one of the world's largest and most important repositories of avant-garde cinema, and a screening venue.

Bill Morgan (b.1949). Writer, archivist, and painter. Educated at University of Pittsburgh, master's fine arts. Exhibited at galleries in New York (OK Harris), Washington, and Boston. Publications include *I Celebrate Myself: The Somewhat Private Life of Allen Ginsberg* and *The Typewriter Is Holy: The Complete Uncensored History of the Beat Generation*. Morgan has also edited more than twenty books by members of that group including Lawrence Ferlinghetti, Allen Ginsberg, Jack Kerouac, William Burroughs, Gregory Corso, and others. As archivist he has organized archives of Allen Ginsberg, Harry Smith, Arthur Miller, Oliver Sacks, and Anne Waldman.

Rani Singh is the director of the Harry Smith Archives. Purported by Smith to be a princess from the Mughal Empire and fluent in several languages, her Punjabi isn't all that proficient. She met Smith at Naropa Institute in 1988 and was his assistant until his death in 1991. Previously she worked as director of special projects at Gagosian Gallery and in Modern & Contemporary Collections at the Getty Research Institute, Los Angeles. Singh joined the Getty in 2000 as a scholar based on her work on Harry Smith. She was responsible for the placement of the Harry Smith Papers there, and the acquisition by the Bob Dylan Center, Tulsa, OK, of Smith's books and records. An arts professional based in Santa Monica, CA, Singh's work focuses on strategic planning and legacy management for artists and artists' estates.

Philip Smith was born a Virgo at the end of the 1967 Summer of Love, and has alternately followed and repudiated a bohemian career during the ensuing years. As a member of the music group Lhasa Cement Plant, he helped fashion unauthorized private soundtracks for the films of Harry Smith and Jordan Belson. A Faustian bargain with economism (cf. A. J. Nock) has obliged him to edit the cheapest American editions of Western literature.

James Wasserman (1948–2020) played a key role in numerous seminal publications of the Aleister Crowley literary corpus. Three of these include his supervision of Weiser's 1976 edition of *The Book of the Law*; his improved second edition of the Thoth tarot deck, published in 1977; and *The Holy Books of Thelema*, a collection of Crowley's inspired (Class A) writings, published in 1983. Harry Smith generously allowed the OTO. to use four of his previously unpublished Tarot designs for the cover of the 1988 paperback. Wasserman's groundbreaking edition of *The Egyptian Book of the Dead*, published in 1994 by Chronicle Books, also bears the stamp of Harry Smith, as Smith shared his love of hieroglyphics with his then-young student. Wasserman's *In the Center of the Fire: A Memoir of the Occult 1966–1989* was published in 2012 by Ibis Press.

Lionel Ziprin (1924–2009), Jewish mystic, poet, and artist, was born and died on the Lower East Side of New York City. Together with his wife, Joanne, he formed the nucleus of a hidden group of creators, beginning in the early 1950s, who had a foundational influence on what was to come. For over half a century, Lionel was deeply esteemed by associates ranging from Harry Smith and Bruce Conner to Thelonious Monk and Bob Dylan. Per Ira Cohen, "He was much larger than a poet … He was one of the big secret heroes of the time."

Harry Smith walking in the Meatpacking District, New York, 1988.
(Photograph by Brian Graham.)